POWER, SPEED & AUTOMATION
WITH ADOBE® PHOTOSHOP®

Titles in the *Digital Imaging Masters Series*:

Power, Speed & Automation with Adobe Photoshop
by Geoff Scott and Jeff Tranberry

*Color Management & Quality Output: Working with Color
from Camera to Display to Print*
by Tom Ashe

*Tools, Techniques & Workflow for Photographers: Using Art
and Science to Realize Your Vision*
by Jodie Steen, Andy Batt, and Candace Dobro

Ideas & Inspiration: To Help You Teach and Learn Photography
by Katrin Eismann

Praise for the series:

Sounds like as close to a dream team as one could get without having to resort to spiritual means. I mean if you could get Ansel Adams to do a section on black and white and landscape–great, but that would require a séance. For the talent living this is a dream team.

– Robert Barnett, QBToo (formally PC-Review Online)

We loved our old Time/Life series of photography books. Time for an update. This series could become iconic.

–Anne Pfeiffer, Instructor

I think that Katrin Eismann's skill in curriculum development is reflected in the approach. I like the approach a lot; I would find it to be a valuable resource and would expect to turn to the texts often for advice.

– Mark Lewis, SUNY Empire State College

I think there is a good balance of technical vs creative.

– Carol Tipping, FRPS EFIAP

I think many of the books on the market are software driven, whereas this series is developed to support the photography industry. There is a world of difference between explaining a feature of a software package and explaining how to get an important photography task accomplished through a software tool.

– Douglas Barkey, The Art Institute of Pittsburgh

POWER, SPEED & AUTOMATION

WITH ADOBE® PHOTOSHOP®

Geoff Scott and Jeffrey Tranberry

SERIES EDITOR KATRIN EISMANN

 Focal Press
Taylor & Francis Group
NEW YORK AND LONDON

First published 2013
by Focal Press
70 Blanchard Road, Suite 402, Burlington, MA 01803

Simultaneously published in the UK
by Focal Press
2 Park Square, Milton Park, Abingdon, Oxon OX14 4RN

Focal Press is an imprint of the Taylor & Francis Group, an informa business

Notices
Knowledge and best practice in this field are constantly changing. As new
research and experience broaden our understanding, changes in research
methods, professional practices, or medical treatment may become necessary.

Practitioners and researchers must always rely on their own experience and
knowledge in evaluating and using any information, methods, compounds, or
experiments described herein. In using such information or methods they should
be mindful of their own safety and the safety of others, including parties for whom
they have a professional responsibility.

Product or corporate names may be trademarks or registered trademarks, and are
used only for identification and explanation without intent to infringe.

Library of Congress Cataloging in Publication Data
Scott, Geoff, 1968-
 Power, speed & automation with Adobe Photoshop / Geoff Scott, Jeffrey Tranberry.
 p. cm.
 1. Adobe Photoshop. 2. Photography—Digital techniques. I. Tranberry,
Jeffrey. II. Title.

 TR267.5.A3S38 2012
 771—dc23

 2011051838

ISBN: 978-0-240-82083-5 (pbk)
ISBN: 978-0-240-82094-1 (ebk)

Contents

Foreword

Every day most of us rely on and use machines, gadgets, and software, but, in all honesty, we have very little idea about how they really work. I'll be the first to admit that the combustion engine baffles me. I'm also a bit envious of the people whose automobiles aren't noisy mysteries and who can change the oil without having to make an inconvenient appointment.

When it comes to Photoshop, many of us have never looked under the hood and are just glad that we know where the gas goes, so to speak. If you want to tune-up your Photoshop engine and take control of your image processing with a deep-dive into Photoshop's preferences, settings and workspaces; if you want to a learn how to automate Photoshop with actions, batching, and scripting . . . then you are holding the key that will put you into the driver's seat.

Even more important than understanding what the many dials, sliders, and scripts do, you'll learn to appreciate that processing one image can be the starting point for processing hundreds, so that you can get back to taking better pictures rather than wasting time slogging through mind-numbing, repetitive image processing.

If all this talk of cars, combustion engines, and scripting make you anxiously lace up your sneakers, then allow me to introduce you to Jeff Tranberry and Geoff Scott, the talented authors of this book. Jeff and Geoff understand Photoshop on a very deep level, as they are both dedicated software developers with many years of experience at Adobe Systems. They wrote this book with the understanding that harnessing Photoshop's power—to process many images very quickly—is only meaningful when it allows you to have more time to make better pictures.

Jeff is an artist turned product manager and Chief Customer Advocate for Adobe Systems Digital Imaging Team, which means that he both develops Photoshop and also listens to and works with many customers to understand how they use it. Geoff is an educator and photographer who was a Senior Computer Scientist at Adobe Systems for seven years. He worked in the Digital Imaging group on Photoshop and Photoshop Elements and began using Lightroom nearly a year before the product was available to the public. Both Jeff and Geoff have taught classes, given presentations, and spoken about the tools of digital photography to groups large and small.

I have known both Jeff and Geoff for many years, and it was within my role as the Chair of the Masters of Digital Photography program at the School of Visual Arts in New York City that I was able to formalize our relationship. Jeff developed and taught the "Scripting & Automation" class for our online program while Geoff was a student in the inaugural year of the online program. As a faculty member in the program, I teach "Advanced Imaging Techniques," and you can imagine how intimidated I was to have a former Adobe software developer in my class. But as all his classmates and I quickly learned, Geoff was a gracious and generous student who applied himself fully and creatively to develop his deep photographic talents, whose images grace the pages of this book. As a teacher, Jeff understands how to break down the complex into manageable building blocks of understanding. I am thrilled that they have collaborated so successfully to create this book on a subject matter that many understand to be important, but do not have the deep understanding to articulate. Jeff and Geoff have done that for us—and now we'll all work more quickly and efficiently because of their effort.

Finally, let me tell you something that I tell all of my faculty members, "Moving sliders and adjusting parameters is never the end goal—creating compelling images is." So, take the time to apply the knowledge in this book, and it will give you more time to create better and more meaningful images.

Katrin Eismann
February 2012

INTRODUCTION

Who What Where Why How or, Rather, Why Who How What Where

Why You Should Read This Book

"It is very easy to be different, but very difficult to be better."

— Jonathan Ive

Have you ever wished Photoshop would do your work for you? Have you ever wanted Photoshop to do it your way? Do you know that you could have both? What you really want is to customize Photoshop. The application already has many features built into it to make you work faster and smarter. Many of these features support your ability to do tasks the way you want. You can build up recipes for your own techniques. You can automate complex tasks to become buttons to push. You can even go beyond the simple customizations to build your own user interface pieces.

Photoshop supports all these things and much more. Not many people know about these techniques. Many who do choose not to spend the time to learn them. You do not have to be an engineer on the Photoshop team to increase your skills at controlling Photoshop.

There are a lot of beginners using Photoshop. There are very few Photoshop engineers. Beginners can make general changes to the way Photoshop works. The engineers can change the smallest pieces of any part of what the application can do. Everyone works with the user interface of the application. There is a surprising amount of power at even this level of control. Each technology shown in Figure I.1 is a new skill set for controlling Photoshop. The more skills you have in Photoshop, the more control you have over how it works. More control means the ability to focus the customizations you make from general to very specific.

This book cannot teach you how to be a Photoshop engineer. It cannot get you access to the source code. If you work through this book, though, you can increase the amount of control you have over Photoshop, ending with a mastery of scripting the application. Going beyond scripting requires professional coding tools and skills not covered in this book.

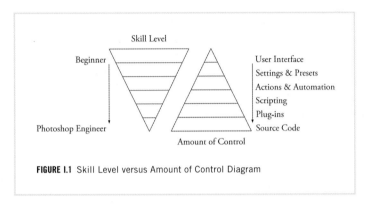

FIGURE I.1 Skill Level versus Amount of Control Diagram

Don't panic. You do not have to be an engineer to learn this stuff. You just need to have a sense of adventure, some patience, and a willingness to work through some ideas that seem difficult when they are first introduced but can become comfortable friends the more you work with them.

Speed

There is never enough time. The number of tasks requiring your time fills up any available space in your day. So it makes sense that one of the first things you want to do is customize Photoshop to speed up your work. There are a few ways to achieve this. You can change how you work in Photoshop. You can change how Photoshop works. You can even change your computer. Just a few simple shortcut keys can speed up how you process or create in Photoshop. You can build your own dialogs or panels customizing the interface. From tuning the application for your hardware to streamlining the menus to filling in the copyright metadata for your photos and beyond, you can save time with customization.

Power

With great power can come great complexity. There is no doubt that Photoshop is a powerful application. The range of what it can do is wide. Anyone doing any kind of visual processing can find tools and features for their work in Photoshop, particularly with Photoshop Extended. There is more than just the scope of how it can be applied to visual information.

There is also a depth to those abilities. There is a level of control over the information and an expressiveness in the available tools. Photoshop is a deep and wide piece of software. Is it any wonder why there are so many books written about it? Is it any wonder why so many people feel they do not use much of its power in their own work?

Part of the problem with all that power is the complexity involved in using it. The user interface is not simple. Many features are hard to notice. Many people do not realize what is already in the application, let alone how to use it. It is hard to be all things to all people. Adobe cannot cut out features or tune them for a specific audience. You can. This book teaches you how to find the power and make it available for your use.

Automation

The promise of computers for many years was automation. Set up a process, then let it run. We have come up with more uses for computers than this, but automation is still part of the fundamentals of computers. Many people do not know that Photoshop can be used for this purpose. Automation can be broken down into four types: one-to-one, one-to-many, many-to-one, and many-to-many. Photoshop has capabilities for each of these types.

One-to-one automation is taking a single file and processing it to create a single, new file. One example is taking a color photo and processing it to be black and white. So is taking a TIFF file and saving it as a JPEG. This type of automation is the most common, and its end goal is repeatability. The task produces predictable results, each time, reliably.

One-to-many automation is taking a single file and creating multiple files from that one file. This task can be just a simple exporting of each layer of a PSD file into individual files. It can also be a more automated process of taking a single image and creating many versions at different sizes or file formats.

Many-to-one automation takes a bunch of files and combines them into a single resulting file. What is a panorama photo but one photo from a combination of many others? Or perhaps building up a single file using a template, adding multiple images into it, and even some data from

a spreadsheet? Panoramas and similar techniques are described in many good books. The second example is described in this book.

Many-to-many automation takes many files and uses them to create many more. How about doing any of these operations to a folder full of image files?

Automation is a way to do all these things. You have to spend time setting up the automation, but the payoff is that the setup takes less time than doing the individual operations yourself. When you are working over a large number of images or a complex process, automation techniques become reliable, repeatable, predictable, and time saving.

Who This Book Is For

"There comes a time when no one's actions but your own seem dramatically convincing."

— **John Ashbery**

This book is written for anyone working with Photoshop who knows there must be some way to do work faster, that there might be a shortcut key for some obscure menu item, and if there isn't one, that there should be a way to specify one. If this is you, know that you are certainly correct.

This book is written for anyone trying to solve atypical problems with Photoshop. These are the problems beyond those for which someone might ask you if you used Photoshop to create an image, such as replacing a person's head with that of a giraffe or zebra. Other books explain those types of techniques. This book explains, for example, how to resize, process, and rename all the images for use in a printed catalog, an online catalog, and a phone, all at the same time while you sleep. Or how to create student ID badges for the new class of 1,200 freshman so that they have them the next day. If this is you, your problem-solving skills with Photoshop are going to get sharper.

This book is written for anyone who thinks it would be cool to build a dialog to automatically make test strips for levels of sharpness to produce a master

print, or wants to have a panel in Photoshop that updates with the tips posted on a blog, or is always accidentally deleting the current layer when pressing the Delete key. If this is you, prepare to make a few things.

Even if you really do not fit any of these categories but want to work smarter in Photoshop, this book is for you.

Assumptions About the Reader

This is not a book for beginners to either Photoshop or their own computer. There are plenty of good books on both subjects. You should know the basics about using Photoshop. It is admittedly a very deep and wide application. Many people using Photoshop daily admit that they know only about 15 to 25 percent of the power available to them. The fact is that many people use different parts of the application. That's okay. As long as you can use the tools, find the menus, understand what a selection is and might be used for, know what an adjustment layer does, and have played with filters, you'll be fine.

You also do not need to know how to write code. This book teaches you those skills, and not all at once. You learn the basics of how to create a script and communicate with the computer. If you already know how, then those parts are easy to skip over, so you can learn just how to communicate with Photoshop itself. You do not need to be a code monkey to do the work in this book.

You do need to be willing to work through some long examples. Completing them can require time and concentration. The ideas are not always immediately obvious. You cannot let that bother you. Remember that Photoshop is deep and wide and that you already know how to swim.

How to Read This Book

"Deciding what not to do is as important as deciding what to do."

— Steve Jobs

Guideline to Learning

This book was written with the belief that the best way to learn is to do. It is full of definitions, but it is really full of examples. These examples are there for you to work through. Step-by-step instructions (sometimes many steps) are provided to walk you through exactly how to use a feature, or build a new piece, or understand what is possible. Some examples build on previous examples. Some are short. Some are long. Each is provided to facilitate your understanding of the subject.

Each example is in some way a problem to solve. That is what you are doing with this book—solving problems. No problems? No reason for this book. These are not math exercises, though it may seem that way at times. These are more like the problems of putting the pieces of a puzzle together in the right order. For some pieces, the order matters; for others, it does not. But as with many problems, there can be a few issues along the way. Sometimes you have to hit the roadblocks to know they are even there to find. Sometimes you must troubleshoot what is happening to really understand the problem better and your solution to it. Customization is an iterative problem. You do something over and over again to tune it to the problem until it does exactly what you want.

The key really is to work through the examples. By doing the work, you learn where in the application things are located. You build up a set of references to make your own changes and solve your own problems. In some cases, the pieces you build with the examples can easily be used in other customizations.

For the most part, the chapters build on one another. In the beginning of the book, this arrangement is a bit loose. By the second half of the book, though, it is much tighter. Skipping chapters can lead to missing key information, assumed knowledge, in later chapters.

Remember, simply reading a book to improve your Photoshop skills is like reading a book to improve your skills with a camera. You must practice the ideas to get the experience, to get comfortable with them, and to be inspired.

Explorations

Although the hope is for you to read each chapter and then play further with the new knowledge, the goal is to help you learn. To that end, many chapters have an "Explorations" section detailing some projects for you to attempt with your new skills. Consider them challenges for your creativity and a chance to find how to solve a problem in your own way.

Where Is the File Located?

Photoshop can create a lot of files beyond those storing image data. Many are used to customize Photoshop to your specifications. You can discover exactly where to find many of these files in these sections throughout the book.

Coding Concepts

This book teaches you how to write code, specifically scripting code. Programming a computer is a complex subject, but there are simple things you can learn that open up the power of Photoshop. The "Coding Concept" sections describe the basics of coding. If you already know how to code, you can easily skip these sections. The sections are not specific to Photoshop, but understanding the topics in each is necessary to be able to fully use scripting.

Conventions Used in This Book

Distinguishing words that are the ideas the book is describing from the names of controls in a window or the variables that appear in the scripts can be difficult. It can get *really* confusing. To make text easier for you to read, the book uses these conventions:

Normal book text Is shown using this font.

User interface text Is shown using this font. These words appear in parts of the operating system and application interfaces, such as the titles of dialogs, menu items, folder names, and so on.

`Scripting code` Is shown using this font to approximate how the text displays in the tools used to write the code.

What the Requirements Are

"We all have operating instructions. Some have thicker books than others."

— **Chris Mahoney**

It's a fact of life in the computer industry that everything changes. That world never seems to stand still. The power and capabilities of computers increase regularly. Each new version of the software takes advantage of these changes to offer more capabilities for the customers. And so we learn to live with requirements placed on us. This book has requirements, so it can describe the techniques for the most people and still be up to date on what is possible.

Your Software

Photoshop is the biggest requirement for this book, for obvious reasons. Although many of the features described in the book exist in previous versions of Photoshop, some of the technology is recent. You learn more if you have any of these versions installed on your computer:

- Adobe Photoshop CS4
- Adobe Photoshop CS4 Extended
- Adobe Photoshop CS5
- Adobe Photoshop CS5 Extended
- or later

This is not a book about Lightroom, but the application is mentioned. There is at least one example directly using it. Lightroom is not a requirement for this book, but if you have it installed, please be sure it is either

- Adobe Photoshop Lightroom 2
- Adobe Photoshop Lightroom 3
- or later

Your Computer

The real requirement for your computer is to be able to run the version of Photoshop that you use to work through the examples. The examples are shown using Photoshop CS5 Extended on Mac OS X 10.5.8, but Windows works just as well for learning the material. The recommended operating system versions are

- Macintosh OS X 10.5 or later
- Windows XP with Service Pack 3, Windows Vista, or Windows 7

Your computer should also have enough RAM and hard drive space for you to run Photoshop smoothly. Most newer computers are just fine for this. Recommended for older computers are at least 1 GB of RAM and 10 GB of hard drive space. More of either memory type is good for doing professional work with Photoshop, but is not required for learning the material in this book.

Where This Book Comes From

"All the effort in the world won't matter if you're not inspired."

— Chuck Palahniuk

The Class

At PhotoshopWorld Boston in April 2009, Katrin Eismann approached Jeff Tranberry about teaching a class on Photoshop Scripting and Automation. Jeff had led workshops on the subject. He was not a programmer but wanted to open up the power of scripting to artists and photographers. The School of Visual Arts was just starting up an online version of its Masters in Professional Studies degree in Digital Photography. Since Jeff lived in Minneapolis and not New York, the opportunity to teach the online version of the class made sense. He accepted the offer.

That spring, Jeff reached out to a few of his Adobe, and former Adobe, friends to get feedback on the class he was developing. One of those was Geoff Scott. Jeff and Geoff had worked together in the Photoshop interface engineering group. Although they had never worked on the same features, they became friends after discovering a mutual interest in comic books. Their meetings usually involved a good meal at a restaurant chosen by Jeff and a long conversation about comics.

Geoff left Adobe in late 2008 and quickly applied to get into the SVA online program. Previously, he had been getting further into photography, as well as teaching classes on Lightroom and other digital tools. He decided to pursue a new career in digital photography, moving away from his career as a software engineer. A master's degree in digital photography was a first step to that goal.

So the two friends' paths crossed again from different directions. Jeff Tranberry taught the class, and Geoff Scott was a student in the class. When Geoff wrote back that he would be in that first class, Jeff jokingly responded, "If you take the class I'm working on, you gotta promise not to show me up too much!"

The Authors

Jeffrey Tranberry is a Product Manager and Chief Customer Advocate for Adobe Systems' Digital Imaging team. He is a 10-year veteran on the Adobe Photoshop Product Development team and is a huge nerd.

Geoff Scott is an educator and photographer. He worked in the software industry as an engineer for 20 years, the last 7 years at Adobe on Photoshop and Photoshop Elements.

Jeff and Geoff both pronounce their names the same way. Both still enjoy reading comic books. Jeff lives in Minneapolis, Minnesota. Geoff lives in San Diego, California. It's been awhile since they had a good meal together.

Acknowledgments

Tom Ruark is the chief architect and engineer of Photoshop scripting. Without his continued work extending the customer's reach into the application, much of this book would not exist. Our special thanks to him, the many people who work on W10 in San Jose, those of the Adobe Minnesota office, the former Adobe San Diego office, and the rest of the Adobe teams worldwide. Our thanks also to Russell Brown and Julieanne Kost for their continued support and inspiration.

For providing interesting script examples and being a great resource, we thank Mike Hale, xbytor, and all the other scripting nerds at ps-scripts.com.

There are many people behind the scenes of a book who make it happen. For pushing the project forward and providing valuable feedback, we thank our agent Neil Salkind, Stacey Walker and Cara St. Hilaire of Focal Press, Chris Casciano, and Candace Dobro. A special thanks to Stacy Swiderski for allowing us to include her in the book.

This book grew out of a class taught at the School of Visual Art for the Masters of Professional Studies in Digital Photography degree. We thank all the in-class and online instructors of that program, as well as Tom Ashe, co-chair of the program. A very special thanks to Katrin Eismann, co-chair of the program, for making this book happen and for asking us to write it.

Jeffrey Tranberry would like to thank his wife, Rachel, and two beautiful daughters, Sophia Maxine and Stella James, for being so patient and understanding.

Geoff Scott would like to thank Moose Peterson, Tony Corbell, and Laurie Rubin for all the encouragement over the years, and also a huge thanks to his parents, sister, and family for all their understanding.

One

CUSTOMIZING

How You Work in Photoshop

Changing the User Interface for Your Work Style and Speed

The designers at Adobe work very hard to make the user interface the best. They are a voice of authority trying to do well by their customers with the tools presented. The job is difficult when you consider the different customer types buying Photoshop: photographers, web designers, graphic artists, comic book colorists, scientists, animators, 3D modelers.... It is hard to be all things to all people. Fortunately, Adobe engineers have made the system flexible. You might not need all the tools or all the panels available. Some keyboard shortcuts might be wasted on features you never use. That's not a problem. You can change all of that. Changing the user interface to speed up your workflow is the first step in making Photoshop do what you want to do quickly and repeatedly.

Keyboard Shortcuts

Nearly all commands in Photoshop are optimized to have keyboard shortcuts. These shortcuts help you to work quickly on your images. How does this happen? Think about a surgeon at the operating table. The surgeon asks for a tool, and another doctor or a nurse places it in the surgeon's hand. The surgeon does not spend time looking for a scalpel and remains focused on the patient. The same working relationship can happen with mechanics fixing a car. Many professional photographers have assistants performing the same type of service, so the photographer can remain engaged with the client, instead of worrying about the lights or the lens or how many photos are left on the compact flash card. Keyboard shortcuts are your assistant inside Photoshop. Your hands ask the keyboard for a tool, and you remain focused on your work, instead of looking through menus.

Think about the following scenario in Photoshop. You add a Curves adjustment layer by using a keyboard shortcut. Next, you press the **B** key to select the Brush tool. You press **D** to set the foreground color to black, so you can start masking your adjustment. You change the softness and size of your brush using the bracket keys (**[]**) to deftly create a mask around an object you want the adjustment to affect. You make

a mistake with your mask, so, with your cursor still over the area of the mask that you want to paint back into with white, you press the **X** key to swap the foreground and background colors. You want to compare the image with the mask and without it, so you click on the mask in the Layers palette with the **Shift** (⇧) key pressed to disable the mask. Something does not look right with the effects of the mask. You click again on the mask with the **Shift** (⇧) key pressed and then click again on the mask with the **Option** (⌥) key pressed to view just the mask without the image shown. You notice that the last paint stroke is not needed, so you press ⌘ + **Z** to undo the last paint stroke. Your mask completed, you click the mask again with the **Option** (⌥) key pressed to see the finished image.

Everything in this scenario was done fluidly, without your stopping and starting to switch tools in the Tool Bar or the type of brush used or the color the brush painted. It all happened quickly and easily with your concentration on the image, not on the tools.

> Commit yourself to memorizing several keyboard shortcuts a week. Every time you choose a new command, determine whether the command has a keyboard shortcut associated with it, memorize it, and use it the next time you use the command. Before long, you'll have all your most common operations memorized. You will spend time thinking about your intentions with the image you develop instead of where a tool or menu item is located.

Discovering Keyboard Shortcuts

Keyboard shortcuts appear throughout the Photoshop user interface (see Figure 1.1). They are shown in the menus next to the commands they represent. They are in the tooltips displayed when you move a mouse cursor over a tool. They can appear in panels in the lists. Keep your eyes sharp as you use Photoshop and you will see the shortcuts you want to use over and over again.

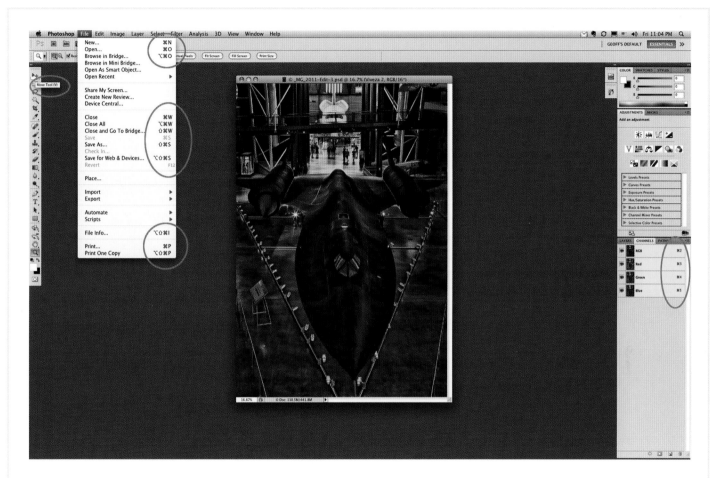

FIGURE 1.1 Places to spot keyboard shortcuts in the Photoshop user interface.

The menus are the easiest place to spot keyboard shortcuts. You might notice that some strange symbols appear next to the shortcuts. In Figure 1.1, notice that the shortcut for **Save for Web & Devices…** is ⌥ ⇧ ⌘ **S**. This indicates that pressing the **Option** (⌥) key and the **Shift** (⇧) key and the **Command** (⌘) key and the **S** key at the same time will invoke the **File > Save for Web & Devices…** command, just as if you had selected it from the menu.

The keys on the keyboard represented by the symbols are known as *modifier keys:*

⌘ **Command** key on Mac / **Control** key on Windows

⌥ **Option** key on Mac / **Alt** key on Windows

⇧ **Shift** key

For menu commands, you almost always press the ⌘ key and another key at the same time. When you are writing about keyboard shortcuts, the convention is to write the keys with the plus (+) character between them to indicate that all keys are pressed at once. For example, ⌘ + S is the keyboard shortcut for saving the current document.

Switching between tools is different from using the menu commands. The shortcut key is simply the character for that tool. There is no need to press a modifier key at the same time. For example, to switch to the Hand tool, press the **H** key. To switch to the Brush tool, press the **B** key. The keyboard shortcuts for the tools are mnemonic, or nearly so, to help you remember them. Here are just a few examples:

B is for the **B**rush tool.

Z is for the **Z**oom tool.

I is for the eye (**I**) dropper tool

V is for the mo**V**e tool.

Finding the keyboard shortcuts for tools is easy. Learning the shortcuts is well worth your time, especially for tools that you use regularly.

You do have to be somewhat careful with the tool shortcuts. If you are typing with the Text tool, pressing the **B** key will type a B character without switching to the Brush tool. Most times, it is obvious when the tool shortcuts will work and when they won't. However, if you find yourself wondering why a tool is not changing, check that you are not typing in a number field or some other control.

Something you will start noticing as you learn keyboard shortcuts is that the more common the operation, the fewer keys needed for that operation. Remember that the shortcut for **Save for Web & Devices...** is

⌥ + ⇧ + ⌘ + S. The shortcut to save the current file is simply ⌘ + S. There are patterns to the shortcuts. Spotting the patterns will help you to remember them.

Useful Keyboard Shortcuts to Learn

Return and Escape Keys

The **Return** key and the **Enter** key both do the equivalent of clicking the **OK** button in a dialog. This is true beyond Photoshop in the operating system and most applications. This extends further to other operations where you can commit a change. For example, if you are transforming a layer, you will notice that the Options Bar shows two new buttons: a circle with a line through it and a check mark (see Figure 1.2). Pressing the check mark button will commit the transform changes you've made. Or you can simply press the **Return** key to do the same thing.

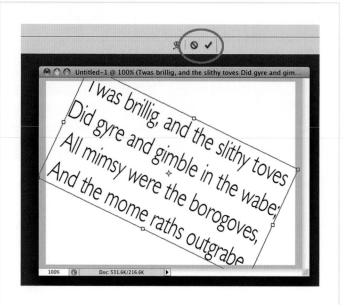

FIGURE 1.2 Cancel and Commit buttons displayed during a free transform of a text layer.

In that same example, if you were to press the **Esc** key, the transformation would be canceled, the equivalent of clicking the button that has the circle with the line through it. This keyboard shortcut also works in dialogs. Pressing the **Esc** key is the same as clicking the **Cancel** button in a dialog. Again, this is a standard for other applications and the operating system.

Option and Shift Keys

The **Option** (⌥) and **Shift** (⇧) keys are modifier keys. Typically, you press these keys when you press other shortcut keys. The resulting command tends to be related to what the command would be without the modifier. For example ⌘+**W** closes the current document. Pressing ⌘+⌥+**W** closes all the open documents.

When a dialog is displayed, pressing the **Option** (⌥) key turns the **Cancel** button into a **Reset** button (see Figure 1.3). Clicking the **Reset** button

(with the **Option** (⌥) key pressed) returns all the values in the various controls of the dialog back to their original settings. This allows you to experiment with the controls without ever losing the values Adobe thought might be most useful to you.

Similar things happen when you are using tools or selecting items in the user interface. For example, clicking on a mask in the **Layers** panel selects the mask (see Figure 1.4). Clicking on the mask with the **Option** (⌥) key pressed at the same time shows the mask only. Clicking on the mask with the **Shift** (⇧) key pressed disables the mask and shows the image without the layer mask. In both cases. clicking the mask a second time with the modifier key pressed returns the image displayed to normal.

A lot of useful functionality is available for many of the tools when you press the modifier keys. Unfortunately, the additional functionality is not easy to discover. These hidden handshakes are what often turn up in the

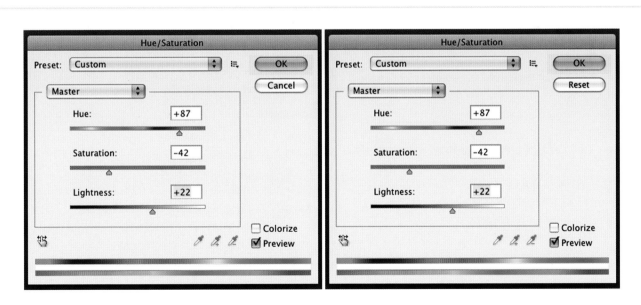

FIGURE 1.3 The Hue/Saturation dialog without and with the option (⌥) key pressed.

FIGURE 1.4 Layer with the mask selected, layer with the mask only shown, and layer with the mask disabled.

tips and tricks articles about Photoshop. Many useful shortcuts are included here.

Tool:

\<tool key\>	Switch to the tool currently shown in that tool slot
⇧ + \<tool key\>	Shift between the tools in the same tool slot
[Decrease brush size
]	Increase brush size
⇧ + [Decrease brush hardness
⇧ +]	Increase brush hardness
D	Set the foreground and background colors to black and white, the defaults
X	Swap the foreground and background colors
Q	Toggle Quick Mask mode on and off
space	Switch to the Hand tool while the **space** is pressed
⇧ + drag	Create straight lines or equilateral polygons

⌥ + **zoom tool**		Zoom out
⌥ + **brush tool**		Switch to Eye Dropper tool

Documents:

⌘ + **N**	New document
⌘ + **O**	Open document
⌘ + **S**	Save document
⌘ + **P**	Print document
⌘ + ~	Cycle through the open documents
⌘ + ⇧ + ~	Cycle backward through the open documents
⌘ + **W**	Close the current document
⌘ + ⌥ + **W**	Close all open documents

Document Views:

F	Cycle through the screen modes (standard, full screen with menus, full screen)
⇧ + F	Cycle backward through the screen modes

⌘ + + Zoom in
⌘ + − Zoom out

Note: Both of these zoom commands follow the default behavior you have chosen in the **General Preferences** window by either checking or not checking **Zoom Resizes Window**. Adding the Opt/Alt key to the shortcut (⌘ + ⌥ + + or ⌘ + ⌥ + -) will reverse the default preference.

⌘ + 0 **View** > **Fit on Screen**
⌘ + 1 **View** > **Actual Pixels**
double-click the Hand tool **View** > **Fit on Screen**
double-click the Zoom tool **View** > **Actual Pixels**
⌘ + **space** + **drag** Zoom to a particular place in the work area

Work Area:

Tab Hide/show panels

Layers:

⌘ + ⇧ + ⌥ + **N** New layer
⌘ + **J** Duplicate layer or new layer via copy
⌘ + ⇧ + **J** New layer via cut
⌘ + ⇧ + ⌥ + **E** New layer via merge visible
⌘ + **G** Group layers
⌘ + ⇧ + **G** Ungroup layers
⌘ + **** Select/deselect layer mask
⌘ + **2** Select/deselect channel composite
⌘ + ⌥ + **A** Select all layers

Transform:

⌘ + **T** Free transform
⌘ + **drag** on center point Skew
⌘ + **drag** on corner point Distort
⌘ + ⇧ + ⌥ + **drag** on corner point Perspective

Selection:

⌘ + **A** Select all
⌘ + **D** Deselect
⌘ + ⇧ + **I** Invert selection

Image:

⌘ + **I** Invert
⌥ + **delete** Fill with foreground color
⌘ + **delete** Fill with background color

History:

⌘ + **Z** Undo/redo
⌘ + ⇧ + **Z** Step forward in history
⌘ + ⌥ + **Z** Step backward in history

Changing and Creating Keyboard Shortcuts

Photoshop has a lot of tools and menu commands. It would be impossible or require too many fingers on your hands to assign a shortcut to everything. Despite the best efforts of the Adobe engineers, you might find that a tool you use regularly does not have a keyboard shortcut. Or it might have one that is so long as to be too uncomfortable to use. Don't panic. You can change the keyboard shortcuts to exactly what you want them to be.

Choose **Edit** > **Keyboard Shortcuts…** from the menus to bring up the **Keyboard Shortcuts and Menus** dialog (see Figure 1.5). Using this dialog, you can change or assign a keyboard shortcut for any of the commands from the menus, panel menus, or tools.

The Smudge tool does not have a keyboard shortcut. There are simply too many tools to assign one to it. Yet it might be one of your favorite tools, and you might use it on a daily basis. Here's how to assign it a keyboard shortcut:

1. Choose **Edit** > **Keyboard Shortcuts…** from the menus (notice that the menu item has a keyboard shortcut) to show the **Keyboard Shortcuts and Menus** dialog.
2. Change the **Shortcuts For:** pop-up menu to **Tools**.
3. Scroll down to show the Blur tool, Sharpen tool, and Smudge tool.
4. Click the list item to select the Smudge tool.

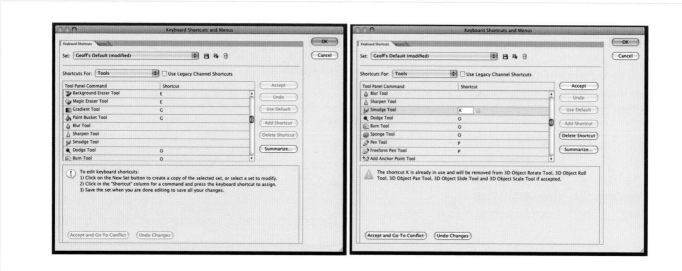

FIGURE 1.5 Changing the keyboard shortcut for the Smudge tool and the warning about doing so.

5. Type the letter **K** in the text field that appears in the list next to the tool.

 Photoshop beeps and notifies you that the keyboard shortcut was already being used by some of the 3D tools. If you accept the change, the shortcut is removed from the 3D tools.

6. Click the **OK** button (or press the **Return** key) to accept the changes and close the dialog.

The Smudge tool now has a keyboard shortcut (the **K** key) that you assigned to it.

Where Is the File Located?

You may have noticed in the **Keyboard Shortcuts and Menus** dialog that you can save the changes that you've made to a separate file. Normally, these changes are just saved with the Photoshop preferences. It is a good idea to save files like this for use on other computers or in case your preferences files get corrupted, accidentally deleted, or reset (see Figure 1.6).

FIGURE 1.6 Saving keyboard shortcuts to a .kys file.

Although you can save the file any place you like, by default, the new keyboard file (with extension .kys) is located at

Mac OS X:

/Users/[user name]/Library/Application Support/Adobe/Adobe Photoshop CS5/Presets/Keyboard Shortcuts/

Windows XP:

\Documents and Settings\[user name]\Application Data\Adobe \Adobe Photoshop CS5\Adobe Photoshop CS5 Settings\Presets \Keyboard Shortcuts\

Windows 7 and Vista:

\Users\[user name]\AppData/Roaming\Adobe\Adobe Photoshop CS5\Adobe Photoshop CS5 Settings\Presets\Keyboard Shortcuts\

Menus

When you went to the menus to edit the keyboard shortcuts, you may have noticed that there was a similar menu item for editing menus. Or perhaps when you looked at the **Keyboard Shortcuts and Menus** dialog, you noticed the **Menus** tab. If so, then you are starting to sharpen your eyes to find the things in Photoshop to make it easier and quicker to do your work. As you may have suspected, you can change the menus in Photoshop.

Changing the Menus

If you want to change your menus, follow these steps:

1. Choose **Edit > Menus...** from the menus to show the **Keyboard Shortcuts and Menus** dialog. The active tab is for the **Menus**.

 Similar to when the **Keyboard Shortcuts** tab is active, the dialog shows a list of menus and their menu items (see Figure 1.7). For each menu item in the menus and in the panel menus, you can change the visibility of the menu item and its display color.

2. Click the triangle icon next to **File** in the list to twist open the list and display the menu items in the **File** menu.

FIGURE 1.7 Dialog to edit the visibility and color of the menu items.

3. Click the eye icon in the Visibility column of **Browse in Bridge...** to hide the menu item from the active menus.

4. Click the **OK** button to accept the changes and close the dialog.

5. Click on the **File** menu to open the menu and see its menu items.

 Notice that the **Browse in Bridge...** menu item is missing. Normally, it would be displayed between **Open...** and **Browse in Mini Bridge...** (or **Open As Smart Object...** for older versions of Photoshop).

6. Choose **Edit > Menus...** from the menus to show the **Keyboard Shortcuts and Menus** dialog.

7. Click the triangle icon next to **File** in the list to twist open the list and display the menu items in the **File** menu.

8. Click the eye icon in the Visibility column of **Browse in Bridge...** to show the menu item again.

9. Click **None** in the **Color** column of the **Browse in Bridge...** menu item to show the color pop-up menu (see Figure 1.8).

10. Select **Orange** from the pop-up menu.

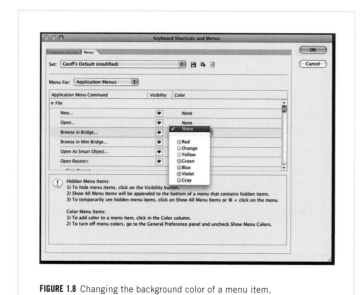

FIGURE 1.8 Changing the background color of a menu item.

important. The real reason why the Adobe engineers allow you to change the menus is that they want to give you the flexibility for situations that they might not know about. Having this capability also helps Adobe to teach you about new features, which is mentioned in the Workspaces section later.

Where Is the File Located?

As with the keyboard shortcuts, you can save the changes you make to the menus into a separate file, distinct from the preferences. You can save the file wherever you want. By default, the file (with an .mnu extension) is located at

Mac OS X:

/Users/[user name]/Library/Application Support/Adobe/Adobe Photoshop CS5/Presets/Menu Customization/

Windows XP:

\Documents and Settings\[user name]\Application Data\Adobe \Adobe Photoshop CS5\Adobe Photoshop CS5 Settings\Presets \Menu Customization\

Windows 7 and Vista:

\Users\[user name]\AppData/Roaming\Adobe\Adobe Photoshop CS5\Adobe Photoshop CS5 Settings\ Presets\Menu Customization\

11. Click the **OK** button to accept the changes and close the dialog.

12. Click on the **File** menu to open the menu and see its menu items.

The **Browse in Bridge...** menu item displays with black text on an orange background. By default, menu items are shown with black text on a white background. As just demonstrated, you can change the appearance of menu items using the **Keyboard Shortcuts and Menus** dialog. And you can undo those changes the same way, as you may want to do with the background color of the **Browse in Bridge...** menu item.

Why has Adobe gone through this trouble for you? Well, you might be working on a laptop. The Photoshop menus are very full, so perhaps you'll want to hide a few of the menu items to shorten them so they display better on a laptop. Perhaps you want to see only the menu items you use regularly. Perhaps there are certain commands you use a lot; color gives a menu item emphasis, making it that much quicker to find. Perhaps you are an educator teaching others which menu items are most

Frame, Docks, Bars, and Panels

The Photoshop user interface is built from many pieces. These pieces are encapsulated in containers. These containers are nested inside one another to keep them organized. Each of these containers has a specific name with specific functionality. You have some measure of control over many of them. Most of the time that control is obvious. Sometimes it is not as obvious.

Working from the outside container into the smallest container, each is described here.

Menu Bar

You should be familiar with the Menu Bar. On a Mac, it is at the top of the main monitor. On Windows, it is at the top of the application window. The Menu Bar contains menus, each containing menu items that send commands to the application. Customization of the menus has already been described in this chapter.

Application Frame

On the Windows operating system, applications have always run inside their own window. All other user interfaces elements are confined inside this single window. This paradigm was not common on the Macintosh operating system. The elements of an application's user interface usually were presented in multiple windows. These windows could mix and mingle with those of other applications. The past decade has seen a change in this arrangement as many applications consolidate to a single window. Instead of many floating windows, a single window shows all the functionality and documents available for that application. Some users consider this an easier way to manage all the pieces of an application. Some are comfortable managing all the windows without the confinement of a single window.

In Photoshop, this window is called the *Application Frame* (see Figure 1.9). You can show or hide the Application Frame by choosing **Window** > **Application Frame** from the menus. The Application Frame can be resized, maximized, minimized, and moved around like any other window. The document windows, panels, and assorted other elements inside the Application Frame are attached to the frame by default. However, these pieces may be removed from the frame to become standalone windows of their own.

Work Area

The work area is the space in which Photoshop displays the user interface. If you are using the Application Frame, the work area is the space inside the frame. If you are not using the Application Frame, the work area is the space inside the monitor (or monitors) that you are using. This area can be filled with other windows and other objects that take up space on the screen. This area does not include the Menu Bar.

Docks

Docks are containers on the edges of the work area that can hold other containers. The default docks are located at the top, left, bottom, and right of the work area. The docks are not visible. They just change the look and behavior of items placed inside them. They provide a convenient way to organize containers at the edges of the work area and leave space for the documents you work on in the middle of the work area.

By default, Photoshop has containers in docks on three sides of the work area. The top dock has the Application Bar and the Options Bar. The left dock contains the Tool Bar. The right side has panels organized into two dock columns. The dock at the bottom of the work area is empty.

Items inside the docks can easily be removed to become floating windows. For the Application Bar, Options Bar, and Tool Bar, drag them outside the dock using the grab bar. This widget is at the top of the Tool Bar and on the left side of the Application Bar and Options Bar. For tab groups or individual panels, drag by the title bar or the top of the tab group out into the work area. When these containers are removed from the docks, they can be placed anywhere in the work area and will float above any open document.

To place a container back into a dock, drag its title bar toward the edge of the work area. When the mouse gets to the edge, a thin blue bar will appear. This is the drop zone for the dock. Release the mouse and the container will be placed back into the dock.

As shown in the default setup for Photoshop, there are two columns of panels on the right side. Likewise, the Application Bar and Options Bar are located at the top. To extend a dock further out into the work area, move a container until the blue drop zone appears; then let go. A new column or row will appear for that dock.

FIGURE 1.9 Photoshop running as an Application Frame and ...

There are a few restrictions when it comes to which docks accept which containers:

- The top dock can hold only the Application Bar and/or the Option Bar.
- The bottom dock can hold only panels and their tab groups.
- The Tool Bar can be placed only in the right or left docks.

Application Bar

The Application Bar is docked at the top of the work area by default. If the Application Frame is being used, the Application Bar is the title bar for the application window. The Application Bar includes some useful buttons and menus to help you manage the many document windows that can be displayed by Photoshop. As with many of the containers,

FIGURE 1.9 ... without the Application Frame.

the Application Bar can be shown or hidden (see Figures 1.10 and 1.11). Choose **Window** > **Application Bar** from the menus to toggle its visible state.

Note: The Application Bar was added to Photoshop CS4 and has been removed from Photoshop CS6. This container may not be available for your use depending on the version of Photoshop you have installed.

However, all the functionality provided by the Application Bar can be found in the menus.

Options Bar

Each tool has options for its use. For example, the Brush tool has options to control the size, hardness, and opacity of the current brush, among many other options. The options for a tool are displayed in the Options Bar.

FIGURE 1.10 The Application Bar as part of the Application Frame.

FIGURE 1.11 The Application Bar floating in the work area.

FIGURE 1.12 The Options Bar floating in the work area.

By default, this bar is docked beneath the Application Bar. Choose **Windows** > **Options** to hide or show the Options Bar. Like the Application Bar, the Options Bar can be docked or can float. If floating, it can be placed anywhere in the work area (see Figure 1.12). It is restricted to being docked only at the top of the work area.

Tool Bar

The Tool Bar is located in the left dock by default. This container shows the various tools available in Photoshop to use on your images. Choose **Window** > **Tools** to hide or show the Tool Bar. The tools in the Tool Bar can be shown as a single column or as two columns (see Figure 1.13).

Press the double arrow icons at the top of the Tool Bar to toggle between these two states.

The Tool Bar can be docked only on the left or right sides of the work area. When docked, the Tool Bar takes up the entire column. It is not possible to dock another container below or above it. You can, however, dock containers on either side of the Tool Bar.

Tab Groups

A tab group is a container for one or more panels. Only one panel is fully displayed in a group. The title bars of the other panels are shown to allow you to switch between them easily. Panels can be grouped

FIGURE 1.13 The Tool Bar displayed with single and double columns, docked and floating.

FIGURE 1.14 All the panels in Photoshop CS5 displayed on a 1920 × 1200 pixel monitor.

together so that they take up less space in the work area. Photoshop has a lot of panels. Each new version seems to add more. Figure 1.14 shows what the work area might look like if all the standard panels in Photoshop CS5 were floating outside the docks, each in its own tab group.

By default, the panels in Photoshop are placed into tab groups that complement each other. There are usually three panels to a tab group. Most likely, you would use only one of those panels at a time. Other tab groups might show additional information or functionality useful to your current task. These groupings have been built up over the many versions

of Photoshop for your advantage. However, you might have your own way of organizing and arranging the panels, which you are free to do.

You can rearrange the order of the tabs in a group. Simply drag the title of one over the top of another and let go (see Figure 1.15). The tabs will change order.

You can move panels from one group to another by dragging the title out of one tab group and dropping it on the tabs of another. You can remove a panel from a group to be on its own by dragging it to an empty space in the work area (see Figure 1.16). Whether in a group with other panels or on its own, a panel is always inside a tab group.

Floating tab groups can even be linked together side by side (see Figure 1.17). Move one group over another until the edge of the bottom group turns blue; then drop it. The tab groups will link together. If you move the mouse too far, the whole bottom tab group will be outlined in blue. If you drop the group, all the panels in both groups will combine into a single tab group.

A tab group takes on the size of the panel being shown. Switching between the panels using the tabs resizes the group. This is true even when the tab group is docked. The smallest size for a group just shows the titles of its contained panels (see Figure 1.18). Double-click on the title of a

FIGURE 1.16 The Layers panel separated from its default tab group.

FIGURE 1.17 Two tab groups linked side by side.

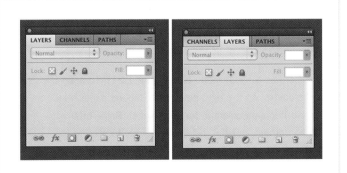

FIGURE 1.15 A tab group being reordered by dragging the Layers panel on top of the Channels panel.

FIGURE 1.18 A tab group reduced to its title height.

panel or the empty space next to the tabs to shrink the tab group to its title height. Double-click again to restore it to its previous height.

Each panel has a unique icon to represent it. A tab group can be displayed as a group of these icons. Click on the double arrow icon in the title bar of the tab group to change the panels to icons. Click the double arrows again to restore the tab group to its previous size. By default, the icons are shown with the panel names (see Figure 1.19). The icon group can be resized to just show the icons. Click on the edge of the group and drag to the left or right to change the size of the icon mode.

FIGURE 1.19 A tab group displayed as iconic with panel titles and without.

When the tab groups are in one of the docks, the same display rules apply. The group can be displayed as a set of icons or just the titles or as full panels. The tab group can be resized (if its displayed panel allows resizing). You can change the panels in each group, and you can change the ordering of the panels inside the dock. You can create a second column in the dock and have those tab groups displayed differently from the first column (see Figure 1.20). You have a lot of variations available for you to organize the panels how you want them to be displayed in the work area.

Panels

A lot of the functionality of Photoshop is expressed in small containers called *panels.* The controls in these panels are grouped together to make it easy for you to perform specific tasks. Panels frequently display information specific to that area of functionality. For example, the Layers panel shows you the title and order of each layer in a document. It also has controls and menus allowing you to manipulate the layers.

Each panel has a title and can be shown or hidden by choosing that title from the **Windows** menu. If a panel is currently hidden, choosing the menu item for that panel shows the tab group containing that panel and makes that panel the frontmost panel in the group. If a panel is currently shown, choosing the menu item for that panel hides the panel and the tab group containing it. Showing a panel places it back at its previous location. This is true whether the tab group had been floating or docked. The panel also shows at its previous size.

Each panel has a flyout menu (see Figure 1.21). To open the menu, click the control on the right side of the tabbed panel titles in a group. The menu items are specific for each panel. Some offer more menu items than others, but the menus are always located in the same spot. Click the panel menu control to see the menu, even if the panel is docked.

Many of the panel menus have a **Panel Options...** menu item. Choose this menu item to further customize the controls in the panel itself.

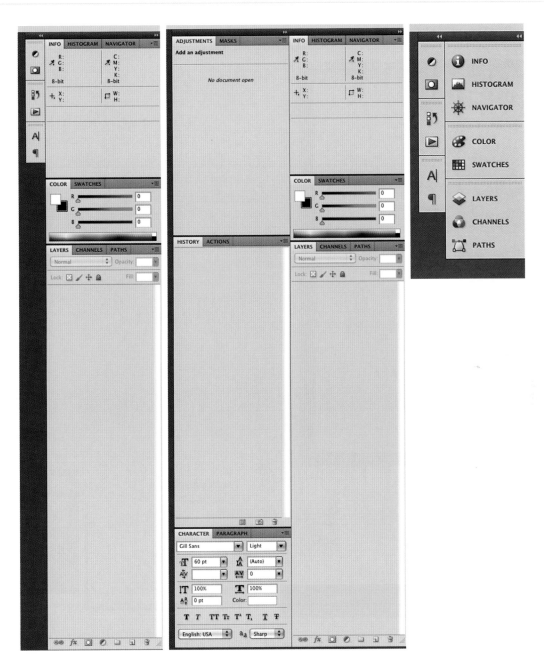

FIGURE 1.20 Docked tab groups displayed in a variety of ways in two columns.

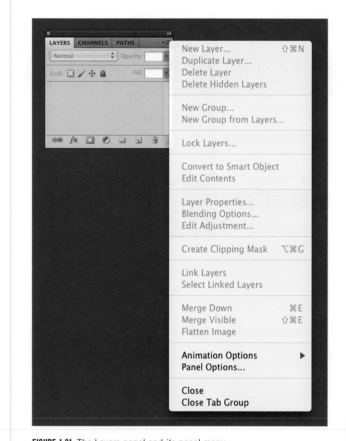

FIGURE 1.21 The Layers panel and its panel menu.

would not want to do it each time Photoshop ran. The good news is that Photoshop saves all this information, restoring it when you run the application again. Collectively, all this information is known as a *workspace.*

Workspaces are so useful that Photoshop allows you to save multiple workspaces and switch between them. Adobe even provides workspaces tailored to specific uses of Photoshop. There is a workspace for doing 3D work, one for painting, one for animation, and a few others. There is one that highlights the new features in the version you are running. (You might have wondered who changes the color of menu items.) There is also a default workspace called *Essentials.*

To switch between the different workspaces, select the workspace you want from the **Window** > **Workspace** menu (see Figure 1.22). You can also use the Workspace menu on the Application Bar to quickly switch between workspaces.

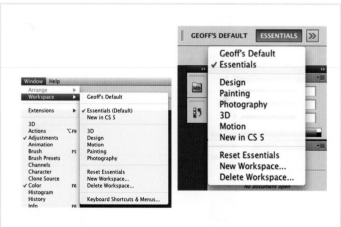

FIGURE 1.22 Switch between workspaces using the menu items in the Menu Bar or Application Bar.

Workspaces

At this point you've set up your custom keyboard shortcuts, perhaps changed some menu items, and placed all the containers in the work area where you want them. Doing all this is a lot of work. You

Follow these steps to switch between workspaces:

1. Choose **Window** > **Workspace** > **New Workspace...** from the menus or choose **New Workspace...** from the Application Bar.

2. In the **New Workspace** dialog (see Figure 1.23), type your name and the word **Default** into the **Name** field.

3. Click to check the **Keyboard Shortcuts** checkbox and click to check the **Menus** checkbox.

4. Click the **Save** button to save your new workspace.

FIGURE 1.23 The New Workspace dialog for creating custom workspaces.

Your workspace now appears everywhere you can switch between workspaces. Many people do not customize the menus or might not create custom keyboard shortcuts. If so, those options are not necessary for the new workspace. The locations and sizes of the various panels and other floating windows are always saved in the workspace.

For some versions, these scripts might only be copying the workspace files and placing them in the correct location. For other versions, like CS5, there is more going on. These are complex scripts that are simple to run.

Workspaces are considered so important that the Photoshop team releases a script to help you migrate the workspace data from one version to the next.

Custom workspaces are saved in their own files, potentially in two files. Photoshop saves your current changes to the workspace but also keeps a copy of the one you originally saved. Changes made to a workspace as you use Photoshop are saved to the modified version of the file. At any time, you can reset the workspace back to the last saved version by choosing **Window** > **Workspace** > **Reset** < **workspace name** > from the menus.

Where Is the File Located?

The originally saved workspace files are located at

Mac OS X (see Figure 1.24):
/Users/[user name]/Library/Preferences/Adobe Photoshop CS5 Settings/WorkSpaces/

FIGURE 1.24 Workspace file locations on Mac OS X.

Windows XP:

\Documents and Settings\[user name]\Application Data\Adobe \Adobe Photoshop CS5\Adobe Photoshop CS5 Settings\ Workspaces\

Windows 7 and Vista:

\Users\[user name]\AppData\Roaming\Adobe\Adobe Photoshop CS5\Adobe Photoshop CS5 Settings\Workspaces\

The most current workspaces, if changed, are located at

Mac OS X:

/Users/[user name]/Library/Preferences/Adobe Photoshop CS5 Settings/WorkSpaces (Modified)/

Windows XP:

\Documents and Settings\[user name]\Application Data\Adobe \Adobe Photoshop CS5\Adobe Photoshop CS5 Settings \Workspaces (Modified)\

Windows 7 and Vista:

\Users\[user name]\AppData\Roaming\Adobe\Adobe Photoshop CS5\Adobe Photoshop CS5 Settings\Workspaces (Modified)\

Useful Strategies with Workspaces

- Please do yourself a favor. Give each custom workspace a meaningful name.

- If you use Photoshop for multiple types of work (web design, photography, page layout…), save a custom workspace for each one. Some panels are more useful than others for certain types of work.

- Look through all the workspaces that Adobe provides. The designers at Adobe have learned a lot about how their customers use Photoshop. Take advantage of all that research and expertise in user experience as a starting place for your own workspaces.

Create your own workspace. Do not just change the default one. You may want to experiment, so you need to be able to return to the workspace you spent so much time building. And you might want to go back to the default workspace (Essentials) provided by Adobe.

Using More Than One Monitor

How you organize your panels and working environment will also be influenced by the number, sizes, and arrangement of the monitors you use.

If you're on a laptop with a small screen, you may choose to have more workspaces with smaller subsets of panels and switch between them for different tasks. On a system with a single monitor that's got more room, you may decide to have a smaller number of workspaces with more panels showing. Or, if you have more than one monitor, you may decide to have workspaces that incorporate your most-used panels on the main monitor and your lesser-used panels on the second monitor.

Another strategy is to use multiple monitors to organize documents and applications. For example, you may want to have the document you are working on located on your primary monitor and then have reference images or materials on a secondary monitor. Or you may use Photoshop on your primary monitor and have Lightroom or Bridge on your secondary monitor.

Exposé and Spaces

Other considerations for organizing your work area include Apple's Exposé and Spaces features. Exposé allows you to quickly see all your open documents arranged next to each other so that none are hiding behind another or to hide all windows quickly to locate a folder or file on your **Desktop**.

Spaces allows you to organize applications and windows into groups. It is similar to custom workspaces in Photoshop, but it applies to your entire **Desktop**, not just to Photoshop alone. Spaces allows for up to four configurations for your **Desktop**, which you can easily switch between. For example, you could have one space dedicated to office applications, another dedicated to your web browser and iTunes, a third dedicated to Photoshop, and the fourth set up for Bridge or Lightroom. That way, each space is dedicated to a specific task, reducing the visual clutter of having all the applications open at once.

You set up Exposé and Spaces in the System Preferences. By default, the **F9** key activates Exposé, and the **F8** key shows you all your Spaces desktops in one view. (If you're using a laptop, you also need to press the **fn** key.) You can also switch between Spaces using the drop-down menu (an array of rectangles with a number in the middle) from the right half of the menu bar.

FIGURE 1.25 Four document windows all combined into a single tabbed document window.

Document Windows

Every image you open in Photoshop displays in a document window. This is common practice in the computer world. Yet even with documents, there are options you can change to customize the information displayed and how the windows work.

Tabbed Document Windows

Often you will have many documents open at the same time. All these open documents can clutter up your work area and lead to a confusion of windows on top of windows in a scrambled order. One solution to tame this type of mess is to use tabbed documents. Instead of each image opening in its own window, all documents open into a single window with a title tab, allowing you to easily switch between them (see Figure 1.25).

Tabbed document windows are similar to tab groups for panels. You can move the tabs around to change the order. You can pull a document out from the others into its own window. Dragging a document close to another's title bar displays the blue line of a drop zone, allowing you to combine multiple documents into one.

Using windows in this manner might be a little jarring. Although the idea of tabs is very familiar, many people are accustomed to one image using one window. Rest assured that using tabbed document windows is an option that you can turn off. Many find the concept useful, preferring the speed of the tabs. The choice is yours.

Standard Screen Mode, Full Screen Mode, Full Screen Mode with Menus

When you open a document, by default, it opens into its own window, which is displayed in the work area. If you are not using the Application Frame, you see gaps between the various panels and windows. Those gaps show your **Desktop** or other applications or other documents, all of which can be visually distracting. You can change this by using

Screen Modes to help you focus on your image. You change the Screen Mode using the menu items found in the **View** > **Screen Mode** menu or the Screen Mode button in the Application Bar. You can also cycle through the modes by using the **F** keyboard shortcut.

The **Standard Screen Mode** is the default, as you might expect (see Figure 1.26). It is the situation previously described with each window open in a single window, with the other windows and your **Desktop** visible in the gaps.

FIGURE 1.26 The Standard Screen Mode.

The **Full Screen Mode with Menu Bar** hides the other windows and **Desktop** by filling the work area and showing only a single image (see Figure 1.27). This is a good work mode because it encourages you to concentrate on one image and maximize its size on your monitor.

The **Full Screen Mode** is really a display mode. Notice that all the panels and menus are hidden (see Figure 1.28). The only thing visible is your image on a black background. This mode shows off the image to good effect. To get out of the **Full Screen Mode**, press the **F** shortcut key to cycle back to the **Standard Screen Mode**.

FIGURE 1.27 The Full Screen Mode with Menu Bar.

FIGURE 1.28 The Full Screen Mode.

FIGURE 1.29 Context menu for changing the background color.

Changing the Background Color

You probably noticed that the background in **Full Screen Mode with Menu Bar** is gray and the background in **Full Screen Mode** is black. If you resize a document window in **Standard Screen Mode**, the background of the window is gray. You can change any of these colors.

If you press the Control key and click or right-click with the mouse on the background, a context menu displays (see Figure 1.29). This menu has the options for changing the background color. Neutral colors tend to be the best to avoid the color illusions your eyes can play. However, you are allowed to change the background to any color you like by choosing the **Select Custom Color...** menu item.

File Information Displays

The document window has two areas that display information about the open image. The first is the title bar (see Figure 1.30). The name of the file is found there, but so is other useful information. If the © copyright

FIGURE 1.30 Image information displayed in the window title bar.

symbol is displayed in the title, then that information is available in the file's metadata (choose **File** > **File Info...** from the menus to see the metadata dialog). The window's zoom percentage is shown next to the title. Next to the zoom amount is the color information about the file. In the figure, the file is an RGB file with 8 bits per channel. If the file has been modified, then an asterisk is placed after the color information, and on the Mac, a black dot appears in the window's close button.

At the bottom of the image window is more information (see Figure 1.31). The zoom percentage is displayed here, but it is also a control. You can click in that text field as you would with any other control and change the zoom value of the window. By default, the information displayed after the zoom value is the document file size. If you click on the control right after that information, a menu is displayed with more options. Perhaps you care most about the color space of the document or the dimensions of the image. Choose the display option from this menu to show the information in the window.

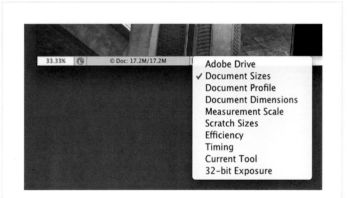

FIGURE 1.31 Image information at the bottom of the image window and the options menu for it.

Preferences

Like most applications, Photoshop has preferences that allow you to change some of its behaviors. A few options apply directly to customizing the user interface. Most have good values that you won't need to change. Others you might feel the need to change to fit how you work.

To access the preferences from the menus, on Max OS X, choose **Photoshop** > **Preferences** > **General**. To access the preferences on Windows, choose **Edit** > **Preferences** > **General**. Or you could use the ⌘ + **K** keyboard shortcut.

There are many preferences in Photoshop. The various options are organized into meaningful groups and put into separate sections. The list of these sections is on the left side of the preferences dialog. Simply click on the section name in the list to show those preferences in the main panel.

This section does not describe all the preferences or even all the groups of preferences. The options described here are those that are related to the user interface, might need more explanation than the titles give, and are worth changing from the defaults.

General

The option **Use Shift Key for Tool Switch** modifies the behavior of tool switching shortcuts (see Figure 1.32). For example, the Brush tool is grouped with the Pencil and Color Replacement tools. With this preference checked, you need to press **Shift** (⇧) + **B** to cycle through the Brush, Pencil, and Color Replacement tools. With the preference unchecked, you simply need to press **B** multiple times to cycle through

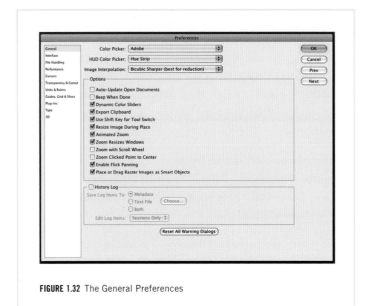

FIGURE 1.32 The General Preferences

Interface

For the most part, Photoshop is set up to use gray or black in its interface. The **Color** and **Border** settings for Screen Modes are set up with good options (see Figure 1.33). However, you may not like the **Drop Shadow** option for **Border**, or you may want the **Full Screen** options to match the other screen modes. Use the pop-up menus in this panel to adjust the look of the Screen Modes.

The option **Auto-Collapse Iconic Panels** is useful for the **Adjustments** panels. If you've set up your workspace with the **Adjustments** panel as an icon, each time you add an adjustment layer, the **Adjustments** panel auto-shows with the options for that layer type (see Figure 1.34). If you want that panel to close when you are finished with it (indicated by clicking elsewhere in the interface), you should check

the three tools in the group. Having this preference checked makes mistakenly toggling through tools less likely.

Zooming out while keeping the window size constant can be a very useful option, for instance, when you want to transform a layer to extend beyond the visible borders of your image. If you want this to be your default choice, be sure to uncheck **Zoom Resizes Window**.

Some users like **Zoom with Scroll Wheel**. You may find that you really like this option and that it speeds up your workflow. If so, keep this option checked. Many applications, such as web browsers, use the scroll wheel to navigate documents, scrolling up and down with the wheel. If this is the right choice for you, leave this option unchecked, its default setting.

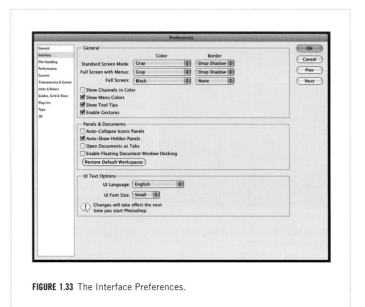

FIGURE 1.33 The Interface Preferences.

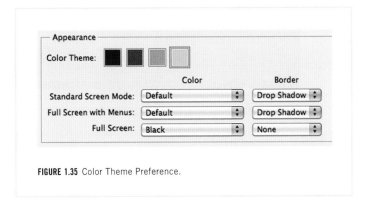

FIGURE 1.34 The Adjustments panel auto-opened when a new Curves layer added.

The **Open Documents as Tabs** setting does what you might think. All new documents open tabbed together into a single window. If you liked tabbed document windows as described previously, then check this option to automatically tab your images. If you prefer the images to open in their own windows, then uncheck this option.

The **Enable Floating Document Window Docking** setting allows you to tab document windows together. If the option is checked, windows snap together when they get close to one another. Unchecking the option keeps all windows separate with no way to tab them together.

Both of the last two options essentially control whether tabbed document windows are available. If you like the tabs, check both of these options. If not, uncheck both of them. This makes the interface consistent and simpler than mixing options. Take some time to work with both modes and then make a decision one way or the other.

Photoshop CS6 includes a new preference for Color Theme (see Figure 1.35). The color theme is reflected as the background color for all the panels and windows shown in the user interface (see Figure 1.36).

Use this preference to control the brightness of the user interface. Working in a dark room using a bright interface can strain your eyes, so a dark color theme might help. Experiment with this preference to find what is the least distracting and most useful to your working environment.

the **Auto-Collapse Iconic Panels**. By default, the option is unchecked, and in the example just given, the panel stays open until you explicitly close it.

The **UI Text Options** setting allows you to adjust the size of the font used in Photoshop's user interface. **Small** displays the most information on smaller screens. **Large** may be useful if you're using a system with a large, high-resolution monitor or if you have vision problems and require a larger font.

FIGURE 1.35 Color Theme Preference.

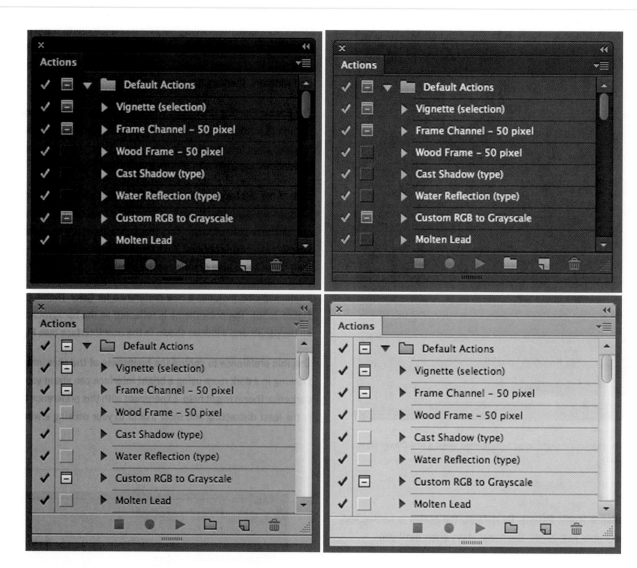

FIGURE 1.36 The Actions panel shown using the four color themes.

Two

CUSTOMIZING

How Photoshop Works for You

Specifying Presets and Settings

Photoshop provides many settings for the various pieces used to edit an image. Tools have settings. New documents have settings. So do other parts of the application you are likely to use regularly. By capturing these settings and saving them to a file, you can create a *preset.* Those values define how a specific feature works in Photoshop, such as how a brush paints on a blank document or how a Camera Raw file is rendered into a document for Photoshop to edit. Many areas of the application allow you to save presets and apply them. Saving these settings allows you to explore features while always retaining the values that you know work. A preset might be one of many that you use for different subjects, styles, or even types of printer paper. Tuning settings for use as presets is a way to customize Photoshop, so you can easily repeat your work.

Tools

Each tool in Photoshop has options, and those options have values. The controls for these options are displayed on the Options Bar.

The **Rectangular Marquee** tool has a **Feather** setting (see Figure 2.1). You can set the tool to always generate the same size rectangle using

Style > **Fixed Size** or just restrict the aspect ratio using **Style** > **Fixed Ratio**. The options for some tools are simple. Other tools are more complex. All the option values can be captured for reuse in a tool preset.

Tool Presets

A tool preset saves the settings for the various tool options. This allows you to quickly return to favorite settings. You can build up presets for different tasks and easily switch between them. You tune the settings for the tool and task, and then you create a preset.

For example, when you're perfecting the quality of a printed image, it is useful to create a version of the image with multiple sharpness values, print it, and then evaluate which sharpness setting works best for the image (see Figure 2.2). If you are printing on $17'' \times 22''$ paper, you do not want to print the whole image at that size and waste a piece of big paper. Instead, you size the image for that paper and then crop an area that is good for the print test. The crop can be printed on an $8.5'' \times 11''$ sample of the sample paper. To help you quickly do that crop, you can create a **Crop** tool preset for an $8'' \times 10''$ area.

FIGURE 2.1 The Rectangle Marquee tool and its options.

FIGURE 2.2 Using the Rectangle Marquee tool as part of creating a sharpness test print.

Tool Preset Picker

Creating a tool preset is easy. On the left end of the Options Bar is the Tool Preset Picker. This control usually shows the currently active tool, but it is also a drop-down control that shows all the tool presets.

In Figure 2.3, the Preset Tool Picker shows the presets for all the tools. Notice the check box labeled **Current Tool Only** at the bottom of the picker list. Click this box to show only the presets for the current tool (see Figure 2.4).

Here's how to use it:

1. Open an image in Photoshop.

2. Choose **File** > **Image Size…** from the menus.

3. Click to uncheck the **Resample Image** check box. For this example, you do not want Photoshop adding pixels to or removing pixels from your image.

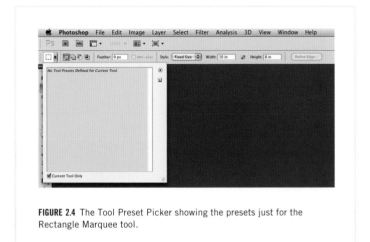

FIGURE 2.4 The Tool Preset Picker showing the presets just for the Rectangle Marquee tool.

4. Type **20.5** in the **Width** or **Height** field (whichever is already the longest side of the image). Notice that the pixel counts do not change, but the **Resolution** does change (see Figure 2.5).

5. Click the **OK** button to apply the change and close the dialog.

6. Click the **Rectangle Marquee** tool to make it the active tool.

7. Change the **Style** menu in the Option Bar to **Fixed Size**.

8. Type **10 in** in the **Width** field and **8 in** in the **Height** field (or vice versa depending on your image).

9. Click the Tool Preset Picker to open the list.

10. Click on the New Tool Preset icon to make a new tool preset for the **Rectangle Marquee** tool (see Figure 2.6).

11. In the **New Tool Preset** dialog (see Figure 2.7), type **10x8 inch Rectangle** in the **Name** field and click the **OK** button to name the new preset.

12. Click the Tool Preset Picker to open the list. Notice that your new tool preset for the **Rectangle Marquee** tool is available in the list.

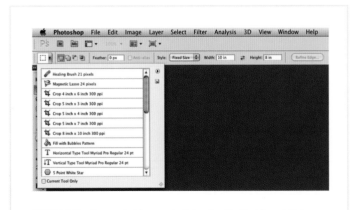

FIGURE 2.3 The Rectangle Marquee tool showing the Tool Preset Picker.

FIGURE 2.5 Resizing an image for printing on 17″ × 22″ paper.

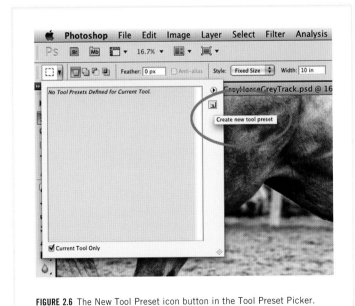

FIGURE 2.6 The New Tool Preset icon button in the Tool Preset Picker.

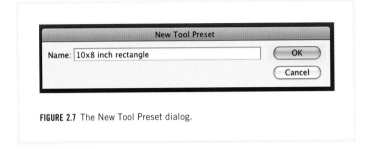

FIGURE 2.7 The New Tool Preset dialog.

13. Click the **Current Tool Only** check box in the Tool Preset Picker to show the presets for all the tools.

14. Click on **Crop 8 inch x 10 inch 300 ppi** in the list to switch the active tool and to use the options from the tool preset (see Figure 2.8).

 The **Crop 8 inch x 10 inch 300 ppi** tool preset is similar to the preset that you just created. There is one key difference: If you click on the image with the **Crop** tool using this preset, you still must drag out a rectangle. The option values keep the crop ratio to 8×10, but you should not quickly select an 8×10 rectangle at 300 ppi resolution.

15. Click on the Tool Preset Picker; then click to choose the **10x8 inch Rectangle** preset that you created, which also switches the active tool to the Rectangle Marquee tool.

16. Using the Rectangle Marquee tool, click on the image. A selection rectangle of the specified size appears on the image. This rectangle is exactly the correct size. You just move it into place and then choose **Image > Crop** from the menus to size the image exactly for the test print.

Whichever tool you use for cropping, the important point here is that there are quick ways to get what you want. After you set up a tool preset, it does not matter what the values currently are for that tool. The preset returns them to the saved values in the preset.

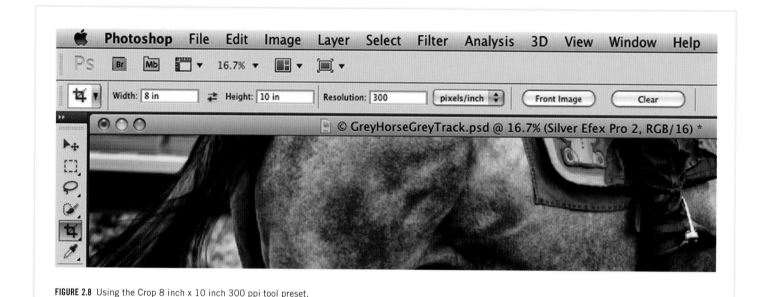

FIGURE 2.8 Using the Crop 8 inch x 10 inch 300 ppi tool preset.

Tool Presets Panel

Another way to access tool preset is using the **Tool Presets** panel. Choose **Window** > **Tool Presets** from the menus to open the panel (see Figure 2.9).

Looks familiar, right? Even the panel menu is nearly the same as the Preset Tool Picker's flyout menu. Notice that there are ways to save and load presets. There are also some sets provided by Adobe (**Art History**, **Brushes**, **Crop and Marquee...**). Choosing **Save Tool Presets...** from the panel menu saves all the currently loaded presets into a single .tpl file.

Where Is the File Located?
Tool Presets files can be saved anywhere. The default locations are

Mac OS X:
/Users/[user name]/Library/Application Support/Adobe/Adobe Photoshop CS5/Presets/Tool/

Windows XP:
\Documents and Settings\[user name]\Application Data\Adobe \Adobe Photoshop CS5\Adobe Photoshop CS5 Settings\Presets \Tool\

Windows 7 and Vista:
\Users\[user name]\AppData\Roaming\Adobe\Adobe Photoshop CS5\Adobe Photoshop CS5 Settings\Presets\Tool\

Preset Manager

Yet another way to access tool presets is through the Preset Manager. Choose **Edit** > **Preset Manager...** from the menus to bring up the **Preset Manager** dialog (see Figure 2.10).

Notice the flyout menu control to the left of the **Done** button. This flyout menu is similar to the others but does not have as many capabilities.

What is different here is the **Preset Type** pop-up menu at the top of the list. You can select from a few other types of presets used with tools. As this menu indicates, Photoshop offers more than just tool presets. There are a few other types, many of which should be familiar to you. You just may have not realized that there was a way to customize these options for your work.

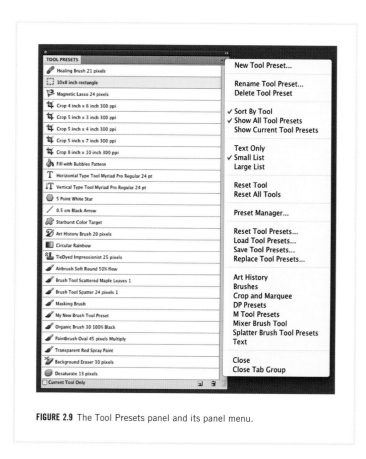

FIGURE 2.9 The Tool Presets panel and its panel menu.

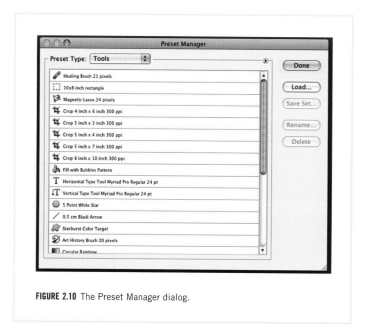

FIGURE 2.10 The Preset Manager dialog.

FIGURE 2.11 The Swatches panel.

Swatches and Styles

Tool presets are not the only preset with their own panel. Two of the others are the **Swatches** and **Styles** presets.

You have probably used the **Swatches** panel before (see Figure 2.11). Clicking on a color chip (a swatch) changes the foreground color, or the background color, if that is what is set up in the **Color** panel. Each swatch is actually a preset; the specific color values are encapsulated into a small data object for reuse. If you click on the New Color Swatch icon button at the bottom of the color grid or click in the blank area of the color grid, the **Color Swatch Name** dialog appears for you to name the new color (see Figure 2.12).

FIGURE 2.12 Color Swatch Name dialog for new color presets.

FIGURE 2.13 New swatch preset shown in the Preset Manager and Swatches panel.

FIGURE 2.14 The Styles panel.

After you name the color swatch, it appears in the **Swatches** panel and in the **Preset Manager** list (see Figure 2.13).

The **Styles** panel shows all the presets for layer styles (see Figure 2.14). As the name implies, styles are applied to individual layers and affect how the layer interacts with other layers, such as how the edges blend or if there is a drop shadow or a beveled edge.

If you are a graphic designer, you probably use the Styles panel a lot. It is mostly used to apply style presets but can also be used to create the preset. Pressing the New Style icon button below the style grid or choosing

New Style… from the panel menu creates a style preset from the layer style of the currently active layer. To edit the style of a layer, double-click in the **Layers** panel on the blank area to the right of the layer's name or choose **Blending Options…** from the **Layers** panel menu to open the Layer Style dialog (see Figure 2.15).

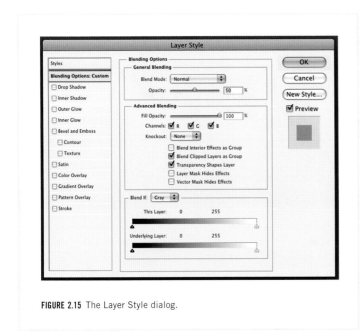

FIGURE 2.15 The Layer Style dialog.

Notice how many options there are just for the **Blending Options: Custom** style. The **Styles** list in the dialog has many other style types, each with its own set of controls. Can you imagine messing with all these controls each time you wanted to use a drop shadow?

When you have all the controls for the style you want, click the **New Style...** button. The **New Style** dialog appears so you can give the new style preset a name (see Figure 2.16).

FIGURE 2.16 The New Style dialog.

As you should expect, after the style preset is created, it is available in the **Styles** panel and the **Preset Manager** and any place the Styles picker appears, such as the Options Bar when the **Custom Shape** tool is selected.

Gradients and Contours

Figuring out how to apply a preset is rarely a problem after you start using the various pickers that appear in Photoshop. Even creating a new preset is not difficult. Sometimes it is hard to figure out how to change the settings captured by a preset. But like many things in the application, after you see it or do it yourself, the process becomes familiar.

A gradient blends one color to another. The gradient controls which colors the blend goes through, how quickly one color transitions to the other, and how smoothly. If you have used the **Gradient** tool, then you have used a gradient preset. The gradient preview is shown in the Options Bar. Click the drop-down control of the preview to open a picker, allowing you to select a different gradient preset (see Figure 2.17).

FIGURE 2.17 The Gradient picker in the Option Bar for the Gradient tool.

FIGURE 2.18 The Gradient Editor dialog.

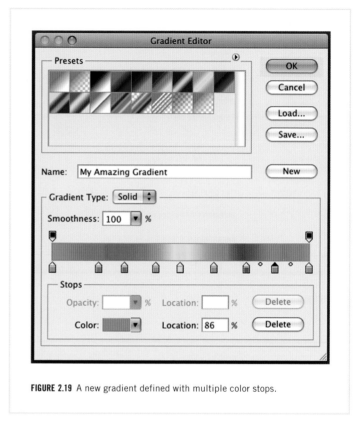

FIGURE 2.19 A new gradient defined with multiple color stops.

To create your own gradient, click on the gradient in the preview on the Option Bar. Doing so opens the **Gradient Editor** dialog (see Figure 2.18).

Making a new gradient involves messing with that gradient bar in the bottom half of the dialog. The example in Figure 2.18 shows a gradient that goes from orange to yellow and back to orange. It has three stops. The stops are the color points. There is the beginning stop and the ending stop on the ends of the gradient bar. There is also the stop in the middle, which is the color yellow in Figure 2.19. You can add other stops and change each of their colors.

Type a name in the **Name** field and click the **New** button to create a new gradient preset. The Gradient picker in the dialog even updates to include the new preset.

Similar to gradients are contours. A contour controls how smoothly and quickly the interior of an object transitions to the edge of the object. This is seen most often with Layer Styles. For example, when you're defining a Layer Style using Drop Shadow, there is a Contour picker in the dialog (see Figure 2.20). It works like the other preset pickers you've seen. Click the drop-down control to open a picker showing the various presets available.

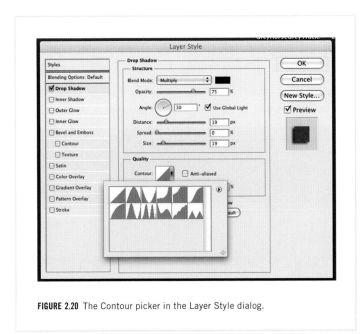

FIGURE 2.20 The Contour picker in the Layer Style dialog.

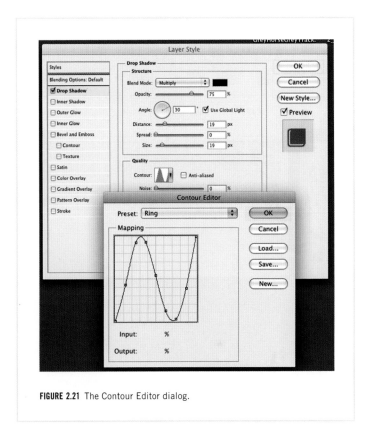

FIGURE 2.21 The Contour Editor dialog.

As with a gradient preset, to create a new contour picker, click on the contour preview to bring up the **Contour Editor** dialog (see Figure 2.21).

Does the **Mapping** control look familiar? It looks like the control for creating a Curves Adjustment. The **Load...**, **Save...**, and **New...** buttons work just as you expect them to. The new contour preset shows up everywhere the other contour presets are available.

Patterns and Custom Shapes

Some presets are not easy to define using controls like sliders or numbers. Sometimes only an image will do. Patterns and custom shapes are visual, so creating those types of presets requires starting with an image.

The **Paint Bucket** tool can fill using a pattern or a solid color. The Pattern picker shows in the Options Bar when the tool is active (see Figure 2.22). With pattern presets, you cannot simply click the preview

to create a new pattern. Instead, you must open an image file and crop away the parts you don't want in the pattern, as shown in the following steps:

1. Open an image file that contains an interesting pattern.
2. Using the **Marquee Rectangle** tool (or the **Crop** tool) select an area of the pattern to use as a preset (see Figure 2.23). Patterns work well as squares, so you might want to hold down the **Shift** (⇧) key when dragging the selection.
3. Choose **Image** > **Crop** from the menus to crop the image down to pattern size (see Figure 2.24).

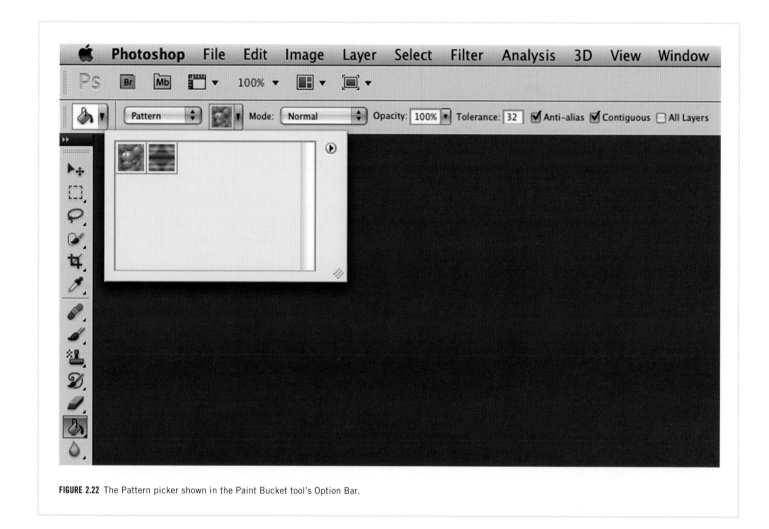

FIGURE 2.22 The Pattern picker shown in the Paint Bucket tool's Option Bar.

4. Choose **Edit > Define Pattern...** from the menus.

5. In the **Pattern Name** dialog (see Figure 2.25), type a good name for your new pattern and click the **OK** button.

6. Choose **File > New...** from the menus and create a new document 800 × 800 pixels.

7. Click to select the **Paint Bucket** tool in the Tool Bar. The tool is grouped with the **Gradient** tool.

8. In the Options Bar, change the pop-up menu from **Foreground** to **Pattern**.

9. From the Pattern picker, choose the new pattern you created.

FIGURE 2.23 Selected area of an image for making a pattern,

FIGURE 2.24 Cropping the pattern out of the image.

FIGURE 2.25 The Pattern Name dialog.

10. Click in the new document to fill it with your pattern (see Figure 2.26).

Creating a custom shape preset is done in a similar way. Shapes are vector-based images. Therefore, you cannot simply open a pixel-based image to create a shape. Instead, you must either open a vector-based image, such as an EPS file or those created by Adobe Illustrator, or draw a shape of your own using the **Pen** tool.

1. Using the **Pen** tool, create a shape in an empty document (see Figure 2.27).

2. Choose **Edit > Define Custom Shape...** from the menus and name the new shape in the **Shape Name** dialog (see Figure 2.28).

3. Click to choose the **Custom Shape** tool from the Tool Bar. The tool is grouped with the **Rectangle** tool and other vector shape tools.

FIGURE 2.26 The new pattern applied to a blank document and the original image basis of the pattern.

FIGURE 2.27 A shape drawn using the Pen tool.

FIGURE 2.28 The Shape Name dialog to create a new custom shape.

4. Choose the new shape you just created from the **Custom Shape** picker in the Options Bar.

5. Drag shapes out in the blank document to see your new custom shape preset being applied (see Figure 2.29).

Where Is the File Located?

The presets described (Swatches, Styles, Gradient, Contours, Patterns, Custom Shapes) can be saved anywhere. The default locations are in their own folders here:

FIGURE 2.29 The new custom shape applied to a blank document using the Custom Shape tool.

Mac OS X:
/Users/[user name]/Library/Application Support/Adobe/Adobe Photoshop CS5/Presets/

Windows XP:
\Documents and Settings\[user name]\Application Data\Adobe \Adobe Photoshop CS5\Adobe Photoshop CS5 Settings\ Presets\

Windows 7 and Vista:
\Users\[user name]\AppData\Roaming\Adobe\Adobe Photoshop CS5\Adobe Photoshop CS5 Settings\Presets\

Brushes

The most complex preset to create and even use is the Brush preset. Photoshop's painting engine improves in nearly each new version released. Many artists use Photoshop to create new images by painting with the digital tools provided. In each version, Photoshop narrows down the differences between traditional tools, such as paint brushes and pencils, and their digital equivalents. All this means that more options are added to simulate how the traditional tools work on the digital canvas.

Brush Panel

The **Brush** panel displays all the controls for defining your own brush. As complexity goes, this one is similar to the **Layer Styles** dialog. There are a lot of option types, and each type has many option values that you can specify. The best way to learn the **Brush** values is to make a brush using the panel, as shown here. As you enter option values, notice how the brush stroke preview changes.

1. Choose **Window** > **Brush** from the menus to open the **Brush** panel.
2. In the **Brush** panel, click on the **Brush Tip Shape** item in the list on the left side.
3. In the tip shape grid, scroll to find the second **Sample Tip** directly below the **Heavy Smear Wax Crayon** tip, as shown in Figure 2.30.
4. Click on the brush tip to select it.
5. Set the **Size** to **40 px** and the **Spacing** to **5%**. Do not worry about the size too much. When you use the brush, you can change its size.
6. Click the **Shape Dynamics** item to specify those option values.
7. Set the **Size Jitter** to **5%**, the **Minimum Diameter** to **30%**, the **Angle Jitter** to **100%**, the **Roundness Jitter** to **50%**, and the **Minimum Roundness** to **25%**.
8. Click the **Scattering** item to specify those option values.

FIGURE 2.30 The Brush Panel with the Sample Tip selected.

13. Click the **New Preset** icon button at the bottom of the panel and then name your brush preset **Organic Brush**.

14. Create a new blank document and paint with the new brush to see how well it works (see Figure 2.31).

The idea behind making this brush is to see an organic edge to the results. All those jitter values are for randomness to be a part of the brush edge. You want the middle part of the painted area to be black but the edges to feather to the white background color.

Brush Presets Panel

The **Brush** panel displays the controls for defining your own brush. The **Brush Presets** panel displays all the brushes you have defined (see Figure 2.32). Choose **Window** > **Brush Presets** from the menus to see the panel. If the brush previews appear gray, click the **Brush** tool in the Tool Bar to make it the active tool.

This panel shows you all the brushes; plus, it allows you to save your brushes and load new brushes for use.

Brush Preset Picker

As you may have noticed, the Brush tool displays a Brush Preset Picker in the Options Bar. If you have the **Brush Presets** panel open and click around in the picker preview grid, the **Brush Presets** panel updates to show the currently selected brush. Although the displays are different, the preset chosen is the same. The picker displays the Small Thumbnail view, and the panel displays the Stroke Thumbnail view. You can use the flyout menus of either to change the views.

Many tools use brush presets. When that tool is active the picker appears in the Options Bar for that tool. Here are the 14 tools that use brush presets: **Brush, Pencil, Mixer Brush, Clone Stamp, Pattern Stamp, History Brush, Art History Brush, Eraser, Blur, Sharpen, Smudge, Sponge, Dodge,** and **Burn.**

9. Click the **Both Axis** check box of **Scatter** to turn it on. Set the **Scatter** to **160%**, the **Count** to **2**, and the **Count Jitter** to **100%**.

10. Click the **Transfer** item to specify those values.

11. Set the **Opacity Jitter** to **15%** and the **Flow Jitter** to **10%**.

12. Uncheck all the rest of the option type items so that none of those values are used making your brush preset.

FIGURE 2.31 Using the new Organic Brush preset.

FIGURE 2.32 The Brush Presets panel with the Organic Brush selected.

FIGURE 2.33 An image for creating a brush.

Other tools are "brushes," but they do not use the brush presets. They use similar but different options and are described later.

Define Brush Preset

As with pattern presets, you can define a brush preset from an image like this:

1. Open an image from which you want to create a brush (see Figure 2.33).

2. If necessary, crop the image to the area needed for the brush (see Figure 2.34).

FIGURE 2.34 The source image for the new brush.

FIGURE 2.35 The Brush Name dialog.

3. Choose **Edit** > **Define Brush Preset...** from the menus.

4. In the **Brush Name** dialog (see Figure 2.35), give the brush a good name.

5. Create a new blank document.

6. Choose the new brush from the Brush Preset Picker.

7. Paint with the new brush in the blank document to test it (see Figure 2.36).

Brush Picker

As mentioned previously, some tools have the word "brush" in their name but do not use the brush presets. These tools and a few others do not use the Brush Preset Picker in the Option Bar. Instead, they use a Brush picker, which has fewer options and no presets (see Figure 2.37). These tools tend to be more about brushing on a selection than a color: **Spot Healing Brush**, **Healing Brush**, **Color Replacement**, **Background Eraser**, and **Quick Selection**.

The options in the Brush picker are similar to those in the **Brush Tip Shape** option in the **Brush** panel.

All the many uses of the word "brush" in Photoshop can lead to confusion. Know that this is not the intent and that there are subtle distinctions between them all. Always keep in mind that brush presets can be your friends by containing the complexities of the tools.

FIGURE 2.36 Using the new brush in an empty document to see the results.

Documents

The presets for documents are used when creating a new document or adding metadata to a document.

New Document Presets

If you choose **File** > **New...** from the menus, the **New** dialog opens for you to specify details about creating a new document. Conveniently, there is a **Preset** pop-up menu with several standard document presets (see Figure 2.38).

FIGURE 2.37 The Brush picker for use with brush-like tools.

These presets cover many common settings for new documents. There is, however, a **Save Preset...** button for you to add a document preset. Clicking this button brings up a new dialog, allowing to name and select options to include in the preset (see Figure 2.39).

Once the preset is saved, it appears in the **Preset** list for new documents (see Figure 2.40).

If you create new documents regularly, then creating a document preset can be worth a small amount of time.

Adobe Camera Raw Settings and Presets

When you're opening a Raw file created by a digital camera, the Adobe Camera Raw (ACR) plug-in is used to read the file and interpret its data (see Figure 2.41). When a Raw file is sent to Photoshop as a new document, it is prepared according to settings that you can customize.

At the bottom of the Adobe Camera Raw plug-in window is a hyperlink showing the current settings for creating the Photoshop document when

FIGURE 2.38 The New dialog for creating documents with pop-up menu open.

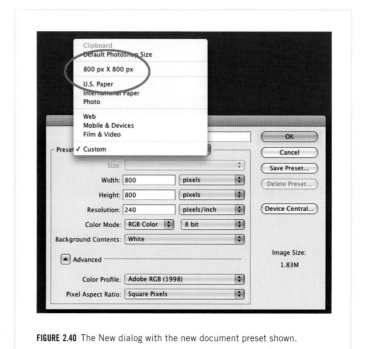

FIGURE 2.40 The New dialog with the new document preset shown.

FIGURE 2.39 The New Document Preset dialog.

you click the **Open Image** button. If you click on the hyperlink, the **Workflow Options** dialog opens, allowing you to change the current settings (see Figure 2.42).

The size of the image and its color settings are set by these values. Color settings are described later in this chapter. The Raw engine renders the file to match the intention set by these values. After the Raw file is rendered, you can edit the pixels by using the various tools in Photoshop. Because these settings are not changed very often, there is no support for saving a preset.

Before the plug-in renders the Raw file, you can adjust it using the various sliders and controls in the Raw editor itself. These controls tend to be

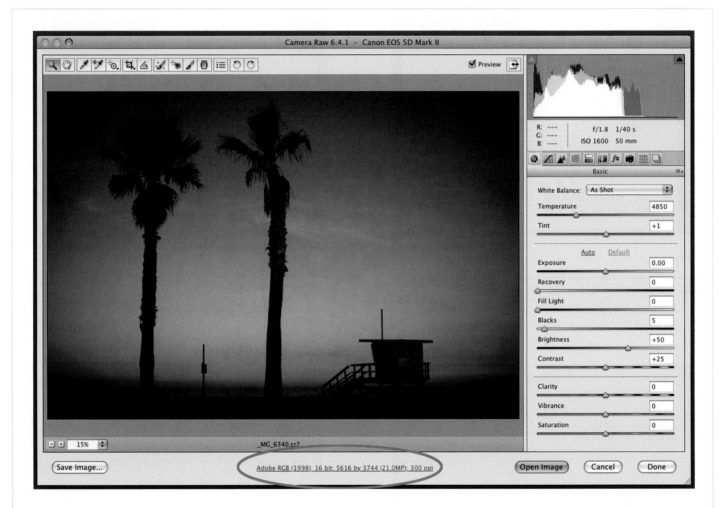

FIGURE 2.41 The Adobe Camera Raw plug-in window.

FIGURE 2.42 The Workflow Options dialog in the ACR plug-in.

FIGURE 2.43 The Save Settings dialog in Adobe Camera Raw.

tuned for each photo shoot or even each image. The range of expression all these controls influence is vast. Thankfully, there is a way to save settings using presets. There is a flyout menu on the right end of the panel title above the panel's controls that looks like the flyout menu control for panel menus. Choose **Save Setting…** from that menu to bring up the **Save Setting** dialog (see Figure 2.43).

This dialog might look familiar if you use Adobe Lightroom and create Develop presets. The dialog offers choices about which values get saved to the new preset. In this way, you can create presets that just change values related to color or sharpness or split toning. There are many possibilities. This flexibility also allows you to apply multiple presets to adjust different values. Clicking the **Save** button allows you to save the .xmp file containing the preset setting values.

Where Is the File Located?
Adobe Camera Raw settings files can be saved anywhere, but by default they are placed in this location:

Mac OS X:
/Users/[user name]/Library/Application Support/Adobe/CameraRaw/Settings/

Windows XP:

\Documents and Settings\[user name]\Application Data\Adobe
\Camera Raw\Settings\

Windows 7 and Vista:

\Users\[user name]\AppData\Roaming\Adobe\Camera Raw\Settings\

Once the preset is saved, it is available in the flyout menu in the **Apply Settings** menu. The new preset can be used as the default settings applied to every Raw file when it is opened by the plug-in. You can share the setting file with others and load it using the **Load Setting...** menu item.

Document Metadata

Metadata is information about an image. This information is not the pixels of the image but other data about the document. With photographs from a digital camera, the metadata frequently includes details about the camera when the photograph was captured, such as the focal distance, the lens used, the date the photograph was taken, and many other details. There is also metadata information that you can specify. One of the most important of these is copyright information. Here's how to set this information:

1. Open a photograph in Photoshop that you took with your camera.
2. Choose **File > File Info...** from the menus. The File Info dialog appears, as shown in Figure 2.44.
3. In the **Description** panel of the **File Info** dialog for your photograph, set the **Copyright Status** value to **Copyrighted**.
4. Type a copyright notice in the **Copyright Notice** field. Be sure to include the year the image was copyrighted. Press **Option + G** to type the copyright (©) symbol.
5. If your website has a page for copyright information and notices, enter the **Copyright Info URL**.
6. Click the **IPC** tab to switch to the **IPC** panel.
7. Type your name in the **Creator** field.

8. Type **owner** in the **Creator's Job Title Field**.
9. Fill out the fields for your address, phone number, email, and website. The idea is to provide the information others would need to find you should they want to license your image for use.
10. When all the information needed for copyright is entered, click the drop-down control on the button circled in red in Figure 2.44 (the **Show Templates Folder** button) and choose **Export...** from the menu that appears.
11. In the **Save** dialog, name the file **Copyright2012.xmp** and save it in the default location.
12. To use a metadata preset, choose **Import...** from the same menu button You get several options for how to place the new metadata in the file info for the open file. It is usually best to replace existing information with the new information.

After you create the copyright preset, you should apply it to each new file you create and any photographs from your digital camera.

Where Is the File Located?
Metadata template/preset files can be saved and loaded from anywhere on the hard drive. The default location for these files is

Mac OS X:
/Users/[user name]/Library/Application Support/Adobe/XMP/Metadata Templates/

Windows XP:
\Documents and Settings\[user name]\Application Data\Adobe\XMP\Metadata Templates\

Windows 7 and Vista:
\Users\[user name]\AppData\Roaming\Adobe\XMP\Metadata Templates\

Color Settings

Color for digital images, sometimes referred to as color management, is a very important yet large topic. There are entire books written just about

FIGURE 2.44 The File Info dialog with copyright data.

this subject. Without going into too much detail, the following sections describe some settings you should learn for controlling how Photoshop reacts when opening documents.

Working Color Space

Photoshop maintains a setting known as the *working color space*. This is the color range possible when editing images in Photoshop. Adobe RGB and sRGB are examples of color spaces.

In general, you want the working color space to be a large range of colors in the same way that you want to use a large bowl when mixing ingredients for cookies. As you edit an image and shift colors and mix how it looks, you do not want any of the color information to spill out of the mixing bowl to be lost forever. Your bowl needs space for you to do work. For this reason, it is a good idea to use Adobe RGB as a working color space.

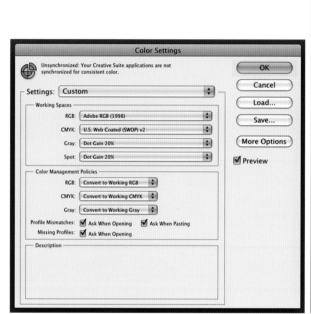
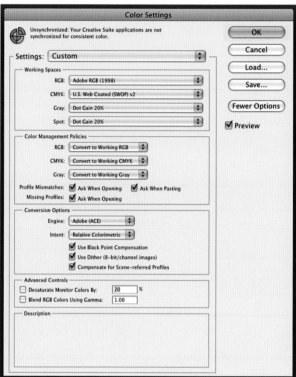

FIGURE 2.45 The Color Settings dialog with fewer and more options shown.

1. Choose **Edit > Color Settings…** from the menus.

2. By default, the **Color Settings** dialog does not show all its options (see Figure 2.45). If you can see the **More Options** button, click the button to see all the settings.

3. In the **Working Spaces** section, set the **RGB** value to **Adobe RGB (1998)**.

4. In the **Color Management Policies** section, set each value (RGB, CMYK, and Gray) to **Convert to Working** (RGB, CMYK, and Gray).

5. Click to check the boxes for **Profile Mismatches: Ask When Opening** and **Ask When Pasting**.

6. Click to check the box for **Missing Profiles: Ask When Opening**.

7. Click the **Save** button to save your color settings as a preset that you can choose through the **Settings** menu in the dialog. Save the file in the default location with a name like *Geoffs***DefaultColorPolicy.csf** (add your own name in place of *Geoffs*). In the comment dialog, enter a comment if you think it will be useful for you to remember these settings.

Basically, what you did in the **Color Settings** dialog is set the working RGB space to Adobe RGB and instructed Photoshop to ask you what to do when it finds a document not using the working space. As you get comfortable

with color management, you may revisit these settings. For now, though, these settings provide a safe way for you to work.

Where Is the File Located?

You can save color settings files (.csf) anywhere on the hard drive. The default location is

Mac OS X:

/Users/[user name]/Library/Application Support/Color/Settings/

Windows XP:

\Documents and Settings\[user name]\Application Data\Adobe \Color\Settings\

Windows 7 and Vista:

\Users\[user name]\AppData\Roaming\Adobe\Color\Settings\

Printing

Considering all the photographs being created today and the range of printers available, it is a shame that people do not print more often. Perhaps it is all the problems related to printing that scare people from doing so. Printing, like color management, is a large topic, and the two topics are related. As with color settings, there are some aspects of printing made simpler using the presets that you can build.

Proof Setup

Photoshop can show you a good approximation of the print you can make. This is a technique called *soft proofing*. Basically, Photoshop uses the selected paper settings to simulate how the image will look when printed. This allows you to add adjustments to the image before you actually put ink to paper.

1. Choose **View > Proof Setup > Custom...** from the menus.
2. In the **Customize Proof Condition** dialog, set the **Device to Simulate** pop-up menu to the ICC profile for your printer and paper. Figure 2.46 shows a custom profile created for Premium Photo Glossy paper made by Illford.

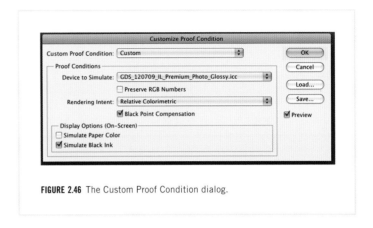

FIGURE 2.46 The Custom Proof Condition dialog.

3. Also, set the values for **Rendering Intent** and **Display Options**. A good book on printing and/or color management will describe these options in detail for you.
4. Click the **Save...** button to save the settings for the proof as a preset.
5. In the **Save** dialog, give the .psf file a good name and save it in the default location.

After you have created a proof preset, you can choose it anytime from the **View > Proof Setup** menu. Using this menu, you can quickly switch to other papers to see which might work best for the current image. You can turn the proof on and off using the **View > Proof Colors** menu item, which is useful to see how colors shift during printing.

Where Is the File Located?

The proof setup files (.psf) can be saved anywhere on your hard drive. The default location is

Mac OS X:

/Users/[user name]/Library/Application Support/Adobe/Color/ Proofing/

Windows XP:

\Documents and Settings\[user name]\Application Data\Adobe \Color\Proofing\

Windows 7 and Vista:

\Users\[user name]\AppData\Roaming\Adobe\Color\Proofing\

Print Settings

When it comes to printing, there are a few fingers in the pie. It is an area where the software, operating system, and printer hardware intersect. Consequently, it can be difficult to accurately describe how to print an image. Aside from that difficulty, it does not prevent some description of saving print settings as presets for reuse. The example presented here is for the Macintosh, but Windows has similar capabilities.

1. Open an image in Photoshop.

2. Choose **File** > **Print...** from the menus to bring up the **Print** dialog (see Figure 2.47).

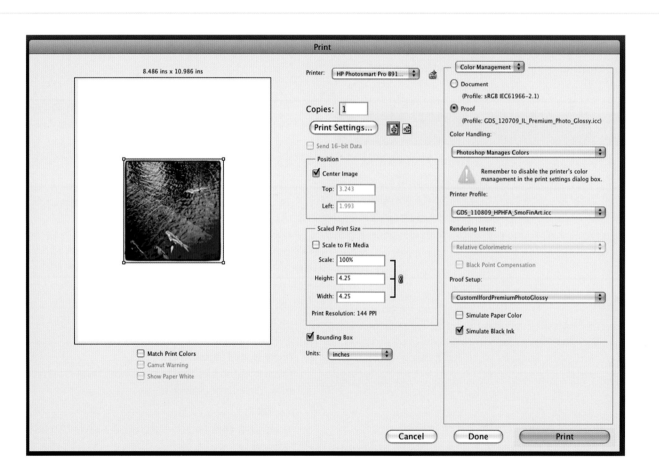

FIGURE 2.47 The Print dialog in Photoshop.

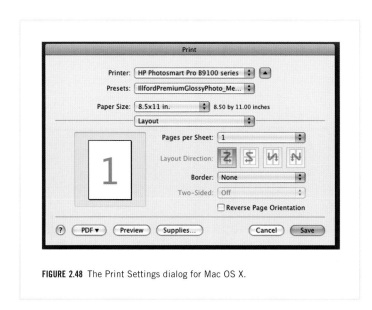

FIGURE 2.48 The Print Settings dialog for Mac OS X.

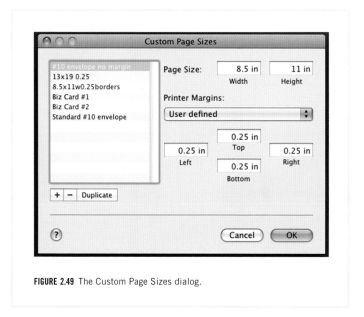

FIGURE 2.49 The Custom Page Sizes dialog.

3. Click the **Print Settings...** button to bring up the **Print Settings** dialog (see Figure 2.48).

4. From the **Paper Size** pop-up menu, choose **Manage Custom Sizes...** to bring up the **Custom Page Sizes** dialog (see Figure 2.49).

5. Click the + button below the list on the left side to create a new page preset. Most printer drivers install with a description of the most common papers. This is a way for you to create presets for paper sizes you frequently use as well as the margins you want. When you're finished, click the **OK** button and your paper specification is the setting shown in the **Paper Size** pop-up menu.

6. After you have made changes to the various panels available in the dialog (some panels such as Layout are common to all printers; others are created by the specific print driver), choose **Save As...** from the **Presets** menu to save those settings.

7. Click the **OK** button to use the new settings and close the **Print Settings** dialog.

8. In the **Print** dialog, click the **Done** button to apply the print settings to the open document.

Using print settings presets is a helpful way for you to tune your printing workflow once and then always be able to repeat it. There are many settings related to creating a successful print. Using presets is one way to make printing much more predictable and reliable.

Three

OPTIMIZING

Your System for Photoshop

Tuning for Performance

This chapter goes beyond speeding up how you can work faster in Photoshop to how to make Photoshop work faster on your computer. The most obvious thing you can do to speed up the performance of Photoshop is to buy the latest computer. Unfortunately, that is an expensive game to play and not really a good solution. Computers improve performance with each new model. However, new operating systems may add new features at the expense of performance gains from the hardware. Fortunately, you do not have to go to extremes to make Photoshop run faster on the computer you already use.

Hardware

Computers are made up of many different pieces. Sometimes keeping up with all the acronyms for the components can be puzzling. It can take a lot of work to learn what the latest technology improvements are to the components you do understand. All these pieces work together. Improving one piece often leads to faster performance, yet improving a different piece might be more suited for your work. It is useful to understand the hardware components and where you can get the most benefit for your performance costs.

64- Versus 32-Bit Architectures

In the past few years, both Macintosh and Windows computers have improved the operating systems (and hardware) to support 64-bit computing. Previously, the computers operated at 32 bit. These two phrases—"32 bit" and "64 bit"—are really descriptions of numbers. A system that supports 64-bit numbers can count higher than a system that supports 32-bit numbers.

As computers work with bigger and bigger chunks of data, they must be able to keep track of the data. Each piece of data has an address. That address is a number. The higher that address number can be, the more data a computer can work with. This idea affects things such as how much random access memory (RAM) can be installed in your computer. A 32-bit system cannot use as much memory as a 64-bit system, even if the memory is installed in the computer. More RAM means more data is loaded into the fast memory for use by applications that can use that memory.

Does 64-bit computing run 32 times as fast or even faster? The short answer is no. There is a cost for all this extra data being used. However, the performance gains are very significant. The gains can easily be twice as fast or even higher. The amount depends a lot on your computer and what you are doing. The exact numbers are unknown in practice. What is not in dispute, though, is that 64 bit is a performance improvement.

If you can run Photoshop in 64 bit, then it is worth doing so. How do you check? On Mac OS X, choose **Photoshop** > **About Photoshop…** from the Photoshop menus. On Windows, choose **Edit** > **About Photoshop…** from the menus. The application version number is shown below the application name in the About box (see Figure 3.1). Next to that number is the indicator of which architecture the application is using: **x64** is for the 64-bit architecture, and **x32** is for the 32-bit architecture.

FIGURE 3.1 The Photoshop CS5 About box showing the version number and architecture number.

That information is useful, but what if the **x64** is not there? Which versions support 64 bit? The answers are a little complicated because of when the work was done for the various operating systems and when the versions of Photoshop were released. Here's a general summary:

Operating System	Photoshop 64-bit Support Added
Windows 7: 64-bit version	Photoshop CS5
Windows Vista: 64-bit version	Photoshop CS4
Macintosh OS X 10.5 and later	Photoshop CS5

How to Run in 32-Bit

It is not enough for your computer hardware and operating system to support 64-bit computing; the software must support it as well. There are a lot of reasons why this takes time for the engineers at all levels to implement 64-bit computing. The good news is that it has been done for the operating systems and for Photoshop. Despite that, other pieces that you may use also have to support 64 bit. You may use plug-ins that are not 64-bit compatible for one reason or another. If that is the case, that plug-in is not available in Photoshop while running in 64-bit mode. So you have to run Photoshop in 32-bit mode to use that plug-in.

On Windows, both versions are installed for you. To run the 32-bit version, just double-click the icon for that version of the application.

On Mac OS X, both versions are also installed for you. However, the operating system hides this from you and offers a different way to select which version is run. To switch the Mac OS X version to run in 32-bit mode, follow these steps:

1. In the Finder, navigate to the **Photoshop CS5** folder and click to select the Photoshop application icon.

2. Choose **File > Get Info...** from the operating system menus. The **Get Info** window opens, as shown in Figure 3.2.

FIGURE 3.2 The Get Info window for the Photoshop CS5 application.

3. Click to check the **Open in 32 Bit Mode** checkbox in the **Get Info** window.

4. Close the **Get Info** window.

5. Run Photoshop normally. Choose **Photoshop > About Photoshop...** to see the About box and check the version number and architecture indicator.

If your plug-ins are only 32-bit compatible, they should show up in the menus when you run Photoshop in 32-bit mode. If you find they are not there, you should check the plug-in manufacturer's website for the latest information. Most plug-ins have been updated for 64 bit at this time. Many companies offer the 64-bit versions as free updates.

RAM: Your Computer's Short-Term Memory

Random access memory, known as RAM, is the place where the computer stores the data for files you have loaded and the applications that load them. The more applications running, the more files opened, and the larger the files in use, the more memory is needed by the computer. Modern computers can handle overflow when it occurs. The computer starts using the hard drive for temporary memory. It pages large chunks of RAM to the hard drive. These pages of memory can be swapped between the hard drive and RAM as needed. The problem is that the hard drive is slow compared to the RAM. The more the computer just uses the RAM, the faster everything runs.

One of the biggest increases in performance can come from increasing the RAM in the computer. When you increase the memory, you see a bigger jump in performance going from 1GB of RAM to 2GB than the increase going from 24GB to 32GB. The sweet spot for cost versus benefit depends on your computer and the type of work you do in Photoshop. If you are editing large photographs and adding a lot of masked layers to the image, then adding RAM helps. If you are combining multiple large images into a single image, like with a panorama, increasing RAM helps. If you are editing photos using Camera Raw and then saving the result as a JPEG file, the benefit may not be worth the price of the extra memory, depending on how much RAM you already have.

What you can do without spending money on RAM is tune Photoshop for the RAM you do have. You do this using the **Performance** panel in the Photoshop preferences (see Figure 3.3).

In Photoshop, choose **Photoshop** > **Preferences** > **Performance...** from the menus on the Mac or **Edit** > **Preferences** > **Performance...** on Windows. The **Memory Usage** section deals with the amount of available RAM that Photoshop is set up to use. It is best to keep the range in the low 70 percent range as suggested by Adobe. However, if you need a little extra, you can adjust this number higher. Just be aware that doing so can affect the rest of the computer, so do not go much higher. Do not change the amount by more than 5 percent before testing the performance to see how the change is working (or not).

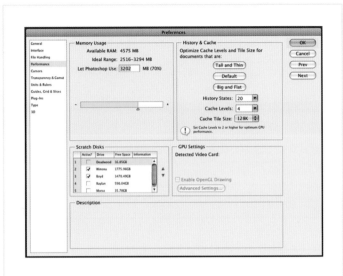

FIGURE 3.3 The Performance preferences.

You might be tempted to allocate 100 percent of the RAM to Photoshop. Resist such big numbers. The operating system needs memory for the computer to work correctly. What happens when an application uses too much RAM is that the computer swaps a lot of those memory pages between the hard drive and the RAM to accomplish even simple tasks. This swapping slows down the whole system, which also slows down Photoshop.

Photoshop has a built-in efficiency gauge to help you tune its performance (see Figure 3.4). This is an option for display at the bottom of document windows.

The percentage displayed for **Efficiency** is how much of given operations are done using the available RAM without using the scratch disk. As you work on images, if you notice this number falling below 95 percent regularly, then you should adjust the setting in the **Performance** preferences. If you still cannot raise the Efficiency number, you should consider buying more RAM for your computer.

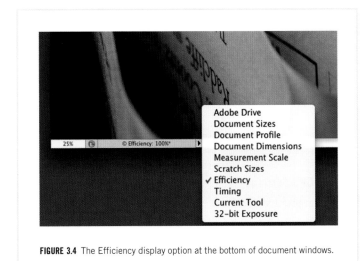

FIGURE 3.4 The Efficiency display option at the bottom of document windows.

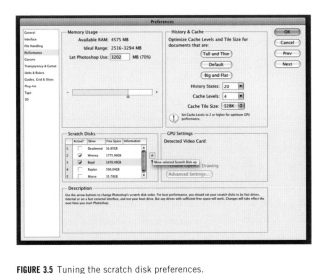

FIGURE 3.5 Tuning the scratch disk preferences.

When you are doing a lot of work in Photoshop, it may also help to not be running too many other applications that use a lot of memory. Multiple applications all using up pieces of your computer's memory can make everything run slower.

Hard Drives and Scratch Disks

As mentioned in the preceding section, the computer will use the hard drive to page memory out of RAM when it needs to. Photoshop does something similar. When you manipulate an image in Photoshop, it keeps a lot of data around in case you need it or for other uses. Sometimes this might be to quickly undo an operation or store history states. Sometimes Photoshop just needs extra memory for the calculations needed when doing adjustments.

The term "scratch disk" is used to mean a hard drive just used for the temporary paging of memory. The hard drive does not have to be empty for it to be of use. Just using a large drive with lots of available space can be helpful. Also helpful is if that drive is a fast hard drive. Numbers change on hardware, but it is good to get hard drives that run at 7200rpm or faster. There is no strict rule about such things, just suggestions.

In the Performance preferences, one of the sections is named **Scratch Disks** (see Figure 3.5). This section shows the available hard drives by name and their available disk space. Simply check or uncheck a drive to use it for a scratch disk. Usually, you want to set the drive with the most available space as a scratch disk. Scratch drives are used from the top of the list to the bottom. To change the order of the list, click to select the drive and then use the arrow buttons next to the list to change the drive's order in the list.

The speed of a hard drive also affects how fast a file is written to disk. If you save a lot of large files, it may be worth the price to upgrade to a faster drive (with more space) to save time when you're writing so many files.

Hard drives can become fragmented. As the drive writes data, then deletes data, and then writes more, data can get written to many smaller places. A document might be split into many parts written all over the drive, just based on how the drive has been used. There are several applications on both Macintosh and Windows computers to defragment drives. The applications may even be installed with the operating system. It is worth running these applications from time to time to defragment the drive and speed up the performance of the operating system and Photoshop.

CPU: The Processor

The CPU is the central processing unit of the computer. This is the main computation piece of the computer. It processes most of the instructions from the operating systems and applications. Often the speed of the processor or how many of them are installed or how many cores contained in each chip are the specifications advertised for new computers. All these specs do affect the performance of Photoshop. The application can take advantage of each of these improvements. It is hard to change processors in a computer, though. Usually, it is when you are purchasing a computer that you need to worry about the CPU. These days, what you want to be sure of is that the processor can support a 64-bit architecture. As time goes on, this is likely to be the only option available to you anyway. For the most part, you do not need to worry about the processor.

GPU and Video Cards

A computer's video card is the hardware piece that processes graphics for display on the computer monitor. The term "GPU" means graphics processing unit. On many computers, you can upgrade video cards, and there are many options available. Why do you care?

Increasingly, the operating systems and applications like Photoshop are taking advantage of the fact the video cards can do image manipulations quickly. Many have built-in support for doing 3D calculations. There is power on the video card that can be used for performance gains.

Having a fast video card or upgrading your existing card may noticeably improve the performance of your work in Photoshop, especially if you are doing a lot of 3D work. In general, you want a card with a lot of video-RAM (VRAM). It is best to check directly with the Adobe documents related to supported video cards.

You might notice that the machine running Photoshop in Figure 3.5 does not have a video card that can be tuned for Photoshop. Not all machines can. Those that can will have settings enabled in the **Performance** and the **3D** preference panels.

The **GPU Settings** section displays the make and model of the video card, and if it can be tuned by Photoshop (see Figure 3.6). The **Advanced Settings...** button brings up another dialog with more options (see Figure 3.7). The **Mode** value is what you are most likely to change.

FIGURE 3.6 The GPU Settings in the Performance preferences.

FIGURE 3.7 The OpenGL Settings dialog.

Basic is for the minimum use of 3D technology. **Normal** is for times when you use features and calculations that take advantage of the GPU processor. **Advanced** is for heavy-duty 3D work. The default setting is **Normal**. Depending on the work you do with Photoshop, you should set this value accordingly.

The 3D Preferences are available in the **Preferences** dialog like other preference settings (see Figure 3.8).

The setting that is most important for performance is the VRAM setting. Similar to the RAM setting in the **Performance** panel, the VRAM setting allocates how much of the video RAM Photoshop can use for its operations. The percentage value for VRAM can be safely set higher than the RAM setting. Few other applications use the VRAM at the same time as other applications. However, the operating system always does use a piece of the VRAM. So again, do not set the value to 100 percent. Numbers between 85 and 95 percent should be fine.

FIGURE 3.8 The 3D Preferences.

If you start noticing strange drawing issues with the monitor, you may want to turn off OpenGL Drawing to see whether the video card is causing the issues. Be sure to restart Photoshop for these changes to take effect. If turning off OpenGL drawing causes the problem to go away, you should go to the manufacturer's website to look for driver updates for your specific video card. Having the latest driver for the video card is a good way to ensure compatibility with Photoshop and to have the latest version of OpenGL, the 3D technology used by most video cards.

Operating System

There is little that you can realistically do to tune your operating system to improve Photoshop performance. However, what you can do is keep your operating system up-to-date. This does not mean that you should always buy the latest release from Microsoft or Apple; just keep your version of the operating system up-to-date. Updates can include performance fixes in addition to bug fixes. You might be surprised how small fixes can make big differences in your work. There are no guarantees with each update, but it is always good to have the latest fixes for your version of the operating system.

Photoshop

Photoshop has several ways to tune performance beyond those directly related to hardware. Although the hardware settings can make the biggest difference to Photoshop's performance, other settings and even your own behaviors also can give big improvements. Many settings related to performance are a push-me-pull-you type of process. Changing one setting affects the overall performance and may undo, in a sense, the improvements made by changes to other settings. Tuning for performance is more art than science and varies depending on the work you do in Photoshop. It is beneficial to know what your options are to help maximize Photoshop's performance for you.

Number of History States

If you haven't already, you may want to increase the number of history states that Photoshop stores. The settings for history states are located in the **Performance** panel of the **Preferences** dialog (see Figure 3.9).

Why are history states part of the Performance preferences? The more history states you store, the more memory (RAM and potentially scratch disk) Photoshop will use. You can have Photoshop store up to 1000 history states. The rule of thumb for history states is the bigger your documents are, the smaller number of history states you want to store. If you're doing layout work or web design, you may want to have hundreds of history states. If you're retouching giant multi-megapixel images, you'll

FIGURE 3.9 The History & Cache preferences.

probably want many fewer history states. Experiment to see what number works best for you.

History Cache

Images in Photoshop are divided into tiles. These tiles are small pieces of the overall image. This is done so that the adjustments made to an image can be performed quickly over small chunks of data, instead of over the entire image. Because there are times when the entire image is not displayed, these tiles can be ordered so the changes are displayed quicker if the tile is visible. Tiling is also done for the various zoom levels to make the zoom quick and seamless.

The larger the image you are editing, the more tiles are needed to display that image. It can be beneficial to increase the **Cache Tile Size** if you frequently work on large images. If you work on smaller images, you want the **Cache Tile Size** to be smaller.

Setting the **Cache Level** is similar to setting the **Cache Tile Size**. If you work on large documents, you want to set this number higher. For smaller documents, set this number lower.

Three buttons can help you keep all of this straight: **Tall and Thin**, **Default**, and **Big and Flat**. Think of these buttons as presets for the **History & Cache** preferences. Each is a suggestion for what the settings should be, depending on the types of images you usually work with.

The point to keep in mind with all these settings is that they affect the computer's memory. The more history states you allow, the more memory required to save the states, which affects how much RAM is used and how much memory is paged out to the scratch disk. All these factors affect performance.

Close Unused Files

As you might expect, the more images you have open in Photoshop, the more memory is required to display them all. If you are done with an image, close it. Fewer document windows means a faster Photoshop.

Clear Available Memory With Purge

Choose **Edit** > **Purge** to view your options for purging some items from memory (see Figure 3.10).

Undo, the system clipboard, and history all use up memory. If you frequently find you get "Out of Memory" messages from Photoshop, you can choose one or more of these menu items to temporarily clear some memory. None of these commands can be undone because they are all related to undoing operations. After the memory is cleared, the data is gone. Use this option as a last resort.

Run Photoshop Only

It may be more and more inconvenient these days to run *only* Photoshop when working on your computer. Yet doing so is a way to free up memory for use by Photoshop, which speeds up the application's performance. Other resources are also freed up in the operating system, the video card, and the hard drive when other applications are closed.

Keep Photoshop Up-to-Date

Keep your version of Photoshop updated, just like you do for the operating system. Photoshop does not release "dot updates" very often, but when it does, you should install the updates. Performance is a major concern for the Photoshop team, so performance fixes do find their way into updates.

The Adobe Camera Raw plug-in updates regularly, mostly to add support for newer cameras. These updates do include fixes. If you are shooting in the Raw file format of your camera, you should keep the plug-in up-to-date.

To update your version of Photoshop and Adobe Camera Raw, choose **Help** > **Updates...** from the Photoshop menus. If updates are available, the Adobe Application Manager launches to show you the updates. The application can download and install any updates for you.

FIGURE 3.10 The Purge menu commands.

Don't Overload Presets

Presets for brushes and styles generate previews for display in the various panels and pickers in the application. Adobe provides several extra sets for most of the presets, and others can be obtained on the web and elsewhere. If you do not use any of these extra groups of presets, do not load them or load them only when you need them. It might also be a good idea to build your own custom sets that contain only the presets you do use. The more presets loaded, the more previews that need to be built, the more memory that gets used when you run Photoshop.

FIGURE 3.11 The Channels Panel Options dialog.

Note this does not mean that you should unload all the presets for each feature. Just don't overload the presets.

Turn Off Thumbnail Displays

A few panels, such as **Layers**, **Channels**, and **Paths,** show previews for their content. When changes are made, these previews are updated, which requires processing time. The previews themselves require memory for storage.

Choose **Panel Options** from any of these panel's menus to bring up the **Channels Panel Options** dialog (see Figure 3.11) and change the size of the thumbnail being drawn.

Four

DUPLICATING

Your Tasks in Photoshop

Recording What You Do So It Can Be Done Repeatedly

Introduction to Actions

The more you use Photoshop, the more you will find yourself doing similar tasks over and over, sometimes the exact same tasks in exactly the same way. Computers are very good at repetition; people mostly are not. Fortunately, the engineers at Adobe have made Photoshop a tool that can easily repeat tasks over and over again for your benefit. One of the ways to accomplish this automation is with actions.

Actions are like teaching Photoshop how to do the work that you do. At a high level, what you are doing is recording the steps performed as you work in Photoshop. Then you fine-tune the resulting action to work for any image. When you have your action working, you simply play that action whenever you want, as often as you want.

Actions are the biggest method used in the Photoshop industry for automating tasks. They are very flexible and can be created to do a lot of your tasks in an efficient manner. Despite all this, actions do have limitations and can be quirky. There are some strategies to making your actions open-ended and generic enough to use with many of your automation needs.

With knowledge and patience, you will find that the time you spend creating actions is repaid with the time you save. As with keyboard shortcuts, building up a recipe book of actions frees you to focus on your creativity instead of your tools.

Examining the Actions Panel

The **Actions** panel is the hub of Photoshop's automation power. Use this panel to create, edit, organize, and play back actions. Choose **Window** > **Actions** from the menu to show the panel, if it is hidden (see Figure 4.1). This panel is usually tabbed together with the **History** panel. Both are very useful, but not as informative as other panels like the **Info** panel or **Layers** panel. Yet the functionality available is very powerful. This is a good panel to minimize and dock next to panels you always keep open.

Photoshop comes with several sets of actions. Loaded by default is the Default Actions set. This set of actions has not changed much since

FIGURE 4.1 Photoshop's Actions panel.

actions were introduced in Photoshop 4.0, yet it still has some useful functionality.

Notice the controls at the bottom of the panel, below the list of actions. The control set looks like a mix of those for a recording device and those at the bottom of the **Layers** panel. The best part is that the controls work just as you expect. From left to right are the Stop, Record, Play, New Set, New Action, and Delete buttons.

Organizing Actions

An *action set* is a collection of actions for organizing all the actions available for you. Open and close the sets, like folders on a hard drive, to show or hide the actions in the set. Unlike layer groups, an action

set cannot be placed inside another set. An action set cannot be played as a whole. Each contained action must be played separately, but as you will find out, this does not really limit you.

To create an action set, click the New Set button at the bottom of the panel (see Figure 4.2) or choose **New Set...** from the panel menu.

In the **New Set** dialog (see Figure 4.3), give the set a descriptive name so you can quickly find it as you work in Photoshop. Then click the **OK** button to create the new set. The set appears as an empty folder in the list of actions in the panel. You will fill this set with the actions you create.

FIGURE 4.3 New Set dialog to create a new action set.

FIGURE 4.2 Clicking the Create New Set control in the Actions panel.

Creating Actions

An action is a series of action steps created by commanding Photoshop to perform a task. Show or hide the action steps by clicking on the disclosure triangle next to the action's name. If an action step has a disclosure triangle of its own, it contains parameters. These are the values of the options used to create the specific action step. Click the triangle to see the parameters in the list.

The best way to learn about actions is to create one. In this chapter, you are going to create three. The first is a simple action to save an image as you might for a website. The second action builds off the first but is more complex and more useful. The third combines actions.

You record an action as follows:

1. Click the New Action button at the bottom of the **Actions** panel or select **New Action** from the panel menu. The New Action dialog opens, as shown in Figure 4.4.

2. Name the new action **Save for Web JPEG 100%**. As with many items you create in Photoshop, be specific when naming them. Be sure that the Set menu shows the action set that you created. No need to assign a function key shortcut or a color to this action. Both options can be changed later, if you want.

3. Click the **Record** button to create the action and start recording the action steps.

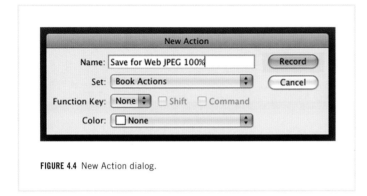

FIGURE 4.4 New Action dialog.

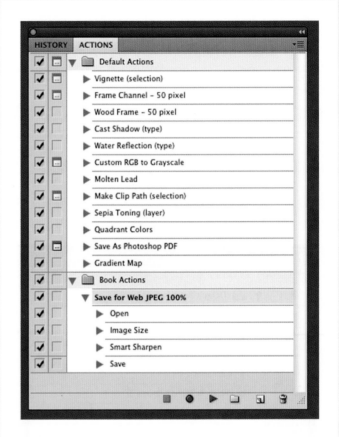

FIGURE 4.5 Completed Save for Web JPEG 100% action showing its action steps.

4. Choose **File > Open...** from the menus to open a document, preferably a horizontal or landscape-oriented image.

5. Choose **Image > Image Size...** from the menus. In the **Image Size** dialog, set the resolution to 72 pixels/inch. Set the pixel dimensions to 720×480 pixels (or something close to those values) for width and height. Set the **Resample Image** menu to **Bicubic Sharper (best for reduction)**. Click the **OK** button to resize the image.

6. Choose **Filter > Sharpen > Smart Sharpen...** from the menus. Set the **Amount** to **60%**. Set the **Radius** to **1.0** pixels. Set the **Remove** menu value to **Gaussian Blur**. Be sure the **More Accurate** box is checked. Click the **OK** button to apply the sharpening.

7. Choose **File > Save As...** from the menus. In the **Save** dialog, navigate to the **Desktop**. Append **_edit** to the end of the filename before the file extension. (For example, change ConcreteCurves1.tif to ConcrereCurves1_edit.tif.) Change the **Format** menu to **JPEG**. Click the **OK** button. The **JPEG Options** dialog appears. Set the **Quality** menu to **Maximum**. Click the **Baseline Optimized** radio button for **Format Options**. Then click the **OK** button to finish saving the new file.

8. After completing the steps, click the **Stop** button at the bottom of the **Actions** panel. You just created a new action. It has four action steps that correspond to the four tasks you performed creating the new file (see Figure 4.5). These actions steps are typical when you resize an image for use on the web.

Playing Actions

To run an action, simply select it in the action list, then click the **Play** button at the bottom of the panel. If you run the **Save for Web JPEG 100%** action that you just created, the file you specified will open and then be resized, sharpened, and saved. If you left the file previously saved on the **Desktop**, it will be replaced with the new file. All the specifics of the tasks you performed were saved in the action, including the filenames and

locations. These details limit the use of your action. For now, that is fine.
The action is still of value to your learning and for building the next action.

Disabling Action Steps

You may have noticed that each action and action step has a check mark next to it in the list. A check mark in this column allows the action step to be used when the action is run. Uncheck the action step to skip it when the action is run.

In the **Save for Web JPEG 100%** action, you can disable the **Open** step and the **Save** step to make the action more usable for other documents than the one originally used to create the document (see Figure 4.6). Open a new document and run the action to verify that the action does what you expect.

Using Playback Options

When you are playing back an action, it may do something unexpected. Often Photoshop plays actions so fast that you cannot tell which step is causing the problem. You can control the speed that actions play back.

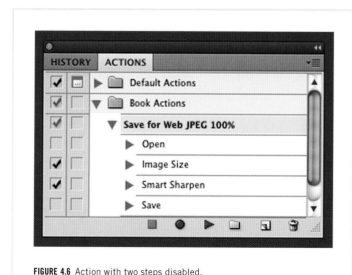

FIGURE 4.6 Action with two steps disabled.

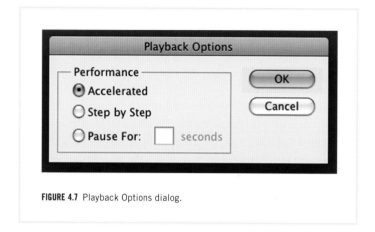

FIGURE 4.7 Playback Options dialog.

Choose **Playback Options...** from the panel menu to open the Playback Options dialog (see Figure 4.7).

The **Playback Options** dialog has the following options:

- **Accelerated**—Plays back the action as fast as possible. Photoshop does not update the image until the action is finished. This is the default to help maximize performance.

- **Step by Step**—Plays back the action at a slower pace, updating the image after each action step.

- **Pause For**—Plays back like the **Step by Step** option, except that it pauses for a specified number of seconds before proceeding to the next action step.

Step by Step and **Pause For** are helpful when you are debugging actions, allowing you to see how the image changes after each step. They allow you to more easily pinpoint where your action is going wrong.

Press the **Command** (⌘) key and double-click an action step to play just that one step in the action. This capability is very useful when testing to find problems in an action. It is also useful if you want to use just that step in your day-to-day workflow.

Editing the Action Options

Double-click the area next to an action's name or choose **Action Options...** from the panel menu to bring up the **Action Options** dialog (see Figure 4.8).

Note that double-clicking the name itself in the list allows you to rename the action directly in the panel. You can change the other parameters only in the **Action Options** dialog. The **Color** option is used only when the **Actions** panel is in Button mode. Selecting a **Function Key** assigns a keyboard shortcut to that action. Be careful assigning function keys because the operating system typically assigns a few by default. Use the System preferences to change how the OS uses function keys as shortcuts.

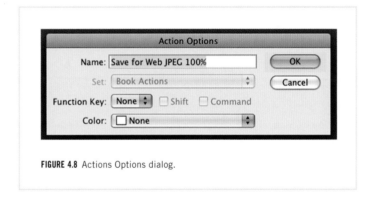

FIGURE 4.8 Actions Options dialog.

FIGURE 4.9 Actions panel in Button mode.

Using Button Mode

Usually, the **Actions** panel is a list of action sets, actions, and action steps. When you are creating actions, this is the best view of the panel. In your day-to-day use of Photoshop, you might consider another view created just for playing actions. From the panel menu, choose **Button Mode** to see this other panel layout (see Figure 4.9).

All the visible actions in the panel are shown as buttons. To play an action, just click the button named for that action. The colors can be used to help spot actions used frequently or perhaps the action's type. The organization is up to you. Assign this color in the **New Action** dialog or by choosing **Action Options...** from the panel menu.

Assigned function keys are displayed on the button as a reminder, too.

To return the panel to Edit mode (the list view), choose **Button Mode** again from the panel menu. As useful as Button mode is, Edit mode is more flexible. It allows advanced users like you to quickly create new actions.

With great power comes great responsibility, which you might not always want to share with others. Assistants or less-advanced users might accidentally edit or delete an action. Button mode is for those users you want only to use actions, not make them.

Editing Actions

As you have already found out, just recording an action is not enough to create a useful action. The best actions are created and then refined to be more useful.

Changing the Settings of an Action Step

In the **Save for Web JPEG 100%** action, you might have noticed that the sharpening was heavy. Open up the **Smart Sharpen** action step to see the settings for that step (see Figure 4.10). The **Amount** value is **60%**. A lower value would sharpen the image but not be so noticeable.

With a document open, double-click the **Smart Sharpen** action step. The **Smart Sharpen** filter dialog opens with the values used by that step. Change the **Amount** to **30%** and click the **OK** button.

The **Smart Sharpen** action step is updated with the new value (see Figure 4.11). Run the action again to verify the change. If the sharpness is not to your liking, you can edit the step until you get good results.

Duplicating an Action

Often the best way to create a new action is to begin with an old one. That is exactly what you are going to do to create your second action. There are more steps to follow creating this action. The steps are broken up with text explaining new ideas. Complete each step to create the new action.

1. Click the **Save for Web JPEG 100%** action and drag it down to the New Action button at the bottom of the panel, or choose **Duplicate**

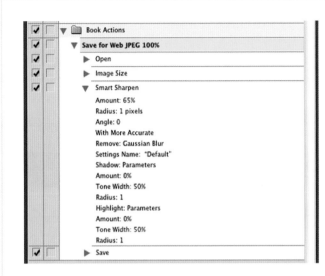

FIGURE 4.10 Settings for the Smart Sharpen action step.

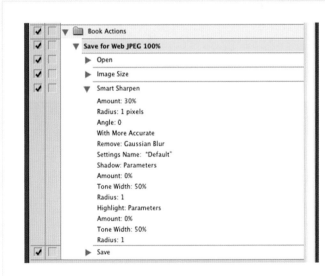

FIGURE 4.11 Revised settings for the Smart Sharpen action step.

from the panel menu. A copy is created and added to the list (see Figure 4.12). This duplicate can be changed, making a second, more complex action.

2. Double-click the action's name in the list and change the name to **Resize for Web JPEG w/ Organic Border** (see Figure 4.13).

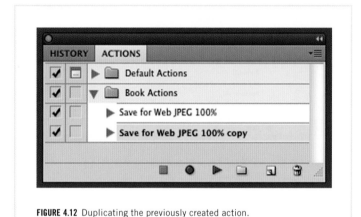

FIGURE 4.12 Duplicating the previously created action.

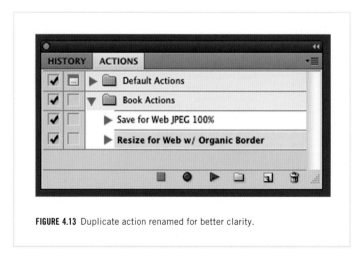

FIGURE 4.13 Duplicate action renamed for better clarity.

Deleting Action Steps

As noted before, the original action had a few extra steps that made it specific. You disabled two steps to improve the action. With this new action, you are going to make it better by removing these two steps.

1. Select the **Open** action step in the **Resize for Web JPEG w/ Organic Border** action (see Figure 4.14) and click the Trash button at the bottom of the panel, or drag the step dropping it on the Trash button. The **Open** step is deleted from the action.

2. Do the same with the **Save** step (see Figure 4.15).

Adding Steps to an Action

You also can add steps to an action. This is where the fun begins.

The first step needed for the new action is to flatten the image. Flattening is useful to make actions that can run on layered files. The action saves a copy, so there is no need to preserve the layers of the

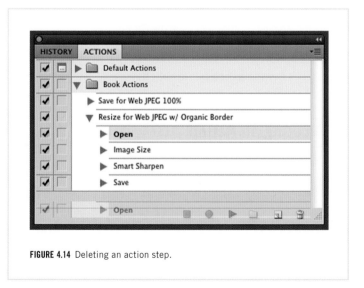

FIGURE 4.14 Deleting an action step.

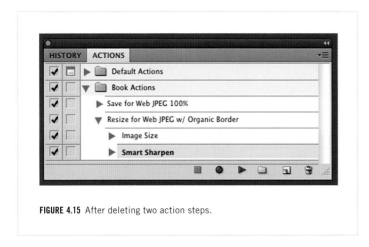

FIGURE 4.15 After deleting two action steps.

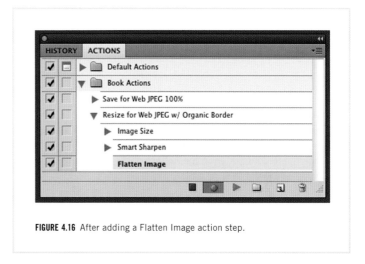

FIGURE 4.16 After adding a Flatten Image action step.

original image and sharpening is best done on the complete image, not just a single layer.

1. Open an image file that has more than one layer, or open a flat image and add a layer to it.

2. If it is not already selected, click to select the **Smart Sharpen** action step.

3. Click the **Record** button at the bottom of the panel to start adding action steps.

4. Choose **Layer > Flatten Image** from the menus. Note that if your document does not have multiple layers, this menu item is disabled, which is why you need an image with layers.

5. Click the **Stop** button at the bottom of the panel to stop recording.

The action now has three action steps: **Image Size**, **Smart Sharpen**, and **Flatten Image**. The new action step is added at the end of the action, as shown in Figure 4.16, because the **Smart Sharpen** step was selected after you removed the **Save** step.

Reordering Action Steps

The **Flatten Image** step really needs to be the first step in the action. You can move it easily.

1. Click and drag the **Flatten Image** step up the list to just below the action's name. You will notice a black bar that goes across the list between the action name and the **Image Size** step. Drop the **Flatten Image** step to place it as the first step in the action (see Figure 4.17).

Now the steps are in the correct order.

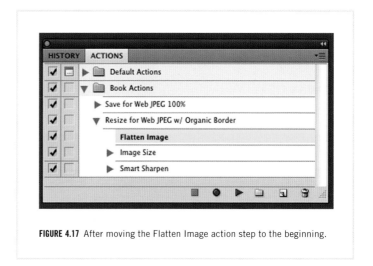

FIGURE 4.17 After moving the Flatten Image action step to the beginning.

Using Fit Image

You created the action using the **Image** > **Image Size...** command from the menus. The specific values used in the options for that dialog were recorded for that action step. That approach works well for images that have the same aspect ratio as the original image. If the action is used on an image with a different aspect ratio, however, the new image will be stretched or squeezed to fit the specific ratio in the **Image Size** action step. There is a better way.

1. Click the **Record** button in the **Actions** panel.

2. Choose **File** > **Automate** > **Fit Image...** from the menus to open the **Fit Image** dialog (see Figure 4.18).

3. Set the **Width** to **720** pixels and the **Height** to **480** pixels. Be sure the **Don't Enlarge** box is checked.

4. Click the **OK** button to close the dialog.

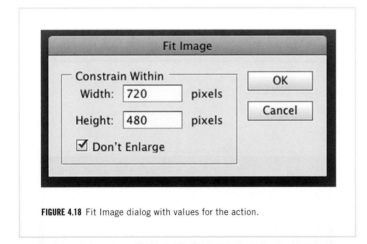

FIGURE 4.18 Fit Image dialog with values for the action.

The **Fit Image** dialog allows you to create an action step more flexible than an **Image Size** step. You can enter values for the maximum values of the image dimensions. This preserves the aspect ratio of the image while resizing it. In this case, the resulting image either has a width of 720 pixels or a height of 480 pixels or both. The image will not be transformed, just resized.

5. Click the **Stop** button at the bottom of the panel to stop recording.

6. The action now has two steps that resize the image (see Figure 4.19). Delete the **Image Size** step (see Figure 4.20).

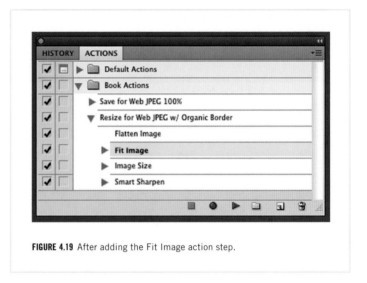

FIGURE 4.19 After adding the Fit Image action step.

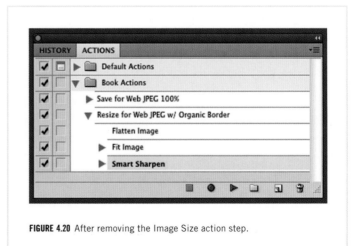

FIGURE 4.20 After removing the Image Size action step.

Adding More Steps

The new action is already better than the original. It can be used for any document. However, the functionality is still the same. You need to add a few steps to make an even better action.

1. Click to select the **Smart Sharpen** action step in the list.

2. Click the **Record** button at the bottom of the panel.

3. Choose **Select** > **All** from the menus.

4. Choose **Select** > **Save Selection...** from the menus.

5. In the **Save Selection** dialog (see Figure 4.21), type **Image_All** into the **Name** field. Be sure the **Channel** menu is set to **New**. Click the **OK** button to save the selection.

6. In the **Layers** panel, double-click on the Background layer. In the **New Layer** dialog (see Figure 4.22), type **Image** into the **Name** field. Click the **OK** button to change the Background layer into a standard layer.

7. Choose **Image** > **Canvas Size...** from the menus.

8. In the **Canvas Size** dialog (see Figure 4.23), change the **Width** to **840** pixels and the **Height** to **600** pixels. Click the **OK** button. You just expanded the image, giving it more area, and making the area around the image transparent.

FIGURE 4.22 New Layer dialog to convert the Background layer to a standard layer.

FIGURE 4.21 Save Selection dialog naming selection Image_All.

FIGURE 4.23 Using the Canvas Size dialog to add a border around the image.

FIGURE 4.24 Using the Canvas Size dialog to add area to the bottom of the image.

FIGURE 4.25 Pick a solid color dialog for creating a solid color layer.

9. Choose **Image > Canvas Size...** again from the menus.

10. This time, set the **Height** to **660** (see Figure 4.24). Press the box at the top and middle of the **Anchor** control to force the image to grow only along its bottom edge. Click the **OK** button to apply the change.

11. Choose **Layer > New Fill Layer > Solid Color...** from the menus.

12. In the **New Layer** dialog, type **Image Background** in the **Name** field; then click the **OK** button.

13. In the **Pick a solid color** dialog (see Figure 4.25), enter **255** in the **R** field, **255** in the **G** field, and **255** in the **B** field to select the solid white color. Click the **OK** button to finish creating the fill layer.

Arranging Layers

The solid color layer is at the top of the layer stack, making the whole image white (see Figure 4.26). This layer is the background of the image. It is the border that you are adding to the image. However, it needs to be the bottom layer in the layer stack.

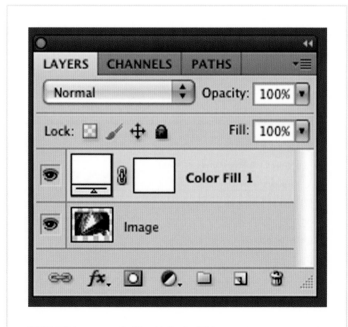

FIGURE 4.26 Layers panel with added color fill layer.

While you are recording the action, you could just move the layer by dragging and dropping it into the right spot in the layers list. You should NOT do this, though. If you use the list, the name of the layer will be used as a setting for that action step. Although it might not be a big problem now, using this technique is a very bad habit. As much as possible, you should make layer operations generic so they can work on any document. There's a better way to move layers when creating actions than using the **Layers** panel.

1. Choose **Layer** > **Arrange** > **Send to Back** from the menus. The keyboard shortcut is ⌘ + ⇧ + [. Either will move the color fill layer to the bottom of the stack without the name of the layer being recorded in the action (see Figure 4.27).

Selecting Layers Via Keyboard Shortcuts

You've moved the layer to the bottom of the stack, but now it is the selected layer. Just as when moving a layer, you cannot use the **Layers** panel to change the selection. Again, the name of the layer selected gets recorded with the action step.

1. Use the ⌥ +] keyboard shortcut to move the layer selection from the color fill layer to the image layer (see Figure 4.28). Note that this is one of those hidden keyboard shortcuts not shown in any menu.

2. Choose **Select** > **Load Selection…** from the menus. In the **Load Selection** dialog (see Figure 4.29), set the **Channel** menu to the **Image_All** value. This is the selection saved previously. Click the **OK** button.

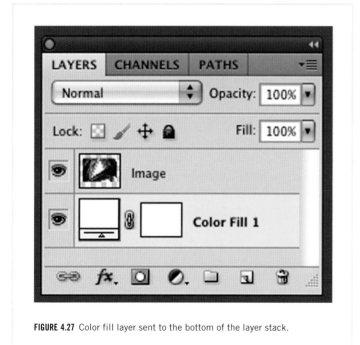

FIGURE 4.27 Color fill layer sent to the bottom of the layer stack.

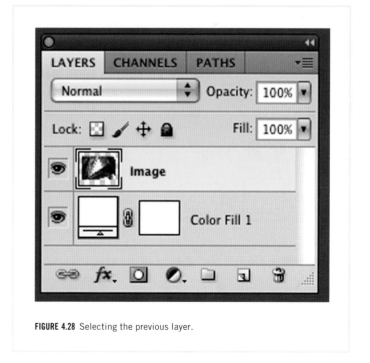

FIGURE 4.28 Selecting the previous layer.

FIGURE 4.29 Load Selection dialog with saved Image_All selection chosen.

FIGURE 4.31 Framed image before the work path stroked with the organic edge brush.

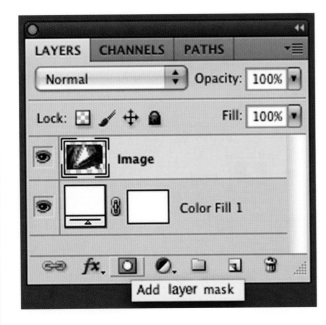

FIGURE 4.30 Mask added to the Image layer with the selection as a start.

3. Click the Add Layer Mask button at the bottom of the **Layers** panel to add a mask to the **Image** layer (see Figure 4.30). Because there was a selection loaded when you created the mask, the mask is white inside the selection and black outside it.

 Remember the phrase "white reveals and black conceals" when creating masks. Think of the color white as light and black as shadows to help you understand what the mask is doing to a layer. So far, the layer mask is not doing anything useful for your image. The mask covers the area that is already transparent on that layer (see Figure 4.31).

Inserting a Path Item

An operation not recorded when creating an action is path creation. Paths are useful for creating clipping masks and getting around action limitations.

1. Choose **Select** > **Load Selection...** from the menus.
2. Again, in the **Load Selection** dialog, set the **Channel** menu to the **Image_All** value. Click the **OK** button.
3. Click on the **Paths** tab to switch to the **Paths** panel. Choose **Make Work Path...** from the **Paths** panel menu to create a work path (see Figure 4.32). In the **Make Work Path** dialog (see Figure 4.33), set the **Tolerance** to **0.5** pixels. Click the **OK** button.

The path is recorded in the action as **Work Path** (see Figure 4.34).

FIGURE 4.33 Make Work Path dialog with suggested Tolerance setting.

FIGURE 4.32 Making a work path from the current selection.

FIGURE 4.34 Paths panel showing the current work path.

Stroking a Path

Another limitation with actions is recording paint strokes using the brush tools. However, you can record stroking a path with a brush.

1. Click on the Brush tool in the Tool Bar. The action records the selection of the brush, but not values of the brush: the size, color, opacity, jitter, and all those other settings available. The next step does that for you.

2. In the Option Bar, click the control to open the Preset menu. Click on the brush preset called **Organic Brush** (see Figure 4.35). If you select a brush preset saved with a color, the action can use the Brush tool with those exact settings.

3. Choose **Stroke Path...** from the **Paths** panel menu (see Figure 4.36).

4. In the **Stroke Path** dialog (see Figure 4.37), choose **Brush** from the **Tool** menu and be sure the **Simulate Pressure** box is unchecked. (**Simulate Pressure** tries to simulate painting where the beginning and ending of strokes have less pressure applied. Not what you want in this case.) Click the **OK** button.

FIGURE 4.36 Stroking the work path from the panel menu.

FIGURE 4.35 Setting the Brush tool to the brush preset needed to make an organic frame edge.

FIGURE 4.37 Stroke Path dialog with the Brush option chosen.

FIGURE 4.38 Delete the path when it is no longer of use.

FIGURE 4.39 Framed image with the organic edge added.

5. Choose **Delete Path** from the **Paths** panel menu to clear the work path (see Figure 4.38).
6. Click the **Stop** button at the bottom of the **Actions** panel to review what you have created so far (see Figure 4.39).

Press the **Option** (⌥) key while clicking on the layer mask to see what stroking the work path does to the mask (see Figure 4.40).

The unique edge is randomly generated by the brush engine. Your brush preset includes the settings for scattering and dynamics of brush size and opacity (see Figure 4.41).

Using "Align Layers To Selection" to Intelligently Position Objects

A common issue when creating actions is moving and aligning objects to work across document shapes and sizes. The **Layer** > **Align Layers To Selection** submenu is used to achieve the result.

FIGURE 4.40 Mask of the frame and edge added to the image.

FIGURE 4.41 All the action steps once the frame has been completed.

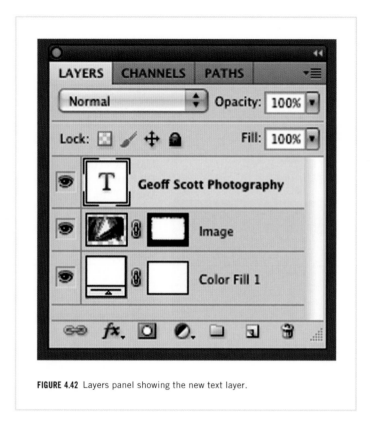

FIGURE 4.42 Layers panel showing the new text layer.

1. Click the **Record** button at the bottom of the **Actions** panel to continue making the action.

2. Click on the Text tool in the Tool Bar. It may take a moment to load in all the fonts on your computer if they have not been loaded by Photoshop already.

3. In the Options Bar, select the font you use for your branding and marketing. Set the font size to about **30** pt. Click the alignment button to be center aligned. Click on the text color control, and in the **Select Text Color** dialog, set the **R**, **G**, and **B** values to **128** so you have a gray color. Click the **OK** button to close the dialog.

4. With the Text tool, click roughly in the middle on the lower border below your image. Type your name, appending that with a space and the word **Photography**. Click the Commit button in the Options Bar to create the text layer (see Figure 4.42).

5. Choose **Select** > **All** from the menus.

6. Choose **Layer** > **Align Layers To Selection** > **Horizontal Centers** from the menu. The text layer you created is centered in the border you've created.

7. Choose **Select** > **Deselect** from the menus.

8. Choose **Layer** > **Flatten Image** from the menus. This step preps the file to be saved as a JPEG for the web (see Figure 4.43).

9. Click the **Stop** button in the **Actions** panel. Your action should look like the one in Figure 4.44.

You've completed a complex action to resize an image and build a border around it that has your branding on it (see Figure 4.45). The image is ready for you to save it for the web. After you finish creating an action, it is always a good idea to run that action on a few other images to see if the results are correct.

FIGURE 4.43 Layers panel with the flattened image.

FIGURE 4.44 Completed action with all the action steps.

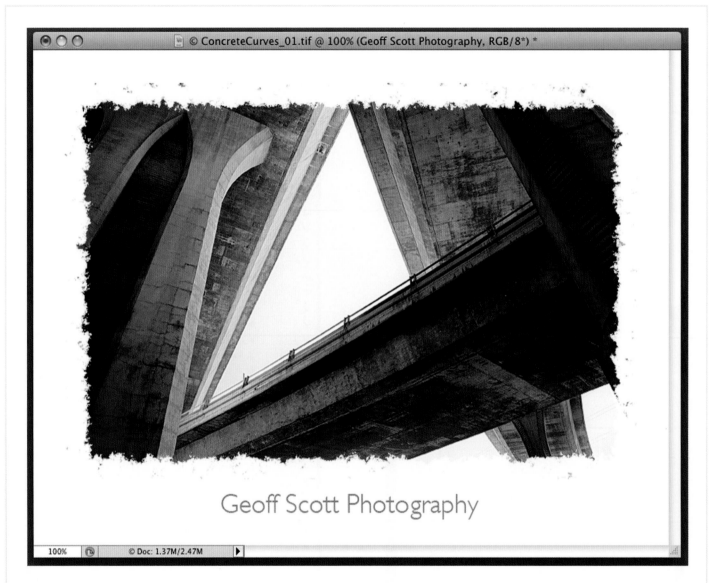

FIGURE 4.45 Image with organic border and photographer's brand added.

Refining Actions

The action you created in the preceding sections contains many tips and tricks to guide you as you create actions of your own. Here are a few more important factors to know about to make your actions even better.

Toggling Dialogs

For the most part, an action runs uninterrupted without any user interaction. However, sometimes it's important to interact with a dialog to make an adjustment or set the amount of an effect during the playback of an action. This can be useful when you're fine-tuning the action to a specific image. In the **Actions** panel, click in the column between the check mark and the action step name to set the Toggle dialog on/off for the step. Not all steps have the toggle because not all recorded tasks use a dialog or have settings to adjust.

Setting the toggle so one or more dialogs show when an action runs is not 100 percent automation. Yet such actions can still save you a lot of time and even guide you through the overall task the action is accomplishing.

Inserting Stop Items

In some cases, you may want to insert a dialog with instructions or a message. For example, if you share an action with a coworker, you might add instructions and a description as the first step in your action. Choose **Insert Stop...** from the panel menu.

In the **Record Stop** dialog (see Figure 4.46), type a message for the user of the action. The message might be a description of what the action does or an important reminder about its capabilities. The **Allow Continue** box specifies whether the message dialog will have a **Continue** button or just a **Stop** button (see Figure 4.47).

FIGURE 4.46 The Record Stop dialog to add a message an action for the user.

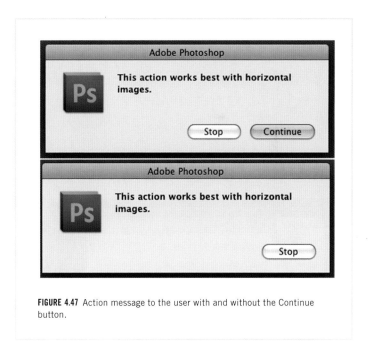

FIGURE 4.47 Action message to the user with and without the Continue button.

Typically, these types of messages are placed at the beginning of an action. However, it is also useful to add a message to the end to notify the user that the action is completed. For some actions, you may want to stop partway through to perform an operation that cannot be recorded.

For example, painting is not recordable. A stop might be added after an adjustment layer is added to allow the user to paint the layer mask. Clicking the **Play** button in the **Actions** panel continues the action on the step after the stop.

Using History Snapshots in Conjunction with Actions

When you run an action, each step creates a history state in the **History** panel. An action with many steps might use up all the history states. That might be a problem if you want to return back to the state before the action was run. Preserving a way to return the document state to before the action was run is accomplished using a history snapshot.

When you are recording an action, your first step should be to create a history snapshot. Click the **Record** button in the **Actions** panel. Hold down the **Option** (⌥) key and click the Create New Snapshot button in the **History** panel (see Figure 4.48).

The **New Snapshot** dialog opens (see Figure 4.49). Type the name of the action in the **Name** field. This is the name that will be

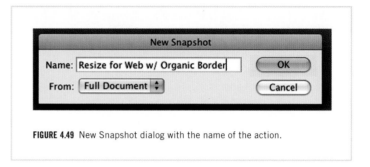

FIGURE 4.49 New Snapshot dialog with the name of the action.

FIGURE 4.48 The History panel has the button to create a new snapshot.

displayed in the **History** panel after the action is complete. Keep the **From** setting on **Full Document**. Click the **OK** button to record creating a snapshot.

After an action is run that creates a history state, that state is displayed near the top of the list in the **History** panel (see Figure 4.50). To return to that state, click on it to undo all the steps performed by the action.

Note that history snapshots are not saved with the image, just as history states are not saved. After the image is closed, that information is gone.

Inserting Menu Items

Some menu commands are not recordable directly. This is particularly true of commands that change the view of an image or anything that does not record a history state. Yet sometimes these changes are useful when you are running an action. For example, you might want an image to be viewed at 100 percent before applying sharpening, so you can see the true effect of the **Smart Sharpen** action step. Fortunately, you can add the command to an action in a different way than recording it.

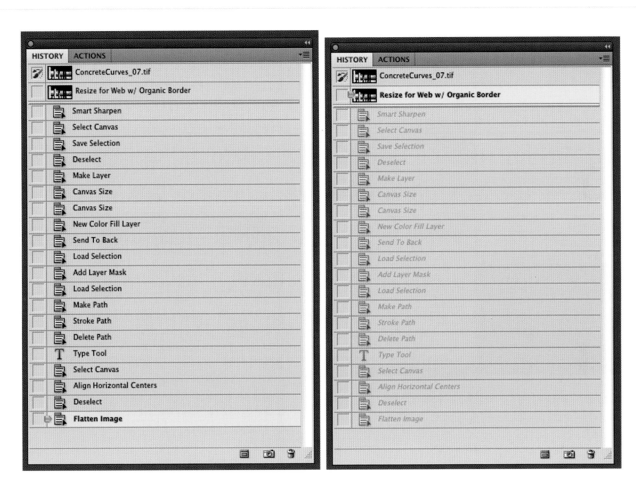

FIGURE 4.50 History panel with states after action run and after snapshot restored.

1. Click on the action step before you want the menu command inserted.

2. Choose **Insert Menu Item...** from the panel menu (see Figure 4.51). The **Insert Menu Item** dialog appears stating that no menu item has been selected (see Figure 4.52).

3. Choose **View** > **Actual Pixels** from the menus.

4. After you select the menu item, its name appears in the **Insert Menu Item** dialog (see Figure 4.53). Click the **OK** button to finish adding the menu item to the action (see Figure 4.54).

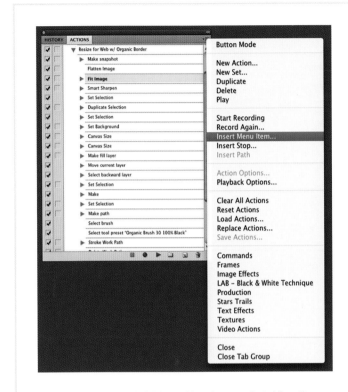

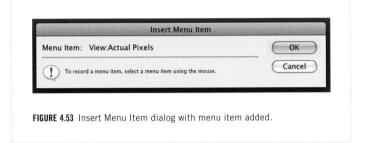

FIGURE 4.53 Insert Menu Item dialog with menu item added.

FIGURE 4.51 Actions panel with Insert Menu Item... selected from the panel menu.

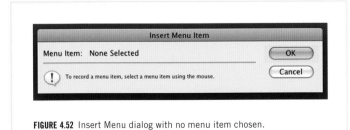

FIGURE 4.52 Insert Menu dialog with no menu item chosen.

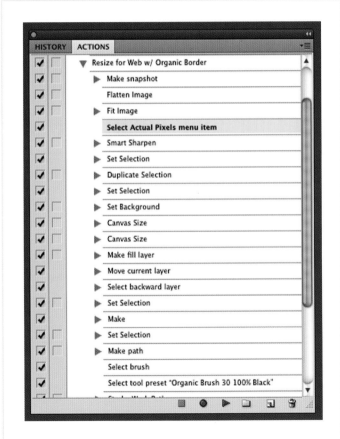

FIGURE 4.54 The new action steps with the menu item added.

107

Using Percentage for Units

Often when you resize a document or place a new object or transform an existing object, what is recorded in the action step is a specific pixel value. Depending on the document, this value might be too specific and create results you do not intend. For example, in the **Canvas Size** step you recorded, it might have been better to adjust the canvas size with percentage values instead of specific pixel values. The values used work well for an image sized down for the web but might not be good for one sized for printing.

> Photoshop allows you to switch the units used by rulers from units such as pixels, inches, and points to percent. Percentages are useful for dealing with images of various aspect ratios and resolutions. You can change the unit values used by many commands by changing the ruler's units.

FIGURE 4.55 Use the context menu for the ruler to change the units used in Photoshop.

Choose **Select > Rulers** from the menus to show the rulers on an open document. You can change the ruler units by right-clicking or **Control** + clicking on the ruler to bring up the context menu and then choosing **Percent** at the bottom of the menu (see Figure 4.55).

You can also set the units using the preferences. On the Mac, choose **Photoshop > Preferences > Units & Rulers** from the menus. On Windows, choose **Edit > Preferences > Units & Rulers** from the menus. Set the **Units : Rulers :** menu to **percent**; then click the **OK** button.

As always, test your actions on a variety of documents to be sure the results are correct. If you start noticing that objects are not in the correct place, check that your action is using percentages instead of real-world unit values.

Running an Action from Another Action

One of the best tips for creating a good set of action tools is to think of them like interchangeable components or ingredients in a recipe. You might create various actions that save a file in different ways—for example, actions that save JPEG files with different compression values or color spaces. You might create actions for standard document sizes you deliver to clients. You might create more actions for effects such as other border types, black-and-white conversions, or simulated film types.

When you have a store of components, you can combine them into various recipes. You do this by creating actions that record the use of other actions. Simply create a new action, and while it is recording, play back the other actions in the order you want.

1. Click the **Create New Action** button at the bottom of the **Actions** panel.

2. Name the action **Sepia w/ Organic Borders**.

3. From the Defaults actions list, click to select the **Sepia Toning (layer)** action; then click the **Play** button at the bottom of the **Actions** panel.

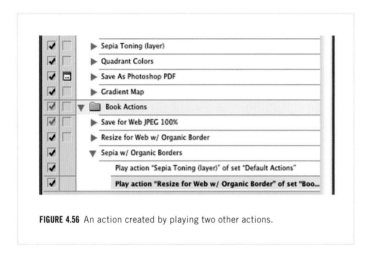

FIGURE 4.56 An action created by playing two other actions.

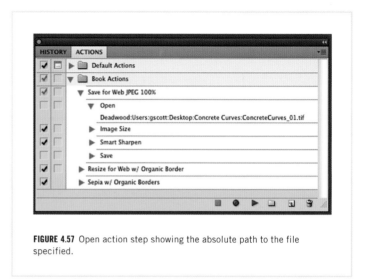

FIGURE 4.57 Open action step showing the absolute path to the file specified.

4. Select the **Resize for Web JPEG w/ Organic Borders** action you previously created and click the **Play** button.

5. Click the **Stop** button.

The new action has only two action steps, both of them playing other actions (see Figure 4.56). This can be very useful. If an action has a problem, the problem can be corrected, and every other action that plays that action is also corrected. Instead of correcting multiple actions, you save time by correcting just one.

Creating actions that play other actions is a strategy allowing you to build up a good recipe book of repeated tasks. This guarantees the repeatability of those tasks, which saves you time.

Creating Actions that Run on Different Computers

Many people have multiple computers or share work across multiple computers with others. Perhaps you have an assistant who needs to run the same action that you do. This can be a problem if your actions that reference files on the hard drive. Opening, saving, importing, and exporting files all require a path to a file.

Actions record the absolute path to a file. The absolute path is the full path from the hard drive name down through all the folders, like the user folder, to the specific file. If you open the action step for the Open step in the first action you created, you will see the absolute path (see Figure 4.57).

Notice that the absolute path contains the name of the hard drive (**Deadwood**) and the user name (**gscott**). For this action to work correctly on another computer, the computer would have to have a hard drive and user with the same names.

The best solution for this type of problem is to tune each action for each machine and user. You know how to modify or replace action steps at this point. It would not take long. This is not an ideal solution, but it is a workaround for this limitation of actions.

Another solution is to avoid creating actions that reference files. For the second action created, you removed both the **Open** and **Save** action steps. In the next chapter, you will find that such steps are not usually necessary anyway.

Saving Actions

Now that you have created, tested, and refined your action, it is time to save that action. It is always a good idea to save and back up any actions you create to avoid losing them if something goes wrong or the action gets accidentally changed or deleted.

The first issue to be aware of is that you cannot save individual actions. You can only save action sets. Click to select the action set you want to save and choose **Save Actions…** from the panel menu.

Where Is the File Located?

Although you can save the file any place you like, by default, the new action file (with extension .atn) is located at

Mac OS X:

/Users/[user name]/Library/Application Support/Adobe/Adobe Photoshop CS5/Presets/Actions/

Windows XP:

\Documents and Settings\[user name]\Application Data\Adobe \Adobe Photoshop CS5\Adobe Photoshop CS5 Settings\Presets \Actions\

Windows 7 and Vista:

\Users\[user name]\AppData\Roaming\Adobe\Adobe Photoshop CS5\Adobe Photoshop CS5 Settings\Presets\Actions\

Loading Actions

To install an action set from a file, you can choose **Load Actions…** from the **Actions** panel menu. Alternatively, you can simply double-click or drag the .atn file onto the Photoshop application icon.

You might have noticed that the **Actions** panel menu has menu items with names such as **Commands**, **Frames**, **Image Effects**, **Production**, and more. These are action sets provided by Adobe. Choose one of these menu items for that set's action to be added to the **Actions** panel. You might find a useful tool in one of these sets or an action that gives you ideas about other actions to create.

Learning More

Learning by Dissecting Existing Actions

Back in the 1990s as the Internet was exploding, the best way to learn how to create web pages was to examine the HTML from existing web pages. Books were out of date the minute they hit the shelves. Digital imaging can be similar. The landscape is changing rapidly. The best way to learn is to dissect what your colleagues are doing. If you are having a problem, go to the web and search for the answer. It's likely someone else has already solved the exact same problem and provided the solution.

The web is also a great place to go for inspiration. Spend a little time every day exploring, looking for inspiration. There are several sites for sharing and downloading actions. It's easy to download someone else's actions and examine the action steps. See how the action achieves its results. Then modify the steps to put your own spin on the technique, solve your particular problem, or fit the idea into your workflow.

Creating Actions for Techniques You Learn from Others

One of the best ways to build your action writing skills is to create an action for each new technique or process you learn. This can be done when reading articles about techniques in magazines or books or on the web or in classes and workshops. Besides challenging your action writing skills, the act of creating the action cements the concept in your mind in a way that is hard to forget. If you ever do forget the steps or settings, the action also serves as a reference of the steps and settings in the process.

Get in the habit of writing, collecting, and organizing actions as your career advances, as you explore, and as you grow as an artist. Actions can become a record of your advances in digital imaging in the same way that images in your portfolio record your creative growth.

EXPLORATIONS

Putting images together is the basis for creating panoramic images. The images stitch together to form a single large photo. But images also can be put together in a more artistic way. The idea is to make the whole bigger than the sum of the parts. Each image on its own might be strong and express an idea. Yet if you take that same image and pair it with another, the resulting combination can create something even more powerful.

The two images might be related or might be very different, creating a synthesis when placed together. At a simple level, this synthesis is how the panels in a comic strip or comic book work. The space between images is a visual pause, allowing your brain to build a connection between the two. In film this is known as a *montage*.

Diptychs are two images placed next to each other to create a new image. Put three together to create a triptych. Images also can be arranged as grids, so the idea is not just a linear one.

A twist on the idea of diptychs is to use a single image. The image is copied, flipped horizontally, and placed next to the original without a border. The result is a mirror diptych (see Figures 4.58 and 4.59).

Building mirror diptychs like these is fairly simple and straightforward but still takes a bunch of messing around that can take time. As an additional exercise, build an action to create a mirror diptych. It's trickier than you might think. Be careful with the units and the way layers are moved around.

FIGURE 4.58 Mirror diptych of a walkway at Revelle College at University of California, San Diego.

FIGURE 4.59 Mirror diptych of "Multiverse" by Leo Villareal at the National Gallery of Art.

Five

REPEATING

Tasks on Many Files

Setting Up and Applying Batch Processing with Actions and Droplets

Actions are great for working with single images, but you can do even more with actions. Batch processing is a technique that allows you to apply Photoshop actions across many files. Batch processing automates large tasks that otherwise might take hours if done file by file. Many tasks are combined into a single task. Photoshop is an image-processing engine. Batch is the way you drive the engine by setting the batch parameters and then letting Photoshop do the work for as long as it needs. This frees you up to do other things with your time.

Additionally, you can turn your batch operations into convenient preset applications called *droplets.* This technique opens up new workflow options in Photoshop, Bridge, Lightroom, and beyond to increase your efficiency.

Batch Processing

Imagine being able to process hundreds, even thousands, of images—adding effects, watermarks, and borders; resizing; and saving for the web—all while you're out shooting for another job or relaxing with friends and family or even catching up on your sleep. Some photographers joke that automation is a way to print money. Automation tools like batch processing are what they are referring to. Your time is valuable. The more time you save by automating your workflow, the more time you have away from the computer.

Setup

Batch processing is the next step in expanding your automation tool box. It builds on what you've created with your actions to make the actions even more useful. As with actions, the best way to learn about batch processing is to practice by using it:

1. Create a new action set in the **Actions** panel by either clicking the folder icon at the bottom of the panel or choosing **New Set...** from the panel menu.

2. In the **New Set** dialog, type **Batch Actions** to give the set a name.

3. Create a new action, like the one in Figure 5.1, by choosing **New Action...** from the panel menu (or clicking the New Action button at the bottom of the panel).

FIGURE 5.1 Actions panel with the new action set Batch Actions.

4. In the **New Action** dialog, type **Batch Resize for Web w/ Organic Border** to name the new action. Be sure the **Set** menu is **Batch Actions**. Click the **Record** button to create the action.

5. In the actions list, click on the **Resize for Web w/ Organic Border** action; then click the **Play** button at the bottom of the panel.

 You might get a warning message from Photoshop if you do not have a file open (see Figure 5.2).

The **Resize for Web w/ Organic Border** action begins by making a history snapshot. The step is titled **Make**. Photoshop cannot make a snapshot if there is no file open. Click the **Stop** button in the message dialog and then click the **Stop** button at the bottom of the **Actions** panel. Open a file, any image file. Then click the **Record** button. Repeat step 5 to continue making the new action.

6. Click the **Stop** button at the bottom of the **Actions** panel.

FIGURE 5.2 Warning message when trying to play the Resize for Web w/ Organic Border action.

You created a new action that plays the one you previously created in Chapter 4 (see Figure 5.3). Remember that you are trying to be efficient with your time. You could re-create the previous action by duplicating all the steps in the original action. However, if changes need to be made, you have to fix the problem in both actions or have one that works correctly and one that does not. It is simpler to fix problems once.

You are dividing the tasks to provide yourself with workflow options. This is a step toward having multiple recipes that might use the same ingredients but are different dishes when served. At the moment, your batch action

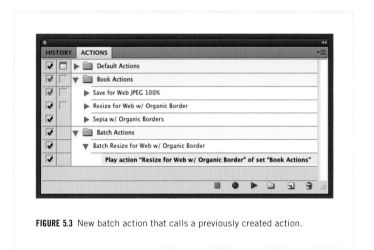

FIGURE 5.3 New batch action that calls a previously created action.

has only a single step. You will add more steps to refine the action for batch processing, after you learn how to set up a batch process using the **Batch** dialog.

Creating a new action specifically for batch allows you to keep the other action to use normally and to add action steps to the batch action that the other action does not need.

Batch Dialog

The **Batch** dialog is the control panel for running a batch process (see Figure 5.4). You enter the details for the batch into the dialog to direct the work you want Photoshop to perform. There are a lot of controls, but you start simply here and then build on your knowledge as you build your batch action.

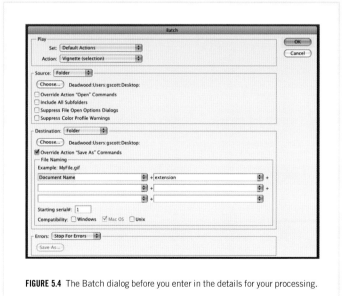

FIGURE 5.4 The Batch dialog before you enter in the details for your processing.

1. Choose **File** > **Automate** > **Batch...** from the menus.
2. In the **Batch** dialog, set the controls to the following values:

 A. In the Play section, change the **Set** menu to **Batch Actions.**
 B. Be sure that the **Action** menu is set to **Batch Resize for Web w/ Organic Border**. This should have been done for you automatically when you completed the preceding step.
 C. Set the **Source** menu to **Folder** if it is not already.
 D. Click on the **Choose** button, and in the **Choose a batch folder...** dialog, navigate into the Photoshop application folder. Click to select the **Samples** folder; then click the **Choose** button.
 E. Set the **Destination** menu to **Folder** if it is not already.
 F. Click the **Choose** button, and in the **Choose a destination folder...** dialog, navigate to the **Desktop;** then click the **Choose** button.
 G. Check the box **Override Action "Save As" Commands**.
 H. In the **File Naming** section, change the first name field from **Document Name** to **BatchTest** by typing in the field.

 I. Change the second name field from **extension** to **2 Digital Serial Number** by selecting the value from the pop-up menu next to the field.
 J. Change the third name field from blank to **extension** by selecting it from the pop-up menu next to the field.
 K. Note that the **Compatibility** checkboxes are just for file naming. These options ensure that the filenames are valid on all the operating systems checked.
 L. Set the **Errors** menu to **Stop for Errors**.

When you are finished, the **Batch** dialog should look something like Figure 5.5. Do not click the **OK** button yet. There is more you should know before you run this batch.

Troubleshooting Batch Processing

It is tricky to create an action to run on 10 or 100 or even more files. When running an action from the **Actions** panel, you can see the results and tweak them for the open image. If there is a problem with the action, you can fix or tune it for that image. The point of automation is to minimize your interaction. Ideally, you click a button and Photoshop does the work reliably.

To accomplish this result, you need to refine the actions that you create. By testing actions on a variety of test files, you solve problems created by files of different sizes, file types, color spaces, and more. Conveniently, a set of test files is available for your testing needs. The **Samples** folder installed with Photoshop contains many challenges to help make you a better builder of quality actions.

Don't worry, if the troubleshooting goes slowly when you start out. Each new action that you create becomes easier, as you anticipate problems and build your actions to avoid known problems. Common problems become quickly recognized. Common solutions become familiar tools. It all starts with your first batch.

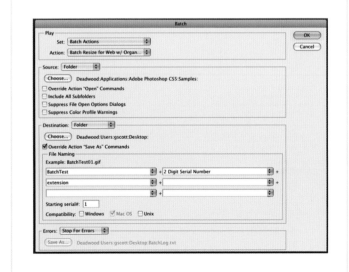

FIGURE 5.5 The Batch dialog after the details are set for the first run.

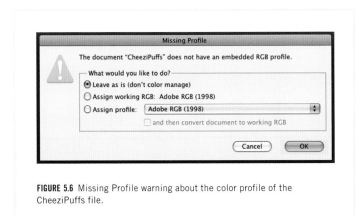

FIGURE 5.6 Missing Profile warning about the color profile of the CheeziPuffs file.

3. In the **Batch** dialog, click the **OK** button to run the batch process.

4. Almost immediately, your batch will have a problem. The **Missing Profile** dialog appears to warn you about the document CheeziPuffs (see Figure 5.6). Click the **Cancel** button to dismiss the warning.

5. Another warning dialog appears to inform you that there was a problem batching (see Figure 5.7). Click the **Stop** button to cancel the batch and solve the problem you found.

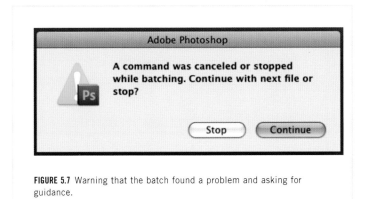

FIGURE 5.7 Warning that the batch found a problem and asking for guidance.

Understanding the Suppress Color Profile Warnings

The problem you encountered is related to the color settings you set up in Chapter 2. You set the option to have Photoshop warn you when an open document does not have an embedded color profile. This is a good problem to know about, but the dialog prevents the batch from running smoothly.

In the **Batch** dialog, there is an option for dealing specifically with this problem. In the **Source** section is a checkbox for **Suppress Color Profile Warnings** (see Figure 5.8). When you're running a batch, using this option ignores the color setting about warning of profile problems—in this case, a missing profile. Instead, Photoshop performs the default behavior of the settings, which would be a conversion to the working color space.

Although using the checkbox is a solution to the problem, the warning dialog also uncovered a bigger problem that you need to take care of. The problem is color modes.

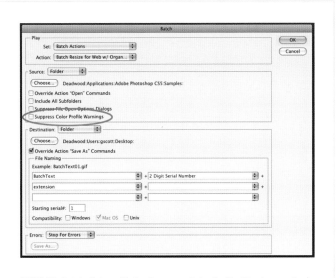

FIGURE 5.8 Batch dialog with the Suppress Color Profile Warnings option highlighted.

Making a Conditional Mode Change

When you're processing a set of files, there is the possibility that one or more of the files is not in the color mode expected. Most files these days are from digital cameras, so they are in the RGB color mode. This is the mode you want to work with files when preparing them for the web. However, you might get other types of files. For example, you might be preparing the files for a color press printer, which uses the CMYK color mode. When you're dealing with automation, it is better to not assume. Instead, you want to explicitly know. In this case, that means telling Photoshop to convert files to the RGB color mode:

1. Choose **Image** > **Mode** > **Grayscale** from the menus to convert your currently open document. Photoshop does not record mode changes if the document is already in the target mode. Because the target result for the action is RGB, you need to convert your document to a different mode. If a warning dialog pops up about switching the modes, click the **Discard** button to complete the mode change.

2. Click to select the **Play action Resize for Web w/ Organic Border** action step of the **Batch Resize for Web w/ Organic Border** action in the **Actions** panel.

3. Click the **Record** button at the bottom of the panel.

4. Choose **File** > **Automate** > **Conditional Mode Change...** from the menus.

The **Conditional Mode Change** dialog, as shown in Figure 5.9, changes the color mode of a document from one of the checked source modes to the target mode. For this action, you are creating images for the web, so all the files need to be RGB.

5. In the **Conditional Mode Change** dialog, check all the **Source Mode** checkboxes, except for the **RGB Color** box. There is no reason to change an RGB mode file to an RGB mode.

6. In the **Target Mode** section, set the **Mode** to **RGB Color** (see Figure 5.10).

7. Click the **OK** button to record the action step.

8. Click the **Stop** button at the bottom of the **Actions** panel.

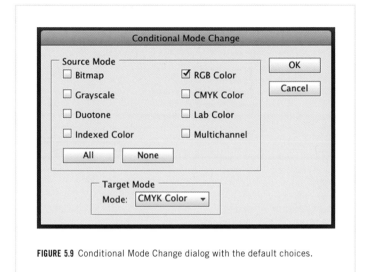

FIGURE 5.9 Conditional Mode Change dialog with the default choices.

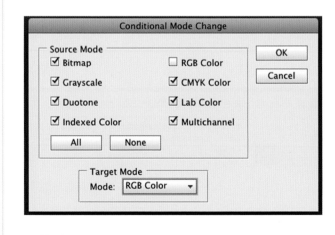

FIGURE 5.10 Conditional Mode Change dialog with values to convert documents to RGB Color.

9. Reorder the steps in the batch action by dragging the new **Conditional Mode Change** step above the **Play action** step.

10. Choose **File** > **Automate** > **Batch…** from the menus to open the **Batch** dialog.

11. Click on the checkbox to set the **Suppress Color Profile Warnings** option. The settings you used last time should already be set in the dialog.

12. Click the **OK** button to run the batch.

> **Warning:** There is a bug in Photoshop CS5 when you run a batch using the **Conditional Mode Change** action step. If you are using Photoshop CS5, the problem you run into is an alert informing you that "Mode of the document is the same as the Target Mode. No conversion performed." There is no workaround to this dialog. You must uncheck the **Conditional Mode Change** action step. This does mean that the problem of color modes continues, but other changes to make Photoshop CS5 save files appear to solve the problem for you. For now, simply uncheck the action step and run the batch again. This bug does not occur in Photoshop CS4 and is fixed in Photoshop CS6. The bug does not occur if the action is run on its own and not as a batch. The action step is too important not to mention it in this book, but take care using it.

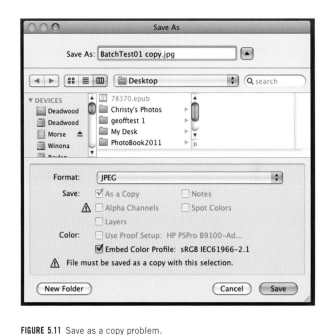

FIGURE 5.11 Save as a copy problem.

A new problem pops up. A **Save As** dialog appears to demand your attention, as shown in Figure 5.11, because the CheeziPuffs file must be saved as a copy.

Click the **Cancel** button and then click the **Stop** button in the dialog that follows it to stop the batch process. This dialog cannot be hidden from the batch process in a normal way by suppressing dialogs. Instead, it forces you to use one of the other batch options.

Writing Errors to the Log File

Now continue as follows:

1. Choose **File** > **Automate** > **Batch…** from the menus to open the **Batch** dialog.

2. Change the **Errors** menu at the bottom of the dialog from **Stop For Errors** to **Log Errors To File**.

3. Click the now active **Save As…** button below the **Errors** menu.

4. In the **Save** dialog that appears, navigate to the **Desktop** to select it as the destination and then type **BatchLog.txt** in the **Save As** field for the filename. Then click the **Save** button to close the dialog.

5. Back in the **Batch** dialog, the path to the log file should now appear next to the **Save As…** button. Click the **OK** button to run the batch process.

Using the Suppress File Open Options Dialog

The batch process gets further this time, but it has a problem with the **Doors.dng** file. Because the file is in DNG format, the Adobe Camera Raw plug-in is shown when the file is opened. Not ideal for

a batch process. You can be thankful there is an option to handle this problem:

1. Choose **File** > **Automate** > **Batch...** from the menus to open the **Batch** dialog.

2. Click on the checkbox to set the **Suppress File Open Options Dialogs** option. It is directly above the **Suppress Color Profile Warnings** option.

3. Click the **OK** button to run the batch process again.

Congratulations! The batch should run successfully without stopping. All the files open, are resized, have a border added to them, and then are closed.

Despite all your efforts, there is a problem. Look on your **Desktop**. New files are not saved with the changes. Not to worry! You've made good progress in making your first batch action. There is not much left to complete it. Remember that creating actions gets easier after you finish the first one.

Adding a Save Action Step

What is missing from the batch action is a save step. The first action you created in Chapter 4, **Save for Web JPEG 100%**, saved the file to the **Desktop**. When you built the **Resize for Web w/ Organic Borders**, you removed that action step. You could re-create the action step, but it is quicker to copy it:

1. In the **Actions** panel, open the **Save for Web JPEG 100%** action so that you can see its action steps.

2. Open the **Batch Resize for Web w/ Organic Border** action so that you can see its action steps.

3. Click to select the **Save** step in the **Save for Web JPEG 100%** action, hold down the **Option** (⌥) key, and drag the step down to the batch action, dropping the step below the play action step. This copies the action step so it is now in both actions (see Figure 5.12).

4. Double-click the copied save action step to bring up the **Save** dialog. Type in a temporary name because you don't really want to do a save, but you do need to record the change. Then click the **Save** button.

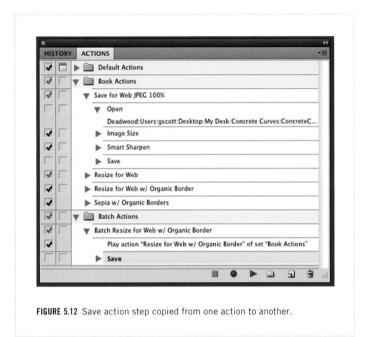

FIGURE 5.12 Save action step copied from one action to another.

The filename does not really matter. In the **Batch** dialog, your settings override the name and location settings of this save step.

5. In the **JPEG Options** dialog, change the **Quality** value from **12** to **9**. This keeps the quality level high for your image, but makes it smaller and quicker to display on the web. Next, click the **OK** button to save your change to the action step.

Converting Bit Depth

Many photos created by high-end cameras capture a lot of colors, more than can be displayed in a JPEG file. A JPEG file supports up to 256 color values per RGB color channel. There are 256 possible values for the red value, 256 for the green value, and 256 for blue value. This format for storing color is known as "8 Bits/Channel" because 256 values can be stored in 8 bits of computer data. You can check the "bit depth" of an image file in Photoshop by looking at the **Image** > **Mode** menu to see which value is checked for that file (see Figure 5.13).

FIGURE 5.13 Where to check in the menus for the bit depth of an image file.

You can check the "bit depth" of an image file in Photoshop by looking at the **Image** > **Mode** menu to see which value is checked for that file.

The **Fish.psd** image file in the **Samples** folder is 16 Bits/Channel. This means it has a range of 65,536 colors per channel. This is too many for a JPEG file. Before your batch action saves the file as a JPEG, it should convert the image to 8 Bits/Channel:

1. Open the **Fish.psd** file from the **Samples** folder. Most likely, this file is currently in the **File** > **Open Recent** list in the menus.
2. Click to select the **Play action "Resize for Web w/ Organic Border"** step in the batch action.
3. Click the **Record** button at the bottom of the **Actions** panel.
4. Choose **Image** > **Mode** > **8 Bits/Channel** from the menus.

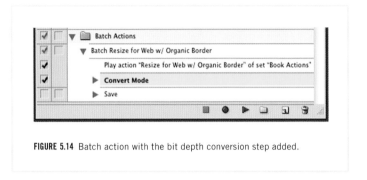

FIGURE 5.14 Batch action with the bit depth conversion step added.

5. Click the **Stop** button at the bottom of the **Actions** panel to stop recording (see Figure 5.14).

Note: With each new version of Photoshop, the application tries to do the right thing. Photoshop CS5 automatically converts 16 Bits/Channel images to 8 Bits/Channel when you save a file as a JPEG. Older versions of Photoshop do not convert for you. It is safest when making your actions to make them robust by adding the conversion step before a save step.

Converting Color Profiles

One of the first options you changed when troubleshooting your batch was to suppress warnings about color profile problems. Your working color space is set to Adobe RGB to allow you more flexibility as you adjust your images. Unfortunately, this color space is bigger than most displays that show web pages. The sRGB color space is best for web images.

You've tuned your actions for opening an image. You also need to tune your actions when saving the image:

1. Click the **Record** button at the bottom of the **Actions** panel.
2. Choose **Edit** > **Convert to Profile...** from the menus.
3. In the **Convert to Profile** dialog (see Figure 5.15), the source space should read **Adobe RGB (1998)**. For the **Destination Space**, choose **sRGB IEC61966-2.1** from the **Profile** menu.

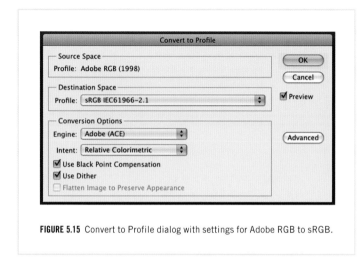

FIGURE 5.15 Convert to Profile dialog with settings for Adobe RGB to sRGB.

4. The rest of the settings are fine with the default values. Click the **OK** button to convert the color profile of the image.

5. Click the **Stop** button at the bottom of the **Actions** panel to stop recording the action.

6. Click to select the new **Convert to Profile current document** action step and drag it above the **Save** step in the batch action (see Figure 5.16).

At this point, you should run the batch process to verify that the changes you've made work. Before you do that, though, take a closer look at Figure 5.16. If you look at the leftmost column, you'll notice that the **Save**

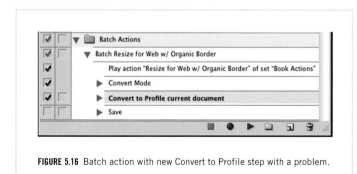

FIGURE 5.16 Batch action with new Convert to Profile step with a problem.

step does not have a check mark. The reason is that the step in the original action was also disabled. (You did this in Chapter 4.) If you were to run the action right now, the files would not be saved.

Noticing a small detail like this can save you time troubleshooting your actions. Sometimes small things cause big frustrations and a lot of wasted time. Remember to verify that all the steps in your actions have the check mark allowing them to run when the action is played:

7. Click in the leftmost column of the **Save** step to activate the step.

8. Choose **File** > **Automate** > **Batch...** from the menus to bring up the **Batch** dialog. No new changes are needed to this dialog, but be sure that the action being used is the **Batch Resize for Web w/ Organic Border**. Click the **OK** button to run the batch process.

Adjusting the Fit Image Step

When the batch is run, each file is opened and processed. Then it is saved and closed. You've specified that the files are saved to the **Desktop**. After all the work you've done, you finally have files to look at.

Just because the files were created does not mean that they are correct. You should verify that there are no mistakes. Remember that the computer does exactly what you command it to do. The problem is that sometimes it is not always obvious exactly what those commands are doing or if some other factor has not been dealt with yet.

Open up all the files created by the batch. Do the files look like you expected? Probably not. Some of the original images are small, so the border takes up most of the space in the resulting image. Also take a look at your logo. Does the text look correct and consistent? For some of the images, the text is too small and the text size changes. Unfortunately, this means you are not quite done creating your batch action.

The first problem is easy to solve. Take a look at the **Fit Image** step in the **Resize for Web** action (see Figure 5.17). The step specifies that the step resizes to fit the image into the dimensions provided but does not enlarge the image. So, if the image is small, the image can get lost in the border created by the rest of the action. Normally, you do not want to

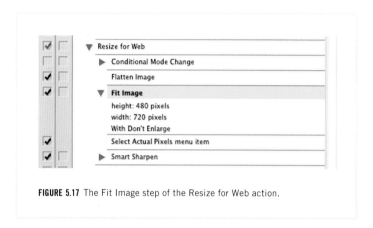

FIGURE 5.17 The Fit Image step of the Resize for Web action.

Changing Image Resolution with Image Size

The second problem with the results of the batch process is that the text is not consistent or the correct size. This problem is trickier. With the **Fit Image** step, Photoshop resizes the image to a pixel size. It does not change the resolution of the image. If the image was originally 300 pixels per inch (ppi), it stays 300ppi. If it was 72ppi, it stays 72ppi. In many cases, the resolution is not that important. Text is an exception. Text is sized differently and is based on the resolution, not the pixels.

Most of the images in the **Samples** folder are set at 72ppi. One is set to 100ppi. Adobe Camera Raw opens the DNG file, so that file has whatever the current setting is for the plug-in, perhaps 240ppi. You can verify all this by opening the images in Photoshop and then choosing **Image > Image Size...** from the menus and checking the **Resolution** in the **Image Size** dialog.

Web images are displayed best at 72ppi, which is the standard resolution for monitors. What you need to do is select a font size for your action step that makes sense for a 72ppi image:

enlarge an image, creating pixels that are not part of the original image. However, you are not making any image much larger than it already is. Photoshop does a very good job in this case.

1. Double-click the **Fit Image** step in the **Resize for Web** action to edit the step parameters.

2. In the **Fit Image** dialog, uncheck the **Don't Enlarge** checkbox to allow Photoshop to make images bigger.

3. Click the **OK** button to save your change to the **Fit Image** step. Figure 5.18 shows the change.

1. Open the result image with the bulldog on the deck. This should be the file named **BatchTest07.jpg** on your **Desktop**.

2. In the **Resize for Web w/ Organic Border** action, double-click on the **Make text layer** step. This will add a new text layer to the document, with all the text selected and not committed yet.

3. Change the font size of the selected text by using the size menu in the Options Bar. A good size for the Gill Sans font seems to be 30 pt. The choice is yours, but pick a size that works for your logo on the image.

4. After choosing a good size, click the check mark button in the Options Bar to commit the change to the action step.

This change fixes the text problem for images that are 72ppi but does not address the problem for images that are not 72ppi. All images run through this process need to be converted to 72ppi. The best place to do this is in the **Resize for Web** action.

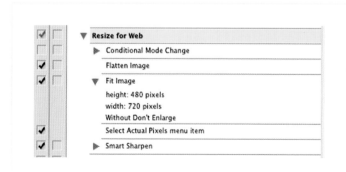

FIGURE 5.18 The Fit Image step showing the Without Don't Enlarge parameter.

Fit Image is the step you use to resize the image. The dialog fits the image to those dimensions but preserves the aspect ratio of the image, as described in Chapter 4. However, you just checked the resolution of images using the

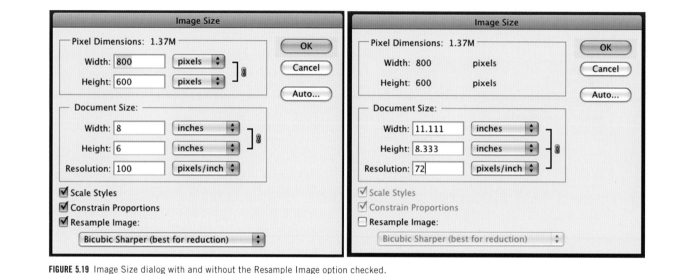

FIGURE 5.19 Image Size dialog with and without the Resample Image option checked.

Resize Image dialog. This dialog is the way you are going to change the resolution of the image without changing the pixel size of the image:

1. Open the result image with the 100ppi resolution. This should be file **BatchTest05.jpg** on your **Desktop**.

2. In the **Actions** panel, click to select the **Fit Image** step in the **Resize for Web** action.

3. Click the **Record** button at the bottom of the **Actions** panel to start adding new steps to the action.

4. Choose **Image** > **Image Size...** from the menus.

5. In the **Image Size** dialog (see Figure 5.19), change the **Resolution** to **72** pixels/inch.

6. Click the **Resample Image** checkbox to uncheck that option. This instructs Photoshop to change just the resolution without changing the document size. Click the **OK** button to record the action.

7. Click the **Stop** button at the bottom of the **Actions** panel to stop recording.

8. Close both of the result images that you opened without saving changes.

9. Choose **File** > **Automate** > **Batch...** from the menus. Make sure that the dialog parameters are correct, particularly which action is being run for this batch. Then click the **OK** button to run the batch.

The batch should run smoothly. All the files are created and look good. Just to be certain that everything went well, you should look at the log file. In the **Batch** dialog, you specified that errors should be written to the file. Open the file to see if any errors were reported. The log file is a standard text file, so you should be able to double-click the file to open it in your computer's default text editor.

In this case, the log file reports no errors. The lines between the Start Batch and End Batch lines are empty. Good to know. This is the result you want each time. You should always check the log file, just in case Photoshop discovered some new problem that needs your attention.

Creating a Successful Batch Process

Creating a successful batch process and the actions that go with it takes time. The work can involve doing a few things over and over again. You fix one problem only to find another right after it. The key is to

keep making progress as you troubleshoot. At some point, no more errors are found, and the batch process is successful.

The next batch process you create will take less time to successfully complete. For one thing, you have a batch action that works well already. You can copy it and change it as needed. This will save you a lot of time.

It is helpful to review how you created your first successful batch process:

1. Create an action that works on one image.
2. Create a batch action that plays the other action.
3. Use the **Batch** dialog to set up and run a batch with the batch action on a small set of test files.
4. Fix any error that you encounter; then rerun the batch again to find the next error until the batch runs without stopping. Remember that it might be helpful to use the **Stop for Errors** option of the **Batch** dialog, but eventually you should use the **Log Errors to File** option.
5. Be sure to add a **Save** step to your batch action and to add the needed conversions for the file type you are saving.
6. Check the resulting files from the batch to see that the images look correct and are consistent with your expectations.
7. Check the log file to be sure no unexpected errors were found.
8. When your batch works successfully on your test images, run it on the large set of files you really want to work with.

Although creating the batch process took a long time, imagine how long it would take you to do the same tasks on a thousand images. Processing a thousand images with a batch takes time, too, but it just does not take much of *your* time. It is the computer that is working hard on the images, instead of you.

Using Batch from Bridge

Batch is an easy process to run from Photoshop. It is also an easy process to run from the Bridge application. Select the files you want to use in Bridge and choose **Tools** > **Photoshop** > **Batch...** from the menus (see Figure 5.20).

FIGURE 5.20 Choosing Batch from the Bridge menus.

FIGURE 5.21 Batch dialog when opened from Bridge.

Bridge opens the **Batch** dialog in Photoshop and sets the **Source** to **Bridge** (see Figure 5.21). The files for the batch are sent from Bridge to Photoshop for batch processing. The dialog works exactly the same as before. The difference is how the source files are specified.

The advantage to using Bridge to start your batch processes is that Bridge is meant for gathering files. You can see what the images look like before the batch. You can also specify a group of files that are not in the same folder using Collections. You can narrow the set of files used in a folder by filtering the results, perhaps by star rating assigned to the images. Photoshop takes all the files in a folder. Bridge has tools to collect images in different ways.

FIGURE 5.22 The Create Droplet dialog with new settings.

Droplets for Batch Processing

You must use Photoshop to build a successful batch process. But you are not limited to using Photoshop to initiate a batch process. You've already learned how to use Bridge to do a batch. Another way is to create a droplet. A droplet is a small application that includes all the instructions of a batch, including the action steps. This small application can be used to initiate batch processes from the operating system and beyond.

Creating a Droplet

Creating a droplet is easy and familiar:

1. Choose **File** > **Automate** > **Create Droplet...** from the menus. This option is conveniently located right below the **Batch...** menu item.

2. The **Create Droplet** dialog is similar to the **Batch** dialog (see Figure 5.22). One of the differences is the **Save Droplet In** section. Click the **Choose...** button in this section.

3. In the **Save** dialog, navigate to the **Desktop**, name the file **ResizeForWebOrganicBorder**. There are more details about droplet naming later. Click the **Save** button to complete the dialog.

4. Back in the **Create Droplet** dialog, choose the **Batch Resize for Web w/ Organic Border** from the **Batch Actions** set.

5. Check the **Suppress File Open Options Dialogs** and the **Suppress Color Profile Warnings** checkboxes to use those options.

6. Set the **Destination** to **Folder** and click the **Choose...** button below it.

7. In the **Choose a folder for the droplet's output...** dialog, navigate to the **Desktop** folder and click the **New Folder** button.

8. In the **New Folder** dialog, type **Resize For Web Organic Border** as the name for a new folder and click the **Create** button.

9. In the **Choose a folder for the droplet's output...** dialog, click the **Choose** button.

10. Check the **Override Action "Save As" Commands** checkbox to use that option.

11. Change the **Errors** menu to **Log Errors To File** and click the **Save As...** button below it.

12. Type **DropletLog.txt** into the name field. The folder selected should already be the **Resize For Web Organic Border** folder you previously created; if not, choose it. Then click the **Save** button.

13. Click the **OK** button of the **Create Droplet** dialog to create the droplet as specified (see Figure 5.23).

FIGURE 5.23 New droplet for resizing images for the web with an organic border.

Easy, right? The process is almost like running a batch. The difference is that you have to save the batch into a droplet file and specify that the result files be saved in a new folder on the **Desktop**.

Running a Droplet

Creating a droplet is easy. Running a droplet is even easier:

1. In the Finder on Mac or Explorer on Windows, navigate to the **Adobe Photoshop** folder in your **Applications** folder and open it.

2. Drag and drop the **Samples** folder onto the **ResizeForWebOrganicBorder** icon on your **Desktop** to run the droplet.

The droplet opens each image file in the folder in Photoshop and processes the file using the batch action.

When the work is completed, check the files in the **Resize For Web Organic Border** folder on your **Desktop**. All the processed files should be in there, as well as the log file. Check them all to be sure that the results are what you expect.

That's it. Easy. After you've created a batch process, using a droplet of that process is simple.

Creating a Droplet for Lightroom

Lightroom is another way to initiate a batch process using a droplet. Lightroom has a lot of automation controls built in, but it does not have all the control over the image processing that Photoshop does. Lightroom organizes your images, and you can create sets of them similar to what you do in Bridge. There are similarities and differences in how each product interacts with batch processing.

Bridge collects the images, sending them one by one to Photoshop for processing. Each time, Photoshop saves the images using the save step in the batch action and naming the file as you specified in the **Batch** dialog.

Lightroom collects all the images in its database for processing, but the batch process is a part of the export process. As part of the export from Lightroom, you specify the location where the new files are saved, the names of the new files, and the file format of the new file. In addition, you instruct Lightroom to use a droplet to run the batch process in Photoshop. Each image is created by Lightroom according to the export specification and then sent to Photoshop for processing. Photoshop saves and closes the file when the processing on it is complete.

Bridge cannot create files. Lightroom can. This difference leads to a difference in how the droplet for your batch is created for use with Lightroom:

1. In Photoshop, choose **File** > **Automate** > **Create Droplet...** from the menus.

2. In the **Save Droplet In** section of **Create Droplet** dialog (see Figure 5.24), click the **Choose...** button.

3. In the **Save** dialog, navigate to the **Desktop** folder as a save location and type **ResizeForWebOrganicBorder_LR** to name the droplet. Then click the **Save** button to close the dialog.

4. In the **Play** section of the **Batch** dialog, set the values as you did when creating previous droplets.

5. Change the **Destination** value to **Save and Close**. Keep the **Override Action "Save As" Command** option checked.

FIGURE 5.24 Creating a droplet for use with Lightroom.

6. Change the **Errors** log file to be saved to the **Desktop**. Because Lightroom is creating the destination folder, the droplet does not know where the folder will be. It is safer to create the file on the **Desktop**, rather than have it buried in a folder that might not be visible when you complete the batch process.

7. Click the **OK** button to create the droplet.

The droplet you just created is on the **Desktop**. Unfortunately it should not stay there. There is a better, more convenient place that allows Lightroom to put the droplet into its **Export** dialog:

8. In Lightroom, you can find this folder by choosing **File** > **Export...** from the menus.

9. At the bottom of the **Export** dialog's right column is the **Post-Processing** section. From the **After Export** menu, choose the **Go To Export Actions Folder Now** menu item. The Finder or Explorer will then open that folder and show it to you.

10. Move the droplet that you've created from the **Desktop** into the folder displayed.

11. In Lightroom, click the **Cancel** button to close the **Export** dialog.

Where Is the File Located?

Mac OS X:

/Users/[user name]/Library/Application Support/Adobe/ Lightroom/Export Actions/

Windows XP:

\Documents And Settings\[user name]\Application Data\Adobe \Lightroom\Export Actions\

Windows 7 and Vista:

\Users\[user name]\App Data\Roaming\Adobe\Lightroom\Export Actions\

Using a Droplet with Lightroom

Lightroom's export process is similar to Photoshop's batch process. The **Export** dialog has more options than the **Batch** dialog, though, so you have to keep in mind what the droplet does to each file as it processes it. Some options you might normally use when exporting are not needed with this droplet.

Do all the following steps in Lightroom:

1. Select a group of photos to have your droplet batch process.

2. Choose **File** > **Export...** from the menus to bring up the **Export** dialog.

3. In the **Export Location** section, change the settings to export to the **Desktop**. Check the **Put in Subfolder** option and type **Processed_Images** for the name of the folder. Because these images are meant for the web, leave the **Add to This Catalog** setting unchecked.

4. In the **File Naming** section, set the **Rename To** menu to **Filename**. Because the files are saved in a new location, there is no chance of writing over an original. You could use a better name template than **Filename**, such as one with a custom name and sequence number. For this example, **Filename** is fine.

5. In the **File Settings** section, set the **Format** to **JPEG**, the **Quality** to **85**, and the **Color Space** to **sRGB**.

6. In the **Image Sizing** section, uncheck the **Resize to Fit** checkbox. The action in Photoshop resizes the images, so these options are not needed for this process.

7. In the **Output Sharpening** section, uncheck the **Sharpen For** checkbox. The action in Photoshop also does the sharpening.

8. In the **Metadata** section, check the **Minimize Embedded Metadata** checkbox. Your images are going on the web. No need for your internal details such as keywords and develop settings to stay with your files. Your copyright metadata is still written to the files, even with this option checked.

9. In the **Watermarking** section, uncheck the **Watermark** checkbox. Your image has your brand on the border, so there's no need for a watermark.

10. In the **Post-Processing** section, set the **After Export** menu to **ResizeForWebOrganicBorder_LR**. This is the droplet you copied to the **Export Actions** folder. If the option is not in the menu, verify that the droplet is in the correct location. If it is in the location, quit Lightroom and run it again. The option should appear.

11. All the settings for this droplet's process are now set. Click the **Add** button at the bottom of the leftmost column to make a preset for these settings. A preset allows you to quickly fill in all these fields with the values you've set for use with the droplet.

12. In the **New Preset** dialog, type **ResizeForWebOrganicBorder** to name the preset and set the **Folder** menu to **User Presets**. Click the **Create** button to finish creating the preset. In the **Export** dialog, the new preset should appear in the list in the left column.

13. Click the **Export** button to kick off the batch process using the droplet that you created.

As always, you should check your resulting files to see that they match your expectations. When they do, you can easily run this process on any group of images from Lightroom using **Export** and the preset you've created (see Figure 5.25).

FIGURE 5.25 Lightroom's Export dialog with settings for using the ResizeForWebOrganic_LR droplet.

Understanding Droplet Limitations

Droplets contain all the action and batch settings for the process. After a droplet is created, you cannot edit the settings inside the droplet. You can only re-create the droplet. For that reason, you should always keep copies of the batch actions used to create a droplet. You never know when you might need to change a setting or fix a problem previously undetected. After you update the action, you can easily re-create the droplet with all the same batch settings.

Like actions, droplets record absolute paths to folders and files. Consequently, many droplets cannot be used on other computers. Despite this limitation, it is possible to create droplets that can be shared. They can even be shared between operating systems.

Before moving a droplet from one operating system to another, archive the file into a zip file. Mac OS X and Windows both have built-in ways to zip and unzip files. Because the droplet is itself an executable, pieces of it might get stripped away during normal copying or emailing of a droplet between computers. It is much safer to move a zip file to preserve all the application pieces.

If the destination computer is a Windows machine, add the .exe file extension to it. On Windows, all applications use the .exe file extension. On Mac OS X, an .exe file extension has no special meaning.

If the destination computer is a Macintosh, drop the unzipped droplet file on top of Photoshop. Photoshop recognizes droplet executable files and changes a few resources to make it run on the Mac OS X operating system. When this is done, the droplet will work normally.

On the Macintosh, droplets created by Photoshop CS4 or earlier versions of Photoshop are made for use with computers using the PPC chip architecture. This means that they run in the Rosetta PPC emulator on the more recent Intel-based Macintoshes. Mac OS X 10.6 and higher do not install the Rosetta emulator by default. If you try to run a droplet created by Photoshop CS4 or earlier, you will be prompted to download and install Rosetta. Installing it is easy to do and needs to be done only once.

Photoshop CS5 initially created PPC-based droplets. This changed with the first update to Photoshop CS5. To update your copy of Photoshop, choose **Help** > **Updates...** from the menus to be guided through the update process. Although the Intel-based droplets created by Photoshop CS5 version 12.0.1 and higher are Intel-based applications, they are 32-bit architecture based, not 64 bit. If your computer runs in 64 bit, you need to set Photoshop to run in 32 bit to work with droplets. See Chapter 3 for more information on how to do this.

Conclusion

Batch processing is a very powerful automation tool. Understanding how to successfully create a batch process is key to building up your automated workflows. This understanding expands the size and range of what you can make Photoshop do for you.

The ideas behind building up a good batch process also are fundamental to scripting. As you create and troubleshoot your actions for batch, you build up knowledge of how things are done in Photoshop. You start to anticipate the problems possible and learn the solutions to solve them. This speeds up your development time creating the processes and makes the results that much more predictable and consistent.

EXPLORATIONS

One thing you should do to every image you create or photograph you take is fill in the metadata for copyright information. In Chapter 2, you created a metadata preset for your copyright information using the **File Info** dialog. Create an action to fill in the copyright metadata using your preset. Then refine a batch process for applying the preset to multiple files. When you have the batch working well, create a droplet for the batch process so that you can use it at any time.

Six

REPEATING

Tasks with External Data

Working with Variables and Data Sets

So far in this book, you have used automation to change a single file into a new file or many files into many new files. You can use automation to do more than just these one-to-one or many-to-many types of operations, however. You also can use it to generate many new files from just a single image file.

For example, many companies create badges for their employees to allow them access to company facilities. Each security badge usually has the photo of the employee, his name, and some other identifying information. Such badges usually have the same design with each employee's specifics different per badge. The badges could be created by hand for each employee. However, doing so would be time consuming for a company of any real size. It would be far better to create a single image that can be used over and over again.

Photoshop's Variables automation process is perfect for solving problems like creating employee badges.

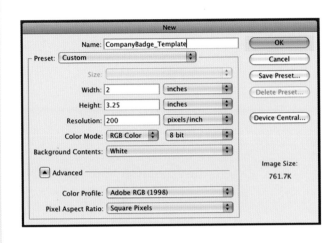

FIGURE 6.1 New document dialog with values for the company badge.

Creating a Template

To create multiple images from a single file, you need to set up that single file. This file is called a *template*. It is a layered Photoshop file built generically. How you set up the file is important. Each layer can potentially be replaced with external data. So how you name and arrange those layers affects how the data is used by the Variables process.

Setting Up The Template File

To begin setting up your template file, follow these steps:

1. Choose **File** > **New...** from the menus.

2. In the **New** dialog (see Figure 6.1), set the **Name** to CompanyBadge_Template, the **Width** to **2 inches**, **Height** to **3.25 inches**, and **Resolution** to **200 pixels/inch.** Then click the **OK** button to create the new image.

3. Choose **View** > **Rulers** from the menu to see the rulers in the document window.

When you're setting up a template file, it can be useful to set up guides. Guides help make sure that the template design is generic enough for all the data that will be run through it. For this example, you add nine guides.

4. Choose **View** > **New Guide...** from the menu. In the **New Guide** dialog (see Figure 6.2), keep the **Orientation** set to **Vertical**. Set the **Position** to **50 px**. Click the **OK** button to add the guide to the document window.

5. Choose **View** > **New Guide...** from the menu. In the **New Guide** dialog, keep the **Orientation** set to **Vertical**. Set the **Position** to **350 px**. Click the **OK** button to add the guide to the document window.

6. Choose **View** > **New Guide...** from the menu. In the **New Guide** dialog, set the **Orientation** to **Horizontal**. Set the **Position** to **50 px**. Click the **OK** button to add the guide to the document window.

7. Choose **View** > **New Guide...** from the menu. In the **New Guide** dialog, set the **Orientation** to **Horizontal**. Set the **Position** to **100 px**. Click the **OK** button to add the guide to the document window.

8. Choose **View** > **New Guide...** from the menu. In the **New Guide** dialog, set the **Orientation** to **Horizontal**. Set the **Position** to **400 px**. Click the **OK** button to add the guide to the document window.

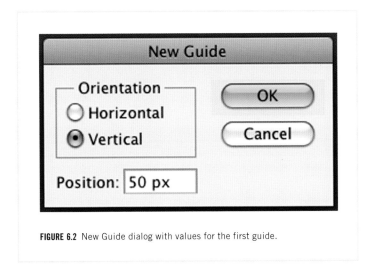

FIGURE 6.2 New Guide dialog with values for the first guide.

9. Choose **View** > **New Guide...** from the menu. In the **New Guide** dialog, set the **Orientation** to **Horizontal**. Set the **Position** to **450 px**. Click the **OK** button to add the guide to the document window.

10. Choose **View** > **New Guide...** from the menu. In the **New Guide** dialog, set the **Orientation** to **Horizontal**. Set the **Position** to **500 px**. Click the **OK** button to add the guide to the document window.

11. Choose **View** > **New Guide...** from the menu. In the **New Guide** dialog, set the **Orientation** to **Horizontal**. Set the **Position** to **550 px**. Click the **OK** button to add the guide to the document window.

12. Choose **View** > **New Guide...** from the menu. In the **New Guide** dialog, set the **Orientation** to **Horizontal**. Set the **Position** to **600 px**. Click the **OK** button to add the guide to the document window.

13. Choose **View** > **Lock Guides** from the menus so that it has a check mark next to the menu item. This way, the guides are all locked and cannot be moved by accident.

14. Choose **View** > **Snap** from the menus so that it has a check mark next to the menu item. This automatically snaps cursor movements to the guides. To be sure, choose **View** > **Snap To** and check that **Guides** is one of the items checked in the submenu.

If the guides in document window do not look correct (see Figure 6.3), then review the steps to see which guide might have been added

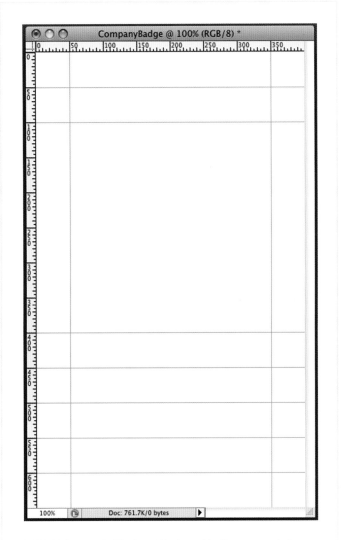

FIGURE 6.3 Document with nine guides for making the company badge.

incorrectly. When adding a lot of horizontal guides, you can easily forget to set the **Orientation** to **Horizontal**.

Another common mistake is that the units are not in pixels. If you look at the ruler, it should show a range from 0 to 400 wide and 0 to 650 tall.

If it does not, then press the **Control** key and click on one of the rulers (or right-click on a ruler). Using the context menu, switch the units to pixels. When you entered the numbers in the **New Guide** dialog, you might have forgotten the units, or it may have used the default units if there was a problem. Pixels in this example are easy to calculate and verify when all the guides are added. Inches and centimeters are tougher.

It is important that you save the template as a PSD file. Later, you will be adding layers to the document and other data.

15. Choose **File** > **Save As...** from the menus.

16. In the **Save** dialog, the name of the file should already be entered as **CompanyBadge_Template**. Navigate to the **Desktop** to save the file there. Set the **Format** menu to **Photoshop**. Click the **OK** button to save the new PSD file to the **Desktop**.

Setting Up The Badge Types

The company badge is created for more than just employees. The company has visitors, too. Most companies also hire contractors on a temporary basis. So there are three type of badges to be created from the template. Each badge has a clear and distinctive look to set it apart from the other badge types. To set up the badge types, follow these steps:

17. Click the **New Layer Set** button at the bottom of the **Layers** panel to create a new layer set.

18. Double-click on the new layer set's name in the layers list and type **Employee** to name the set.

19. In the Tool Bar, click to select the Rectangle tool.

20. In the Options Bar, click on the color chip to set the color of new rectangles. In the **Color Picker** dialog, set the **R** value to **0**, set the **G** value to **0**, set the **B** value to **255**, and click the **OK** button.

21. Using the Rectangle tool, drag out a rectangle in the document window that covers the top 50 pixels all the way across (pixels 0–400 wide and 0–50 tall). Dragging out this rectangle

> If you can see the **Swatches** panel when a **Color Picker** dialog is visible, you can click on the color chips in the **Swatches** panel to set the color in the dialog to the color that was clicked. You'll notice the mouse pointer switch to the eyedropper icon. This is a great reason to have the **Swatches** panel open. You can also click on the foreground and background color chips in the Tool Bar. You can even click in an open document to set the color in the picker.

creates a new shape layer. Because you just created and renamed the layer set, the new layer is automatically added to the Employee set.

22. Using the Rectangle tool, drag out a rectangle in the document window that covers the bottom 50 pixels all the way across (pixels 0–400 wide and 600–650 tall).

23. In the Tool Bar, click to select the Text tool.

24. Choose a good font from the Options Bar. Set the font size to **18 pt** or something close to it. Set the text alignment to be center justified. Click the color chip and change the color to white.

25. Click on the document in about the middle horizontally (200 pixels) and at the bottom vertically of the top colored rectangle. Type **Employee** and then click the Commit (check mark) button in the Options Bar to add the new text layer.

26. Click on the document in about the middle horizontally (200 pixels) and at the bottom of the document vertically. Type **Employee** and then click the Commit (check mark) button in the Options Bar to add the new text layer.

27. If either of the new text layers is not centered or in the right place, use the Move tool to adjust the position of the layer. Be sure to select the layer in the **Layers** panel before trying to move a layer.

You've added the new layers to make the employee badge type distinctive and clear (see Figure 6.4). However, the layer names are not really useful. Useful layer names help make using the Variables automation process much easier.

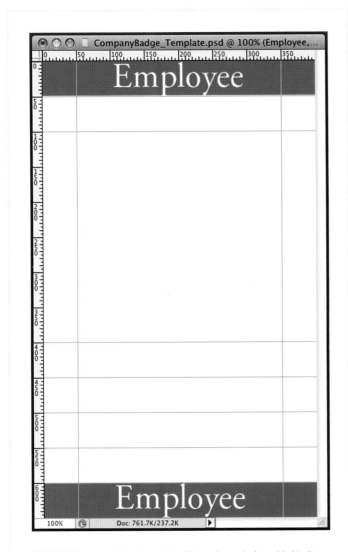

FIGURE 6.4 Company badge template with employee design added to it.

28. Double-click on the name of the topmost text layer in the **Layers** panel list. Change the name from **Employee** to **EmpTextB**.

29. Double-click on the next text layer's name. Change the name from **Employee** to **EmpTextT**.

30. Double-click on the name of the topmost shape layer in the **Layers** panel list. Change the name from **Shape 2** to **EmpColorB**.

31. Double-click on the next shape layer's name. Change the name from **Shape 1** to **EmpColorT**.

Changing the layer names makes them more meaningful. Now each name is unique and descriptive, helping to reference the layer's content. For example, **EmpColorB** refers to the employee color for the bottom of the badge.

Your **Layers** panel should look like the one in Figure 6.5.

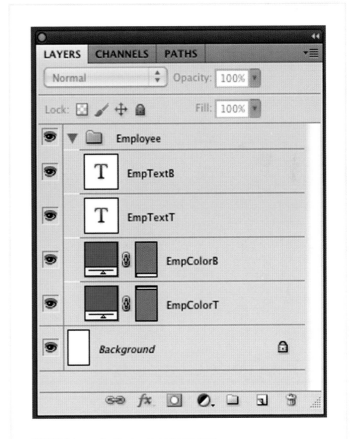

FIGURE 6.5 Layers for the employee badge type.

There are two more types to create. You could simply repeat all the steps done for the employee type and use new values for the other types. But there is another way: You can copy the entire layer set and make changes to the new layers. Here's how:

32. Click the triangle next to the **Employee** layer set to close the layer set.

33. Click on the **Employee** layer set to select it. Then drag it down to the bottom of the list, dropping it on the New Layer button. This creates a duplicate layer set named **Employee Copy**.

34. Double-click on the name of the new layer set and change the name from **Employee Copy** to **Contractor**.

35. Click the triangle next to the name to open the **Contractor** layer set to see the layers in the set.

36. Click in the Tool Bar to select the Text tool.

37. Click on the text at the top of the document to select it and then double-click to select the entire text line.

38. Type **Contractor** to change the text in the layer and then click the check mark button in the Options Bar to commit the change.

39. Click on the text at bottom of the document to select it and then double-click to select the entire text line.

40. Type **Contractor** to change the text in the layer and then commit the change.

41. Double-click on the color chip of the topmost shape layer in the **Layers** panel list.

42. In the Color Picker dialog, set the color **R** to **0**, **G** to **255**, and **B** to **0** (or click on the green color chip in the top row of the **Swatches** panel). Then click the **OK** button to change the color of the shape layer to green.

43. Double-click on the color chip of the next shape layer in the **Layers** panel list.

44. In the Color Picker dialog, set the color to green and then click the **OK** button to change the color of the shape layer.

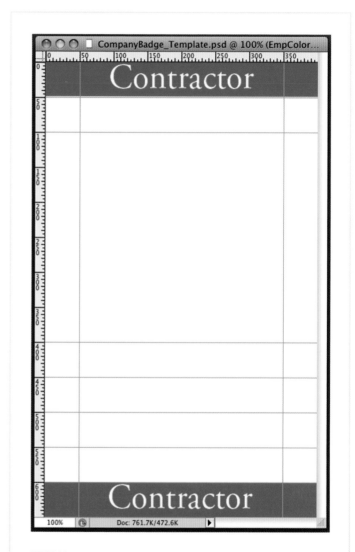

FIGURE 6.6 Company badge with the contractor type shown.

The look for the contractor badge type is complete, as you can see in Figure 6.6, but the names of the layers are still the same as those used by the employee layers. The contractor layer names also must be changed to be unique.

45. Change the text layer name from **EmpTextB** to **ConTextB**.

46. Change the text layer name from **EmpTextT** to **ConTextT**.

47. Change the shape layer name from **EmpColorB** to **ConColorB**.

48. Change the shape layer name from **EmpColorT** to **ConColorT**.

Your **Layers** panel should now look like the one in Figure 6.7.

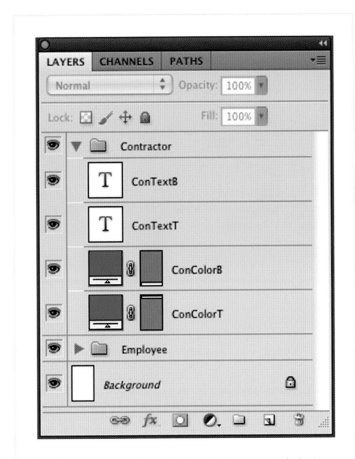

FIGURE 6.7 Layers panel with the new layers for the contractor badge type.

Two badge types down, one more to create. As you did with the contractor type, you are going to copy a whole layer set and change it for the new type:

49. Click the triangle next to the **Contractor** layer set to close the layer set.

50. Click on the **Contractor** layer set to select it. Then drag and it down to the bottom of the list, dropping it on the New Layer button. This creates a duplicate layer set named **Contractor Copy**.

51. Double-click on the name of the new layer set and change the name from **Contractor Copy** to **Visitor**.

52. Click the triangle next to the name to open the **Visitor** layer set to see the layers in the set.

53. Click in the Tool Bar to select the Text tool.

54. Click on the text at the top of the document to select it and then double-click to select the entire text line.

55. Type **Visitor** to change the text in the layer and commit the change.

56. Click on the text at bottom of the document to select it and then double-click to select the entire text line.

57. Type **Visitor** to change the text in the layer and then commit the change.

58. Double-click on the color chip of the topmost shape layer in the **Layers** panel list.

59. In the Color Picker dialog, set the color **R** to **255**, **G** to **0**, and **B** to **0** (or click on the red color chip in the top row of the **Swatches** panel). Then click the **OK** button to change the color of the shape layer to red.

60. Double-click on the color chip of the next shape layer in the **Layers** panel list.

61. In the Color Picker dialog, set the color to red and then click the **OK** button to change the color of the shape layer. The result is shown in Figure 6.8.

62. Change the text layer name from **ConTextB** to **VisTextB**.

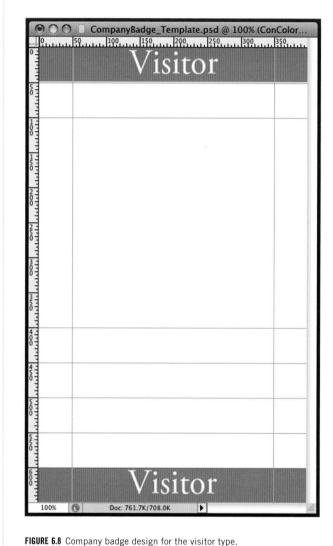

FIGURE 6.8 Company badge design for the visitor type.

FIGURE 6.9 Layers for the visitor badge type.

63. Change the text layer name from **ConTextT** to **VisTextT**.

64. Change the shape layer name from **ConColorB** to **VisColorB**.

65. Change the shape layer name from **ConColorT** to **VisColorT**.

Your **Layers** panel should now look like the one in Figure 6.9.

66. Click the triangle next to the **Visitor** layer set to close the layer set.

That was a lot of work to set up the designs for the employee, contractor, and visitor badge types. Each badge type has four layers. The work is simple but repetitive. The design provides for a lot of flexibility, though. You can change the colors and the text for each badge at both the top and the bottom of the badge. Keep in mind that company badges change. Therefore, setting up the template like this goes a long way toward keeping it useful for changes in the future.

Setting Up the Employee Photo

So far, the badge template really does not include information specific to each individual person. That changes now. Every badge includes a photo of the person. Here's how to add it:

67. Open a photo file that shows the headshot of an employee.

68. Click on the Move tool in the Tool Bar to select it.

69. Click on the headshot with the Move tool and drag it over to the company badge template's document window; then drop it on the window to create a new layer with the photo in the template.

70. Close the headshot file.

71. In the template, a new layer was created with the employee photo. Choose **Edit** > **Free Transform** from the menus. Resize and reposition the headshot so that it fits into the square space in the template (pixels 50–350 wide and 100–400 tall). The guides will help you place the photo in the correct area (see Figure 6.10). For now, do not worry about the aspect ratio of the photo; just be sure it fills the square area. The aspect ratio for each photo is corrected later in the process.

72. Change the name of the photo layer from **Layer 1** to **EmployeePhoto**.

Your **Layers** panel should now look like the one in Figure 6.11.

Setting Up the Employee Information

A photo on a badge is not enough. It is helpful to have a few more specifics about the individual on the badge to identify the person. Continue as follows:

73. Click the Text tool in the Tool Bar to select it.

74. In the Options Bar, change the font size to **14 pt**, the text alignment to left justified, and the text color to black.

75. Click on the document on the leftmost guide horizontally (50 pixels) and at the bottom vertically of the rectangle below the employee photo. Type **Geoff** and click the Commit (check mark) button in the Options Bar to add the new text layer.

76. Click on the document on the leftmost guide horizontally (50 pixels) and at the bottom vertically of the rectangle below the previous text layer.

77. Change the font size to **18 pt**.

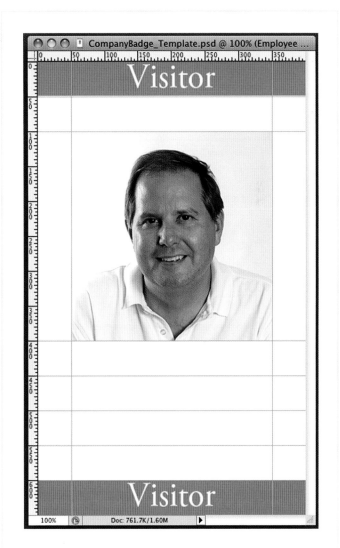

FIGURE 6.10 Company badge with the employee photo.

78. Type **Scott** and click the Commit (check mark) button in the Options Bar to add the new text layer.

79. Click on the document on the leftmost guide horizontally (50 pixels) and at the bottom vertically of the rectangle below the previous text layer.

FIGURE 6.11 Layers panel with the employee photo.

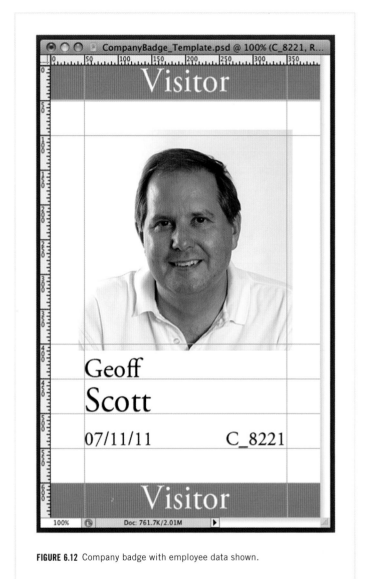

FIGURE 6.12 Company badge with employee data shown.

80. Change the font size to **10 pt**.

81. Type **07/11/11** and click the Commit (check mark) button in the Options Bar to add the new text layer.

82. Click on the document on the rightmost guide horizontally (350 pixels) and at the bottom vertically as the previous text layer.

83. Change to right justified.

84. Type **C_8221** and click the Commit (check mark) button in the Options Bar to add the new text layer. The badge is shown in Figure 6.12.

As with the previous sections, the layers need to be renamed, so they are unique and clear:

85. Change the text layer name from **C_8221** to **EmployeeID**.

86. Change the text layer name from **07/11/11** to **HireDate**.

87. Change the text layer name from **Scott** to **LastName**.

88. Change the text layer name from **Geoff** to **FirstName**.

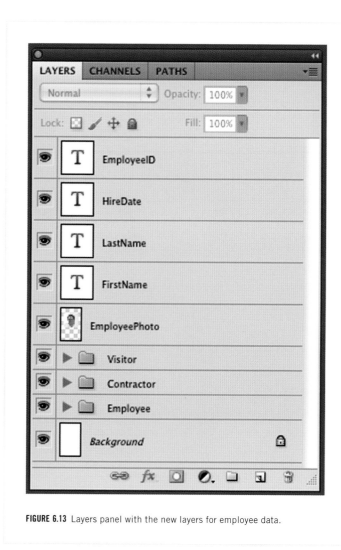

FIGURE 6.13 Layers panel with the new layers for employee data.

Your **Layers** panel should now look like the one in Figure 6.13.

The template is now complete. It has layers for all the different information needed for a company badge. Each layer has a unique name to help with the process.

Defining Variables

When the template is complete, you need to explain to Photoshop about each layer. This is known as *defining the variables.* Each layer has a name that represents the data that will be replaced by the automation process. For example, the text layer named **LastName** will end up having the last name of the person for whom the badge is being created.

Variables Dialog

As with many automation features, you define the variables using a specific dialog:

1. Choose **Image** > **Variables** > **Define...** from the menus to open the **Variables** dialog (see Figure 6.14).

FIGURE 6.14 The Variables dialog set up for defining the variables of the process.

The Description section tells you that the dialog is used to "assign a variable to the layer to control its visibility, replace a text string, or replace pixels."

As you use the Variables dialog, keep an eye on this section. Helpful information appears explaining the various options when you roll the mouse pointer over a control.

In this dialog, you go through layer by layer to define a variable type to the layer and a name for the variable. You can use the Layer pop-up menu to choose the layers one by one as you define them, or you can use the Next and Previous arrows beside the menu to go through the layers one at a time, in order (see Figure 6.15). As you define a variable for a

FIGURE 6.15 The previous and next layer controls in the Variables dialog.

layer, an asterisk (*) is appended to the layer name in the **Layer** menu of the dialog. This symbol helps you track which layers have variables.

Text Replacement Variables

The most straightforward variable type to define is the one for text replacement. Text layers are used for this purpose. When the automation process is run, the text in the layer is replaced with the text from the data set. You'll learn more on how that is done shortly. For now, it is enough to just define the variable.

The topmost layer in the template file is the **EmployeeID** layer. This is a text layer. Start with this layer shown in the dialog.

1. Click on the box next to **Text Replacement** to select this option for the **EmployeeID** layer.
2. In the **Name** field, change **TextVariable1** to **EmployeeID**. This change gives the variable a useful name that corresponds to the layer name.
3. Click the Next arrow to switch to the **HireDate** text layer.
4. Click on the box next to **Text Replacement** to select this option.
5. In the **Name** field, change **TextVariable1** to **HireDate**.
6. Click the Next arrow to switch to the **LastName** text layer.
7. Click on the box next to **Text Replacement** to select this option.
8. In the **Name** field, change **TextVariable1** to **LastName**.
9. Click the Next arrow to switch to the **FirstName** text layer.
10. Click on the box next to **Text Replacement** to select this option.
11. In the **Name** field, change **TextVariable1** to **FirstName**.

You have now defined all the text replacement variables for the badge. Each layer is created so that its text can be replaced with the data for a specific individual. There are four text layers and now four text replacement variables.

Pixel Replacement Variables

Photoshop primarily deals with pixels. So it makes sense for there to be a variable type for pixels. In the case of the badge, you want the employee photo to be replaced for each person, just as you've set up the text

replacement variables for the other information. Follow these steps to replace the pixels:

1. Click the Next arrow to switch to the **EmployeePhoto** layer.
2. Click on the box next to **Pixel Replacement** to select this option.
3. In the **Name** field, change **PixelVariable1** to **EmployeePhoto**.

Pixel replacement has a few options: **Method**, **Alignment**, and **Clip to Bounding Box**. For this example, you use the default settings. However, you can explore what the various options are by rolling the mouse pointer over the **Method** menu and seeing how the **Description** section changes (see Figure 6.16). Additional information is given to explain each method.

The **Alignment** control has nine boxes in a square with the center box black. You can click on any of the boxes to change the alignment for the new pixels. The default is center aligned, but you may need others, so the other options are provided.

Only the **Fill** and **Conform** methods use the **Clip to Bounding Box** option. This option masks out the areas of the replacing pixels that fall outside the bounds of the original pixels.

Visibility Variables

No doubt you noticed that both the text and pixel replacement variables had an option for visibility. This option is used when you want to show or hide layers. For example, if the badge is being created for an employee, the layers for the visitor information are not needed. Visibility is a TRUE or FALSE type of variable. Either the layer is visible, or it is not. No text to replace nor pixels to replace; just show the layer or hide the layer.

You are going to use a trick to do even better than this:

1. Click the Next arrow to switch to the **Visitor** layer set (see Figure 6.17).

FIGURE 6.16 Description of the Fit method of replacing pixels.

FIGURE 6.17 Defining a variable for a layer set.

2. Notice that the layer set has the **Visibility** option. Click on the box next to **Visibility** to select this option.

3. In the **Name** field, change **VisibilityVariable1** to **Visitor**.

4. Click the Next arrow to switch to the **VisTextB** layer. You don't need to define a variable for this layer because you just defined one for the layer set containing this layer. This also goes for the **VisTextT**, **VisColorB**, and **VisColorT** layers.

5. Choose **Contractor** from the **Layer** menu to switch to the **Contractor** layer set.

6. Click on the box next to **Visibility** to select this option.

7. In the **Name** field, change **VisibilityVariable1** to **Contractor**.

8. Choose **Employee** from the **Layer** menu to switch to the **Employee** layer set.

9. Click on the box next to **Visibility** to select this option.

10. In the **Name** field, change **VisibilityVariable1** to **Employee**.

11. Click the **OK** button to save all the changes you've made and close the **Variables** dialog.

12. Choose **File** > **Save** from the menus to save the changes you've made to the file—defining the variables.

All the variables for the company badge have been defined (see Figure 6.18). Not every layer has a variable defined for it, however. In some cases, those layers will change based on the data used in the process, but the layer set containing those layers has the variable instead. This setup simplifies things for you as you build up the data. In general, the simpler the setup, the easier it is to create the data and run the process.

Creating Data Sets

Through all the work you've done so far, you've built a single file that can be used to automatically generate many other files. The generated files are for the individual badges for the company employees, contractors, and visitors. Each individual has specific information collected into a data set. All the sets are entered into the template file using the **Variables** dialog.

FIGURE 6.18 Variables dialog showing all the defined variables.

Creating By Hand

The same **Variables** dialog you used to define the variables is the one you use to create data sets. You can enter in all the data by hand using this dialog. Although you would not typically enter the data by hand, it is useful to know how and to help find problems before you try running the automation process on a lot of data. The process is as follows:

1. Choose **Image** > **Variables** > **Data Sets...** from the menus to open the **Variables** dialog.

2. To the right of the **Data Set** menu, click on the New Data Set button, as shown in Figure 6.19, to create a new data set based on the values in the template file.

In the **Variables** section of the dialog, all the variables and their values are shown for the current data set (see Figure 6.20). You can use the Previous and Next arrows to the right of the **Name** menu to see the values one at a time. Clicking these arrows changes the controls shown for the **Value**

FIGURE 6.19 Variables dialog with no data sets entered.

section. These controls can be changed for each variable's value in the data set.

If you look closely at the values in the data set, some don't really make sense. This data set has the person as an employee, a contractor, and a visitor. This would never happen in real life. It's useful to correct the data, as shown here:

3. Using the **Name** menu, change the menu to show the data for the **Employee** variable.
4. Click the control to change the data to **Invisible**.
5. Using the **Name** menu, change the menu to show the data for the **Visitor** variable.
6. Click the control to change the data to **Invisible**.
7. Be sure that the **Preview** checkbox is checked so that you can see any changes made in the template file (see Figure 6.21).

FIGURE 6.20 Variables dialog with a data set created from the template file's data.

FIGURE 6.21 Variables dialog with the corrected data set.

The corrected data should appear in the dialog, and the template badge shown should have changed so that the badge is a contractor, not a visitor (see Figure 6.22).

8. Click the **OK** button to save the corrected data. When you do this, the template will change back to the way it looked before you

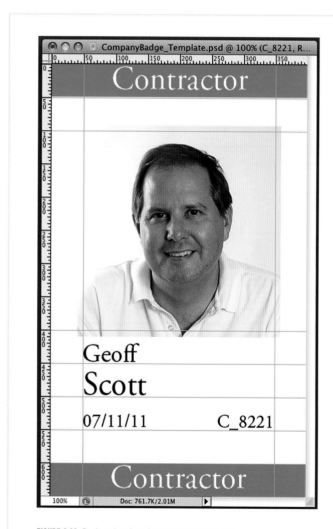

FIGURE 6.22 Badge showing the corrected data set.

corrected the data set. The data set was only being previewed by the **Variables** dialog. The data set will be saved with the file when you do a save, but the data in the template layers has not changed.

9. Choose **Image** > **Variables** > **Data Sets...** from the menus.

10. In the **Data Set** text field, type to change the name of the set from **Data Set 1** to **Geoff Scott**.

11. Click the New Data Set button to create a second data set.

12. Type to change the name of the set from **Data Set 2** to **Jeff Tranberry**.

13. For the **Contractor** variable, click to change the **Value** to **Invisible**.

14. Click the Next Variable arrow to see the **Employee** variable.

15. Click to change the **Value** to **Invisible**.

16. Click the Next Variable arrow to see the **EmployeeID** variable.

17. Type to change the **Value** from **C_8221** to **6789**.

18. Click the Next Variable arrow to see the **EmployeePhoto** variable.

19. Click the **Select File...** button and choose a file using the **Image Replacement** dialog to replace the current headshot with another face. Click the **Open** button to dismiss the **Image Replacement** dialog and see the new face in the template.

20. Click the Next Variable arrow to see the **FirstName** variable.

21. Type to change the **Value** from **Geoff** to **Jeff**.

22. Click the Next Variable arrow to see the **HireDate** variable.

23. Type to change the **Value** from **07/11/11** to **03/15/00**.

24. Click the Next Variable arrow to see the **LastName** variable.

25. Type to change the **Value** from **Scott** to **Tranberry** (see Figure 6.23).

There are now two data sets defined for the badge template file. The first was created from the data in the template file and then corrected. The second you just created by hand, entering in all the data for each variable. If you click to show the Data Set menu, it should have two data sets: one for **Geoff Scott** and one for **Jeff Tranberry**.

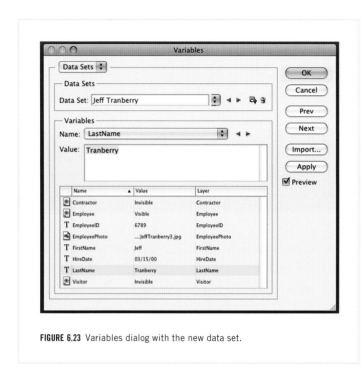

FIGURE 6.23 Variables dialog with the new data set.

With the new data set selected and the **Variables** dialog open, the template file shows the data for **Jeff Tranberry**. Proceed as follows:

26. Click on the Next Data Set arrow to cycle back to the **Geoff Scott** data set. Notice that the template file updates and so do the values for all the variables. However, the photo does not change.

27. Change the **Name** menu to show the **EmployeePhoto** variable. Notice that the value for the variable is **Do Not Replace**. This value was set when the data set was created and used the original photo from the template. Now that the template has multiple data sets, this variable needs a value for the **Geoff Scott** data set.

28. Click the **Select File...** button and choose a file using the **Image Replacement** dialog to replace the current headshot with another face. Click the **Open** button to dismiss the **Image Replacement** dialog and see the new face in the template.

29. Click on the Next Data Set arrow again to return to the **Jeff Tranberry** data set.

30. Click the **Apply** button on the right side of the dialog and then click the **OK** button.

The dialog closes, but the template file now looks like it did with the **Jeff Tranberry** data set. Clicking the **Apply** button replaces the data in the actual layers with the values from the data set. This is how you can create a single badge using a new data set entered by hand. The template file can be printed or saved as JPEG file for use elsewhere.

31. Choose **File** > **Save** from the menus to save all the changes you have made to the template file by adding the two data sets.

Creating a CSV File

Entering a data set by hand is fine for one data set. Imagine having to do a hundred data sets by hand. It would not be practical. Large amounts of data, like employee records, tend to be kept in databases. Databases are very good at retrieving data, sorting that data, and exporting it for use by other computer programs. With this exported data file, a program like Photoshop can import the data and use it to process the data—in this case, to create badges for each person.

The Variables process uses a comma-separated value file, known as a .csv or CSV file. The file is exactly what it sounds like. Data values are entered in the file and separated by commas. CSV files can be created with simple text editing programs, as well as programs like spreadsheets.

This section of the chapter explains in general terms how to create the CSV file for your data sets instead of trying to explicitly tell you step by step how to make the file. These general instructions cover using both a spreadsheet like Microsoft's Excel or Apple's Numbers, as well as using a text editor.

Using a spreadsheet means using rows and columns to organize data (see Figure 6.24). Each row is a single data set. Each column is all the data for a single variable. For this example, a row is a person. A column might be a variable like the last names of the people for whom the badges are being created.

Here are some key points to keep in mind when creating the data file:

- Enter the variable names in the first row. These are the names of the variables you used in the dialog to define the variables in the template file in Photoshop. Remember that all the variables had unique names that clearly described the data that would be used by that variable. Be sure that each variable you defined in the template file has a column in your spreadsheet.

- Each row must be completely filled in. There cannot be missing data for a variable. For example, if the person is not an employee but is a visitor, that person does not have an employee ID number or a hire date. Instead, a visitor ID number must be generated and entered into the spreadsheet. In this case, the visitor is given a number starting with "V_" and then the count for the number of visitors on the date the visitor badge was created. The hire date value is set to the date of the visit. In the data set shown in Figure 6.24, the second person has an **EmployeeID** of **V_011** and **HireDate** of **Jul 23, 2011**.

- Visibility variables have only one of two values: **TRUE** or **FALSE**. No other values are valid. Notice that in the data sets in Figure 6.24 the **Employee**, **Contractor**, and **Visitor** columns all have values and that each person has a single **TRUE** value in only one of those three boxes. A person can only be an employee, a contractor, or a visitor.

- The values for the **EmployeePhoto** column are filenames, just filenames. This indicates that the files will be in the same folder as the data file (the CSV file). If you want, you can specify full path names to files. This information might be useful if the files are kept on a server rather than kept locally.

> Each row must be completely filled in. There cannot be missing data for a variable.

After you have entered the sample data, save the file. Then export the file as a CSV file. The exporting process should be straightforward, but if you have any problems, consult the application's manual or online help. All spreadsheets should be able to easily handle this task, so you should not have a problem.

The exported CSV file is really just a text file with the .csv file extension. Open the file in a text editor, such as TextEdit or NotePad, to look at it. It should look something like the one shown in Figure 6.25.

Notice that all the data is still roughly in rows and columns. Each line of text is a row representing a single person. Each row has data separated

	A	B	C	D	E	F	G	H
1	EmployeeID	HireDate	LastName	FirstName	EmployeePhoto	Employee	Visitor	Contractor
2	6789	Mar 15, 2000	Tranberry	Jeff	JeffTranberry3.jpg	TRUE	FALSE	FALSE
3	V_011	Jul 23, 2011	Swiderski	Stacy	StacySwiderski.jpg	FALSE	TRUE	FALSE
4	C_8221	Jul 11, 2011	Scott	Geoff	GeoffScott.jpg	FALSE	FALSE	TRUE
5								

FIGURE 6.24 Sample data set created using a spreadsheet.

```
EmployeeID,HireDate,LastName,FirstName,EmployeePhoto,Employee,Visitor,Contractor
6789,"Mar 15, 2000",Tranberry,Jeff,JeffTranberry3.jpg,TRUE,FALSE,FALSE
V_011,"Jul 23, 2011",Swiderski,Stacy,StacySwiderski.jpg,FALSE,TRUE,FALSE
C_8221,"Jul 11, 2011",Scott,Geoff,GeoffScott.jpg,FALSE,FALSE,TRUE
,,,,,,,
,,,,,,,
,,,,,,,
,,,,,,,
,,,,,,,
```

FIGURE 6.25 Sample data in the CSV file.

by commas. Each data item is the value of the data for a specific variable for that person.

Here are some important points to notice:

- The values for the hire dates are formatted and enclosed in quotations marks. The date formatting includes commas, so the quotation marks indicate that the value is a single piece of data, despite the comma.

- The formatting of the dates is as it appeared in the spreadsheet. This is different from the formatting used in the template file, which was "07/11/11." Photoshop will use the data exactly as it appears in the CSV file, not as it appears in the template. If you want a specific format, use the spreadsheet application's capabilities to format the dates.

- There are a bunch of rows with just commas. These were empty rows exported by the spreadsheet.

> There must not be a comma at the end of a row. The row ends with data. A comma would mean that more data was expected.

Remember that Photoshop uses the CSV file, not the spreadsheet file. The CSV file is really just a text file. Almost any program that processes data can create a text file. Setting up your system to create a CSV file with all the employee data for a company is beyond the scope of this book.

It is best done with your local IT person, who has access to the company database and knows how to build the data sets. The task may be tricky, but it should not be difficult.

Importing Data Sets

Now that you've created data sets as a CSV file, you can import the data from the file into your template file.

1. Choose **Image** > **Variables** > **Data Sets...** from the menus.

2. In the **Variables** dialog, click the **Import...** button.

3. In the **Import Data Set** dialog, click the **Select File...** button. Use the **Open** dialog to navigate to and select the CSV file that you created with all the data sets. Then click the **Open** button.

4. In the **Import Data Set** dialog (see Figure 6.26), be sure to set the **Encoding** to **Automatic**, check the option **Use First Column For Data Set Names**, and check the option **Replace Existing Data Sets**.

5. Click the **OK** button to import the data sets from the CSV file.

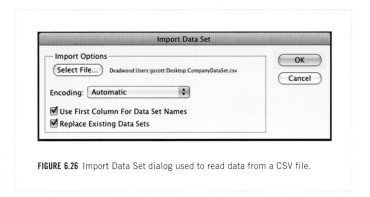

FIGURE 6.26 Import Data Set dialog used to read data from a CSV file.

At this point, problems may occur. For example, the warning dialog shown in Figure 6.27 might appear.

In this example, the problem stems from those extras rows of commas in the CSV file. Data set 4 was empty. To get past this message, delete all the lines of empty commas from the CSV file. Then redo the import as described in steps 2–5 in this section.

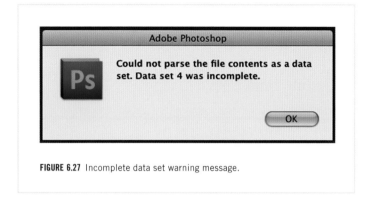

FIGURE 6.27 Incomplete data set warning message.

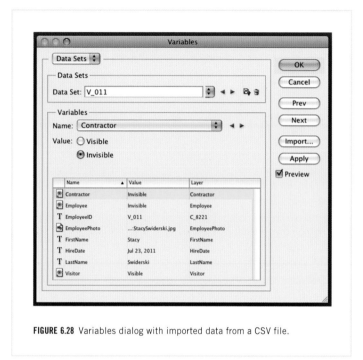

FIGURE 6.28 Variables dialog with imported data from a CSV file.

You may run into other problems when importing the data sets. Sometimes the warning messages are not very useful or specific. If you run into problems, open your CSV file and look at the information called out in the "Creating a CSV File" section earlier. Does each row have a value for each column? Are there extra commas? Are values such as dates enclosed within quotations marks to hide the commas in the formatting? Are the variable names spelled exactly the same way as in the template file, including the case (upper or lower) for each letter?

Troubleshooting can be frustrating and time consuming. Just look at each line of data to verify that it makes sense and follows the rules mentioned previously. If there are a lot of data sets, edit the file down to one or two or even three data sets so that you can easily look at the information.

When the data is imported correctly, the **Variables** dialog updates with the new data set (see Figure 6.28). If the badge shown by the template file does not update with the new data, use the Next Data Set or Previous Data Set arrows to force an update and see the new data displayed.

You specified that the previous data set, which you entered by hand, be replaced. So there are only three data sets in this example. The name of the data sets was taken from the first column of data, which in this case was the **EmployeeID**. That number should be unique, so it is a good way to identify each data set. The three data sets represent an employee, a contractor, and a visitor. Cycle through the data sets to be sure that the data was imported correctly. Then proceed as follows:

6. Click the **Apply** button and then click the **OK** button.
7. Choose **File > Save** from the menus to save all the changes you have made to the template file by importing the data sets.

You've done a lot of work to save a template file with just a little bit of data. What you have been doing this whole time has been setting up your process. Similar to building up a batch process, you have made everything using a small set of data so that you are able to work out all the problems before using it on a big set up of data. When you have your process working correctly, you can import a large number of data sets to create badges for every employee in the company.

Applying Data Sets

The **Variables** dialog is really used to set up the entire process. You clicked the **Apply** button to change the data values used by the

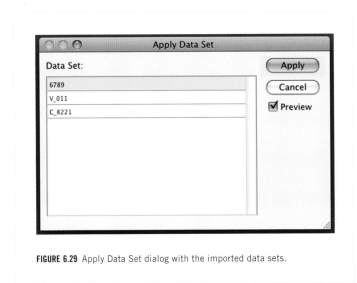

FIGURE 6.29 Apply Data Set dialog with the imported data sets.

template itself. You could use the **Variables** dialog to change the values each time. A better way, however, is to use Apply Data Set as follows:

1. Choose **Image** > **Apply Data Set...** from the menus.
2. In the **Apply Data Set** dialog (see Figure 6.29), click on the name of the data set in the list to change the data set displayed by the template.
3. When you have the data set you like, click the **Apply** button to close the dialog.

Creating Files for Each Data Set in the Template

You've created your template file and filled it with data. What you really want to do now is create a new layered Photoshop file for each data set. That was the whole point of learning the Variables process—creating

many files from a single file. You want to create a badge for each person. After doing all that work, it is time to let Photoshop do the work for you, as follows:

1. Choose **File** > **Export** > **Data Sets as Files...** from the menus.
2. In the **Save Options** section of the **Export Data Sets as Files** dialog (see Figure 6.30), click the **Select Folder...** button to specify the destination folder for the new files in dialog that appears and click the **Choose** button when finished.
3. Set the **Data Set** menu to **All Data Sets**. You can export new files for each data set individually, but it is quicker and easier to do them all at once.
4. The **File Naming** section is similar to the one in the **Batch** dialog. You have options for picking pieces of the names and adding elements such as data set counts. The choices are yours. Just be sure the resulting names are unique and easy to identify.
5. When you are done with the setup in the dialog, click the **OK** button to run the automation process.

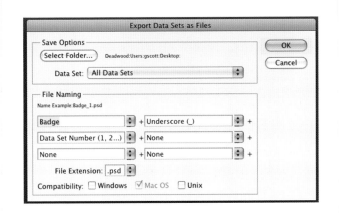

FIGURE 6.30 The Export Data Sets as Files dialog for creating files from each data set.

Photoshop processes each data set quickly using the template. The resulting files are created where you specified. Each badge is now ready to be printed for each person (see Figure 6.31). You've built a flexible system that can be modified to add new badge types and to change the design of the existing types. You can create a badge for one person or a thousand people easily.

Using a single image file to create multiple image files can be very powerful. Many things have similar designs with just a few pieces of data making each unique. Employee badges for a company are just one example. This process could be used to create a weekly calendar or baseball cards or business cards or pages in a product catalog. The possibilities are not endless, but knowing the process may make you think up new ideas that it can be used for.

FIGURE 6.31 Final badges for employee, visitor, and contractor.

EXPLORATIONS

Weekly calendars are a popular way to keep track of your appointments and also to view interesting art regularly. As an artist, you probably know people who would love to have a calendar of your work. A weekly calendar has 52 images with 52 captions. The basic design of a calendar does not change per week; just the days of the week, the caption, and the image change. This makes it ideal for using Variables to create one (see Figure 6.32).

Build a template file for a desktop calendar. Then create the data set and image files needed. Use the Variables process to combine them all together to create 52 images that form the pages of your calendar.

May week 21 2010

Monday
24

Tuesday
25

Wednesday
26

Thursday
27

Friday
28

Saturday Sunday
29 30

Luau Name Tags

FIGURE 6.32 Page of a weekly calendar created using Variables.

Seven

BUILDING

Your Own Panels

Introduction to Using Configurator

One of the most sophisticated tools for customizing Photoshop is Configurator. This tool lets you build your own panels. It relies on Flash technology but does not require you to know anything about Flash. Instead, you build a panel in a visual editor, dragging and dropping the pieces onto a blank panel.

Configurator was created by a special research group at Adobe called Adobe Labs. The researchers there build technology and release it in the hope that others will build upon it. Configurator is such a project. Designed for use with Photoshop or InDesign, Configurator at its basic level is simple to use, yet is also capable of adding powerful technology into Photoshop.

configurator2_p1_052
610.air

FIGURE 7.1 The Configurator installer file downloaded from Adobe Labs.

Getting the Tool

Unfortunately, the Configurator tool is not installed with Photoshop. You have to download it and install it yourself. It is available on the Adobe Labs website.

Downloading and Installing the Tool from Adobe Labs

Follow these steps to download and install Configurator for yourself:

1. Open your favorite browser and go to **http://labs.adobe.com/ technologies/configurator/**.

Note: You may have to log in to the site with your Adobe web account. This is a free account that Adobe uses for licensing purposes. If you do not have an account set up, you may need to create one.

2. Follow the instructions on the Configurator page to download the installer. Download the Configurator 2.0 installer for Photoshop CS5 or the Configurator 1.0 installer for Photoshop CS4. All examples in

this book are for Configurator 2.0, but the previous version is similar. The downloaded file will be called something like **configurator2_p1_052610.air** (see Figure 7.1).

Note: The file you download is an Adobe Integrated Runtime (AIR) application installer file. It relies on the AIR technology to run and install Configurator. If you do not have Adobe AIR installed, you also should download it. There should be a link on the Configurator page to the AIR installer page. The page may be **http://get.adobe.com/air/**. Use the downloaded installer file to install the Adobe AIR technology.

3. Double-click the downloaded Configurator's .air file to run the installer. The installer dialog opens, as shown in Figure 7.2.

4. Click the **Install** button to continue the install process.

5. Set the install options to start the application after the installation and set the **Installation Location** to be the **Adobe** folder in the **Applications** folder on your hard drive (see Figure 7.3). These should be the installer defaults. Then click the **Continue** button.

FIGURE 7.2 The Configurator installer dialog.

FIGURE 7.3 Configurator location and startup install options.

Note: When the installation is complete, Configurator starts up. Because it is an Adobe AIR application, it automatically checks the version of AIR installed. If the version installed is not the latest, you may be prompted to download and install the update. Doing so is a good idea because you are using the latest version of both Configurator and Photoshop.

Using the Tool

Configurator is like any other application, even though it is running inside the Flash Player. It is worth taking a moment to point out a few key details and differences. Because Configurator is an AIR application, it is self-contained. It has its own menus. On the Mac, this means there are two menu bars: one at the top of the main monitor like other applications and the other at the top of the Configurator application window. The menus in the application window contain the commands used with Configurator. This setup can be confusing when you first start using the tool, but you get used to it. Keyboard shortcuts work normally and are standard.

The Configurator application window is simple to use and understand. On startup, the main work area has some useful instructions (see Figure 7.4). The instructions are high level but give a good overview of how to build a panel for use in Photoshop (and InDesign). This chapter goes into more depth, of course.

As a way to start building a panel and display it in the main work area, follow these steps:

1. Choose **File** > **New Panel** from the application window menus or click the **Create Panel** button below the instructions in the work area.

2. In the **Create Panel** dialog, choose **Photoshop CS5** from the **Select Product** menu and click the **OK** button.

FIGURE 7.4 The Configurator application window on startup.

The work area is divided into three main areas: left, right, and center (see Figure 7.5). At the top is the menu bar and a help button.

The left side of the Configurator work area primarily contains a panel with a list of categories that open to display objects. This panel is called the Object Palette. The Object Palette contains objects that represent functionality in Photoshop or are used to display information in the panel itself. Each object category (Tools, Commands, Action/Script, Widgets, Containers) is described in detail throughout this chapter. When building a panel, you drag an object from this area onto the panel in the center work area.

FIGURE 7.5 The Configurator work area layout with an empty panel.

The center area of the Configurator work area is the Panel Editor. As you build your panel, you move the pieces of the panel around in this area to design the panel. The layout created in this area is the way the panel is shown in Photoshop. You can grow, move, shrink, and select the items in the Panel Editor by clicking on the individual objects.

The right side of the Configurator work area is the Inspector. As you select items in the Panel Editor, the details about the object are displayed here. You can change individual values for the various properties of the objects, including the properties of the panel itself. The details shown in the Inspector change based on the currently selected object because the

objects tend to have different attributes. As you move the mouse pointer over these attributes, tooltips appear with details about the attributes. The smaller area, below the area displaying the attributes, is the Outline View.

> As your panels get more complex and objects are nested inside other objects, the Outline View shows you the hierarchy of the objects and allows you to easily select an object without requiring you to click on it in the Panel Editor.

Building a Simple Panel

As usual, the best way to learn about making something is to do it. In this example, you build a simple panel to get you used to the tools.

Panel

You created a new panel in the previous section (steps 1 and 2). The empty panel is in the Panel Editor. If the panel is not selected, click to select it now. The **Panel** object is a wrapper object around all the controls you want displayed in Photoshop. There are not many attributes for a panel. They are grouped into two parts: **Basic Attributes** and **Open/Close Scripts**.

The Basic Attributes detail how the panel is displayed (see Figure 7.6). The **Script** attribute is an advanced feature described in Chapter 11.

Now continue as follows:

1. Change the **Name** attribute from **untitled-1** to **Selection**. Notice that the name displayed in the panel's tab changed.

2. Change the **Height** to **400**. You'll notice that the panel in the Panel Editor grew taller.

3. Click on the **T** control to the right of the **Current Locale** pop-up menu. This brings up the **Locale List** dialog (see Figure 7.7). If you want to change or add support for other localizations, select the locale code in the left window and click the > button to copy the code to the right side. The locales on the right side are supported by your panel. Be sure to

FIGURE 7.6 Attributes for a panel.

read the Adobe documentation about adding support for other locales. Your simple panel will support the locale only for the U.S. version of English (**en_US**). Click the **Cancel** button to dismiss the dialog.

The **Persistent** panel attribute is for memory and performance tuning. The default value of **True** keeps the panel loaded into memory, even when the panel is not shown. A value of **False** loads the panel on demand. Adobe recommends that this attribute be set to **False** when you are building

FIGURE 7.7 The **Locale List** dialog for selecting a panel's localization setting.

FIGURE 7.8 The first rows of tools in the Object Palette.

FIGURE 7.9 Guides to help you place objects in a panel layout.

and troubleshooting a panel. You should set the value to **True** when you are finished and before you share the panel with others.

4. Set the **Persistent** attribute to **False**.

Tools

Adding tools to a panel is the most basic functionality of Configurator. You may have noticed that the more you work with Photoshop, the more you work with the same set of tools over and over. Photoshop has a lot of tools, many of them specialized. One customization not allowed in Photoshop is changing the Tool Bar or its tools. You cannot change the order of the tools, which tools are displayed, or the shape of the Tool Bar. With Configurator, you can make a custom tool bar and hide the one supplied by Adobe. Or you can create a panel that shows off specialized tools.

You work with the tools as follows:

1. Click the disclosure triangle for the **TOOLS** in the Object Palette to show the tool icons (see Figure 7.8).

2. Click and drag the Move tool (the tool in the first row of the **TOOLS** list) and drop it in the upper-left corner of the **Selection** panel in the Panel Editor. You'll notice blue lines that appear to help you place the icon on the panel (see Figure 7.9).

As you place objects into the panel, the Inspector updates with the attributes for the objects placed. The attributes appear below the attributes for the panel (see Figure 7.10). Common attributes are Size, Tooltip, Visibility, and Position in the panel.

FIGURE 7.10 Attributes for the Move tool object added to the panel.

3. Click and drag each of the tools in the next row of tools. These are the various Marquee tools. Place the tools in a row below the Move tool in the panel. Use the guides to place the tool icons.

4. Click and drag each of the tools in the next row of tools. These are the Lasso tools. Place the tools in a row below the row of Marquee tools.

5. Click and drag each of the tools in the next row of tools. These are the Selection Brush and the Magic Wand tools. Place the tools in a row below the Lasso tools.

When you are done, your panel should look like the one in Figure 7.11.

6. Click the display triangle for the **TOOLS** to close the list of tools displayed in the Object Palette.

FIGURE 7.11 Selection tools placed in the panel.

Commands

Building your own tool bar has its advantages. It could help streamline your interface and speed up your work in Photoshop. But most of the power of Photoshop is found in its menus. The problem with the menus is that there are so many menu items. All those menu items makes it hard to quickly find the ones you are looking for. Configurator allows you to add menu items as buttons to your panel. To do so, follow these steps:

1. Click the disclosure triangle next to **COMMANDS** in the Object Palette list to show the top level of commands available:

 • **Main**—These commands correspond to the menu items in Photoshop. They are organized in the same hierarchy as the menus in the menu bar.

 • **Panel**—These commands are those found in the panel menus. They are organized by the panel.

 • **Tools**—These commands display bigger buttons with words instead of tool icons. Each command selects a tool.

 • **Script**—These more advanced commands are detailed in Chapter 11.

2. Click the disclosure triangle next to **Main** to display the commands for the menus.

3. Click the disclosure triangle next to **Select** to display the commands for the **Select** menu.

4. Click and drag the **All** command to the panel and place it below the last row of tools.

5. Click and drag the **Deselect** command to the panel and place it next to the **All** button.

6. Click and drag the **Inverse** command to the panel and place it next to the **Deselect** button.

7. Click and drag the **Color Range** command to the panel and place it beneath the row of **All**, **Deselect**, and **Inverse** command buttons.

8. Click and drag the **Refine Edge** command to the panel and place it next to the **Color Range** button.

9. Click and drag the **Load Selection** command to the panel and place it beneath the row of **Color Range** and **Refine Edge** command buttons.

10. Click and drag the **Save Selection** command to the panel and place it next to the **Load Selection** button.

When you are done, the panel should look like the one shown in Figure 7.12.

FIGURE 7.12 Selection panel with the tools and commands placed.

FIGURE 7.13 The search box in the Configurator work area.

Searching for Commands

Above the Object Palette is a search box (see Figure 7.13). Enter terms here to find the commands in the menus. The results show up in the Object Palette and can be dragged to the panel.

> A search box is part of the Configurator to make finding menu commands easier. It is not always obvious where a command might be located. Searching is quick and easy, almost like using keyboard shortcuts.

Using the Panel in Photoshop

The following sections describe how to use your panel in Photoshop.

Saving the Panel

To save your panel, do the following:

1. Choose **File** > **Save Panel** from the Configurator application window menus. In the **Save Panel** dialog, save the panel as **Selection.gpc** on the **Desktop**.

Configurator creates the **Selection.gpc** file. It also creates a **Selection.assets** folder. In the **Selection.assets** folder is a **Locales** folder. The **Locales** folder has a folder for each locale you specified in the **Locale** attribute for the panel, which in this case is a folder for the **en_US** locale. In this folder is a **dictionary.xml** file. As you might expect from the filename, this is a dictionary that Photoshop uses to translate words. As mentioned previously, if you are developing for other locales, you should read the Adobe documentation for the most current information. Otherwise, you don't need to look at or modify the **dictionary.xml** file or any of the folders for localization.

Previewing the Panel in Configurator

Although you've been laying out your panel in the Panel Editor, it can be useful to preview what the panel looks like without all the layout controls, as shown next. There is limited functionality in the **Preview** window, but it is a good first step to troubleshooting a panel before putting it in Photoshop.

1. Choose **File** > **Preview Panel** from the menus.

A good representation of the panel is shown on the left side of the **Preview** window (see Figure 7.14). You can move the panel and even use a few of the controls. If you click on a tool button or a command button, text appears in the right column. This text provides information about how the button communicates to Photoshop. This text may not mean much at the moment, but when you start learning scripting, it will become more useful.

Notice there is also a menu showing the locale code. This menu is a control to help you test the layout for other localizations.

2. When you are done previewing your panel, click the close box for the **Preview** window in the upper-right corner.

Exporting the Panel from Configurator

Your panel is built for use in Photoshop, but it cannot be used in the application yet. You must export the panel, as shown here, and place it where Photoshop looks for it:

FIGURE 7.14 Previewing the panel in Configurator.

FIGURE 7.15 Exported files for the **Selection** panel in the **Panels** folder.

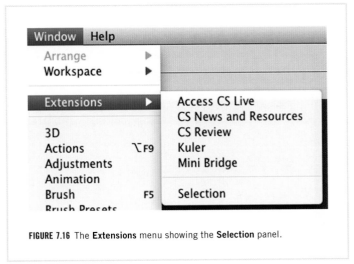

FIGURE 7.16 The **Extensions** menu showing the **Selection** panel.

1. Choose **File** > **Export Panel** from the menus.

2. A dialog appears, showing **Locate the Photoshop CS5 Plug-In Panels folder** in the title bar. The dialog should already show the correct place, but be sure that it shows the folder for **/Applications/ Photoshop CS5/Plug-Ins/Panels/** and then click the **Select** button.

3. A message dialog appears to let you know that the panel was successfully exported. Click the **OK** button to close the dialog.

Configurator creates files in the location that you selected (see Figure 7.15). If you do much web or Flash development, some of these files might have familiar file extensions. Remember that Configurator builds Flash-based panels, so this makes sense. You could look at these files and folders in more detail, but doing that is not really important now. What matters is that they were created in the right place, where Photoshop looks for panels when it starts.

Loading and Finding the Panel in Photoshop

When you're ready to load and find the panel in Photoshop, do the following:

1. Start the Photoshop application. If you had Photoshop running when you exported your panel, quit Photoshop and then restart it.

2. Choose **Window** > **Extensions** from the menu to see the panels in the submenu (see Figure 7.16).

Photoshop ships with a few panels developed by Adobe and others. The **Selection** panel that you created is in the lower part of the menu. This area is the place where all the panels loaded from the **Plug-Ins/Panels** folder are located.

3. Choose **Window** > **Extensions** > **Selection** to open the **Selection** panel (see Figure 7.17).

The panel works just like any other Photoshop panel. Give it a try. Click on the tool buttons and watch the tools change in the Tool Bar. Change a tool in the Tool Bar and see it change in the **Selection** panel. All of the tools and commands should work as expected.

Revising the Panel

As you work with the panel, you may find things that need to be fixed or changed. For example, the **Selection** panel can be resized to almost any size. This is a poor design. There is no data that changes in the panel. The layout is fixed, so the panel does not need to be resizable. There is also a lot of empty space at the bottom and the right side of the panel. To revise the panel, follow these steps:

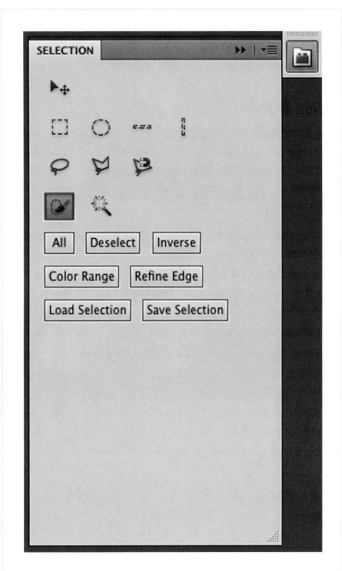

FIGURE 7.17 The **Selection** panel expanded from a docked icon in Photoshop.

1. In the Configurator, click the panel in the Panel Editor to select it.

2. Click and drag the bottom-right corner of the panel to resize the panel. The size of the panel displays in a tooltip near the mouse pointer. Move the borders around until the panel is about 186 × 242 pixels.

3. In the Inspector, set the **Width (minimum)** to **186**.

4. Set the **Height (minimum)** to **242**.

5. Set the **Width (maximum)** to **186**.

6. Set the **Height (maximum)** to **242**.

7. Choose **File** > **Save Panel** from the menus.

8. Choose **File** > **Export Panel** from the menus to re-export the panel for use in Photoshop.

9. In the **Locate the Photoshop CS5 Plug-In Panels folder** dialog, choose the same folder as you did previously, which the dialog should automatically show you, and click the **Select** button.

10. Because you are re-exporting the panel, you are replacing the previous panel currently being used by Photoshop. Configurator shows a warning dialog to be sure you know what you are doing (see Figure 7.18). Click the **Yes To All** button to complete the export.

FIGURE 7.18 Overwrite warning when re-exporting the panel.

11. A message dialog appears to let you know that the panel was successfully exported. Click the **OK** button to close the dialog.

The panel is open in Photoshop, so although you re-exported the panel, those changes are not currently loaded into Photoshop. The panel in Photoshop is still resizable. Fortunately, you changed the **Persistent** attribute of the panel to **False**. This change forces the panel to be reloaded whenever the panel is opened. This reload takes a small amount of time. In everyday use of a complete panel, this hiccup of a reload would get annoying. However, when you're developing a panel, this moment of time is much faster than quitting Photoshop and restarting to reload the panel with your changes.

12. In Photoshop, either choose **Window** > **Extensions** > **Selection** to close the panel or click the close box on the panel itself.

13. Choose **Window** > **Extensions** > **Selection** to show the panel again.

Notice that the panel did take a moment to redraw itself. That was the reload. Now you should not be able to resize the panel at all. In fact, the resize control is no longer shown in the panel.

If the panel still does not look good to you, go back to Configurator, adjust the panel, re-export it, and reload it in Photoshop.

> This is the normal process for developing a panel. First, you build a rough version; then you refine it, changing things and retesting the result until the panel is done. When the panel is complete, you change the **Persistent** attribute of the panel to **True** and export it a final time.

Using More Panel Objects

Your first panel is simple. Configurator is capable of building much more complex and sophisticated panels than the **Selection** panel, however. There are a number of objects that you glimpsed in this process but did not use for the panel. The panels use Flash technology, so there are few limits to what you can achieve in a panel. Anything that Flash can do for a website can be done for a panel, including animation, video, and sounds. But do not let the scope of that discourage you. Configurator comes with a number of simple objects for your ease of use.

Action Buttons

In the **ACTION/SCRIPT** category of objects is one of the most useful objects that can be placed in a panel: the **Action** button. This button plays the action you specify. So rather than having the **Actions** panel open, finding the action in the action set, and hitting the Play button, you can build a panel with a button, like this:

1. Click the disclosure triangle next to **ACTION/SCRIPT** in the Object Palette list to show the objects.

2. Resize the panel to make room for a new, big button. Remember to set the panel's minimum and maximum sizes to the new panel dimensions.

3. Click and drag an **Action** object from the Object Palette to the panel.

4. Resize the **Action** button to fill the space you added to the panel.

5. With the **Action** button selected, set the **Label** attribute of the button in the Inspector to **Sepia**.

6. Set the **Action Name** to **Sepia w/ Organic Borders**, an action you created in Chapter 4.

7. Set the **Action Set** to **Book Actions** (see Figure 7.19).

8. Save and re-export the panel.

9. In Photoshop, close and reopen the panel to reload it.

10. Open an image file and click the **Sepia** action button to run the action.

> **Note:** The **Action/Script** category includes other objects titled **Script** and **Script File**. These two objects are described in Chapter 11.

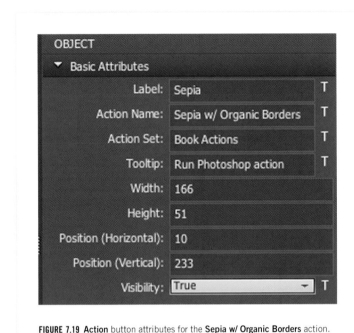

FIGURE 7.19 Action button attributes for the **Sepia w/ Organic Borders** action.

Widgets

Widget is the generic term for a control placed into a user interface. Buttons, checkboxes, pop-up menus, and text fields are examples of widgets. Configurator includes several different widgets for use in panels.

- **External Panel Loader**—This widget can load in another Configurator panel. That panel must be saved in the parent panel's .assets folder.

- **Feature Search Widget**—Similar to the search box in Configurator that searches for Commands, this widget is a search field for use in Photoshop itself. The result shows the commands found, and clicking on the command executes that command.

- **HRule**—This widget loads a horizontal rule or line.

- **HTML**—This widget opens a rectangular box for loading a local or remote web page.

- **Movie Player**—This widget loads a rectangular box for displaying a movie file. These files can be in FLV format or any MOV file that Flash supports. Recommended encoding for the video is H.264.

- **Pop-up Panel**—This widget opens a new window to display another file like a movie, an image, a SWF file, or a URL.

- **SWF or Image Loader**—This widget is a rectangular box that loads a GIF, JPEG, PNG, or SWF file into the panel. The first three of these are image formats. The last is a Flash file format. The object has a **Location (URL)** attribute used to specify the file. The value can be a URL to a website or web address, a relative file path, or an absolute file path. You'll learn more details about this in the "Adding a Logo Image" section later.

- **Simple Text**—This widget is a rectangular box for static text. In the Inspector, you can either enter the text directly into the **Text** attributes edit field or click the Pencil icon to bring up a text editor to easily enter a lot of text.

- **Spacer**—This widget is an empty rectangle. It can be useful for panels that resize or for adding a design element such as a simple rectangle.

- **VRule**—This widget loads a vertical rule or line.

Advanced Containers

Sometimes it is useful to fit a lot into a small space. Containers can help you do this. For example, in Photoshop, most panels are grouped together with other panels into tab groups. The panels are placed one on top of the other with one panel visible and only the tabs of the others visible. You switch between the panels by clicking on the tabs to display the other panels.

As you may have suspected, the container objects are in the **CONTAINERS** category of the Object Palette. Note that container objects have child objects. They can also contain other containers. They are

similar to folders on your hard drive that may contain files and other folders. These objects are available for use:

- **Accordion**—The accordion container is similar to tabs but is more vertical than horizontal. Clicking on a title opens that contained pane and closes the open pane. The panes open in an accordion-like manner.

- **Canvas**—The canvas container is the most basic container object. It contains other child objects as placed. This feature can be useful for formatting objects in the panel.

- **HBox**—The HBox container arranges its child objects into a horizontal row automatically. This feature is useful for laying out objects automatically.

- **HDividedBox**—The HDividedBox container provides a horizontal split bar that can be adjusted between two columns of objects.

- **Tab Navigator**—The Tab Navigator container has child panes accessible via tabs.

- **Tab Navigator (Menu)**—The Tab Navigator (Menu) container has child panes like the Tab Navigator but also has a pop-up menu with the name of the tabs for easy switching.

- **VBox**—The VBox container arranges its child objects into a vertical column automatically.

- **VDividedBox**—The VDividedBox container provides a vertical split bar that can be adjusted between two rows of objects.

Polishing Your Panel

Now you're ready to polish up your panel with some final changes.

Adding a Logo Image

Adding images to the panels you produce might be useful. For one thing, you might want to show your branding for the tools you create. Just as your website has your logo on it, panels that you share should show your logo. You can add one like this:

1. Create a logo image file. Size the image to fit in your panel.

2. Save the logo image as a GIF, JPEG, or PNG file.

3. Copy the image file into the **Selection.assets** folder, which is next to the saved panel file named **Selection.gpc** (see Figure 7.20).

FIGURE 7.20 The panel logo file placed in the .assets folder for the panel.

4. In Configurator, add a **SWF or Image Loader** object to your panel.

5. Size the object to logo size. For example, if your logo is 166×50 pixels, set the object **Width** attribute to **166** and the object **Height** attribute to **50**.

6. Next to the **Location (URL)** attribute, click on the Paper icon to bring up the **Select a File** dialog. The dialog should automatically open showing the contents of the panel's .assets folder. Click to select the image logo file and click the **Select** button.

7. Move all the other objects in the panel to create space at the top of the panel.

8. Move the logo to the top of the panel and rearrange the other objects to fit together with good spacing (see Figure 7.21). Be sure also to adjust the panel's minimum and maximum width and height attributes.

9. Choose **File** > **Save Panel** from the menus.

FIGURE 7.21 Panel with the logo file placed at the top.

10. Choose **File** > **Export Panel** from the menus and replace the panel already being loaded into Photoshop.

11. In Photoshop, reload the panel and check that the panel looks correct with the new logo image.

When you export the panel, the entire .assets folder, which now includes your logo file, is copied over to the panel location. Configurator takes care of the file management for you.

Adding a Panel Icon

You may have noticed that every panel in Photoshop has its own panel icon. These icons show up when the panel is collapsed. Similar to adding your logo to your panel, adding a distinct panel icon for the panel shows a level of professionalism. It is easy to do:

1. Create a 48 × 48 pixel image file in Photoshop.

2. Create an icon image for your panel that represents either your brand or the functionality of the panel. This icon is for the normal display state of the icon.

3. Save the icon file as a PNG file with the name **SelectionNormal.png** in the **Selection.assets** folder.

4. Adjust the icon image by shifting the icon or adding color or a bevel or some other effect to distinguish it from the normal icon image. This icon is for the rollover display state of the icon.

5. Choose **File** > **Save As...** from the Photoshop menus, naming the file **SelectionRollover.png** with the file format set to **PNG**. The location for the file is next to the previous one.

6. In Configurator, choose **File** > **Export** from the menus and replace the panel already being loaded into Photoshop.

7. In the Finder or Explorer, navigate to the location where you exported the panel. This is inside the **Panels** folder inside the **Plug-Ins** folder inside the **Photoshop** folder.

8. Open the **Selection** folder.

9. The folder contains a **Selection.mxi** file and a **content** folder. In the **content** folder are a few files for your panel and the **Selection.assets** folder.

10. Copy the two icon files from the **Selection.assets** folder to the **content** folder (see Figure 7.22).

11. Quit Photoshop.

12. Restart Photoshop.

Unfortunately, loading the icon does not work the way loading the panel does. You must quit Photoshop for it to find the new files. When you restart Photoshop, the icons will be in use and may be visible (see Figure 7.23). Docked panels can be minimized to icons. This is the icon that you created. If all the files are placed correctly, the normal icon shows. The rollover icon shows when you move the mouse pointer over the panel icon.

FIGURE 7.22 Copying the panel icon files into the correct folder.

1. In the Configurator, click the panel in the Panel Editor to select it.
2. In the Inspector, change the **Persistent** attribute from **False** to **True**.
3. Choose **File** > **Save Panel** from the menus.
4. Choose **File** > **Export Panel** from the menus to re-export the panel for use in Photoshop.

Sharing Panels

As with many things you have built using this book, it can be helpful to share your creations with others. Whether you sell your panels or simply give them to friends or officemates to use, there are a few steps that will make it simple to share your panel.

Creating an Installer

A tool installed with Photoshop is the Adobe Extension Manager (see Figure 7.24). This tool was created to help you manage and even share extensions to Adobe applications like Photoshop. It can create an installer for your panel.

FIGURE 7.23 **Selection** panel with branding logo and panel icon.

Adobe Extension Manager CS5.app

FIGURE 7.24 The Application icon for the Adobe Extension Manager.

Completing Your Panel

Having built your panel, tested it, polished it, and used it for a while without making further changes, you are now ready to complete its development:

176 Power, Speed & Automation with Adobe Photoshop

One of the files created when you exported your panel is the .mxi file. This is an Adobe Extension Information file. It holds information about the panel, such as which files it uses and which applications it is for. Instead of copying all the files exported from Configurator, you can use this file and Adobe Extension Manager.

1. Double-click on the **Selection.mxi** file. This will launch the Adobe Extension Manager. If you are running the application for the first time, it may ask you a few questions to help its setup. Answer these questions as best makes sense for your system.

2. In the **Save** dialog, navigate to the **Desktop** and keep the name of the file as **Selection.zxp**. Click the **Save** button.

You just created an installer for your panel (see Figure 7.25). The **Selection.zxp** file can be sent via email or posted on the web for download without its losing any of its important contents.

FIGURE 7.25 The icon for the panel installer.

Installing a Panel

Installing a panel is just as easy as creating the installer:

1. Double-click the **Selection.zxp** file. This will launch the Adobe Extension Manager.

2. If this is the first time you've installed an extension, a dialog appears requiring your acceptance of the terms for installing extensions. This is a precaution by Adobe's legal department, but you should read it, and if you agree, click the **Accept** button.

3. A dialog appears to warn you that the extension is from an unknown vendor (see Figure 7.26). In this example, the vendor is you, so click the **Install** button to continue installing the extension.

FIGURE 7.26 A warning dialog about the extension about to be installed.

4. If you are installing your panel on the same system that you built it on, a warning dialog appears to let you know that a panel already exists with the same name and asks if you want to replace it. Click on the **Yes To All** button.

5. If Photoshop is still running, you must quit the application for the install to be completed. A warning message may appear to tell you to do so.

After you have successfully installed the panel, the Adobe Extension Manager will let you know and give some useful information (see Figure 7.27). Note that the Extension Manager can be used to uninstall the panel or to disable it. You can even upload the panel to Adobe Exchange to share it with others.

FIGURE 7.27 After the panel has been successfully installed.

EXPLORATIONS

One of the most common operations to perform on a photograph is to sharpen it. A related operation is blurring an image (or part of an image) to encourage the viewer's eyes to look at other areas of a photo. Photoshop provides many tools and menu items for these and other traditional photography processes.

Build a panel gathering in the tools and processes you might use in a traditional darkroom so that they are easy to find. You might also add processes that simulate photographic looks such as grain, noise, color shifting, black and white, and other filters.

SCRIPTING

Photoshop

Learning the Tools to Start Scripting Photoshop

Introduction to Photoshop Scripting

Before you learn how to script Photoshop, it is worth learning why you might want to do so. After all, Photoshop has actions, which are powerful tools for automation. Actions are easy to use and relatively easy to create. Actions record operations you perform on an image. Those same operations are played back on one or more other files. Although this capability may be straightforward and powerful enough for many uses, it is basically a "monkey see, monkey do" scenario.

Actions do not include automated decision making related to data encountered during playback. Adding intelligence to an automated process is the area in which scripting excels. A script can query an image document for information and respond in different ways based on the answer to the query or even use the result later in its process.

For example, it can be useful for a script to know the name of a document or the name of each layer in a document. Useful tasks include workflow-savvy renaming of layers based on the document name, something an action cannot do. A script can process multiple parts of a document by finding out about the content of each layer or each channel. Text can be replaced. Metadata can be filled in. Layers can be added.

Scripts can reach beyond Photoshop to interact with other files and even the operating system itself. Scripts can read text from a text file, using it to adjust data in an image file or even build new files. This can go beyond what is available using the Variables process in Photoshop. Scripts can also create text files. Scripts can create and name new folders on the hard drive. Scripts can interact with other applications and documents on your computer. Scripts can pass information between Photoshop and Bridge or even simply just work with both at the same time.

Scripts can build user interfaces enabling nonscripters to use your tools. This capability can be as simple as a single menu item added to Photoshop or as complex as a dialog box with controls for the parameters of the operations being performed by the script.

Scripting allows more power and control over Photoshop than any of the other automation features available. This level of power and control comes with more responsibility—more than the other processes so far. To be successful, you need to learn how the computer does its work. You must learn the details and specificity of things. You must learn a bit about logic and decision making. You must learn about data, parameters, functions, and errors.

The benefit of learning how to script is the range of what you can do with it. Before scripting, you rode on the rails of what Photoshop offered. With scripting, you are the driver, deciding which roads to take.

Supported Scripting Languages

Photoshop supports three scripting languages:

- **AppleScript**—A Macintosh scripting language from Apple
- **VBScript**—A Windows scripting language from Microsoft
- **JavaScript**—A cross-platform scripting language originally developed by Netscape

AppleScript and VBScript are not cross-platform. They do have the advantages of support from the operating system vendors and more access to the operating system and other applications than JavaScript.

JavaScript is an easy language to learn with a lot of documentation and support available on the Internet. The language is very commonly used on websites. A common misperception is that JavaScript is some variation of the programming language Java, which was developed by Sun Microsystems. JavaScript was created about the same time as Java. Most likely driven by a marketing strategy, Netscape named its new language JavaScript to ride the rising popularity of Java. But JavaScript and Java do not really have anything in common beyond the name.

Scripting languages are known as interpretive languages in the computer industry. The script, a collection of text that includes computer

commands, is run through an application and interpreted by that application as the application runs. The application reads the script and responds internally according to its own programming. Examples of scripting languages include JavaScript, Perl, LISP, and Ruby. DOS scripts are interpreted by Microsoft's operating system. UNIX shell scripts are interpreted by the UNIX operating systems.

Computer languages such as C/C++, Pascal, Fortran, and Objective-C are compiled languages. The written code is translated into machine language, which is run directly by the computer, instead of an application or the operating system. In a sense, the interpretation takes place before the code is run instead of while the code is run. Photoshop is written primarily in C++.

Because JavaScript is cross-platform, widely used, and easy to learn, you'll learn to script Photoshop using this language. Because of JavaScript's popularity, it was promoted to a standardized language by the European Computer Manufacturers Association (ECMA). Most still refer to the language as JavaScript, but it is now also known as ECMAScript. Adobe built its scripting language from the ECMAScript standard. Technically, Adobe extended the language to support scripting Adobe applications. Or put another way, Adobe extended the functionality of its applications to support scripting. The Adobe language is called ExtendScript.

ExtendScript Toolkit

You can write code in any text editor. Code is just text. Other tools make that text understandable to an application, the operating system, or the machine. Because code is text, it can be written by any application that can save a plain-text file. There are many applications capable of doing this. Fortunately, Adobe makes your choice of tool for writing scripts an easy one.

The ExtendScript Toolkit is installed with Photoshop for your script-writing needs. The toolkit is more than just a text editor. It includes information to help you write, run, and troubleshoot scripts for Adobe applications.

Where Is the File Located?
Mac OS X:
/Applications/Utilities/Adobe Utilities—CS5/ExtendScript Toolkit CS5/
Windows XP, 7, and Vista:
\Program Files\Adobe\Adobe Utilities\ExtendScript Toolkit CS5\

Accessing the Documentation

In addition to the tool for writing scripts, Adobe installs examples and documentation in the same folder as the ExtendScript Toolkit application. The documentation is good reference material. If you get confused about functionality not detailed in this book, the Adobe documentation provides additional details on the tool and on specific scripting techniques. Some of these files are found in the **SDK** folder (SDK means Software Development Kit).

- **ExtendScript Toolkit ReadMe.pdf**—This document contains release notes for the toolkit and lists new features from the previous version of the toolkit. This information may not be very useful unless you've used the previous toolkit.
- **JavaScript Tools Guide CS5.pdf**—Located in the **SDK** folder, this document is full of technical details about both the scripting toolkit and about the scripting language itself. As you build more scripts to explore the capabilities available, this document describes how to do things you might not know about.
- **Adobe Intro To Scripting.pdf**—Located in the **SDK/<your language>** folder, this document is a primer for learning how to script. It covers many of the same topics as the scripting chapters in this book.

The **SDK/Samples** folder contains sample code provided by Adobe. This code can provide solutions and inspiration for solving problems in your own coding efforts. The **javascript** folder contains many .jsx files, which are the scripts. As you become more comfortable scripting, these examples can be useful to view how others write code.

Additional documentation is provided in the Photoshop application folder. There is a **Scripting** folder in the **Adobe Photoshop CS5** folder. The most important of these documents is the **Photoshop CS5 JavaScript Ref.pdf** file, which is a reference to all the nouns and verbs that Photoshop responds to in scripts. It is like a dictionary; it is a reference you may refer to frequently as you code your scripts.

Thinking about Scripting

Where should you begin scripting? Many people fear that scripting is complicated, difficult, and frustrating. A couple of analogies might help to make scripting more approachable.

The first analogy is the children's game Mad Libs. In the game, you are given a story with words missing. Sentences are shown with blanks for nouns, verbs, and adjectives. One player asks another player for words based on the grammatical description provided and then reads the completed story aloud. For example:

The _____ (adjective) _____ (noun—singular animal) sat in her favorite _____ (noun—singular thing) and _____ (verb—past tense) a _____ (noun—singular).

Scripting is similar. There is no need to write the whole story from scratch. You just need to fill in the blanks with a few nouns and verbs. The nouns used in scripting Photoshop are things like "documents," "layers," and "channels." The verbs are things like "filtering," "resizing," "transforming," and "saving."

The second analogy is cooking, specifically recipes. Think of dessert recipes for fruit salad containing Jello, Cool Whip, and pudding. You probably know these kinds of recipes: Add milk or water to a box of powder, add a can of fruit, and smother in Cool Whip. Sounds easy, right? It is. But the ingredients of that powder can include sugar, gelatin, adipic acid, artificial flavor, disodium phosphate, sodium citrate, fumaric acid, and the colorant red 40. Sounds like a science project. You might know it better as Jello.

Scripting can be the same. You can reuse someone else's complex ingredients as long as you know how to use them in the context of your recipe. Code is reused all the time and is encouraged. Why not copy something you know works and change it to fit the task at hand? Sometimes you won't even have to change the code. After a while of creating scripts yourself, you'll start stealing code from yourself.

Creating a Scripting Template

It is rare to start writing a script from scratch. Usually, you start with a template or an existing script, modifying it to solve a new problem or provide a new solution to a solved problem. So the first thing you are going to write is a template file. Use this file to begin all your scripting projects. It will help keep your code organized, allowing you to find the pieces of your code easily.

1. Run the ExtendScript Toolkit application (see Figure 8.1), so you can create a template document.

2. In the empty text document shown in the tab **Source1**, type the following code exactly as it is shown here. The code will change colors as you type, and the toolkit recognizes the syntax.

```
// template.jsx
// Copyright 2006-2011
// Written by Jeffrey Tranberry

/*
Description:
This is a template to help you begin scripting.
*/

// enable double clicking from the
// Macintosh Finder or the Windows Explorer
#target photoshop

// Make Photoshop the frontmost application
app.bringToFront();
```

FIGURE 8.1 The ExtendScript Toolkit development workspace.

```
/////////////////////////////////////////
// SETUP
/////////////////////////////////////////

/////////////////////////////////////////
// MAIN
/////////////////////////////////////////

/////////////////////////////////////////
// FUNCTIONS
/////////////////////////////////////////
```

3. Chose **File > Save As...** from the menus. In the **Save As** dialog, name the document **template.jsx** and save it to the **Desktop**.

This file is a simple script that starts Photoshop, making it the frontmost application. That's it. As a script, it does not have much use. Its real use is to provide blank areas for you to fill in. As you work through the examples in the scripting chapters of this book, the **template.jsx** file is the file you will start with each time.

Looking in detail at the text in the **template.jsx** file, you should notice a few things. Most of the lines of text start with // and then continue with some text (sometimes even more / characters). These lines are comments. The comments are for a human to read and are ignored by the computer. The // notifies the application running the script to skip this line because it does not contain code. It is important to point out that this is known as a *line comment* because the comment is only for that one line. If the text needs to continue to the next line, then the next line must also start with the // characters.

The second section of text in the **template.jsx** file starts with the characters /* on one line and then has two lines of text followed by a line with the */ characters. This is a *block comment*. The text between these two markers is ignored by the application running the text. The text is again intended for a human reader instead of a computer. Block comments start with /* and run until the */ character combinations are found. They can continue for as many lines of text as there are in the file. Block comments are useful for disabling large blocks of code. The problem is that the /* and */ must appear in pairs. The block comments

cannot nest one inside of another. So for comments intended for a human reader, it is best to use line comments.

Other than all the comments, there are only two lines of code in the template. The first is

```
#target Photoshop
```

This line tells the application running the script which Adobe application the script is intended for. In this case, the script is to run inside Photoshop. Because scripts can run in the ExtendScript Toolkit and other Adobe applications, this important line causes Photoshop to run if it is not already.

The other line of code is

```
app.bringToFront();
```

This line commands the target application to become the frontmost application being run by the user. The application's windows and menus move to the foreground of the operating system. There are two pieces to this line of code: app is the noun identifying the running application—in this case Photoshop; and bringToFront() is the verb telling the noun to do something. You'll learn more about these ideas later in this chapter.

> The semicolon (;) character ends the line of code like a period ends a sentence.

Writing Your First Script

Now it's time to write your first script that actually does something inside Photoshop, not that it will do much. Small steps are needed at first. You'll be running soon enough.

1. In the ExtendScript Toolkit with the **template.jsx** file open, choose **File > Save As...** from the menu. In the **Save As** dialog, name the file **helloworld.jsx** and save it to the **Desktop**.

2. In the **helloworld.jsx** file, type the following lines in the MAIN section of the code:

```
// Display a dialog with the text "Hello, World!"
alert("Hello, World!");
```

3. Choose **File** > **Save** from the menu to save the script.

4. Click the Play button in the toolbar at the top right of the file (see Figure 8.2) or choose **Debug** > **Run** from the menus.

5. If you do not have Photoshop running, the toolkit shows a dialog asking if you want to run it (see Figure 8.3). Click the **Yes** button.

FIGURE 8.2 Toolbar buttons in the ExtendScript Toolkit.

FIGURE 8.3 Confirmation dialog for launching Photoshop.

FIGURE 8.4 **Hello, World!** message shown in Photoshop.

6. After Photoshop starts up, an alert dialog appears with your **Hello, World!** message (see Figure 8.4).

7. Click the **OK** button to close the dialog.

This message is a tradition when you're learning to code. It is not much, but it is friendly. Although the script is simple, you should consider what you just did: You told Photoshop to do something and it did. You did not use the mouse or a menu or a keyboard command. You just wrote some text. You coded some commands in a language that Photoshop can interpret, and it did what you asked.

This first step may not seem very useful, but it is. Using the alert() command is very helpful when you are troubleshooting your code. If something in a script goes wrong, a message in the script can tell you how far you got in the script. Because scripts can query Photoshop for data, an alert() can display that data. There is a reason this is the first thing all coders learn: It is very useful. As your scripts get more and more complicated, this simple command will save you frustration.

Installing and Running Photoshop Scripts

You wrote your first script and ran it inside the ExtendScript Toolkit. As you no doubt noticed in previous chapters and from your own explorations of Photoshop, there are scripts that run in Photoshop from its own menus.

The **File** menu has a **Scripts** submenu. Each menu item is actually a script. You can look at the code yourself.

Where Are the Files Located?
Mac OS X:
/Applications/Adobe Photoshop CS5/Presets/Scripts/

Windows XP, 7, and Vista:
\Program Files\Adobe Photoshop CS5\Presets\Scripts\

To install your script and run it from the Photoshop menus, follow these steps:

1. Quit Photoshop. You'll need to restart it for Photoshop to see your script.
2. In the Finder or Explorer, copy the **hellowworld.jsx** file from the **Desktop** to the **Scripts** folder detailed in the "Where Are the Files Located?" section above.
3. Run the Photoshop application.
4. Choose **File > Scripts > helloworld** from the menus. The alert dialog with your message appears again, like it did when you ran the script from the ExtendScript Toolkit.

You can assign a keyboard shortcut to a script. However, do not assign a shortcut that uses the **Option** (⌥) key. The key runs the script in Debug mode and launches the ExtendScript Toolkit.

There are other ways to run the script. You can double-click the **helloworld.jsx** script file. Because the file was created by the ExtendScript Toolkit, the application opens the file and asks if you want to run the script in Photoshop. A similar method of running the script is to drag and drop the script file on the Photoshop icon or on the ExtendScript Toolkit icon. You can also choose **File > Scripts > Browse...** from the Photoshop menus to find and select a script to run.

Most commonly when you are creating a script, you run the script from the toolkit until it is working and polished. Then, when you are done, you copy it to the **Scripts** folder to use it in Photoshop whenever you need to.

Coding Concepts: Variables, Data Types, Strings, Operators, and Functions

Code is writing that commands a computer or application to do something. People communicate with one another all the time, but there are cultural nuances that occur. Sometimes things are left unsaid, or things are left up to interpretation. Human communication can be messy. In some ways, each of us communicates in our own way, expecting the rest of the world to understand us. It is our style or personality. It is also rare that when we communicate with others we are issuing commands. Most of our day-to-day life does not have to be exact.

Computers require exactness in communication. Actually, it is not a requirement, but it is the result. A computer does exactly what you tell it to. The problem is that you may not realize what you told it to do. The computer is literal. You must communicate with it as if you were a computer. As a human being and most likely as an artist, you are accustomed to expressing yourself in your own way. If you do this with a computer by writing code how you think it should be done, you are doomed to frustration because the computer will do exactly what you tell it instead of what you wanted.

Here are a few points to keep in mind as you learn to code:

* Code is interpreted from the top of the file to the bottom. In your first script, the `#target photoshop` command executed first, then the `app.bringToFront();` command, and finally the `alert ("Hello, World!");` command. Order is important. This rule does have an exception when it comes to functions, which are detailed later in the chapter.

- Spelling matters. Computers are exact, so what you write must be exact. This can be like choosing one menu item versus another, except that it is words that are important.

- Some words are reserved. These words are usually special in the language itself. Trying to use a reserved word would be like naming your dog "Cat." Doing so would only lead to confusion. Fortunately, the reserved word list is small. Reserved words are also referred to as *keywords.*

- Most commands are a single line of text, and that line usually ends with a semicolon (;) just like the end of a sentence usually ends with a period. As with sentences, you'll learn when a line does not need a semicolon, but in general, you'll end each line of code with a semicolon.

> It's useful to format your code so that you can read it easily. This means adding spacing around commands, writing commands one line at a time instead of all on the same line, and adding comments. The computer generally does not care about any of these things. They are just good habits that help you read the code while you write it and when you look at it much later after you forgot exactly how it works. They also help others to read your code.

Just as sentences and Mad Libs have grammar rules and parts made up of words that are nouns, verbs, and adjectives, code has its own grammar and parts. This is one of the reasons why coding refers to computer languages. There are rules. There are parts that follow those rules, sometimes in different ways. The sections that follow describe some of those rules and parts.

Variables

A *variable* is a container. It is a box used to store data. The box has a name, which you assign to it. The data in the box may change as the script runs, but the name of the box does not change. The box is called a *variable,* and the data is known as a *value.* A value can be a number, a color, a size, text, or an object such as a document or layer.

Before you use a variable, you must let the computer know about it. This process is called *declaring the variable.* In essence, you are building the box and giving it a name before you try to put something into the box. When you declare a variable, you can also assign it a value.

To declare a variable, you use the keyword `var` followed by a space and the name of the variable. To assign the variable a value, place an equal (=) character after the variable followed by the value.

For example, if you write a script for a shirt design company, you might declare some variables like this:

```
var shirtColor="red";
var shirtSize="medium";
var shirtLogo="penguin";
```

To change the values of those variables, you would write code like this:

```
shirtColor="blue";
shirtSize="large";
shirtLogo="tiger";
```

The variable names stay the same, but the values change.

There are a few rules when naming a variable:

- The name must not have any spaces in it. Instead of using spaces, run the words together and use "camel case" to separate the words, such as `shirtColor` for shirt color and `shirtSize` for shirt size.

- The name can contain only alphanumeric characters (the letters a–z and the numbers 0–9) and the underscore (_) character.

- The name must start with a letter or the underscore character. Names cannot start with numbers; for example, `shirt_color`, `_shirtColor`, and `shirtColor9` are valid variable names, but `9shirtColor` is not.

Those are the rules. Here are some style conventions to keep in mind with variables:

- Use meaningful names that give you an idea what the data in the variable represents. Do not simply use a letter or two letters. Code can be very mathematical, but this is not algebra. This is communication with a language. `layerOpacity` is a good variable name; `op` is not a good name.
- Scripters tend to start variable names with a lowercase letter, for example, `shirtColor` and `layerOpacity`. Use uppercase letters for new words in the variable name. This is usually referred to as "camel case." Objects that have names that start with uppercase letters do not tend to be variables.

Data Types

Data is more than just a value. Data has a type. Think about nouns: They are a person, place, thing, or idea. These are types. Data types help you to understand what the data is and helps the computer store it and work with it.

Variables can be set to one of the following data types:

- **Number**—A number like 42, 2.5, –17, or 0
- **String**—A grouping of ordered text enclosed by a single quotation mark (') or double quotation marks (") like "red" or "twas brillig and the slithy toves did gyre and gimble in the wabe" or 'mostly harmless'
- **Boolean**—A value of `true` or `false`

Believe it or not, it is not always obvious what the data type is in a variable. Fortunately, there is a command to get the data type from a variable. This command is useful because, in scripting, the data type of a variable can change based on the value assigned to it. To get the data type, use the `typeof` command followed by the variable name:

```
alert(typeof myNumber);
```

In the ExtendScript Toolkit, create a new file by saving the **template.jsx** file as **workingWithVariables.jsx** and type in the code to make it look like this:

```
// workingWithVariables.jsx
// Copyright 2007-2011
// Written by Jeffrey Tranberry
/*

Description:
This script demonstrates how to work with variables.
*/

// enable double clicking from the
// Macintosh Finder or the Windows Explorer
#target photoshop

// Make Photoshop the frontmost application
// in case we double clicked the file
app.bringToFront();

/////////////////////////
// SETUP
/////////////////////////

/////////////////////////
// MAIN
/////////////////////////

// Define a variable with the value of 10
var myNumber=10;

// Display a dialog with the value of the variable myNumber
alert(myNumber);

// Define a variable with the value of a string "Jeff"
var myName="Jeff";

// Display a dialog with the value of the variable myName
alert(myName);

// Define a variable with the boolean value of true
var isMarried=true;
```

```
// Display a dialog with the value of isMarried
alert(isMarried);

// Define several variables as integers
var a=1;
var b=2;
var c=3;
var d=4;

alert(a);
alert(b);
alert(c);
alert(d);

// Define several variables as strings
var myName="Jeff";
var wifesName="Rachel";
var daughtersName="Sophia";
var dogsName="The Todd";

alert(myName);
alert(wifesName);
alert(daughtersName);
alert(dogsName);

// Change a variable to the number value of 5
myNumber=5;

// Change a variable to the string value of "Jeff"
myName="Jeff";

// Change a variable to the boolean value of true
isMarried=true;

// Change a variable to the value of the object app
myApplication=app;

// Define a variable and leave the value undefined
var yourGrade;

alert(typeof myNumber); // number
alert(typeof myName); // string
```

```
alert(typeof isMarried); // boolean
alert(typeof myApplication); //object
alert(typeof yourGrade); //undefined

// Change the type of the variables
// Change a variable to the value of "5" as a string
myNumber="5";

// Change a variable to a boolean value of false
myName=false;
// Change a variable to the value of the object app
isMarried=app;

// Change a variable to the numeric value 4
yourGrade=4;

alert(typeof myNumber); // string
alert(typeof myName); // boolean
alert(typeof isMarried); // object
alert(typeof yourGrade); // number

/////////////////////////
// FUNCTIONS
/////////////////////////
```

When you are done, run the script to see the results. As expected, Photoshop pops up a lot of alert dialogs to pass along the messages about the variables.

Strings

A *string* is a sequence of characters made from letters, numbers, or symbols. In JavaScript, the backslash character (\) is a special character, called an *escape character*. It modifies the interpretation of the character that immediately follows it. The combination of the backslash character with another character is called an *escape sequence*.

When working with strings, you may need to modify quotation marks that are part of a string by using an escape sequence so that the quotation

mark is not interpreted as the end or start of a new string. Examine the following code to see that the strings in the second and third alert are not interpreted correctly.

Notice how the syntax code coloring in the toolkit breaks down:

```
// Have Photoshop display an alert box with a simple string
alert("I'm learning to script Adobe Photoshop. Won't you
join me?");
```

```
// Have Photoshop display an alert box with a string that
// requires escaping single quotes
alert('I'm learning to script Adobe Photoshop. Won't you
join me?');
```

```
// Have Photoshop display an alert box with a string that
// requires escaping double quotes
alert("I'm learning to script "Adobe Photoshop." Won't
you join me?");
```

If the strings were escaped correctly, the syntax highlighting would display the entire string as red or purple, depending on the quotation mark used for the string. To escape either a single or double quotation mark in a string, simply precede the character with a backslash character (\):

```
// Have Photoshop display an alert box with a simple
string
alert("I'm learning to script Adobe Photoshop. Won't you
join me?");
```

```
// Have Photoshop display an alert box with a string that
// requires escaping single quotes
alert('I\'m learning to script Adobe Photoshop. Won\'t
you join me?');
```

```
// Have Photoshop display an alert box with a string that
// requires escaping double quotes
alert("I'm learning to script \"Adobe Photoshop.\" Won't
you join me?");
```

You can also format strings into multiple lines using \n to start a new line of text:

```
// Have Photoshop display an alert box with a
// formatted string in it. Use \n to create new line.
alert("Hello, School of Visual Art!\nWelcome to
scripting Photoshop,\n\nSpring Semester, 2010.");
```

```
// Have Photoshop display an alert box with a
// formatted string in it, but this time format the
// code onto multiple lines so it is more readable.
alert("Hello, School of Visual Art!\n" +
"Welcome to scripting Photoshop,\n\n" +
"Spring Semester, 2010.");
```

In the last example, notice that the plus (+) character is used to concatenate, or combine, the strings together. You will explore more ways to manipulate strings as you work through the scripting chapters of this book.

Operators

Operators are symbols used for math or mathlike operations. When using operators, you can add numbers, concatenate strings together, and compare values. The following are arithmetic operators:

+ (addition)
– (subtraction)
* (multiplication)
/ (division)
% (modulus)

Using the ExtendScript Toolkit, open the **template.jsx** file and save it as **workingWithOperators.jsx**. Work through this section by typing the following code in the MAIN section of the file and running the script to see the results:

```
// add numbers
alert(6+1);
```

```
// subtract numbers
alert(6 - 1);
```

```
// multiply numbers
alert(6 * 2);

// divide numbers
alert(6 / 2);

// modulo numbers
alert(6 % 4);
```

The plus (+) symbol operates in a unique way when applied to strings or a combination of strings and integers. On one hand, if all the values are integers, the plus (+) operator will add the numbers together. On the other hand, if the values are strings, the plus (+) operator will concatenate them, adding the second string to the end of the first, creating a longer string of characters. Here's an example:

```
// Create 3 variables, they are stings because of the
quotes.
var a="5", b="6", c="7";

// Use the (+) operator to concatenate the strings
alert(a+b+c);

// Set the variables to numeric values.
a=5;
b=6;
c=7;

// Use the (+) operator to give the value
// of the added numeric values, in this case 18.
alert(a+b+c);
```

If one value is a string, or both values are, then the plus (+) operator concatenates the two values together as a string. Remember an integer in quotation marks acts as a string, as shown here:

```
// Set variables so two are numeric and one a string.
a=5;
b=6;
c="7";
```

```
// Use the (+) operator to add all three together.
// The first two integers are added to make 11 and "7"
// is concatenated on the end to give 117.
alert(a+b+c);
```

You can concatenate strings that are literals, not just variables that have string values, as in this example:

```
// Define some variables using strings
var me="Jeff";
var wife="Rachel";
var daughter1="Sophia";
var daughter2="Stella";
// Define a variable with concatenated variables
var family=me+", "+wife+", "+daughter1+" and "+
daughter2 +".";

alert(family);
```

You can use the Number() function to force strings to be interpreted as numeric values:

```
// forcing strings to behave as numerics

// set variables, each are strings because they are in
quotes
var one="1";
var two="2";
var three="3";
var four="Four";

// Concatenate the two strings, the result should be '12'
alert(one+two);

// Use Number() to force the strings to be interpreted as
// numeric values, resulting in a value of '3'
alert(Number(one)+Number(two));
```

When you use multiplication and division operators, numbers with quotation marks around them will be treated as numeric values, and not as strings, as in this example:

```
// As long as the variables are actually numbers with
// quotes around them multiplication and division
// operators coerce the strings to numeric values

// Results in a value of 6
alert(two * three);

// Results in a value of 1.5
alert(three / two);
```

If the data types are a mix of numbers and strings (or objects), the operation results in a value of NaN (Not a Number):

```
// Trying to perform (-) (*) and (/) operations on a mix of
// integers and letters results in a value of NaN.
alert(three - four);
alert(three * four);
alert(three / four);
```

These behaviors are the result of JavaScript being an untyped programming language. This makes JavaScript more flexible, but you need to understand the mixing behaviors to get expected results.

In addition to standard arithmetic operators, there are special operators for incrementing (increasing) and decrementing (decreasing) variables:

++ (increment by 1)
-- (decrement by 1)
+= (increment by an arbitrary amount)
-= (decrement by an arbitrary amount)

They work as follows:

```
// ++ increments numbers by 1
var myNumber=10;
myNumber++;

alert(myNumber);

// -- decrements numbers by 1
myNumber--;
```

```
alert(myNumber);

// += increments numbers by an arbitrary amount,
myNumber += 5;

alert(myNumber);
```

There are some subtle behaviors regarding the order of terms when using operators to increment or decrement when declaring a variable:

```
myNumber=15;
var incrementedNumber=myNumber++;

// Because the ++ comes after myNumber, JavaScript
// assigns the value before incrementing it.
alert(incrementedNumber);

myNumber=15;
var otherNumber=++myNumber;

// Because the ++ comes before myNumber, JavaScript
// increments the value before assigning the value
alert(otherNumber);
```

Operators for incrementing and decrementing become very useful when you are creating loops in your scripts, which is covered in Chapter 10.

Functions

Operators are like verbs in coding languages. Operators do something to nouns, such as variables. Another verblike term in coding is a *function.* Functions do something, usually with the help of nouns. Functions are lines of code put together for common use in any script or for use multiple times in the same script. Your scripts have used a few functions already, such as `alert()` and `Number()`.

There are three pieces to using a function: the name of the function, parameters, and the result. All functions have a name, just like all

variables have names. Many functions have *parameters*. These are values passed in to the function as data for the function to work on. Most functions have a result, which is the data passed back to the function's code, as you can see here:

```
result=functionName(parameters);
```

The parameter for the `alert()` function is a string. These characters are the message displayed by the alert dialog in Photoshop. The `alert()` function does not return a result value. The `Number()` function does return a result. The `Number()` function takes a string as a parameter and returns the numeric value of that string as the result.

ExtendScript provides many functions for you as part of the language. `Number()` and `alert()` are two of those functions. In Chapter 9, you'll learn how to write your own functions. Photoshop scripts can use special functions. These methods are part of the Photoshop Document Object Model (DOM), which is described later in this chapter.

Programmers often interchange the words "function," "method," "routine," "procedure," and "subprogram." They do this because each word means nearly the same thing. For the sake of consistency, use the term "method" to describe commands built into the Photoshop DOM and use the term "function" to describe custom commands not part of the Photoshop DOM.

Coding Concepts: Classes, Objects, Properties, and Methods

The coding pieces described so far have been fairly simple. They are the basics and are very mathematical in nature. There are more complex pieces needed to really start using the power of scripting Photoshop. The new pieces start using ideas a step away from basic math. The step is toward more real-world items. Collectively, these ideas are called *object-oriented programming*.

Classes

A *class* defines something in the real or computer world by giving it data and functions that work with it. A class is a noun, similar to a data type like a number or string. The difference is that a number just has a single piece of data—the number. There are operators and functions that work on numbers, but they may also work with other types like strings. A class can have multiple variables with data meaningful to it and functions that work on that data specifically.

An example of a class in the real world is a car. Think of a definition of a car. A car has a make, model, manufacturing year, color, and license plate number. A car can go forward, it can stop, it can turn, and it can honk its horn. This is a decent definition of a car class. It is not specific about a particular car, but it describes cars in general.

Objects

Objects are specific instances of a class. For example, you might drive a car that is a blue 1966 Ford Mustang with a license plate number of 3RAH567. That specific car is an object. It is an instance of the car class. If you ask the object what color it is, the answer is blue.

An object is like a specific variable. In the previous code examples, you defined a variable `myNumber`, assigned it a value, and did things with it, such as changing its value. You have also already been using an object in each of your scripts:

```
app.bringToFront();
```

`app` is an object. It is the variable name for a specific instance of a class. The class is an application, and the specific instance is the running application—in this case, the application Photoshop. The object `app` was set up for you by the scripting environment. Its class is defined by the engineers at Adobe.

Properties

The data of an object is called a *property*. With the example of the car, the properties are the make, model, manufacturing year, color, and license plate number. The specific properties of the car object described

are Ford, Mustang, 1966, blue, and 3RAH567. Properties are the variables of an object. The variables hold the data that makes the object unique.

Not all classes have properties. It is not required, but it is common for a class and its object instances to have properties with specific data values.

Methods

A *method* is a function defined with a class. Frequently, a class's methods change or use the object properties to do something. Sometimes methods just return the value of the properties. For example, with the car, there might be a method `describe()` that returns a string describing the car object. With the specific car object, the `describe()` method would return the result **1966 Ford Mustang with plate 3RAH567**.

`bringToFront()` is a method defined by the application class. In your scripts, the code `app.bringToFront()` tells the specific object `app` to call its method `bringToFront()`. This causes the Photoshop application to be the frontmost application in the user interface of the computer.

To call an object's method, you use the following syntax:

```
object.method(parameters);
```

Look familiar? Remember that computers are very specific. There are a few things to point out in the syntax. There is a period (.) between the object and the method. That period is important. It tells the computer that you want it to call that specific method on that specific object instance. Notice that there are open and closing parentheses after the method name. There might be parameters in those parentheses, but there will always be parentheses. The parentheses identify the method name as a method. And finally, there is the semicolon (;). Remember that it is like the period at the end of a sentence.

Examples of calling methods on objects are

```
app.bringToFront();
myCar.describe();
```

Photoshop Document Object Model (DOM)

The code you've learned so far has been generic ExtendScript. This code would work with any ExtendScript-enabled application. So far, nothing has been specific to Photoshop, and so nothing has really been that useful to you yet.

What really starts to give you control over the power of Photoshop is knowing the classes defined and the objects created at runtime by Photoshop. They are like the ingredients in a recipe or the characters in a story. Some are types like "the guy in the red shirt" or "the plucky comic relief." Some are individuals like Sherlock Holmes or Wednesday Addams.

You need to know how to look up and correctly communicate with the objects provided by Photoshop. The key to doing that is learning about the Document Object Model.

What Is a Document Object Model?

The Document Object Model, frequently referred to as DOM, is a programming interface for scripting applications like Photoshop. Think of it like a dictionary for working with the application's objects, specifically with the documents that an application opens. Every application creates its own DOM, just like every human language has its own dictionary.

Objects such as documents are complex. Each defines a lot of data and methods for manipulating that data. Objects also contain other objects. Think of the example of a car. A car has four wheels. Each wheel is an object. Each wheel has a tire, a hubcap, lug nuts, and a rim. A car also has an engine made up of many other parts. It also has a steering wheel, which is different from a wheel that has a tire. A car is an object that contains other objects, many of which also contain other objects. Boxes within boxes. Wheels within wheels. Objects within objects.

An application's DOM describes all these objects, their data, their methods, and the subobjects it contains.

Dissecting Photoshop Objects

Think about Photoshop as a container or folder. The first folder contains everything. This is the Photoshop application object. You have already addressed it in your scripts with this line of code:

```
app.bringToFront();
```

The name of the application is `app`; in this case, it is specifically the Photoshop application. Because it is an application, it has some standard methods defined for it, such as `bringToFront()`. Because the application is Photoshop, it also has specific methods defined for it, such as `batch()`, `doAction()`, and `makePhotoMerge()`.

If you continue thinking about the `app` object as a folder (see Figure 8.5), the folder inside that one is the document you are working on. It has a specific name: `activeDocument` (see Figure 8.6).

If you continue to explore the objects from the outside in, the next object is the layer being worked on. Its specific name is the `activeLayer` (see Figure 8.7).

FIGURE 8.6 The `activeDocument` object as a subfolder of the `app` object.

FIGURE 8.5 The `app` object as a folder.

FIGURE 8.7 The `activeLayer` object as a subfolder of the `activeDocument` object.

FIGURE 8.8 The `activeLayer` object's `name` property.

This example of the Photoshop DOM is simple. You know from various descriptions and exercises in this book that Photoshop is not simple. There are a lot of features and details. Yet this simple example already gives you a structure that you can use to great effect. Most of the manipulations you do in Photoshop involve a document and its layers.

Object Model Viewer

Knowing that there is a DOM organized and available for your scripting use is one thing, but you need to be able to explore it. Fortunately, the ExtendScript Toolkit helps you to do that.

1. Choose **Help** > **Object Model Viewer** from the ExtendScript Toolkit menus.

2. At the top of the left column, below the word **Browser**, change the pop-up menu from **Core JavaScript Classes** to **Adobe Photoshop CS5 Object Library** (see Figure 8.9).

3. In the **Classes** panel, click on **Application** in the list to view details about the class. Notice that the **Properties and Methods** panel updates to include specifics about the **Application** class.

4. In the **Properties and Methods** panel, click on **ActiveDocument: Document** in the list. Notice the description about the object.

As a person knowledgeable about Photoshop, you know that there is likely more than one layer and that each layer has several properties, such as its name, its visibility, its opacity, its blending mode, and more (see Figure 8.8).

Each of the containers has a name that can be used in a script to get its properties and to call its methods. Knowing the names of the objects and the hierarchy of the objects, you can write code to get the name of the layer being worked on in Photoshop, as in this example:

```
// Display a dialog with the current layer's name
alert(app.activeDocument.activeLayer.name);
```

FIGURE 8.9 Object Model Viewer from the ExtendScript Toolkit.

5. In the **Classes** panel, scroll to find **Layer** in the list and click on it. The **Properties and Methods** panel updates to show the details about the **Layer** class. Notice that properties show the name followed by a colon (**:**) and the data type of the property—for example, **name: string** and **opacity: number**. Methods are at the bottom of the list; they show the name of the method, the parameters the method requires, and possibly the data type of a return value—for example, **duplicate (relativeObject, insertionLocation): Layer**, which creates a copy of the layer.

Create a new script file from the **template.jsx** file and save it to the **Desktop** as **layerProperties.jsx**. Add the following code in the MAIN section of the script:

```
// Display a dialog with the current Layer's blendMode
alert(app.activeDocument.activeLayer.blendMode);

// Display a dialog with the current Layer's opacity
alert(app.activeDocument.activeLayer.opacity);

// Display a dialog with the current Layer's lock state
alert(app.activeDocument.activeLayer.allLocked);

// Display a dialog with the current Layer's visibility
alert(app.activeDocument.activeLayer.visible);

// Display a dialog with the current Layer's bounds
alert(app.activeDocument.activeLayer.bounds);
```

Save and run the script to see the results. Remember to have a document already open in Photoshop. The alerts show the values. As you have done in the past with other pieces of data, you can assign these values to variables. Even more useful, because you know the names of the properties of the Photoshop objects, you can change the values of those properties, as shown here:

```
// Set the current Layer's blendMode to MULTIPLY
app.activeDocument.activeLayer.blendMode=BlendMode.
MULTIPLY;

// Set the current Layer's opacity to 50%
app.activeDocument.activeLayer.opacity=50;

// Set the current Layer's locked state to false
app.activeDocument.activeLayer.allLocked=false;

// Set the current Layer's visibility to false
app.activeDocument.activeLayer.visible=false;
```

Remember that you have access to the properties of the Photoshop objects and to the methods. You could add `app.activeDocument.activeLayer.remove()` to your script. This would delete the active layer. Be careful doing that with documents that have only a single layer.

Use the **Object Model Viewer** to explore the Photoshop DOM. There are a lot of objects and properties and methods available to you as a scripter. Write some lines of code to set a few values and call a few methods on other objects. You know enough to be dangerous but not too dangerous. With your skills, you can create the equivalent of a good Jello fruit salad. It is easy to make and not too fancy. Although you could not open a restaurant with just that recipe, it is a start for learning how to make a tasty meal. The same is true with your scripting skills. You are just starting.

EXPLORATIONS

The alert() function is one way to help troubleshoot scripting problems. The alert() function has the advantage of stopping a script to display information. This allows you to stop a script if things are going wrong. The problem is that too many alerts can get annoying, so you end up just clicking the **OK** button repeatedly without paying attention to the messages.

A common alternative to using the alert() function is to instruct the script to write information to the **JavaScript Console**. The **JavaScript Console** is a panel along the top right of the ExtendScript Toolkit window. The following code uses both ways of passing information back during the running of a script.

```
// show an alert dialog to the user
alert("Snakes. Why'd it have to be snakes?");

// show a message on the JavaScript console
$.writeln("Asps. Very dangerous. You go first.");
```

Rewrite **layerProperties.jsx** using the $.writeln() method of displaying messages rather than the alert() function.

CUSTOMIZING

Photoshop-Created Scripts

Beyond the Photoshop DOM with the ScriptingListener Plug-in

Coding Concepts: Functions and Arguments

Functions were introduced in the preceding chapter as the verbs in your scripting Mad Libs. Like verbs, functions do things. They imply action and functionality. Your scripts have included a few functions. As your scripts started using the Photoshop Document Object Model (DOM), they included methods, which is what functions defined on objects are called. Functions are very useful, and the best thing about them is that you can build your own.

Understanding Function Details

As previously described, three pieces are necessary to use a function: the function name, parameters, and result. When you're calling a function, these pieces can be generalized to this type of code:

```
result = functionName(parameters);
```

Now look at these pieces in more detail:

- `functionName` must be unique. Creating a function named `alert()`, for example, might confuse the computer and cause unexpected results. You can use both the **Object Model Viewer** and the Data Browser in the ExtendScript Toolkit to verify that a function name is unique.

- `parameters` are not required for every function. The method `bringToFront()` does not take any parameters. You have already used the function `alert()` with one parameter: a string displayed in a dialog. Functions can have any number of parameters. When calling a function, you place each parameter in the parentheses that follow the `functionName`. Separate the parameters with commas. The order of the parameters is very important.

- `result` is not required for every function. Some functions do not return data to the script that called the function. `alert()` does not return a value, and neither does `bringToFront()`. Or, to be precise, the code you've written so far did not use the return value. Other functions return result values, which can be assigned to a variable, used as part of a mathematical operation, used in decision-making code, or used as parameters to other functions. Or, the return value can be ignored and its data discarded by the script.

> Always pass the parameters in the correct order; otherwise, your results may be unexpected.

Passing Arguments to a Function

One way to understand arguments and how they work is to look at some examples. One that is straightforward is Gaussian blur. In Photoshop, if you choose **Filters > Blur > Gaussian Blur...** from the menus, the **Gaussian Blur** dialog appears (see Figure 9.1).

The Gaussian Blur filter is simple. It has only one control: the radius used for the blur. A function for this filter might be called `blurGaussian()` and have one parameter called `radius` that is in pixels. It happens that there is a function for this filter. When you use the **Object Model Viewer** in the ExtendScript Toolkit (which you open by choosing **Help > Object Model Viewer** from the menus), the `ArtLayer` defined in the Photoshop DOM has a method named `applyGaussianBlur(radius)` (see Figure 9.2).

Notice that everything you need to use the method is shown in the description. It is a method of the `ArtLayer` class. The `functionName` is `applyGaussianBlur()`. There is one parameter named `radius`, which is a number that is the pixel width of the blur with a valid number range of 1.0 to 250.0.

The exact details of how the Gaussian blur is calculated and applied to the layer are hidden, much like they are hidden when you use the filter in Photoshop. Those details are not important. What is important is that you

FIGURE 9.1 The Gaussian Blur filter in Photoshop.

FIGURE 9.2 The `applyGaussianBlur()` function definition in the Object Model Viewer.

can apply a Gaussian blur using a script by passing a single parameter. The following example does the same thing the filter does in the Photoshop example shown previously:

```
app.activeDocument.activeLayer.applyGaussianBlur(5.3);
```

A more complex example of parameters is the familiar `alert()` function. If you search for "alert" using the **Object Model Viewer**, you find the definition shown in Figure 9.3.

Notice the three parameters listed in the function definition: `message`, `title`, and `errorIcon`. Look at the definition for each parameter in the **Object Model Viewer**. Two of the parameters are optional. Neither `title` nor `errorIcon` has to be included when the function is called

in a script. In fact, according to the definition, these parameters are ignored on the Macintosh.

In the scripts so far, calls to `alert()` passed a single string parameter to the function to display as the message of the dialog. If you want to display more information on Windows, you could add parameters to your `alert()` calls like this:

```
alert("Hello, World!", "My Custom Title", true);
```

Notice that the parameters in this line are separated by commas and that the last parameter is a Boolean data type. Passing in `true` for the `errorIcon` parameter tells Photoshop to display a special icon in the dialog to indicate an error has occurred (see Figure 9.4).

FIGURE 9.3 Definition of the `alert()` function in the Object Model Viewer.

FIGURE 9.4 Alert dialogs with and without optional parameters in use on Windows.

If you do not want to display the error icon, you could use either of these calls:

```
alert("Hello, World!", "My Custom Title", false);
alert("Hello, World!", "My Custom Title");
```

The third parameter is a Boolean, so passing the value `false` is valid. However, as indicated by the second example here, the parameter is not needed if the value is `false`. Look again at the function definition in Figure 9.3. For the parameter `errorIcon`, the definition states that the default value is `false`. The two lines of code have the same result and are both valid code. Yet, it is the second one that you would use because it is simpler.

Also, note that the parameters are always in the correct order. If a Boolean value of `false` were passed as the second parameter on Windows, an error would occur. On Macintosh, the second and third parameters are ignored for `alert()`.

Defining and Implementing Your Own Functions

That FUNCTIONS section is in your **template.jsx** file for a reason. You can and will define your own functions in your scripts. It is a simple yet powerful part of coding. To define your own function, follow these rules:

- Use the keyword `function` in your script to declare that you are *defining* a function instead of *calling* one.
- Use a unique `functionName`.
- Inside matched parentheses, list any parameters separated by commas. Each parameter must have a unique name. It is helpful to give parameters meaningful names.
- Inside matched curly braces { } , write the code for the function itself.
- Use the `return` keyword followed by a value to return a result value. You also can use `return` by itself to simply signal to return from the function back to the calling code, but a `return` call is not required.

Create a new script file from the template, save it as **distanceFunction.jsx**, and add the following code:

```
/////////////////////////
// MAIN
/////////////////////////
// Get the distance between the points (5, 9) and (12, 15)
var dist=distance(5, 12, 9, 15);
alert(dist);
/////////////////////////
// FUNCTIONS
/////////////////////////
// Compute the distance between two points
function distance(x1, y1, x2, y2)
{
    var dx=x2 - x1;
    var dy=y2 - y1;
    return Math.sqrt(dx*dx+dy*dy);
}
```

This is a simple formula from geometry. It uses the `sqrt()` method of the `Math` class to calculate the square root. The return value is 5.

Notice that the function code defined in the FUNCTIONS section is located after the code that calls the function in the MAIN section. Scripts are run from the top to the bottom of the file. So how does this work?

Scripts are read multiple times. One of those times, everything is set up and defined for the computer in its own language; then the file is read again and run in the order of the file. In this case, the `distance()` function is defined in the first read of the file, so that when the code is run in the second read, the `distance()` function has been defined and the computer is aware of it.

There is more to this operation, but this explanation provides the essence of what is happening. What is important is that you know that functions can be defined at the bottom of the script file, even though the code executes from the top of the file down.

ScriptingListener Plug-in

Playing an Action from a Script

There is a lot of power defined in the Photoshop DOM. However, there are many commands missing from the DOM. One way around this limitation is to create an action and call it from a script.

For example, to call the action you built in Chapter 4, create a new script file from your template file, save it as **doAction.jsx**, and add this code to the MAIN section:

```
// run the action "Resize for Web w/ Organic Border"
// from the action set "Book Actions"
doAction("Resize for Web w/ Organic Border", "Book
Actions");
```

There is a problem with this approach. If you share your script, the other machine needs not only the script, but also the action it calls. Unfortunately, it is not possible to embed the action into the script itself.

There is, however, a way to record steps for scripting, similar to creating an action. Adobe provides a special plug-in, ScriptingListener, that is available when you install Photoshop, but it is inactive. It outputs JavaScript as you work with Photoshop. The resulting code can be dissected and incorporated into your own scripts.

Installing the ScriptingListener Plug-in

The ScriptingListener plug-in is installed on your computer when you install Photoshop. However, Photoshop cannot use the plug-in until you move it to the correct place.

1. Quit Photoshop if it is currently running.
2. Copy the **ScriptingListener.plugin** file from the **/Applications/Photoshop CS5/Scripting/Utilities** folder to the **/Applications/Photoshop CS5/Plug-Ins** folder (see Figure 9.5).
3. Relaunch Photoshop.

Copying the plug-in file is better than simply moving the file. The plug-in slows down Photoshop, so it is not a feature you always want or even need while using Photoshop everyday. To disable the plug-in, simply move the file from the **Plug-Ins** folder to the **Trash**. By copying the file initially, you are sure to always have a copy of the plug-in to install when creating scripts.

Understanding the Log File

Like actions, the ScriptingListener plug-in records. However, it can only record tasks that can be recorded as part of an action. The recording produces JavaScript code to re-create the tasks you performed in Photoshop. These operations are written to a log file instead of an action. That log file is **ScriptingListenerJS.log** on your **Desktop**. To determine whether a task is recordable, you need to view the log file while you use Photoshop.

On the Macintosh, double-click the log file to open it in the Console application. As you work in Photoshop, the Console window for the log file updates, adding the new code. Click the **Clear Display** button in the Tool Bar to clear the log file.

On Windows, open the log file in any text editor or the ExtendScript Toolkit to see the code recorded by the plug-in.

FIGURE 9.5 Copying the **ScriptingListener.plugin** file for use in Photoshop.

You will notice that the recorded JavaScript is not easy to read. It is not like the code you have been writing in your scripts. Instead, it is closer to machine language than to JavaScript.

Follow these steps to view the file:

1. In Photoshop, open a file or create a new document.

2. Clear the **ScriptingListenerJS.log** file so that it is empty.

3. In Photoshop, choose **View** > **New Guide...** from the menus.

4. In the **New Guide** dialog, set the **orientation** to **Vertical** and the **Position** to **50 px**. Then click the **OK** button.

 This is the code recorded in the log file:

```
// =====================================
   var idMk=charIDToTypeID( "Mk  " );
      var desc52=new ActionDescriptor();
      var idNw=charIDToTypeID( "Nw  " );
         var desc53=new ActionDescriptor();
         var idPstn=charIDToTypeID( "Pstn" );
         var idPxl=charIDToTypeID( "#Pxl" );
         desc53.putUnitDouble( idPstn, idPxl,
50.000000 );
         var idOrnt=charIDToTypeID( "Ornt" );
         var idOrnt=charIDToTypeID( "Ornt" );
         var idVrtc=charIDToTypeID( "Vrtc" );
         desc53.putEnumerated( idOrnt, idOrnt, idVrtc );
      var idGd=charIDToTypeID( "Gd  " );
      desc52.putObject( idNw, idGd, desc53 );
executeAction( idMk, desc52, DialogModes.NO );
```

5. In Photoshop, choose **View** > **New Guide...** from the menus.

6. In the **New Guide** dialog, set the **orientation** to **Horizontal** and the **Position** to **100 px**. Then click the **OK** button.

 The code recorded this time is as follows:

```
// =====================================
   var idMk=charIDToTypeID( "Mk  " );
```

```
   var desc54=new ActionDescriptor();
   var idNw=charIDToTypeID( "Nw  " );
      var desc55=new ActionDescriptor();
      var idPstn=charIDToTypeID( "Pstn" );
      var idPxl=charIDToTypeID( "#Pxl" );
      desc55.putUnitDouble( idPstn, idPxl,
100.000000 );
      var idOrnt=charIDToTypeID( "Ornt" );
      var idOrnt=charIDToTypeID( "Ornt" );
      var idHrzn=charIDToTypeID( "Hrzn" );
      desc55.putEnumerated( idOrnt, idOrnt, idHrzn );
   var idGd=charIDToTypeID( "Gd  " );
   desc54.putObject( idNw, idGd, desc55 );
executeAction( idMk, desc54, DialogModes.NO );
```

In each case, the recorded code is verbose. There is a lot of code for what seems like a simple task. Look closely at the two recordings. Look line by line. The code is similar in each case. There are a few differences worth pointing out, however.

The first recording has these two lines:

```
      desc53.putUnitDouble( idPstn, idPxl, 50.000000 );
      var idVrtc=charIDToTypeID( "Vrtc" );
```

The second recording has these two lines:

```
      desc55.putUnitDouble( idPstn, idPxl, 100.000000 );
      var idHrzn=charIDToTypeID( "Hrzn" );
```

Notice that the two numbers are 50 and 100 (with a bunch of zeros after the decimal point). Notice the parameters "Vrtc" and "Hrzn". These are the values you entered into the **New Guide** dialog to create the guide. "Vrtc" must mean vertical, and "Hrzn" must mean horizontal. If you copy these two recordings into a script and run the script, Photoshop adds two new guides to the active document: one vertical at 50 pixels and the other horizontal at 100 pixels.

Creating a Reusable Function from ScriptingListener Code

You are able to record a set of steps—just as you would for an action—as JavaScript, saving a script for that "action." This is a way to embed an action into a script and be able to share it with others. Doing so would be a little boring and overkill. If all you want to do is run an action, then create one. With a script, what you want to do is give yourself options.

What if you want to create a guide anywhere, just like the dialog does in Photoshop? That's a good idea for a function. Creating a guide requires only two options in the dialog: the orientation and position.

Create a new script file from the template, save the file as **makeGuide.jsx**, and add this code to the FUNCTIONS section (feel free to copy from the recording and change as needed):

```
// recorded code to create a new guide
function makeGuide(orientation, pixelPosition)
{
    var idMk=charIDToTypeID( "Mk  " );
    var desc54=new ActionDescriptor();
    var idNw=charIDToTypeID( "Nw  " );
    var desc55=new ActionDescriptor();
    var idPstn=charIDToTypeID( "Pstn" );
    var idPxl=charIDToTypeID( "#Pxl" );
    // use the pixelPosition parameter
    desc55.putUnitDouble(idPstn, idPxl, pixelPosition);
    var idOrnt=charIDToTypeID( "Ornt" );
    var idOrnt=charIDToTypeID( "Ornt" );
    // use the orientation parameter
    var idHrzn=charIDToTypeID( orientation );
    desc55.putEnumerated( idOrnt, idOrnt, idHrzn );
    var idGd=charIDToTypeID( "Gd  " );
    desc54.putObject( idNw, idGd, desc55 );
    executeAction( idMk, desc54, DialogModes.NO );
}
```

In the MAIN section of the script, add this code:

```
// create a new guide
makeGuide("Vrtc", 72);
// create another guide
makeGuide("Hrzn", 72);
```

Save and run the script. Two new guides are added to the active document in Photoshop. Note that it is important to use only the values "Vrtc" and "Hrzn" for the orientation parameter. If you use anything else, unexpected results may occur, or nothing may happen at all.

It is important to notice what is happening with this script. You define a function and then call it twice. If you want to add more guides, you would add more calls to the makeGuide() function. The function saves you from typing the same code over and over again. In this case, the code would have to be copied twice. No real big savings. But if 10 new guides were needed, that would be a big savings in typing. But that's not the real savings. What if you need to fix a mistake in the code or add something to it? Instead of having to update everywhere you create a new guide, you just change the function, changing that code just once. Functions save you time troubleshooting and modifying code.

By creating a function from the ScriptingListener code, you hide away the complexity of the generated code. This makes your script more readable. It also helps you to remember what it is you were really trying to do when creating the script. Although it may not seem like much now with these simple scripts, as your scripts become more complex, being able to read the code is important.

Best Practices for Using the ScriptingListener

- Record a task multiple times using different settings to figure out which pieces of the recorded JavaScript are the parameters.
- Clear the log file before doing any task in Photoshop. The more tasks recorded, the harder it is to discover the code you need for just that step.

- Take care to minimize the changes you make to recorded code. Do not change the order of the code. Simply add parameters and use the parameters in the correct spot. By changing too many things, you run the risk of breaking the recorded code. Along the same lines, take care when reformatting the code for your script.

- After you have created your script, move the **ScriptingListener.plugin** file from the **Plug-Ins** folder to the **Trash**. As stated before, Photoshop runs faster without the plug-in, and you don't need the log file unless you are writing scripts.

- When possible, do not use the ScriptingListener at all. Try to find a function for what you want to do in the Photoshop DOM. Many tasks are available. Your becoming familiar with the DOM is worth the effort. Code written using the DOM is more readable than the code from the ScriptingListener.

> After recording a task, copy the code to a script and make a function out of it. Build your scripts one task at a time.

Coding Concepts: Conditionals and Decision Making

A big advantage to scripting a solution to a problem rather than creating an action is that scripts can have intelligence built in. Scripts can make decisions depending on the data available. Scripts can be written to decide whether something is true and then do something, or else do something different. Scripts make comparisons. They can check if a value equals another value or is greater than another value. There is even logic available to make complex decisions, such as if this or that but not the rest, then do something. Comparison, logic, and control are key parts of scripting. They are not supported by actions.

Comparison Operators

Comparison operators are similar to the computational operators introduced in the preceding chapter. Those operators were basic math symbols like add (+), subtract (−), multiply (*), and divide (/). Computational operators take two values and return a mathematical result. Comparison operators, shown here, compare two values and return a value of `true` or `false`:

== (equality) compares whether two values are equivalent

!= (not equal) compares whether two values are not equivalent

> (greater than) compares whether one value is greater than another

>= (greater than or equal to) compares whether one value is greater than or equal to another

< (less than) compares whether one value is less than another

<= (less than or equal to) compares whether one value is less than or equal to another

It is important to note that the equality symbol with comparisons is == and not the equal operator =. The single = is actually an assignment operator. Assignment is a statement such that a variable `theAnswer` is assigned a value 42. Equality is a question testing whether `theAnswer` has the value 42. The `alert()` in the following code shows a value of `true`:

```
// create a variable and assign it a value
var theAnswer = 42;
// check if the value of theAnswer is 42
alert(theAnswer == 42);
```

You are probably accustomed to such operators as tools of mathematics. However, they can also be used with strings. For instance, you can check whether or not two string variables have the same value. You can even use the other comparison operators such as greater than (>) to check the alphabetical order of two strings. Such comparisons are based on the ASCII values for the individual characters, which defines `'a'` to be smaller than `'b'`. Here are some examples:

```
// define some strings to compare
var name1 = "adams";
var name2 = "carroll";
var name3 = "carroll";
// compare the strings
alert(name1 < name2);
alert(name2 == name3);
alert(name2 >= name3);
```

In each of these cases, the value shown in the `alert()` is true.

Control Statements (`if`, `if else`, `switch`)

Conditional operators are used most often as part of control statements. Control statements ask questions and then respond according to the answer. Here's a simple example using the control keyword `if`:

```
// a simple question with a simple response
var theAnswer = 42;
if (theAnswer == 42)
    alert("The ultimate answer to life, the universe, and everything!");
```

In this simple example, the variable `theAnswer` is compared to the value of `42`. If the comparison is `true`, then `alert()` displays a message. Notice the simple syntax or grammar of the comparison code. There is an `if` followed by a comparison in parentheses, which is followed by a single line of code. This is the most basic syntax of a control statement. However, it is much more common to have more than one line of code respond to a control statement. The code changes slightly in that case:

```
// a simple question with a more complex response
var theAnswer = 42;
if (theAnswer == 42)
{
    alert("The ultimate answer to life, the universe, and everything!");
    alert("But what is the question?");
}
```

Notice that the two lines of code after the comparison are surrounded by curly braces `{ }`. The braces set off a new block of code. They tell the computer that all the code in the braces is to be executed only if the comparison is `true`. If the comparison results in `false`, none of these lines of code are executed by the computer. The curly braces can also be used for the single line of code after the `if` in the simple example, but they are not required.

Change the code just a little and the `alert()` messages do not display:

```
// a simple question with a more complex response
var theAnswer = 11;
if (theAnswer == 42)
{
    alert("The ultimate answer to life, the universe, and everything!");
    alert("But what is the question?");
}
```

This code illustrates the need for the next control statement: `else`. It is not enough to respond only to `true` values. It is necessary also to respond to `false` values. If something is true, then do this; else do that, as in this example:

```
// a simple question with two possible responses
var theAnswer = 11;
if (theAnswer == 42)
{
    alert("The ultimate answer to life, the universe, and everything!");
    alert("But what is the question?");
}
else
{
    alert("Still computing the ultimate answer.");
}
```

This syntax is simple and obvious. But note that an `else` requires that there was an `if` previously. Also notice the curly braces `{ }` being used around a single line of code.

What if you need to do more complex conditional code with a response to more than two answers? It is possible to create complex code quickly in such a situation, but one way to simplify the code is to use `else if` like this:

```
// a simple question with three possible responses
var theAnswer = 11;
if (theAnswer == 42)
{
    alert("The ultimate answer to life, the universe, and everything!");
    alert("But what is the question?");
}
else if (theAnswer < 42)
{
    alert("Have not arrived at the ultimate answer yet. Keep going.");
}
else // theAnswer > 42
{
    alert("Passed by the ultimate answer already. Go back.");
}
```

The comment after the `else` statement here is for your own readability. The computer does not read comments. In this case, the comment explicitly states the case that causes the code in the curly braces to execute.

There is no real limit to how many `else if` conditions you can add to code like this. There are some practical ones you should keep in mind, however. In the preceding code example, the last conditional could have been `else if (theAnswer > 42)`, but that was unnecessary. The previous code had already narrowed the possible answers, so there was no need to do another comparison. The value of `theAnswer` could only be greater than 42 by that point. You would not add a conditional `else if (theAnswer < 11)` either, because the first `else if` took care of that case. Working with conditional

statements like this takes some practice, but with a little thought, it can be simple.

What if there are a lot of potential answers that need responses? You could write an `else if` conditional for each response, but there is another conditional statement that might prove more useful. The `switch` statement is made for comparing the same variable to multiple values and responding to each, as shown in this example:

```
// a simple question with many possible responses
var theAnswer = 42;
switch (theAnswer)
{
    case 39:
        alert("Getting warm.");
        break;
    case 40:
        alert("Warmer!");
        break;
    case 41:
        alert("Red hot!");
        break;
    case 42:
        alert("The ultimate answer!");
        break;
    case 43:
        alert("Passed it by!");
        break;
    default:
        alert("Still computing.");
}
```

The syntax for the `switch` statement is trickier than the others. Notice where the curly braces are placed. Notice that there is the word `case` followed by a potential answer, then a colon (`:`) character, then some code, and then a `break` command. That `break` command completes a response for that `case`. Without the `break`, the computer executes all code until it finds a `break` command or finishes the `switch` statement.

In complex cases, this may be what you want, but more likely you just want the code to execute a single response.

Many responses are represented by many cases. Each `case` is compared to the value in the parentheses following the `switch` statement. Notice that there is also a `default` response. This is like having an `else` at the end of a lot of `else if` statements.

The `switch` statement is the most complex of the conditional statements. The `if`, `else if`, and `else` statements are easier because you use them everyday in your own communications with other people.

Notice that the syntax for the code is getting more complex. The reason is that the scripting ideas being used are more complex. The syntax is complex so that the computer knows exactly what you intend with the code. This means you need to take care when starting to use conditional statements.

Conditional statements make decisions. Based on the question being asked, code is executed or not. The number of responses is based on the questions being asked. You can even ask questions inside the responses. Just be sure to remember the syntax and pair up the curly braces to avoid confusion.

Logical Operators

Logical operators are the conjunctions of the scripting world. These symbols combine multiple comparisons together using

`&&` (and) returns `true` if both parts are true; otherwise returns `false`

`||` (or) returns `true` if either part is true; otherwise returns `false`

Comparisons return Boolean values (`true` or `false`). Logical operators do the same thing, which makes them ideal for use with conditional statements.

There is also one logical operator that is not a conjunction but does return a `true` or `false` value:

`!` (not) returns `true` if the value is `false` and returns `false` if the value is `true`

With the logical operators, scripts can make sophisticated decisions, as shown here:

```
// if the document's bit depth is 16 bit or 32 bit
if ((app.activeDocument.bitsPerChannel ==
BitsPerChannelType.SIXTEEN)
    || (app.activeDocument.bitsPerChannel ==
BitsPerChannelType.THIRTYTWO))
{
    // convert the document to 8 bit
    app.activeDocument.bitsPerChannel =
BitsPerChannelType.EIGHT;
}
```

Notice the use of the `||` operator in the `if` statement. Two comparisons are being checked. If either of the comparisons returns `true`, then the `activeDocument` is converted to 8 bits per channel (see also Figure 9.6). Actually, that is not entirely correct; because the operator is the `||` (or), the computer tests one comparison. If that value is `true`, then the response is executed. If the first comparison returns `false`, then the second comparison is checked. If the second comparison returns `true`, then the response is executed.

Notice all the parentheses and how they pair up. The parentheses are nested to make the two comparisons a single comparison for the `if` statement. Using parentheses is a good idea so that you can keep the code clear for you to read and troubleshoot.

You can easily start making more complex conditionals like these:

```
// If the document's color mode is BITMAP
if (app.activeDocument.mode == DocumentMode.BITMAP)
{
    // you can't go directly to RGB from bitmap, so
    // convert it to GRAYSCALE
    app.activeDocument.changeMode (ChangeMode.
GRAYSCALE);
```

FIGURE 9.6 The definition of `BitsPerChannelType`.

```
    // then to RGB
    app.activeDocument.changeMode(ChangeMode.RGB);
}
else if ((app.activeDocument.mode == DocumentMode.CMYK)
    || (app.activeDocument.mode == DocumentMode.
GRAYSCALE)
    || (app.activeDocument.mode == DocumentMode.
INDEXEDCOLOR)
    || (app.activeDocument.mode == DocumentMode.LAB))
{
    // or else if the document's color mode is CMYK,
GRAYSCALE,
    // INDEXEDCOLOR or LAB, convert it to RGB
    app.activeDocument.changeMode(ChangeMode.RGB);
}
```

In the preceding code, the activeDocument is converted to the RGB color mode unless it is already an RGB document. Notice there is not an else statement, just if and else if statements. The bitmap mode is special when converting to RGB, so it gets its own response.

Using the confirm() Function

The decision making so far in the script examples has all been done by the computer based on the data. What if you need the person running the script to provide some decision making? There is a function, similar to the **Insert Stop...** command for actions, that displays a message to the user and asks a yes or no question.

The confirm() function is similar to the alert() function. Both display a message, but the confirm() dialog displays **Yes** and **No**

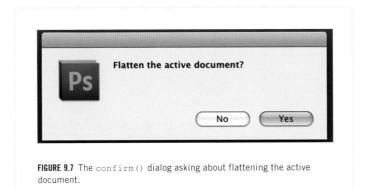

FIGURE 9.7 The confirm() dialog asking about flattening the active document.

buttons (see Figure 9.7). The confirm() function returns a Boolean value (true or false), which can be used in the script's decision making. Here's an example:

```
// ask the user about flattening the document
var flatten=confirm("Flatten the active document? ");
if (flatten)
    app.activeDocument.flatten();
```

The code does not test explicitly against true or false. Instead, it just tests the value of the flatten variable. Because confirm() returns only true or false, the if statement can simply check the value.

The confirm() function involves simple user interaction because all it can do is ask yes/no questions. Sometimes, though, that is all the interaction a script needs to make a decision. Scripts are capable of much richer interactions. They are detailed further in the chapters to come.

EXPLORATIONS

Photoshop has many filters available for use on your images. The functionality for a few of these appears in the Photoshop DOM. However, there are some that are not so easy but might be fun to have for your automated processes. The filters available when you choose **Filter** > **Filter Gallery...** from the menus appear in the **Filter Gallery** dialog. This is a collection of many of the artistic filters. These filters typically have multiple parameters to adjust based on the image and what your intentions are for applying the filter.

The `alert()` and `confirm()` functions provide some limited interaction with the user of your scripts. Another function allowing input from the user is the `prompt()` function. It is in the **Core JavaScript Classes**. It prompts the user to enter a value into a simple dialog. That value is returned to the code for the script to use in its process.

Look up the `prompt()` function in the **Object Model Viewer** to learn its syntax. Then use the ScriptingListener plug-in to record while you apply a filter available in the **Filter Gallery**, such as the **Cross Hatch** filter. Write a script that uses the `prompt()` function to ask the user to enter one of the parameter values needed for use with a **Filter Gallery** filter. Use default values for the other parameters as necessary.

Ten

CONTROLLING

Documents

Learning to Work with Documents and Filenames

The most common object you are likely to work with using the Photoshop DOM is a document. Writing a script to work on a single document might be useful. Writing a script to work on many documents is more powerful. Recall that the Photoshop automation technique for this procedure is batch processing.

A batch process usually opens each file in a folder, runs an action on it, saves the file with a new name and file format, and then closes the file. The preceding chapter described how to run an action from a script. That chapter also showed how to create a function with the ScriptingListener plug-in and go further with the tasks.

This chapter expands your skills to include working with documents and repeating tasks safely. By the end of the chapter, you won't be able to write a script that can completely replace the **Batch** dialog, but you will be well on your way to doing so.

Coding Concepts: Working with Strings and Arrays

An aspect of files is dealing with filenames. Dealing with filenames means understanding *strings*. Filenames are strings—a sequence of characters—that can be manipulated by scripting code. Sometimes renaming files is easy to do using the coding concepts you've already learned, such as concatenating a number at the end of a string. More complex situations are common, though, such as removing a word from the middle of a filename. The scripts you build also need to be able to control filenames outside the batch process. JavaScript has many useful methods for changing strings.

Trimming Strings with `slice()`

Digital cameras name files in peculiar ways that may not always be useful. A file named **IMG_0918.CR2** is an example of a Raw file from a Canon camera. Because the filename is a string, it can be assigned to a variable to show how to manipulate strings in a script.

Create a new script file from the template, save it as **charactersAndStrings.jsx,** and add the following code:

```
//////////////////////////
// SETUP
//////////////////////////

// sample filename string to learn with
var myFileName = "IMG_0918.CR2";
```

A script that processes files might save the changes as a new JPEG file. The first change you need to make is to trim the file extension off the end because the new file uses **.jpg**. The variable `myFileName` is a string because its data is a sequence of characters. In JavaScript, a string is an object with properties and methods. You can find the details of the `String` class using the **Object Model Viewer** in the ExtendScript Toolkit (see Figure 10.1). It is listed in the **Core JavaScript Classes** category.

Removing the last few characters of a string is easy to accomplish using the `slice()` method of the `String` class. The definition of `slice()` shown in the **Object Model Viewer** indicates there are two parameters to pass to the method when it is called: `startSlice` and `endSlice`. These parameters are numbers denoting indices where the function trims the string. Imagine the string `"IMG_0918.CR2"` is a loaf of bread and each character is a slice of the loaf. To remove the last four slices of bread, you count from the right side of the loaf (ignoring the quotation mark characters because they are not the data of the string, just a way to show the data). For `slice()`, a negative number for an index means to count from the end of the string. To create a new string without the last four characters of the original string, pass a value of −4 for the `endSlice` parameter.

The new filename starts with the same characters as the original filename. To do this, pass a value of 0 for the `startSlice` parameter. The first character in the sequence of a string always has an index of 0. This idea is explained in more depth in the section on arrays.

Add the following code to your **charactersAndStrings.jsx** file to trim the file extension from the filename in your script:

FIGURE 10.1 The `String` class shown in the Object Model Viewer.

```
/////////////////////////
// MAIN
/////////////////////////

// Slice off the last four characters
alert(myFileName.slice(0, -4));
```

Calling `slice(0, -4)` specifically trims off the last four characters of `myFileName`. In this coding example, using a call of `slice(0, 8)` results in the same string of `"IMG_0918"`. However, a call to `slice(0, 8)` really trims off every character after the eighth character in the string. That is different from slicing off the last four characters of the string. If the

string were a longer filename, `slice(0, 8)` would return a different string than `slice(0, -4)`. The same is true if the filename is shorter.

> It is important when writing code to know exactly what you want the call to accomplish. The difference between trimming the last four characters and returning the first eight characters is subtle but can create problems that are hard to troubleshoot.

The filename prefix `"IMG_"` is not very useful. You might want to slice off those first four characters, so you can create a more useful filename. To slice those four characters off the beginning of the string, call `slice()` with a value of 4 for the `startSlice` parameter.

Add this code to **charactersAndStrings.jsx** to see the results:

```
// Slice off the first four characters
// and the last four characters·
alert(myFileName.slice(4, -4));
```

The slicing of the filename so far results in a string of `"0918"`, which is not very descriptive. It's time to take that important part of the filename and add a useful prefix and the correct file extension for the new file. Remember that the plus (+) operator, when used with strings, concatenates the strings together. That's what is needed here.

Add this code to **charactersAndStrings.jsx** to see a completed filename:

```
// Slice off the last four characters
// and the first four characters
// and add "CraigsBirds_" to front of the string
// and add the file extension for JPEG files
alert("CraigsBirds_"+myFileName.slice(4, -4)+".jpg");
```

To explore using `slice()` on a real filename, open a file in Photoshop and use `app.activeDocument.name` in your script. Using the **Object Model Viewer**, you can find the definition of this property:

1. In the **Object Model Viewer**, change the pop-up menu in the **Browser** section from **Core JavaScript Classes** to **Photoshop CS5 Object Library**.
2. In the **Classes** list, find and click on **Application**. Notice in the resulting definition shown that "you can use the pre-defined global variable *app*" to access the properties and methods of the Photoshop application.
3. In the **Properties and Methods** list, find and click on **activeDocument: Document** to see the definition of this property—the frontmost document.
4. In the **Classes** list, find and click on **Document** to see the properties and methods of this class.
5. In the **Properties and Methods** list, find and click on **name: string** to see the definition of this property (see Figure 10.2).

The **Object Model Viewer** is your friend. It is a valuable resource for finding out the names of useful objects such as the `activeDocument`, discovering the data type of various properties, and identifying the parameters required by the methods. It is also a useful place to find which functions have been defined for important objects such as `Document`.

Extracting Strings with `substr()` and `indexOf()`

Another way to create a new string from an existing string is to use the `substr()` method. This method creates a substring from a starting index and counts the next characters to extract. The method takes two parameters: `start` and `length`.

Add the following code to the **charactersAndStrings.jsx** script:

```
// Use substr to return the four middle characters
alert(myFileName.substr(4, 4));

// Use  substr to return just the fourth character
alert(myFileName.substr(3, 1));
```

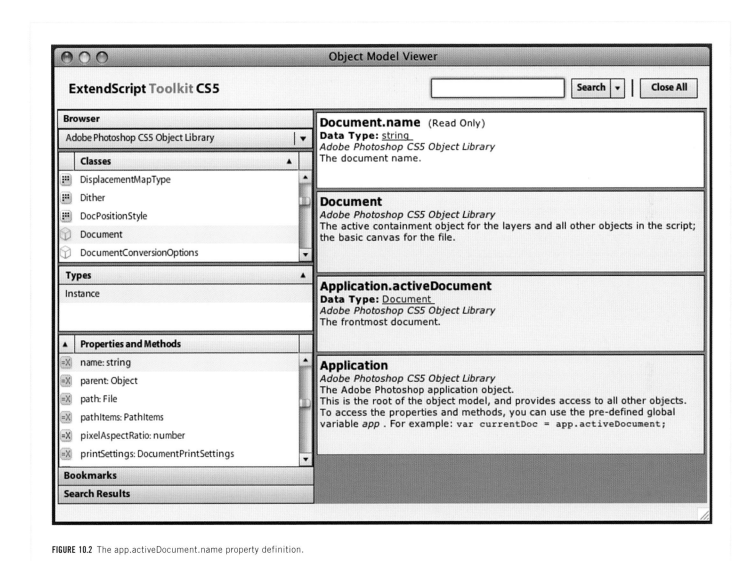

FIGURE 10.2 The app.activeDocument.name property definition.

The four middle characters of `myFileName` form the string `"0918"`. The fourth character of `myFileName` is `'_'`. Notice the `start` index for each of the two calls to `substr()`. In the first call, `start` has a value of 4. The middle four characters of `myFileName` start with the fifth character of the string. String indices begin at 0. So the index for the fifth character is one less than you might normally count, so $5 - 1 = 4$.

This is why the next call to `substr()` has a `start` value of 3 to get the fourth character in the string.

Although `substr()` is similar to `slice()`, it is the parameters that show the real difference. With `slice()`, you have to know or calculate the position of the start and end of the string you wish to create from

the original string. With `substr()`, you have to know or calculate where the string you want starts and how many characters it has. There are methods that search inside a string to find the index of substrings or characters. For example, you can use a method such as `indexOf()` to search for the first instance of an underscore `'_'` character and then pass the returned index to `substr()` to get the sequence of the file, which can then be used to create a more meaningful name.

Now add the following code to the **charactersAndStrings.jsx** script:

```
// find the first underscore
alert(myFileName.indexOf("_"));

// use the first underscore index to build a file name
var myIndex = myFileName.indexOf("_");
alert("CraigsBirds_" + myFileName.substr(myIndex +
1, 4) + ".jpg");
```

The `indexOf()` method returns 3 for the index of the underscore, to which the code adds 1 to get the index of the first number of the sequence number of the file. The call to `substr()` returns the string `"0918"`. This code builds the same filename string as the previous code did. The difference is that the original filename string can have any number of characters in the prefix before the underscore, not just `"IMG_"`.

Add the following code to the **charactersAndStrings.jsx** script:

```
// build the new file name
var myIndex = myFileName.indexOf("_");
var mySeqNum = myFileName.substr(myIndex + 1, 4);
var newFileName = "CraigsBirds_" + mySeqNum + ".jpg";

// find the first underscore in the new name
alert(newFileName.indexOf("_"));
```

The index of the underscore character in the new filename is 11. That index could be used to build other filename strings. For example, you might have a script that takes an image and reformats it for a thumbnail on the web, for a banner add, and for a preview. Each

file might be saved with a different prefix string each time: `"thumb_"` and `"banner_"` and `"preview_"`. Using the techniques detailed in your **charactersAndStrings.jsx** script, you can both build each of those filenames and repurpose those filenames for other new files.

Working with Arrays

A string is a sequence of characters. It is an ordered sequence of characters—one character follows another in a specific order. Those characters have an index specifying where in the order the character is located. If you generalize this definition of a string, you have an array.

An array is an ordered sequence of data assigned to a variable. For a string, the data is characters. For an array, the data can be any valid data type or object. For example, the Photoshop DOM keeps arrays of the current documents opened, the layers in a document, the paths, the channels, and other pieces of documents and other objects in the DOM. Or an array might simply be a collection of numbers.

A practical difference between an array and a string is how it is created. Strings are created whenever you assign a variable data that happens to be a string. There is no magic to creating a string. With an array, you must be explicit when you create the variable. This involves the use of the bracket characters [and].

Create a new script file now from the template, save it as **arraysAndStrings.jsx,** and add the following code:

```
/////////////////////////
// SETUP
/////////////////////////

// Create a string
var myName = "Jeff";

// Create an array
var myFamily = new Array(4);
myFamily[0] = "Jeff";
myFamily[1] = "Rachel";
```

```
myFamily[2] = "Sophia";
myFamily[3] = "Stella";

// Another way to format when creating an array
var myFamily2 =["Jeff", "Rachel", "Sophia", "Stella"] ;

/////////////////////////
// MAIN
/////////////////////////

// alert each of the items in the first array
alert(myFamily[0] );
alert(myFamily[1] );
alert(myFamily[2] );
alert(myFamily[3] );

// alert each of the items in the second array
alert(myFamily2[0] );
alert(myFamily2[1] );
alert(myFamily2[2] );
alert(myFamily2[3] );
```

The first array in this example is explicitly made by creating a new object of class type `Array`. As you might suspect, you can look up the `Array` class in the **Object Model Viewer**. The declaration for the first array states that the array has 4 items. Then one by one, each array index is assigned data. The first item in the array is index 0 and has the value "`Jeff`". The second item in the array is index 1 and has the value "`Rachel`". And so on.

The second array is explicitly created with all the same values, but the code is more succinct than the code for the first array.

Instead of creating the array and then index by index assigning values, the second array is simply created with an ordered set of values. That ordered set is a list of strings separated by commas and enclosed in brackets []. The index values are automatically filled in order from left to right.

Notice that the brackets [] are used to specify the index of the array data. The first item in the array is `myFamily[0]` . Those brackets are important. They indicate that the code is addressing the data in the array, not the array itself.

Now add the following code to the **charactersAndStrings.jsx** script:

```
// what is the data type of the variable myFamily
alert(typeof myFamily);

// what is the data type of the first item in myFamily
alert(typeof myFamily[0] );
```

The first `alert()` shows that `myFamily` is an object. The second `alert()` shows that `myFamily[0]` is a string. The variable `myFamily` is an `Array` object. The data in the first item of the `myFamily` array is string data.

Each array has a `length` property. The `length` is the number of items in the array.

Next, add the following code to the **charactersAndStrings.jsx** script:

```
// Get the number of items in the array
alert(myFamily.length);
```

When you're writing scripts for Photoshop, it can be useful to find out how many documents are open or how many layers are in a document. The `length` property allows you to do this.

As mentioned previously, arrays (and strings) start with index 0 (see Figure 10.3). This numbering scheme can seem kind of goofy, but you do get used to it.

The string `myFileName` starts at index 0 and has a `length` of 12. If you wanted to walk the characters you would start at 0 and then count to 12 going one character at a time. It might help if you think of the index as the start of the data instead of the end of the data for that item, kind of like a ruler. A line that is 1 inch

IMG_0918.jpg

```
0  1  2  3  4  5  6  7  8  9  10  11  12
```

FIGURE 10.3 An illustration of array indices.

long starts at 0 and goes until it crosses the 1 inch marker on the ruler.

Using `toString()` to View Arrays

As you demonstrated in your script, an array is of type `object`. That's not really useful if you want to look at all the items contained by an area. Fortunately, there is a quick way to do that using the `toString()` method of the `Array` class.

Add the following code to the **charactersAndStrings.jsx** script:

```
// Force the object array into a string using toString()
alert(myFamily.toString());
```

The string created may not be pretty, but it does show the items in the array. Other classes have the `toString()` method. In each case, the method returns a string that describes the object. You will encounter this method again as you work through the book's coding examples.

Working with Delimiters

The list of items in the array `myFamily` were turned into a string with each item separated by a comma (`,`) character, as you might expect. Commas are common for separating one value from another. In Chapter 6, you created a comma-separated value (CSV) file for the data. In your

experience with computers, you also may have run across tab-separated values, in which the data items are separated by a tab character. In all these cases, as in the following, a single character is used to separate the values in a list. A character used in this way is called a *delimiter*.

Jeff,Rachel,Sophia,Stella

Jeff Rachel Sophia Stella

Jeff_Rachel_Sophia_Stella

In each of these examples, a single delimiter (comma, tab, and underscore) is used to create the string displayed. The tab character can be hard for humans to spot, but to a computer it is as obvious as an underscore.

Using `join()` for Better Array Formatting

As shown, the delimiter for the `toString()` method of the `Array` class is a comma. If you want to use something else as a delimiter, you can use the `join()` method to format the array differently. Using `join()`, you are not even restricted to a single character, but can use a string instead.

Add the following code to the **charactersAndStrings.jsx** script:

```
// join() the array adding an underscore between items
alert(myFamily.join("_"));

// join() the array adding a \n line break between items
alert(myFamily.join("\n"));

// join() the array with a comma and a space between items
alert(myFamily.join(", "));
```

Using `split()` to Create an Array from a String

The opposite of `join()` is the `split()` method. Using `split()`, you can create a new array from a string of items separated by a common delimiter.

Add the following code to the **charactersAndStrings.jsx** script:

```
// Create a variable for a string of words separated
// by a comma delimiter
var myList = "Milk,Eggs,Butter,Bread";

//Convert a String into an array using split()
var myArray = myList.split(",");

// show each of the items in the array
alert(myArray[0] );
alert(myArray[1] );
alert(myArray[2] );
alert(myArray[3] );
```

The `split()` method creates an array and automatically populates it with each item in the string separated by the delimiter.

Strings and arrays are similar data types. It can be useful to convert between them. Remember that each is a class object, so each has methods that you can look up in the **Object Model Viewer**.

Flattening, Saving, and Closing Documents

Batch processing documents is a powerful way to do something to multiple documents. As you are discovering, scripting allows you to do even more with decision making and logic built in the process. The previous section explained how to use strings and arrays to help you create good filenames. This section starts dealing with the documents to save all the changes you've made with a script.

Flattening Documents

When you're processing documents, it is often useful to *flatten* the document's layers to help create a smaller file, which uses less space on a hard drive. Flattening is also useful when you're saving the processed document in a file format that cannot save layers, such as a JPEG

or PNG file. In some versions of Photoshop, attempting to save an unflattened file as a JPEG causes a warning message to display and interrupt your script.

As explained earlier in this chapter, `Document` is a class in the Photoshop DOM, so you can use the **Object Model Viewer** to look at its methods and properties. The method to flatten a document is `flatten()`. As you might expect, this is a very simple bit of code.

To see how flattening works, create a new script file from the template, save it as **saveAsJPEG.jsx,** and add the following code:

```
//////////////////////////
// MAIN
//////////////////////////

// flatten the active document before saving
app.activeDocument.flatten();
```

Saving Documents

Saving documents is not a simple process. Use the **Object Model Viewer** to look up the `Document` class and then look at the `save()` method. Notice that this method takes no parameters. This makes sense if you think about it. In Photoshop, the **File > Save** menu item simply saves the current document to the same place and same file format as it already is. However, if you're working on a new document, it has never been saved before. In that case, a series of dialogs pop up to ask you questions about where to save the file, which format to save it, and which file format options you want to save it with. The same is true if you use **File > Save As...** to create a new document from an existing document. In the **Object Model Viewer**, look at the `saveAs()` method (see Figure 10.4). It is not as simple as the `save()` method.

The second parameter to `saveAs()` is `options:any`. Not the most descriptive of definitions, but as you already know, each file format has its own options to set when saving. JPEG is a common file format, and the

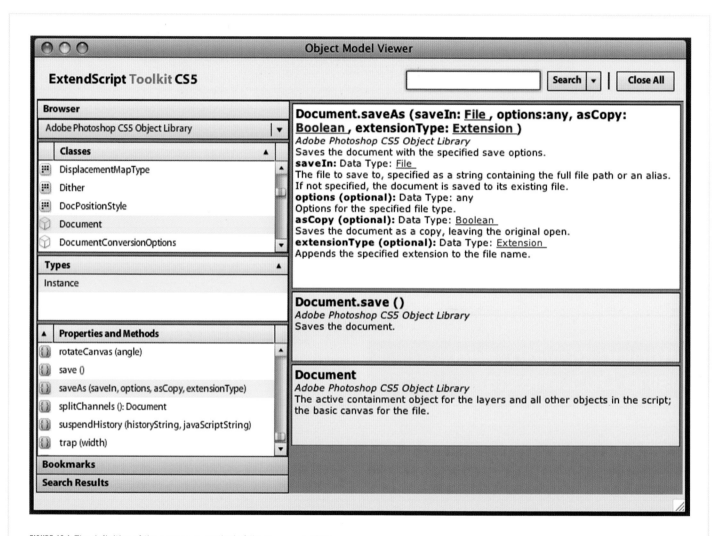

FIGURE 10.4 The definition of the saveAs() method of the Document class.

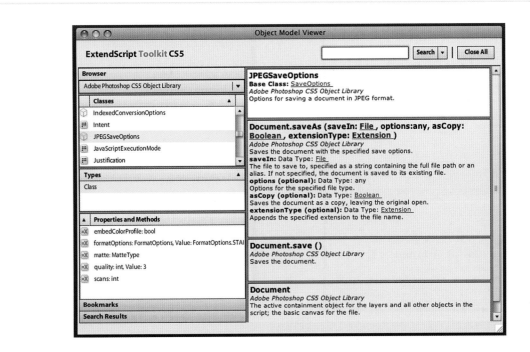

FIGURE 10.5 The definition of the `JPEGSaveOptions` class.

Photoshop DOM provides a class called `JPEGSaveOptions`. Look up that class in the **Object Model Viewer** to see its properties (see Figure 10.5).

The properties of the `JPEGSaveOptions` class should look familiar. Each can be related back to the options shown in the Photoshop dialog when you save a JPEG file (see Figure 10.6).

In the **Object Model Viewer**, if you click on each of the properties of the `JPEGSaveOptions` class, the definition appears in the right column. Notice that `formatOptions` is another data type with a default value of `FormatOptions.STANDARDBASELINE`. Click on the blue underlined `FormatOptions` link to see the other values available. Three values are available: `STANDARDBASELINE`, `OPTIMIZEDBASELINE`, and

`PROGRESSIVE`. Those are the same values displayed in the **JPEG Options** dialog in the **Format Options** section (see Figure 10.7).

The `JPEGSaveOptions` class has a lot of properties. To see them, add the following code to the **saveAsJPEG.jsx** script:

```
// fill out the JPEG options for saving
var myJPEGOptions = new JPEGSaveOptions();
myJPEGOptions.embedColorProfile = true;
myJPEGOptions.formatOptions = FormatOptions.
STANDARDBASELINE;
myJPEGOptions.matte = MatteType.WHITE;
myJPEGOptions.quality = 3;
myJPEGOptions.scans = 3;
```

FIGURE 10.6 The Photoshop **Save As** dialog.

FIGURE 10.7 The Photoshop **JPEG Options** dialog.

Look at the `saveAs()` method again. The first parameter is `saveIn:File`. `File` is a class that is essentially the path to where the file is saved, including the filename. In fact, the path is what you can use when creating a `File` object. Conveniently, there is a data constant called `Folder.desktop` provided in the Core JavaScript Classes; this constant represents the **Desktop** of your hard drive (see Figure 10.8).

The **Desktop** is an easy place to find on any machine, so it makes a good place to save new files. To do so, add the following code to the **saveAsJPEG.jsx** script:

```
// save the current file as a JPEG on the Desktop
var myFile = new File(Folder.desktop + "/" +
activeDocument.name + "1" + ".jpg");
```

```
app.activeDocument.saveAs(myFile, myJPEGOptions,
true);
```

Notice that the path for the `File` includes the "/" string. This is the delimiter character for file paths between folders and, in this case, between folders and files.

Also notice that the `JPEGSaveOptions` object uses all the default values. If those are the values you want to use when saving a JPEG file, it is easier to simply create the object and not assign those values to any of the properties. The result would be just the same.

For this sample script, you saved the file as a JPEG. There are, of course, other options because Photoshop does support other file formats. Using the **Object Model Viewer,** you can easily find the options classes

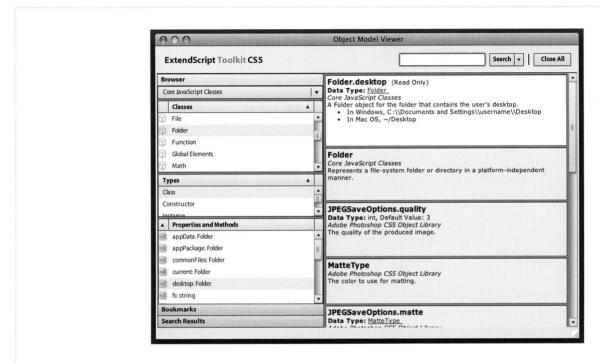

FIGURE 10.8 The definition of `Folder.desktop`.

`GIFSaveOptions`, `PNGSaveOptions`, `TiffSaveOptions`, and other file formats. They work the same way the `JPEGSaveOptions` object does, but with different properties (options) to fill in.

Closing Documents

The last step when saving a document, particularly if you are doing a batch, is to close the document. As you might guess, the `Document` class has a `close()` method. Use the **Object Model Viewer** to see that the `close()` method includes the optional parameter `saving: SaveOptions`. Click on `SaveOptions` to see the list of possible values for this type: `DONOTSAVECHANGES`, `PROMPTTOSAVECHANGES`, and `SAVECHANGES`. The default for `close()` is to prompt the user to save

changes before closing the document. In your script, you have already saved the document. So you do not need to prompt the user, nor do you need to save additional changes.

To close the document, add the following code to the **saveAsJPEG.jsx** script:

```
// close the document
app.activeDocument.close(SaveOptions.
DONOTSAVECHANGES);
```

Notice that you are telling the `activeDocument` to close. Because that is the one you have been processing, you do not want to save the changes you've made because you already saved the changes into the new JPEG file.

Coding Concepts: Using Loops

Loops are a coding concept that repeats a series of steps over and over again. A loop repeats a specific set of code until its stopping condition is triggered. Then the script continues normally. There are a few types of loops with subtle differences between them. Loops can be useful for tasks such as batch processing files and many other more generalized operations. They are a powerful part of coding.

Using `while` Loops

The simplest loop is the `while` loop. The `while` tests a condition, and while that condition is true, the loop repeats. A simple `while` loop uses a counter to keep track of how many times the loop has repeated and stops after a predetermined number of repeats.

To see loops in action, create a new script file from the template, save it as **whileLoops.jsx,** and add the following code:

```
/////////////////////////
// MAIN
/////////////////////////

// create a counter to track the number of repetitions
var i = 0;

// repeat the action inside the loop 5 times
while (i < 5)
{
    alert("Repetition #" + i);
    i++;
}

// tell the user the loop has ended
alert("Made it out of the loop!");
```

Look at the code step by step. The first thing that happens is that a variable is created with a value of 0. The variable counts how many times the loop has been run. A common coding convention is to name such simple variables i. The next thing that happens in the script is that the `while` statement checks whether i is less than 5. Because i < 5 evaluates to `true`, the loop runs the code in the curly braces { }. The loop shows an alert stating how many times the loop has run. Then the loop increments i by 1. This is a very important step. The counter variable keeps track of how many times the loop runs, and the `while` statement checks that counter variable. If the counter variable never changes, the loop continues to run, a situation known as an *infinite loop*. Infinite loops are bad. It's better to catch them when writing the code than when running the code.

After the counter variable is incremented, the `while` loop checks again whether i < 5. After the first loop, i is 1, so it is less than 5 and the loop runs again. All the code in the curly braces runs. This repeats while i is less than 5. Eventually, i has a value of 5. The `while` statement checks i < 5, which is `false`, so the loop does not repeat. Instead, the script skips over all the code in the curly braces beneath the `while,` and the code shows an alert letting the user know that the loop is done.

Notice that the code for the `while` loop is similar to the code for an `if` statement. If some conditional test is true, the code within the curly braces is run. If not, that code is skipped. The difference here is that the code is repeated, and if you are not careful, that is the only code that will run.

Here's a more real-world example. Add the following code to the **whileLoops.jsx** script:

```
// create a variable to track how many documents
// have been processed
var i = 0;

// repeat an action inside a loop
// for all the open documents
```

```
while (i < app.documents.length)
{
     alert("The current document is named " + app.
documents[i].name);
     i++;
}
```

```
// tell the user how many documents were processed
alert("The script processed " + i + " documents.");
```

There are a few issues to notice in this script. The `Application` object has an array of all the open documents. Because it is an array, the code knows how many open documents there are and can ask each document its name. The loop works exactly the same as the previous loop, except that this loop is dependent on the number of open documents instead of the number 5. Ten open documents cause the loop to run 10 times. More importantly, having no open documents means that the loop does not even run once. If there are no open documents when the script is run, Photoshop will report that the script processed 0 documents. This is a nice safety feature to keep in mind. Other ideas about writing safe code are described later in this chapter.

The loop code is simple, but imagine what you can do with it. You could loop over a bunch of open documents, process the image in some way, save the result as a JPEG file, close the document, and process the next document. The preceding loop code does not change the number of open documents. The type of batch operation just described would, however. To see how this works, add the following code to the **whileLoops.jsx** script:

```
// process each open file like batch might
while (app.documents.length > 0)
{
     // process the frontmost document
     alert("The current document is named " +
app.activeDocument.name);

     // close the active document without saving it
```

```
     app.activeDocument.close(SaveOptions.
DONOTSAVECHANGES);
}
```

Here, the `while` checks whether there are any open documents. The `name` of the `activeDocument` is displayed in an alert. That document is closed. Then the loop runs again. Because each document is closed at the end of the loop, a different document becomes the frontmost document and `activeDocument` changes. Also, the number of open documents eventually reaches 0, and the loop stops. No variable is needed to keep track of the current count of checked documents.

This simple structure of looping through all the open documents is the basis for many scripts. You will find yourself copying and modifying this code many times as you create your own script.

Using `do while` Loops

Another loop similar to the `while` loop is the `do while` loop. Its syntax is a bit different, with the `while` statement coming at the end of the loop. To use this loop, add the following code to the **whileLoops.jsx** script:

```
// create a counter variable
var i = 0;

do
{
     alert("Do While Repetition #" + i);
     i++;
} while (i < 5)
```

This code looks similar to the first `while` loop you wrote. The difference is that the stop condition in the `while` statement is tested at the end of the loop instead of the beginning of the loop. This placement guarantees that the loop runs at least once because there is nothing to stop it at the beginning. This little difference is a reason why the `do while` loop is not used much. It is part of the language, so it is a tool you should be aware of. You may find a good use for it (they do exist). Just be careful if you find yourself using `do while`; there might be a better loop structure to use.

Using `for` Loops

The `for` loop structure is similar to the first `while` loop code you wrote, just structured differently. The `for` loop explicitly uses a counter variable to track how many times the loop can run.

To see how this loop works, create a new script file from the template, save it as **forLoops.jsx,** and add the following code:

```
//////////////////////////
// MAIN
//////////////////////////

// repeat this action 5 times
for (var i = 0; i < 5; i++)
    {
        alert("Repetition #" + i);
    }

// tell the user the loop has ended
alert("Made it out of the loop!");
```

Notice that the declaration of the counter variable `i` and the incrementing of that variable is now inside the parentheses following the `for` statement. In a way, the syntax of the `for` loop makes sure that you think about how many times your loop will run and what can stop it. Using a `for` loop is common if counting is involved. This is a little different from the `while` loop, which typically uses other tests to stop the loop.

This next example uses a `for` loop over the layers of a document. Add the following code to the **forLoops.jsx** script:

```
// loop over all the layers in the frontmost document
for (var i = 0; i < app.activeDocument.layers.length; i++)
{
    // process the layer
    alert("The layer is named " + app.activeDocument.
layers[i] .name);
}
```

Notice that `activeDocument` has an array named `layers` that holds the `Layer` objects for that document. As with many other objects in the Photoshop DOM, each `Layer` object has a `name` property.

Note: You should be sure to have a document open in Photoshop before running the script. Otherwise, `activeDocument` is empty, and trying to access the `layers` property will cause an error to display.

Using Loops within Loops

Something that may not be obvious is that you can use loops within loops. The loops do not even have to be the same kinds of loops. For example, you might want to process each layer in each open file in Photoshop. To do so, add the following code to the **forLoops.jsx** script:

```
// process each open file like batch might
while (app.documents.length > 0)
{
    // process the frontmost document
    alert("The current document is named " + app.
activeDocument.name);

    // process each layer in the document
    for (var i = 0; i < app.activeDocument.layers.
length; i++)
    {
        // process the layer
        alert("The layer is named " + app.
activeDocument.layers[i] .name);
    }

    // close the active document without saving it
    app.activeDocument.close(SaveOptions.
DONOTSAVECHANGES);
}
```

This code simply combines the previous two loops. The outer `while` loop walks through the open documents. It processes each document using the inner `for` loop to process each layer in the document. The inner loop finishes and the outer loop continues; in this case, it closes the frontmost document without saving changes. As before, because the document closes, a new document becomes the `activeDocument`, and the loop repeats until all the documents have been processed.

Something to be careful about when you create loops within loops is the name of your counter variables. The code can get confused if a counter variable is named `i` in the outer loop, and the inner loop also uses a counter variable named `i`. If only for your own ability to read the code, be careful not to declare variables with the same names.

Handling Error Detection and Failing Gracefully

So far, the code examples in this chapter have been useful but not exactly safe. Many times a script was created assuming that there was an open document to work with. This is fine as you are learning, but as you start to really create scripts and share them with others, your scripts need to be safer. It may sound strange, but you will be surprised by what people will do with your scripts if you let them. The computer can be very specific in what it expects, and you need to do the same. Part of writing safe code is detecting when errors occur, avoiding problems you can predict (such as knowing the code requires a document to work properly), and handling all those expected and unexpected situations gracefully.

Using the `suspendHistory()` Method

Part of failing gracefully is always allowing a script's user to easily undo what the script has done. Your script may do exactly what it is supposed to do, but the user should always be able to undo the changes, within reason. Some tasks are beyond Photoshop's control to undo, such as uncreating a new file that a script saved.

Photoshop records history states for each operation. As described in Chapter 3, a limited number of history states is kept around before the information is gone and cannot be explicitly undone.

You encountered this problem previously with actions. Each action step records a history state. It is possible for a complex action to overflow the history states so that the action cannot be completely undone. A workaround for that problem was to create a history snapshot.

Scripts have the same problem as actions. Each command may record as a history step, if it would have done so normally using the Photoshop user interface. However, scripts have a better solution to the problem than creating a history snapshot: Scripts can create a single history step.

Using the **Object Model Viewer**, you find that the `Document` class has a method called `suspendHistory()` (see Figure 10.9). This method wraps all the history states a script would normally create into a single history state.

The way this method works is that it calls a function that contains all the code for the single history state. You pass the name of this function as the second parameter to the `suspendHistory()` method. The first parameter is the history state name that is displayed in the **History** panel. Both parameters are passed as strings.

To use this method, create a new script file from the template, save it as **suspendHistory.jsx,** and add the following code:

```
/////////////////////////
// MAIN
/////////////////////////

// create a custom history step for this script
app.activeDocument.suspendHistory("My History State",
"myRemoveChannels()");

/////////////////////////
// FUNCTIONS
/////////////////////////

// a wrapper function for the script's functionality
```

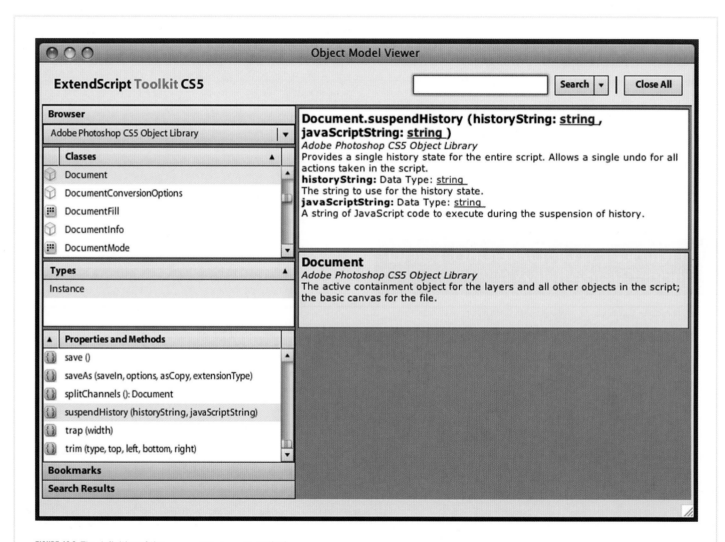

FIGURE 10.9 The definition of the `suspendHistory()` method.

```
function myRemoveChannels()
{
    // delete all the channels in the activeDocument
    app.activeDocument.channels.removeAll();
}
```

This script really does only a simple task. What is important to note is that you successfully created your own history state in Photoshop. The `suspendHistory()` method calls the function `myRemoveChannels()`, which is where the heavy lifting for the script occurs. If you were to add more tasks to the script, they would go into this function. (You might want to rename the function to keep it descriptive.)

If you run the script with a document open, it works fine. If you run the script without a document open, an error occurs. Detecting whether there is an open document is simple to do. The code can check if there is at least one open document and run the code that creates the history state (and the rest of the code). If there are no open documents, it can display an alert to give the user more instructions on how to use the script.

To add this alert, change the code in the MAIN section of **suspendHistory. jsx** to this:

```
/////////////////////////
// MAIN
/////////////////////////

if (app.documents.length > 0)
{
    // create a custom history step for this script
    app.activeDocument.suspendHistory("My History
State", "myRemoveChannels()");
}
else
{
    alert("This script requires an open document to run
correctly.");
}
```

If there are any open documents, the `app.documents` array has a length greater than 0. This is a simple way to avoid a lot of errors. You can use this sample code as the basis for many of the scripts you will write. It is a clean way for your script not only to fail gracefully, but also to allow the user to easily undo (or recover from) the tasks your script performs.

Handling Errors with `try` and `catch` Statements

Sometimes it is easy to figure out what must be true for a script to run, such as when at least one document must be open. As you've just done, you can code around known requirements like that. Requirements are not always easy to anticipate, but they are not too difficult. At least such issues can be anticipated. If there is no document open, you cannot ask the `activeDocument` its `name`, for example.

Much harder to anticipate and handle are the unexpected errors that occur. Users do unusual things. Computers sometimes return unexpected data. A new version of or update to Photoshop might change how a method works, or you might not have known about a special case your code needed to handle. Errors happen. Fortunately, JavaScript has a way to help deal with the unexpected. The `try` and `catch` statements are your friends. They are the bodyguards around your code to keep your user safe from harm.

You place the `try` statement at the beginning of a block of code that is surrounded by curly braces { } . This is similar to a `while` statement placed at the start of a looping block of code. The `try` statement instructs Photoshop to try to run the code inside the curly braces. If something goes wrong, Photoshop jumps out of that block of code. If something goes wrong inside the `try` block of code, Photoshop runs the code inside the `catch` block following it.

To see how these statements work, create a new script file from the template, save it as **tryCatch.jsx,** and add the following code:

```
/////////////////////////
// MAIN
/////////////////////////

try
{
      // delete all the channels in the activeDocument
      app.activeDocument.channels.removeAll();
}
catch(e)
{
      // something went wrong
      alert(e);
      alert("This script requires an open document to run
correctly.");
}
```

Even though you already know how to code for the case when a document is required, this code is an easy way to test for a known problem and illustrates `try` and `catch`. In this case, if the script is run without an open document, you see the messages shown in Figures 10.10 and 10.11.

The error returned in the variable `e` to the `catch` code block is trying to be descriptive. In this case, you know that it is telling you that there is no

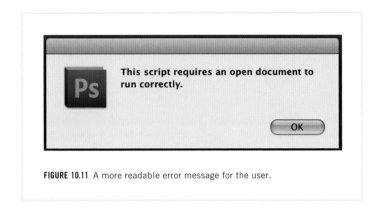

FIGURE 10.11 A more readable error message for the user.

activeDocument available and therefore no `channels` array that can call the `removeAll()` method.

The second error message, of course, is the one that you wrote explicitly. It might help you troubleshoot the code and even solve problems as you encounter them. Then you can find those areas where a simple `if` statement that checks something, such as if a document is open, can be handled and worked around.

It is not always so easy to determine what went wrong. As you are developing scripts, it is useful to, at least, show the error passed to the `catch` block. Showing the error might help you troubleshoot the code and even solve problems as you encounter them.

Change the code in **tryCatch.jsx** to this:

```
/////////////////////////
// MAIN
/////////////////////////

try
{
```

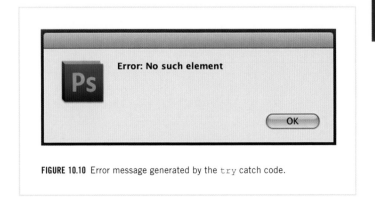

FIGURE 10.10 Error message generated by the `try` catch code.

```
if (app.documents.length > 0)
{
    // delete all the channels
    app.activeDocument.channels.removeAll();
}
else
{
    alert("This script requires an open document
to run correctly.");
}
}
```

```
catch(e)
{
    // something went wrong
    alert("An unexpected error occurred and the script
did not complete.");
    alert(e);
}
```

When possible, it is always best to inform the user with a useful message about what went wrong. If the issue is something the user can correct, the script can be run again. But you should, at least, inform the user when something unexpected happened and the script did not complete.

EXPLORATIONS

A common technique for going through the items in an array is to get the length of the array and then loop that many times to work on each item in the array, which you get using the brackets [] and the current index to access the item.

As described in the section on the `while` loop, there is a way to loop without using an index into an array. An example in that section describes testing whether there are any open documents, processing the active document, closing the document, and then testing again for open documents. The array of open documents shrinks as each loop is run because the active document is closed each time. Eventually, there are no open documents.

You can do something similar using the `pop()` and `push()` methods on the `Array` object. Arrays are actually objects and have methods. The `pop()` method returns the last element in an array and removes it from the array. The array shrinks each time the `pop()` method is called. When you use `pop()` in a loop, eventually the array `length` will be 0. The opposite of `pop()` is `push()`. It adds an item to the end of an array.

Use the **Object Model Viewer** to look up the `Array` object in the **Core JavaScript Classes**. Then look at the `pop()` and `push()` methods. Write a script to build up an array of family members, perhaps using the `prompt()` function to get the names as comma-separated values from the user; then add a text layer for each name to a new document, using `pop()` to loop through the names. Save the resulting file as a flattened PNG file.

Eleven

ADDING

Scripts to Your Panels

Advanced Configurator

Just as you want to write scripts for certain tasks instead of actions, you might want to use a script in the custom panels you build instead of using actions. Configurator has good support for scripts. You can embed a script into the panel itself or have the panel run a script in an external file. You can reference other types of files as well. You can also combine scripts and actions. When your custom panel is complete, you can modify the installer built by the Adobe Extension Manager to handle all the extra files.

Always create, test, and troubleshoot your scripts using the ExtendScript Toolkit. The toolkit was built to make scripts for Adobe applications. Also, by creating a script using the toolkit, you always have a backup version of the script for use when creating other scripts.

Using Scripts with Configurator

The Configurator tool allows you to create buttons in a panel that can run scripts. The code for the script can either be embedded into the button or saved in an external file the button has a reference to. Both approaches have advantages, and although neither one is difficult, there are a few tricks worth knowing about.

Writing Scripts for Configurator

There are few points to keep in mind when you develop scripts for use with the Configurator tool:

- Always create, test, and troubleshoot your scripts using the ExtendScript Toolkit. The toolkit was built to make scripts for Adobe applications. Configurator does not have many of the reference and debugging features that the toolkit does. Coding, debugging, and archiving your scripts are faster processes when you use the toolkit. Also, by creating a script using the toolkit, you always have a backup version of the script for use when creating other scripts.

- Configurator does not always maintain the formatting of your code. This can make it hard to read. This is another good reason to always have a .jsx file of your script.

- With some uses, Configurator takes your code and essentially puts it all on one line. Single-line comments that use the double slash // will comment out the rest of the script. Instead, you should use the multiline comment syntax that begins with a slash and an asterisk /* and ends with an asterisk and a slash */. For this reason, you should create a new scripting template file for use with Configurator.

To write a script in the ExtendScript Toolkit, create a new script file, save it as **configuratorTemplate.jsx**, and add the following code:

```
/* configuratorTemplate.jsx

Copyright 2007-2011
Written by Jeffrey Tranberry */

/*
Description:
This is a template to help you begin scripting for
Configurator.
*/

/* enable double clicking from the
Macintosh Finder or the Windows Explorer */
#target photoshop

/* Make Photoshop the frontmost application
in case we double-clicked the file */
app.bringToFront();

/* SETUP */

/* MAIN */

/* FUNCTIONS */
```

Remember as you use this template to use /* and */ when making all comments. Other than this change, scripts you write in the

ExtendScript Toolkit will work exactly the same way when used in a Configurator panel.

Following the preceding suggestions, you are going to create the script for your Configurator panel before you build the panel itself. In the ExtendScript Toolkit, create a new script file from the **configuratorTemplate.jsx** file, save it as **removeAllChannels.jsx**, and add the following code:

```
/* MAIN */

try
{
    if (app.documents.length > 0)
    {
        /* create a single history step */
        app.activeDocument.suspendHistory("Delete
All Channels", "myMain()");
    }
    else
    {
        alert("This script requires an open document
to run correctly.");
    }
}
catch(e)
{
    /* something went wrong */
    alert("An unexpected error occurred and the script
did not complete.");
    alert(e);
}

/* FUNCTIONS */

/* a container function for the real work of the script */
function myMain()
{
    /* Remove all Alpha Channels */
    app.activeDocument.channels.removeAll();
}
```

Test and troubleshoot this script using the ExtendScript Toolkit. You may need to create an image document that has a few alpha channels to really be sure the functionality is correct.

Adding a Script Button

Now that you have a good script, you need to create a panel for it using the Configurator tool:

1. In the Adobe Configurator 2.0 application, choose **File** > **New Panel** from the Configurator menus. Remember that Configurator's menus are at the top of the application window because it is an AIR application.

2. In the **Panel** section on the right side of the Inspector, change the **Name** attribute from **untitled-1** to **Beginning Scripts**.

3. In the same panel, change the **Persistent** attribute from **True** to **False** using the pop-up menu. Remember that this is done when developing panels, so you do not have to start and restart Photoshop every time you change the panel using Configurator.

4. Click the triangle widget to open the group **ACTION/SCRIPT** in the Object Palette on the right side of the Configurator.

5. Drag out a **Script** button and place it on the panel.

6. Place the button so it is in the upper-left corner with a margin; then size it so it spans across the panel to the opposite side margin (see Figure 11.1).

7. In the Inspector panel, change the **Label** attribute for the **Script** button from **Script** to **Remove All Alpha Channels** and change the **Tooltip** attribute from **Run JavaScript** to **Run a script to remove all alpha channels**.

8. In the ExtendScript Toolkit, choose **Edit** > **Select All** to select all the text in the **removeAllChannels.jsx** script and choose **Edit** > **Copy** to copy all the code.

9. In the Configurator, click to place the cursor in the **Script** attribute of the **Script** button; then press ⌘ + **V** to paste the code into the field.

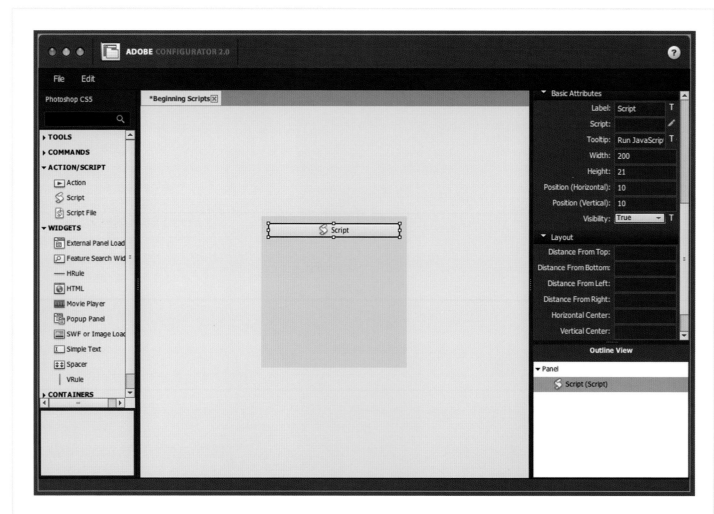

FIGURE 11.1 Configurator panel with a **Script** button.

Note: A bug in Configurator (possibly in AIR) requires you to use the keyboard shortcut instead of the menu to paste the code into the field. With the cursor in the **Script** field, open the **Edit** menu to look at the menu items. Notice that the **Paste** menu item is disabled and there is no blue outline around the field. Close the menu, and the blue outline reappears around the field. What seems to be happening is that the open menu is taking the focus from the field. Because you cannot paste into a menu, the **Paste** menu item is disabled. The workaround for this situation is to use the keyboard shortcut ⌘ + **V**.

will cause a syntax error when run in Photoshop. Select the extra text and press the **Delete** key to remove it.

12. Unfortunately, that is not the only correction needed in the script. Code like `#target photoshop` must always be on its own line. The **Text Editor** dialog allows you to do this. Click to place the cursor before the # character of `#target` and press the **Return** key. Then place the cursor after the last p character of `photoshop` and press the **Return** key. Failing to make this change causes a syntax error when the code is run in Photoshop. After you have made these changes, the code should look like the code shown in Figure 11.2 (right).

In Configurator, the **Text Editor** dialog shown in Figure 11.2 allows editing with some formatting, such as new lines. If you find you have problems with a script, you can format this code looking for syntax errors. The formatting is even saved. It might help you troubleshoot problems.

10. Click the Pencil icon next to the **Script** attribute to see the entire script as formatted by the Configurator.

11. Looking at the **Text Editor** dialog, you may notice that two copies of the script were pasted into the **Script** field, as shown in Figure 11.2 (left). If the script is doubled, you must get rid of the extra code because it

FIGURE 11.2 The initial and corrected script code for the **Remove All Alpha Channels** button.

Note: The Configurator menus are disabled while the **Text Editor** dialog is open. If you want to paste the code for the script, you need to press ⌘ + **V** to use the keyboard shortcut for **Edit** > **Paste**. Pasted code retains its formatting and does not place it all on a single line.

13. Click the **OK** button to close the **Text Editor** dialog and save your changes to the script.

14. Choose **File** > **Save** from the Configurator menus and save the file as **Beginning Scripts.gpc** on the **Desktop**.

15. Choose **File** > **Export Panel** from the Configurator menus. The dialog should show the correct folder (**Plugins/Panels**) to place the panel. You should see any previous panels (like **Selection** from Chapter 7). Click the **Select** button to export the new panel.

16. If you are running Photoshop, quit and restart to load the new panel. Remember that the **Persistent** attribute works after the first time Photoshop is run.

17. In Photoshop, choose **Window** > **Extensions** > **Beginning Scripts** from the menus to open the new panel.

18. Click the **Remove All Alpha Channels** button in the panel. With no file open, Photoshop should show an alert with the message "This script requires an open document to run correctly."

19. Open your previous test file with a few alpha channels. Click on the **Remove All Alpha Channels** button again. This time, the channels should be removed and a history state is added to the list titled **Remove All Channels**.

That was messy, wasn't it? There are a few quirks in the Configurator to work around when using a **Script** button. Aren't you glad to learn about them here rather than on your own? Sometimes the tools are not perfect, so you must improvise to find a solution. Use the **Text Editor** dialog to paste your code into the **Script** button to preserve its formatting. Remember to use the keyboard shortcut when pasting. **Script** buttons do have their use, but a good solution to their problems is to use a **Script File** button instead.

Adding a Script File Button

The other object that can be added to a panel to run a script is the **Script File** button. Instead of the code for the script being embedded into the button itself, the button references a script file and runs the script in the file. Here's how to add the button:

1. Drag out a **Script File** button and place it on the panel below the **Remove All Alpha Channels** button.

2. Size the button so it spans across the panel to the opposite side margin.

3. Change the **Label** attribute to **Remove All Alphas w/ File** and change the **Tooltip** attribute to **Remove all alpha channels using a script file** (see Figure 11.3).

4. On the **Desktop**, copy the **removeAllChannels.jsx** file into the **Beginning Scripts.assets** folder, which is also on the **Desktop** (created when you saved the panel).

5. In Configurator, next to the **Script File** attribute, click the Document icon to open the **Select a File** dialog. The dialog should show the contents of the **Beginning Scripts.assets** folder. Click on the **removeAllChannels.jsx** file to select it and click the **Select** button.

6. Choose **File** > **Save** from the application menus to save your changes.

7. Choose **File** > **Export** from the application menus. You should be able to just click the default buttons of the dialogs to remove the already-exported version of the panel.

8. In Photoshop, close the **Beginning Scripts** panel and open it again to reload the panel (the **Persistent** attribute makes this possible). The new panel should have both the **Remove All Alpha Channels** button and the **Remove All Alphas w/ File** button.

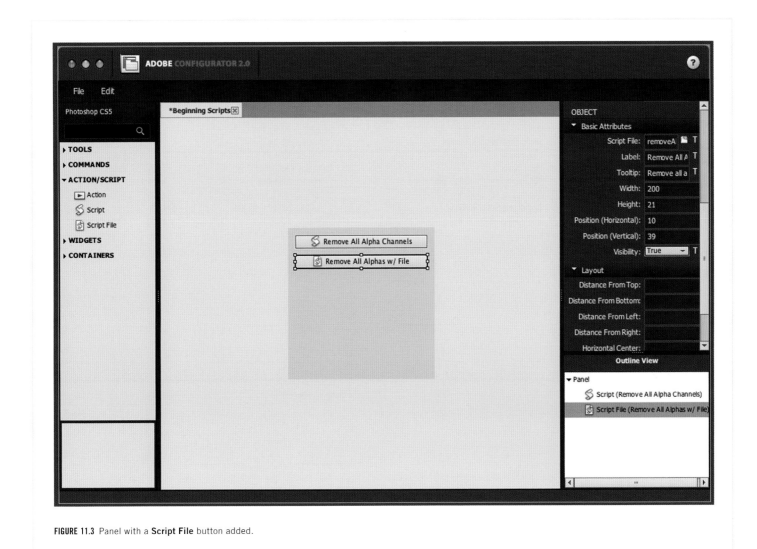

FIGURE 11.3 Panel with a **Script File** button added.

9. Test that the buttons both work and create exactly the same results.

If you navigate to the **Photoshop CS5/Plugins/Panels** folder, open the **Beginning Scripts** folder, open the **content** folder, and finally open the **Beginning Scripts.assets** folder, you find the **removeAllChannels.jsx** file

(see Figure 11.4). Remember that the panel export process copies the folder and all its contents, so it copies your script file, too.

One advantage to using the **Script File** button that might not be obvious to you yet is that it is useful for scripts that are very big or contained in multiple files. All the scripts you've written so far have been small and

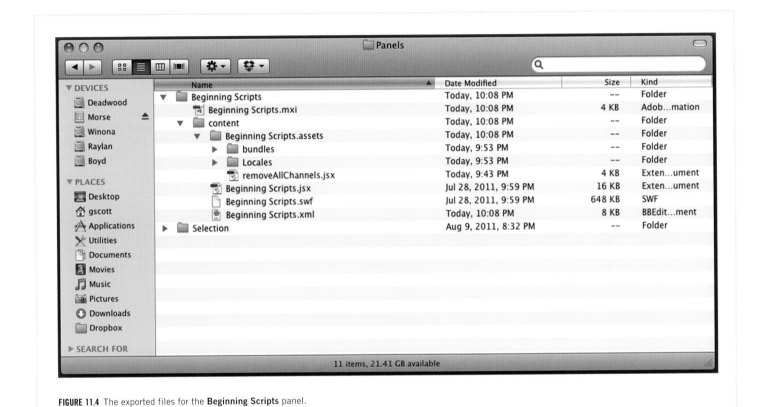

FIGURE 11.4 The exported files for the **Beginning Scripts** panel.

simple. As you build more scripts, the amount of code increases. It can be useful to have common functions in separate files for use in multiple scripts. This topic will be described more fully in the next chapter. For now, you might find little difference between the two scripting buttons. Which one you use for your panels is your choice.

Using Other External Files with Configurator

Script files are not the only useful external files you might want to integrate into your custom panels. Using external files requires some additional knowledge involving their use.

Using Cross-platform and Localized Paths

On computers, the location of a file is specified by a path. The path is a string that shows the hierarchy of folders to the file. For example, on Mac OS X, the path to the Photoshop CS5 application is

/Applications/Adobe Photoshop CS5/Adobe Photoshop CS5.app

Paths like this have been shown throughout this book and may already be familiar to you. As you might guess, paths on Mac OS X may be different from those on Windows, even if they are paths to a copy of the same file.

Paths can be *relative* or *absolute.* An absolute path, like the preceding one, shows the full folder hierarchy from the root level of the hard drive. A relative path shows the folders from one folder to another. For example,

on Mac OS X, the relative path from the Photoshop CS5 application to the ExtendScript Toolkit CS5 application is

../Utilities/Adobe Utilities-CS5/ExtendScript Toolkit CS5/ExtendScript Toolkit.app

The **../** at the beginning of the path means to go up the folder structure one level—in this case, to the **Application** folder—and then continue following the path. File paths are like street addresses that locate files.

Some paths have shortcuts built into the Photoshop DOM. A script can access these shortcuts as the starting place to build a path. The application object has a path property that you can access with `app.path` in your scripts. The path is a string, and as with all strings in JavaScript, you can easily add to them using the plus (+) operator.

> Most of the files you care about as a scripter and builder of panels are all placed relative to the Photoshop application. Naturally, there is a built-in shortcut for this location.

Something you may not know is that paths may be localized for non-English systems. Specifically, many of the folders in the Photoshop application folder have localized names, so they are more familiar to non-English speakers. This can be a problem for you as a coder. Do you know the word "plug-ins" in all languages? Probably not. Fortunately, the Photoshop script-running environment does. You just have to use the `localize()` function to translate one key into the translated word:

```
/* Localized path to the Plug-Ins folder */
var strPlugInsFolderDirectory = localize("$$$/
LocalizedFilenames.xml/SourceDirectoryName/id/
Extras/[LOCALE]/[LOCALE]_Plug-ins/value=Plug-ins");
```

The `localize()` function takes a long string that is a key representing a word that has been translated into many languages. The function returns the correctly translated word for that key based on the locale of the operating system. You should really read the Photoshop documentation on Configurator and localization to get the full details of what is happening in the preceding code. The gist is that `strPlugInsFolderDirectory` ends up with the string "Plug-ins"—the name of the folder inside the Photoshop application folder where plug-in files are located.

This capability is important when you want to do something such as access a specific file located in the asset folder of the panel you built. Fortunately, the title of the **Panels** folder inside the **Plug-ins** folder is not localized, so you don't have to ask for its name. Instead, you can build the path to the folder easily with this code:

```
/* Localized path to the Plug-Ins folder */
var strPlugInsFolderDirectory = localize("$$$/
LocalizedFilenames.xml/SourceDirectoryName/id/
Extras/[LOCALE]/[LOCALE]_Plug-ins/value=Plug-ins");

/* Localized path to the Panels folder in the Plug-ins folder */
var strPanelsFolderDirector = app.path.toString() + "/"
+ strPlugInsFolderDirectory + "/Panels/";
```

This code combines the use of the **app.path** value, the localized name of the **Plug-ins** folder, and the knowledge that panels are located in the **Panels** folder inside the **Plug-ins** folder.

Loading and Playing an Action from a Script

Chapter 7 describes how to add an **Action** button to a panel to play an action. Chapter 9 describes how to use `doAction()` to play an action from a script. Both techniques rely on the action already being loaded into Photoshop. If Photoshop is on your system, you can control this.

You want to create panels (and scripts and actions) for general use, which is trickier.

The process of saving and loading action sets is described in Chapter 4. As you know, files added to the .assets folder get copied over for use in Photoshop when the panel is exported by Configurator. The files are also bundled up into the .mxi installers created by the Adobe Extension Manager. Naturally, this also is the place where you copy action set files for use by your panel's scripts.

1. In Photoshop, create a new action set and name it **Panel Actions**.

2. Holding down the **Option** (⌥) key, click and drag the **Save for Web 100%** action from the **Book Actions** set to the **Panel Actions** set.

3. Click on the name of the copied action, go to the end of the name, and remove the word **copy**. The word **copy** was added when you copied the action to the **Panel Actions** set.

4. Copy the **Resize for Web** and **Resize for Web w/ Organic Borders** actions from the **Book Actions** set to the **Panel Actions** set. Remove the word **copy** from the names of each of the copied actions.

5. Click the **Panel Actions** set to select it.

6. Choose **Save Actions...** from the panel menu.

7. Using the **Save** dialog, save the **Panel Actions.atn** file to the **Desktop**.

8. Drag the **Panels Action** set to the Trash icon at the bottom of the **Actions** panel to delete the set. You'll be loading it with your panel and script later.

9. Copy the **Panel Actions.atn** file into the **Beginning Scripts.assets** folder.

What you need next is a script to load the **Panels Action** set from the file and play the **Resize for Web w/ Organic Borders** action. The script can be added to a **Script** button placed in the panel. Every time the button is clicked, the script runs the action.

There is a problem to consider first, however. If the script loads the action set each time, the **Actions** panel will fill with that set. The script really needs to load the action set only if it is not already loaded. Unfortunately, there is no way to do this using the Photoshop DOM or using the ScriptingListener plug-in.

A really nice thing about scripting is that a lot of talented scripters share their solutions to problems online. Two good forums for Photoshop Scripting are

* Photoshop Scripting User-to-User Forums on Adobe.com: **http://forums. adobe.com/community/photoshop/photoshop_scripting**

* PS-Scripts Photoshop Scripting Forums: **http://www.ps-scripts.com/**

Searching the forums usually yields solutions to most problems you are likely to encounter.

10. Using your favorite web browser, go to **http://www.ps-scripts.com/**.

11. Type **actionset actions script** in the **Search** field at the top of the page and click the **Search** button.

12. There are a few results, but not too many, which is a good sign. Scroll down until you see the result titled **Actionset / Actions Script** posted by **rajdeeprath**. Click on the title to see the post.

13. Scroll down to find the response by **Mike Hale**, which includes a bunch of code.

14. The posted code includes a function near the top called `getActionsSets()`. You can review the rest of the code, but it is this function that is most useful for your purposes.

You could copy and modify the code yourself. Instead, using the ExtendScript Toolkit, create a new script file from the **configuratorTemplate.jsx** file, save it as **getActionSets.jsx,** and add the following code:

```
/* MAIN */

/* get users actions sets */
var mySets = getActionSets();

/* walk through the action sets */
for (i = 0; i < mySets.length; i++)
{
     /* show the name of the action set */
     alert(mySets[i]);
}

/* FUNCTIONS */

/* Functions to get the list of action sets currently
installed
     written by Mike Hale
     http://www.ps-scripts.com/bb/viewtopic.php?
t=2463&highlight=getactionsets */

/* shorthand to convert char ID to a type ID */
function cTID(s)
{
     return app.charIDToTypeID(s);
}

/* get the list of action sets currently installed */
function getActionSets()
{
     var i = 1;
     var sets = [];
     while (true)
     {
          var ref = new ActionReference();
          ref.putIndex(cTID("ASet"), i);

          var desc;
          var lvl = $.level;
          $.level = 0;

          try
          {
               desc = executeActionGet(ref);
          }
          catch (e)
          {
               break;     /* all done */
          }
          finally
          {
               $.level = lvl;
          }

          if (desc.hasKey(cTID("Nm  ")))
          {
               var set = { };
               set.index = i;
               set.name = desc.getString(cTID("Nm  "));
               set.toString = function() { return this.name; };

               set.count = desc.getInteger(cTID("NmbC"));

               set.actions = [];

               for (var j = 1; j <= set.count; j++)
               {
                    var ref = new ActionReference();
                    ref.putIndex(cTID('Actn'), j);
                    ref.putIndex(cTID('ASet'), set.index);

                    var adesc = executeActionGet(ref);
                    var actName = adesc.getString(cTID('Nm '));

                    set.actions.push(actName);
               }

               sets.push(set);
          }
          i++;
     }
     return sets;
};
```

You could spend a lot of time dissecting the code in this function, but it includes many things this book has not covered. It also includes code similar to that generated by the ScriptingListener plug-in. What you should do is run your script to see whether it works. The script should show alerts with the name of each action set you have installed in Photoshop.

With the two functions in **getActionSet.jsx**—cTID(s) and getActionSets()—you can write a script to load and run a specific action from a specific action set without loading the set multiple times. Create a new script file from the **configuratorTemplate.jsx** file, save it as **loadAndRunAction.jsx,** and add the following code:

```
/* MAIN */

try
{
    if (app.documents.length > 0)
    {
        /* create a single history step for this
script */
        app.activeDocument.suspendHistory("Resize
for Web w/ Organic Border", "myMain()");
    }
    else
    {
        alert("This script requires an open document
to run correctly.");
    }
}
catch(e)
{
    /* something went wrong */
    alert("An unexpected error occurred and the script
did not complete.");
    alert(e);
}

/* FUNCTIONS */

/* where everything happens for the single history state */
```

```
function myMain()
{
    loadAndRunPanelAction("Beginning Scripts",
"Panel Actions.atn", "Panel Actions", "Resize for Web w/
Organic Border");
}
```

The code so far is just set up and should mostly be familiar. The new piece is the function call to loadAndRunPanelAction(). This function has a bunch of parameters that specify which panel, action file, action set, and action are to be run by the script. You may have noticed that the cTID(s) and getActionSets() functions are generic so they can be used by any script. The loadAndRunPanelAction() function is also generic and will, in fact, use the cTID(s) and getActionSets() functions.

Now add the following code to **loadAndRunAction.jsx**:

```
/* load and run the specified action */
function loadAndRunPanelAction(panelName,
actionFileName, actionSet, actionName)
{
    /* Localized path to the Plug-Ins folder */
    var strPlugInsFolderDirectory = localize("$$$/
LocalizedFilenames.xml/SourceDirectoryName/id/
Extras/[LOCALE]/[LOCALE]_Plug-ins/value=Plug-ins");

    /* The Path to the action file you want to load */
    var actionFile = File(app.path.toString() + "/" +
strPlugInsFolderDirectory + "/Panels/" + panelName + "/
content/" + panelName + ".assets/" + actionFileName);

    /* Set actionLoaded to false until we find a match */
    var actionLoaded = false;

    /* get users actions sets */
    var sets = getActionSets();

    /* walk through the layer sets */
    var i = 0;
    while(i < sets.length && !actionLoaded)
```

```
    {
         if (sets[i] == actionSet)
         {
              /* If we find a match set it to true */
              actionLoaded = true;
         }
         i++;
    }

    /* load the action, if needed */
    if (!actionLoaded)
    {
         try
         {
              load(actionFile);
              actionLoaded = true;
         }
         catch(e)
         {
              /* loading the action file failed */
         alert("Photoshop had problems loading the
action file\n" + actionFile);
         }
    }

    /* then play it. */
    if (actionLoaded)
    {
         try
         {
              doAction(actionName, actionSet);
         }
         catch(e)
         {
              /* catch user cancellations. We don't
want an error in Photoshop for the user stopping the action
from one of the action Stop commands */
         }
    }
}
```

The basic idea for the function is to check whether the action set is loaded. It gets the list of action sets from `getActionSets()` and walks through looking for the right set by name. If the action set is not found, the `load()` function loads the file, which is in the **contents** folder of the exported panel. (Remember this script is meant to be run from the panel.) When the function is sure the action set is loaded, it then runs the action using the `doAction()` call.

Continue as follows:

15. Copy the `cTID(s)` and `getActionSets()` functions from the **getActionSets.jsx** file to the **loadAndRunAction.jsx** file and save the file.

16. In Configurator, choose **File** > **Export Panel** from the application menus to export the **Beginning Scripts** panel, which ensures that the **Panel Actions.atn** file is in the correct location.

17. In the ExtendScript Toolkit, run the **loadAndRunAction.jsx** file to test the script.

18. When the script is working correctly, copy the **loadAndRunAction.jsx** file into the **Beginning Scripts.assets** folder.

19. In Configurator, add a **Script File** button to the panel, change the label to **Resize for Web w/ Organic Border**, and have the button use the **loadAndRunAction.jsx** file in the **Beginning Scripts.assets** folder.

20. Choose **File** > **Save** from the application menus to save your changes.

21. Choose **File** > **Export Panel** from the application menus to export the **Beginning Scripts** panel.

22. In Photoshop, close and reopen the **Beginning Scripts** panel to refresh it.

23. Click the **Resize for Web w/ Organic Border** button to test that it works.

24. In the **Actions** panel, trash the **Panel Actions** set and test the **Resize for Web w/ Organic Border** button again.

Creating that one simple button may seem like more work than it is worth. That may be true, but very little of that work was new to you. Think about what you gained: a script function that can intelligently load an action from an action file and play that action. The function (functions, actually) is valuable because it can be used with any panel and action set in the future. The best scripting solutions are either very

simple or involve many pieces that work well together. You just created a sonic screwdriver for your Photoshop customization toolbox.

Adding a Button to Open a Web Page

Because you are building panels, you might want to allow users a quick way to go to your website to see more of your work or get updates or to leave feedback or donate money. The point is to have a button on your panel that opens a browser to a web page you specify.

The `File` object has the `execute()` method. This method does the same thing as if you had double-clicked on that file in the Finder or Explorer. Double-clicked files open with the application associated with that file type. A file with the .html file extension opens in a browser. Conveniently, HTML files can tell a browser to go to another web page.

In a text editor (such as the ExtendScript Toolkit), create a new document, save it on the **Desktop** as **index.html**, and type this HTML into the file:

```
<?xml version="1.0"?>
<!DOCTYPE html PUBLIC "-//W3C//DTD XHTML 1.0 Strict//EN"
        "http://www.w3.org/TR/xhtml1/DTD/xhtml1-
strict.dtd">
<html xmlns="http://www.w3.org/1999/xhtml">
<head>
      <title>Jeff Tranberry</title>
      <meta HTTP-EQUIV=REFRESH CONTENT="0; URL=http://
www.tranberry.com/">
</head>
<body>
      <p><a href="http://www.tranberry.com/">Jeff
Tranberry</a></p>
</body>
</html>
```

This web page takes advantage of a metadata trick that forces the page to update after zero seconds. When the page updates, it goes to the URL in the `<meta>` tag, which in this case is `http://www.tranberry.com/`. Although potentially unnecessary, it is always a good idea to also include a link to the web page in the body of the page, in case the refresh trick does not work, so the user can click the link to go to the page. Here's how:

1. Copy the **index.html** file into the **Beginning Scripts.assets** folder.

2. In the ExtendScript Toolkit, create a new script file from the **configuratorTemplate.jsx** file, save it as **openURL.jsx,** and add the following code:

```
/* MAIN */

/* Localized path to the Plug-Ins folder */
var strPlugInsFolderDirectory = localize("$$$/
LocalizedFilenames.xml/SourceDirectoryName/id/
Extras/[LOCALE]/[LOCALE]_Plug-ins/value=Plug-ins");

/* Localized path to the HTML file */
var htmlFileName = app.path + "/" +
strPlugInsFolderDirectory + "/Panels/Beginning
Scripts/content/Beginning Scripts.assets/index.
html";

/* Open the HTML file that redirects to the URL */
File(htmlFileName).execute();
```

3. In Configurator, choose **File** > **Export Panel** to export the panel's files (and new **index.html** file) into its place in the Photoshop folder. In the script, this is the place where `htmlFileName` specifies where the file is located.

4. In the ExtendScript Toolkit, save and run the script to test that it opens to the correct web page.

5. When the script works correctly, copy the **openURL.jsx** file into the **Beginning Scripts.assets** folder.

6. In Configurator, add a **Script File** button to the panel, change the label to **Go to Tranberry.com**, and have the button use the **openURL. jsx** file in the **Beginning Scripts.assets** folder.

7. Choose **File** > **Save** from the application menus to save your changes.

8. Choose **File** > **Export Panel** from the application menus to export the **Beginning Scripts** panel.

9. In Photoshop, close and reopen the **Beginning Scripts** panel to refresh it.

10. Click the **Go to Tranberry.com** button to see that it works.

Referencing a Script from a Panel

Although panels built from Configurator are nice for creating a good user interface to organize and present commands in Photoshop, there are some limitations with panels:

- Commands run from panels are not recorded when you create new actions.
- You cannot assign a keyboard shortcut to scripts run from the panel. You can assign keyboard shortcuts only to scripts that appear in the **File** > **Scripts** menu.

To get around these problems, you can create a **Script File** button that references a script that appears in the **File** > **Scripts** menu. Doing so allows actions to record the task, have it available for use by buttons in the panel, and allows a user to assign a keyboard shortcut to it.

The **Script File** button also has a limitation to work around. It only allows for platform- and language-specific paths. So you need a script that specifies the path to a script that appears in the **File** > **Scripts** menu. Follow these steps to create one:

1. Copy the **loadAndRunAction.jsx** file from the **Beginning Script.assets** folder to the **Adobe Photoshop CS5/Presets/Scripts** folder. This folder contains the script files for the scripts that appear in the **File** > **Scripts** menu.

2. Quit and restart Photoshop to load the new script file into the **File** > **Scripts** menu.

3. Choose **File** > **Scripts** > **loadAndRunAction** from the menus to test that your script works correctly.

4. If you do not have the ScriptingListener plug-in installed, quit Photoshop, copy the **ScriptingListener.plugin** file from the **Adobe Photoshop CS5/Scripting/Utilities** folder to the **Adobe Photoshop CS5/Plug-ins** folder. Quit and restart Photoshop to load the plug-in.

5. Open a document and then choose **File** > **Scripts** > **loadAndRunAction** from the menus.

6. Open the **ScriptingListenerJS.log** file and select the code for running the script.

7. In the ExtendScript Toolkit, create a new script file from the **configuratorTemplate.jsx** file, save it as **runScriptFromFileScriptsMenu.jsx**, and paste the code from the log file. The result should look like this:

```
/* MAIN */

/* Run the script "loadAndRunAction" from the File >
Scripts submenu */
var idAdobeScriptAutomationScripts =
stringIDToTypeID( "AdobeScriptAutomation Scripts" );
    var desc2 = new ActionDescriptor();
    var idjsNm = charIDToTypeID( "jsNm" );
    desc2.putString( idjsNm, "loadAndRunAction" );
    var idjsMs = charIDToTypeID( "jsMs" );
    desc2.putString( idjsMs, "undefined" );
executeAction( idAdobeScriptAutomationScripts,
desc2, DialogModes.NO );
```

8. Copy the saved **runScriptFromFileScriptsMenu.jsx** into the **Beginning Script.assets** folder.

9. In Configurator, add a **Script File** button to the panel, change the label to **File** > **Scripts** > **loadAndRunAction**, and have the button use the **runScriptFromFileScriptsMenu.jsx** file in the **Beginning Scripts.assets** folder.

10. Choose **File** > **Save** from the application menus to save your changes.

11. Choose **File** > **Export Panel** from the application menus to export the **Beginning Scripts** panel.

12. In Photoshop, close and reopen the **Beginning Scripts** panel to refresh it.

13. Press the **File** > **Scripts** > **loadAndRunAction** button to see that it works.

After all these scripting buttons have been added to the panel, it should look like the one shown in Figure 11.5.

The finished panel is not pretty. It is meant as a reference to all the different ways to use scripts and script files from a panel. After all that work, your **Panels** folder should look like the one in Figure 11.6.

Notice that the **loadAndRunAction.jsx** file is still present in the **Beginning Scripts.assets** folder. This is so that the other scripting buttons continue to work. The file is also in the **Adobe Photoshop CS5/Presets/Scripts/** folder.

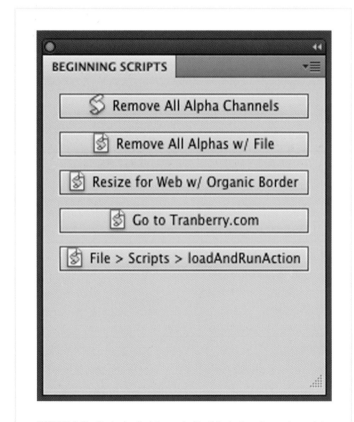

FIGURE 11.5 The **Beginning Scripts** panel with all the buttons for running scripts.

Building an Installer for Multiple Files to Multiple Locations

If you want to share the **Beginning Scripts** panel, there is a problem. The installer .mxi file generated by the Adobe Extension Manager includes all the files in the .assets folder of the panel but does not install the **loadAndRunAction.jsx** file so it appears in the **File > Scripts** menu. You must modify the installer file to include instructions for this.

Making Simple Modifications to the .mxi File

If you look at the **Beginning Scripts** folder in the **Panels** folder, you will see the **Beginning Scripts.mxi** file. As you may recall from Chapter 7, this is an Adobe Extension Information file. It holds the file information about the panel. You can use this file with the Adobe Extension Manager to create a .zxp installer file for your panel like this:

1. Open the **Beginning Scripts.mxi** file in a text editor, such as the ExtendScript Toolkit. The .mxi file is an XML file, which is similar to an HTML file and decently readable.

2. Change the line with the `author` tag so that it lists you as the author:

```
<author name="Jeff Tranberry & Geoff Scott" />
```

3. Change the text between the `descriptor` tags to something more meaningful like "Beginning Scripts" is a panel created as a reference for how to use scripts in a panel.

4. You can change the text for the `ui-access` instructions and add a `license-agreement`. The choice and wording are up to you.

Adding Files to the Installer

The most important part of the .mxi file to modify is the `<files>` section. You change it like this:

5. Copy the line with the `file` tag and paste it below the original one so that the `<files>` section looks like this:

FIGURE 11.6 The Panels folder after all the work has been completed to this point.

```
<files>
        <file source="content" destination="$panels/
Beginning Scripts"/>
        <file source="content" destination="$panels/
Beginning Scripts"/>
</files>
```

6. Change the second file tag to look like this:

```
<file source="myScripts" destination="$Scripts"/>
```

The source folder is a new folder you will create. You will call it **myScripts** and put it in the same folder as the **Beginning Scripts.mxi** file and the **content** folder. The destination is a special shortcut to the **Adobe Photoshop CS5/Presets/Scripts** folder. This can be found in the **mxi_file_format.pdf** file available on the Adobe website and elsewhere.

What this change to the .mxi file means is that any file placed into the **myScripts** folder is copied to the **Scripts** folder in the **Presets** folder by the installer.

7. Save the changes you've made to the **Beginning Scripts.mxi** file.

8. Create a new folder in the same folder as the **Beginning Scripts.mxi** file you are modifying and name the folder **myScripts**.

9. Copy the **loadAndRunAction.jsx** file into the **myScripts** folder.

10. Double-click on the **Beginning Scripts.mxi** file to run the Adobe Extension Manager application.

11. Save the **Beginning Scripts.zxp** file to the **Desktop** and quit the Adobe Extension Manager.

Congratulations. You created a nontrivial panel, all its support files, and the installer that goes with it. You can share this file with others, and it will work the same on their systems as it does on yours.

Twelve

SCRIPTING

Complex Workflows

Working with Events, Files, and Folders and Organizing Your Scripts

Believe it or not, the scripts you've written so far have been fairly simple. Some scripts unlock some of the power of Photoshop. Others integrate into Photoshop or actions or panels built by Configurator. Some of these scripts can save you time and be part of other automation processes. But you still have further to go to really start making useful scripts.

There are techniques to integrate scripts into all Photoshop tasks or just specific ones. There is still the **Batch Processing** dialog to completely replace. There is more you can do with the operating system itself. Combining many of these ideas creates a complex set of tools that you should keep organized to keep them effective. This chapter builds on the foundation of the work you've done so far. After this chapter, you will be ready to build real-world solutions to big problems.

Customizing Photoshop Events

Every time you choose a menu item or click a button in Photoshop, an event gets created representing what just occurred. Partially, the reason is that so many things in the application can be done so many different ways. When you press a keyboard shortcut, that activity creates an event. When you select a menu item, that activity may create exactly the same event. The event is handled by code elsewhere in Photoshop. Events are part of why you can create actions by recording what you do in Photoshop and part of how **Undo** and the **History** panel work.

You already know a lot about customizing how events get created—keyboard shortcuts, menu customizations, actions, panels, scripts, and so on. What you may not know is that you can also customize how Photoshop responds to specific events. The **Script Events Manager** allows you to tie into the Photoshop event system. The **Script Events Manager** listens for events and can play an action or run a script based on the event.

Enabling and Running the Script Events Manager

By default, the **Script Events Manager** is disabled. So a key part of using this feature is to let Photoshop know you want to use it. Here's how:

1. Choose **File > Scripts > Script Events Manager** from the menus to open the **Script Events Manager** dialog.

2. Click the **Enable Events to Run Scripts/Actions** checkbox to enable the feature (see Figure 12.1).

3. Click on the **Photoshop Event** pop-up menu and choose **Open Document** from the menu.

4. Click on the **Script** pop-up menu and choose **Open As Layer** from the menu (see Figure 12.2).

5. Click the **Add** button to add the event and its script response to the list.

6. Click the **Done** button to close the dialog.

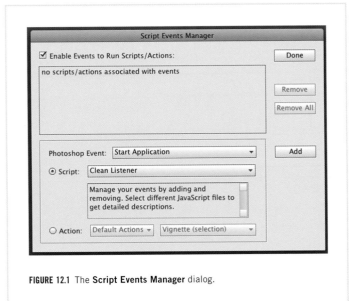

FIGURE 12.1 The **Script Events Manager** dialog.

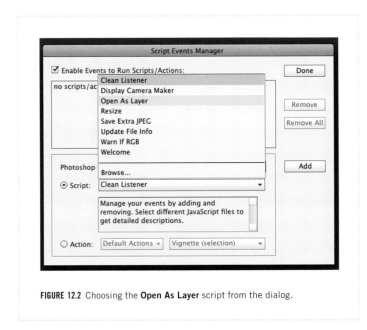

FIGURE 12.2 Choosing the **Open As Layer** script from the dialog.

7. Open a flattened document such as a JPEG file to test that the event and response happen. After you open the document, look at the **Layers** panel. The new document should have a single layer named for the document. You can add a mask to the layer and adjust it as you would any other layer. If the script did not run, the layer would be titled **Background** and you would not be able to change it like a layer.

As you may have noticed, the **Script Events Manager** dialog has a default list of events for you to choose from, most of which are self-explanatory:

- **Start Application**
- **New Document**
- **Open Document**
- **Save Document**
- **Close Document**
- **Print Document**
- **Export Document**
- **Everything**

The **Script Events Manager** dialog also has a list of default scripts that you can attach to Photoshop events:

- **Clean Listener**—Convert Scripting Listener code to Photoshop DOM code. Assign this to **Everything** and then look for the **CleanListener .jsx** file on your **Desktop**.
- **Display Camera Maker**—Display the XMP metadata for the camera make and model.
- **Open As Layer**—Promote a document with only a background layer to a layer with the document's name.
- **Resize**—Open the **Image Size** dialog prepopulated with 100×100 pixels.
- **Save Extra JPEG**—Save an extra JPEG file next to the active document.
- **Update File Info**—Open the **File Info** dialog.
- **Warn If RGB**—Switch the active document's color mode to **RGB**.
- **Welcome**—Show a simple alert.

And, of course, you can expand both of these lists.

Attaching a Script to an Event

Adobe provides a few scripts, but, of course, now that you know how to script, you want to attach your own scripts to events. In the **Script Events Manager** dialog, choose **Browse...** from the **Script** pop-up menu (see Figure 12.3). Then navigate to the script file you want to use.

You also can add your scripts to the items that appear in the **Script** pop-up menu. Place script files into the **Adobe Photoshop CS5/Presets/Scripts/ Event Scripts Only** folder (see Figure 12.4).

Where Is the Folder Located?

Mac OS X:
/Applications/Adobe Photoshop CS5/Presets/Scripts/Event Scripts Only/

Windows XP, 7, and Vista:
\Program Files\Adobe\Adobe Photoshop CS5\Presets\Scripts \Event Scripts Only\

FIGURE 12.3 Browse to use your own scripts.

As with many other customizations you have done, you need to quit and restart Photoshop for any script files added to the **Event Scripts Only** folder to show up in the dialog.

If you add a script to the **Event Scripts Only** folder, it shows up in the pop-up menu using the filename—for example, **removeAllChannels.jsx**. This is not always the most useful and descriptive text to use in an application. However, you can easily add a display name and description to a script as follows:

1. Using the ExtendScript Toolkit, open the **removeAllChannels.jsx** file and add the following code:

```
/* SETUP */
var begDesc="$$$/JavaScripts/removeAllChannels/
Description=Remove all alpha channels from the active
document." // endDesc
```

FIGURE 12.4 The **Event Scripts Only** folder location on the hard drive.

```
var begName = "$$$/JavaScripts/removeAllChannels/
MenuName = Remove All Alpha Channels" // endName

// on localized builds we pull the $$$/Strings
// from a .dat file
$.localize = true;
```

2. Save the file and copy it to the **Event Scripts Only** folder.

3. Quit and restart Photoshop to load the new script file.

4. Choose **File > Scripts > Script Events Manager** from the menus.

5. Choose **Remove All Alpha Channels** from the **Script** menu (see Figure 12.5).

Notice that the title and description appear in the dialog. This approach is much better than using **removeAllChannels.jsx** in the dialog.

Attaching an Action to an Event

The other option for attaching a custom response to an event is to attach an action. The steps work the same way as attaching a script to an event. The action has to be loaded into your **Actions** panel for it to appear in the **Script Events Manager** dialog. Follow these steps to load an action:

1. Choose **File > Scripts > Script Events Manager** from the menus.

2. In the dialog, choose **Save Document** from the **Photoshop Event** pop-up menu.

3. Click the **Action** radio button; then select **Book Actions** from the first pop-up menu and **Resize for Web w/ Organic Border** in the second pop-up menu.

4. Click the **Add** button to attach the action to the event (see Figure 12.6).

5. Click the **Done** button to close the dialog.

6. Open a flat document such as a JPEG file.

7. The open event triggers the script **Open As Layers.jsx**, which promotes the background to a real layer.

8. Choose **File > Save As...** from the menus and save the file as a Photoshop .psd file. Because the document has a layer, this should be the default file format. Click the **Save** button to close the **Save As** dialog.

When you click the **Save** button, this triggers the action that you attached to the event **Save Document**. The action runs and the image is changed according to your action (see Figure 12.7). In this example, the

FIGURE 12.5 The **Remove All Alpha Channels** script in the **Script Events Manager** dialog.

FIGURE 12.6 Attaching an action to an event with **Script Events Manager**.

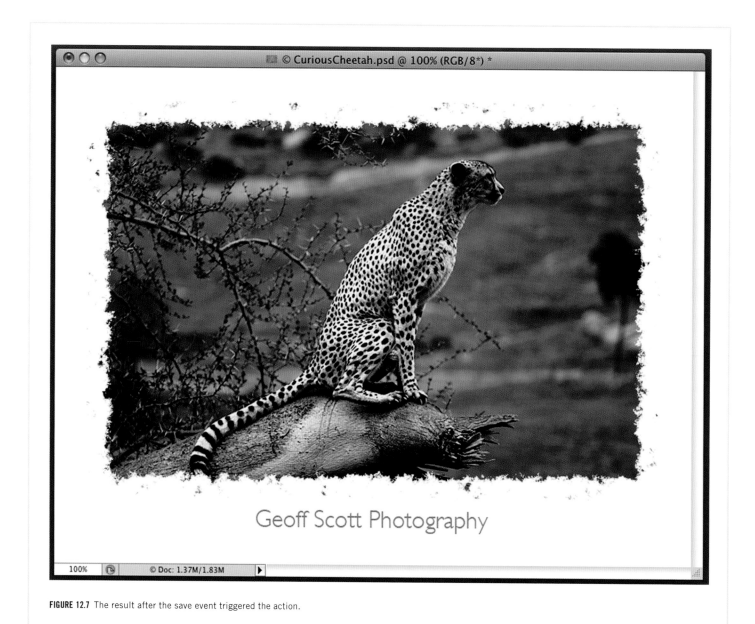

FIGURE 12.7 The result after the save event triggered the action.

document is still the Photoshop .psd file that you saved. The original file has not been changed, nor has the file that you saved.

When might this procedure be useful to you? Imagine you work for a design agency that creates content for catalogs. Saving a new file could trigger an action that resizes and repurposes your image for multiple purposes, such as a file for the printed catalog, one for the online catalog, one for the online thumbnail, and so on. If you create the action well, you could create and save all these extra versions of the image from a single menu selection or keyboard shortcut event.

Adding Custom Events

Adobe includes only a few events in the dialog by default. Fortunately, you can add events for other Photoshop operations. This task is not trivial, so you have to do a bit of work. In this example, you are going to create a script to rename the layer created by a **Layer** > **New Layer By Slice** menu item using the ScriptingListener plug-in, figure out what the event codes are for the **New Layer By Slice** event, and add it using the **Script Events Manager** dialog. Follow these steps to get started:

1. Copy the **ScriptingListener.plugin** file from the **Adobe Photoshop CS5/Scripting/Utilities/** folder to the **Adobe Photoshop CS5/ Plug-ins/** folder.

2. Quit and restart Photoshop to load the plug-in.

3. Open a flat file again. The **Open Document** event promotes a flat document to a layered document.

4. Choose **Layer** > **New Layer Based Slice** from the menus.

5. Change to the **Slice Select Tool**. The tool is stacked with the **Crop** tool, so click to hold down the **Crop** tool, move the mouse cursor to select the bottom tool in the tool stack, and then release the mouse button.

6. Double-click on the image to bring up the **Slice Options** dialog (see Figure 12.8).

7. In the dialog, change the **Name** field to **My Custom Name** and click the **OK** button to close the dialog.

FIGURE 12.8 Slice Options dialog.

8. In the ExtendScript Toolkit, using the template file, create a new file named **autoNameLayerBasedSlice.jsx**.

9. Open the **ScriptingListenerJS.log** file, select the code from the last event, and paste the code into the **autoNameLayerBasedSlice. jsx** file.

10. Wrap the code in a new function named `nameLayerBasedSlice` with the parameter `layerName`.

11. In the function code, find the line near the middle that contains `putString(idNm, "My Custom Name")` and change `"My Custom Name"` to `layerName` as follows:

```
/* FUNCTIONS */

// =========================================
function nameLayerBasedSlice(layerName)
{
    var idsetd = charIDToTypeID( "setd" );
        var desc69 = new ActionDescriptor();
```

```
var idnull = charIDToTypeID( "null" );
    var ref44 = new ActionReference();
    var idslice = stringIDToTypeID( "slice" );
    var idOrdn = charIDToTypeID( "Ordn" );
    var idTrgt = charIDToTypeID( "Trgt" );
    ref44.putEnumerated(idslice, idOrdn, idTrgt);
desc69.putReference( idnull, ref44 );
var idT = charIDToTypeID( "T    " );
    var desc70 = new ActionDescriptor();
    var idNm = charIDToTypeID( "Nm  " );
    desc70.putString( idNm, layerName) );
    var idsliceImageType = stringIDToTypeID
( "sliceImageType" );
    var idsliceImageType = stringIDToTypeID
( "sliceImageType" );
    var idImg = charIDToTypeID( "Img " );
    desc70.putEnumerated( idsliceImageType,
idsliceImageType, idImg );
    var idslice = stringIDToTypeID( "slice" );
    desc69.putObject( idT, idslice, desc70 );
  executeAction( idsetd, desc69, DialogModes.NO );
}
```

12. Add the following code to the **autoNameLayerBasedSlice.jsx** file to make a good script with good error handling and useful information for the title and description:

```
/* SETUP */
var begDesc = "$$$/JavaScripts/AutoNameLayerBasedSlice/
Description=Assign this to the Make Slice event. This will
name the slice with the currently active layer's name." //
endDesc
var begName = "$$$/JavaScripts/AutoNameLayerBasedSlice/
MenuName=Auto Name Layer Based Slice" // endName

// on localized builds we pull the $$$/Strings
// from a .dat file
$.localize = true;
```

```
/* MAIN */
try
{
    //name the slice with the currently active layer's
name
    nameLayerBasedSlice(app.activeDocument.
activeLayer.name);
}
catch(e)
{
    /* something went wrong */
    alert("An unexpected error occurred and the script
did not complete.");
    alert(e);
}
```

13. Copy the **autoNameLayerBasedSlice.jsx** file to the **Event Scripts Only** folder.
14. Quit and restart Photoshop to load your script file.

You created a script to rename a slice. However, you still need to determine the specifics for the event itself.

15. In Photoshop, choose **File** > **Scripts** > **Script Events Manager** from the menus.
16. Notice that the **Auto Name Layer Based Slice** appears in the **Script** pop-up menu. This is the script you just created.
17. Click on the **Photoshop Event** pop-up menu to open it and scroll down to the bottom to select the **Add an Event...** menu item (see Figure 12.9).
18. The **Add an Event** dialog appears (see Figure 12.10). Notice that there are blank fields for the **Event Name** and **Descriptive Label**. You need to determine the event IDs for the **Layer** > **New Layer Based Slice** menu command.
19. Look in the **ScriptingListenerJS.log** file to locate the code two `executeActions` before the code you copied to create the `nameLayerBasedSlice()` function, as shown here:

FIGURE 12.9 The **Add an Event...** menu item in the **Script Events Manager** dialog.

FIGURE 12.10 The **Add an Event** dialog.

```
// =============================================
var idMk = charIDToTypeID( "Mk  " );
    var desc66 = new ActionDescriptor();
    var idnull = charIDToTypeID( "null" );
        var ref41 = new ActionReference();
        var idslice = stringIDToTypeID( "slice" );
        ref41.putClass( idslice );
```

```
    desc66.putReference( idnull, ref41 );
    var idUsng = charIDToTypeID( "Usng" );
        var desc67 = new ActionDescriptor();
        var idType = charIDToTypeID( "Type" );
        var idsliceType = stringIDToTypeID( "sliceType" );
        var idLyr = charIDToTypeID( "Lyr " );
        desc67.putEnumerated( idType, idsliceType,
idLyr );
        var idLyr = charIDToTypeID( "Lyr " );
            var ref42 = new ActionReference();
            var idLyr = charIDToTypeID( "Lyr " );
            var idOrdn = charIDToTypeID( "Ordn" );
            var idTrgt = charIDToTypeID( "Trgt" );
            ref42.putEnumerated( idLyr, idOrdn, idTrgt );
        desc67.putReference( idLyr, ref42 );
    var idslice = stringIDToTypeID( "slice" );
    desc66.putObject( idUsng, idslice, desc67 );
executeAction( idMk, desc66, DialogModes.NO );
```

Event IDs are not always obvious. Usually, two are needed, and they tend to appear near the top of the ScriptingListener code. In this case, the two codes you are looking for are `"Mk "` and `"slice"`. Notice that there are two space characters after the `Mk` in the first event ID string.

20. In the **Add an Event** dialog in Photoshop, type **Make Slice** in the **Event Name** field. This is what is displayed in the **Photoshop Event** pop-up menu in the **Script Events Manager** dialog (see Figure 12.11).

FIGURE 12.11 The **Make Slice** event.

FIGURE 12.12 Attaching a script to the **Make Slice** event.

21. Type **Mk ,slice** in the **Descriptive Label** field. Remember that there are two space characters after the **Mk** characters. This field does not have a good name. What this field really asks for are the two event IDs separated by a comma.
22. Click the **OK** button to close the dialog.
23. In the **Script Events Manager** dialog, be sure that the **Auto Name Layer Based Slice** item is set in the **Script** pop-up menu.
24. Click the **Add** button to attach the script to the event (see Figure 12.12).
25. Click the **Done** button to close the dialog.

Deleting the Script Events Manager Preferences

It should be obvious by now how to remove an individual event from the manager: Select the event in the list and click the **Remove** button. Click the **Remove All** button to remove all the events from the list. You can

disable the **Script Events Manager** feature by clicking to uncheck the **Enable Events to Run Scripts/Actions** checkbox.

All those options are useful and will get you out of a lot of trouble when making custom events. However, when you add new events, as you did for the **Make Slice** event, that information is not so easy to edit or change. The **Script Events Manager** has its own preference file for your developing convenience, in case you need to delete it to start from scratch.

Where Is the File Located?

Mac OS X:

/Users/[user name]/Library/Preferences/Adobe Photoshop CS5 Settings/Script Events Manager.xml

Windows XP:

\Documents and Settings\[user name]\Application Data\Adobe \Adobe Photoshop CS5\Adobe Photoshop CS5 Settings\Script Events Manager.xml

Windows 7 and Vista:

\Users\[user name]\AppData/Roaming\Adobe\Adobe Photoshop CS5\Adobe Photoshop CS5 Settings\Script Events Manager.xml

Working with Files and Folders

Chapter 10 described a few issues related to working with Photoshop documents. Although the terms are used in similar ways in everyday speech, "documents" and "files" are really two different ideas. A *file* is the data stored on a hard drive. The file is formatted a particular way, such as a JPEG or PNG. It has a location in the folder hierarchy of the computer's hard drive. A *document* is the data as it is used in an application such as Photoshop. On the hard drive, the data may be stored as a JPEG file, but in Photoshop, the document is a collection of pixels and other data stored in the computer's RAM. Files are physical bits stored electronically, and documents are abstract data that do not exist when the application quits.

This section describes a few ways to control files using scripting.

Presenting a Dialog to Select a Folder

If you create scripts that do any sort of batch processing, you may want the user to specify the folder where the processed files are saved. You may also want to allow the user the ability to specify which folder full of files will be processed.

In the ExtendScript Toolkit, choose **Help > Object Model Viewer** to open the reference tool. The **Core JavaScript Classes** has an object named **Folder**. Click on the **Folder** object in the list (see Figure 12.13).

This issue may not be clear, but the **Types** list has the **Instance** item selected. If you look through the **Properties and Methods** list, you find all the properties and methods available for an instance of a **Folder**. An instance is a specific object of the class. It is YOUR car, instead of A car.

Your car has a specific license plate number. A car has a license plate. The difference is specific versus generic. Instances have properties, which have specific values. But classes, which are general, have properties and methods that are general to the class. A **Folder** instance has a specific path on the hard drive. The **Folder** class has a **desktop** property, which is the path to the **Desktop** folder. That path does not change, so the property is a class property instead of an instance property.

If you click on the **Class** item in the **Types** list, the **Property and Methods** list changes (see Figure 12.14).

Scroll down the **Properties and Methods** list to find the method **selectDialog()**. This is the call that allows a user to specify a folder. You are going to use it by modifying the script that saved a document as a JPEG

FIGURE 12.13 The **Folder** object instance definition.

FIGURE 12.14 The **Folder** class definition.

file. There are a few twists, but the script is straightforward. In the ExtendScript Toolkit, using the template file, create a new file named **batchSaveJPEG.jsx**.

Next, add some code to ask the user for a folder to process:

```
/////////////////////////////
// MAIN
/////////////////////////////

// ask the user for a folder to process
```

```
var inputFolder=Folder.selectDialog("Choose a folder
to process");
```

Notice that the method call is made on the `Folder` class. The result of the call is `inputFolder`, which is an instance object of type `Folder`.

If the user decides to cancel the dialog for selecting a folder, `inputFolder` is `null`, which is a special value indicating an empty object. If the user selects a folder, a `Folder` instance is returned; otherwise, no object is created and returned from the method. Therefore, it is a good idea to check if `inputFolder` is an object and, if so, check if there are files in this object worth processing.

Add the following code to **batchSaveJPEG.jsx**:

```
if (inputFolder !=null)
{
    // get the files in the folder
    var processList=filterFilesForImages
    (inputFolder);
    if (processList.length>0)
    {
        // since there are image files to process,
        // ask the user for a folder to place the new files
        var outputFolder=Folder.selectDialog("Choose a
folder for the new files")
        if (outputFolder !=null)
        {
            try
            {
                // process all the image files and save them
                processAndSaveFiles(processList,
outputFolder);
            }
            catch(e)
            {
                // something went wrong
                alert("An unexpected error occurred and
the script did not complete.");
                alert(e);
```

```
            }
        }
    }
    else
    {
        // no image files were found, so let the user know
        alert("No images files found in that folder.");
    }
}
```

The `inputFolder` is passed to a function you have not written yet called `filterFilesForImages()`, which returns an array of files that are all image files that can be opened in Photoshop. If that list is not empty, the user is asked for an output folder in which to save all the processed files. If the user did not cancel the dialog, the files are processed and saved in another function you have not written yet named `processAndSaveFiles()`.

The next step is to write the `filterFilesForImages()` function to create a list of image files. Add the following code to **batchSaveJPEG.jsx**:

```
/////////////////////////
// FUNCTIONS
/////////////////////////

// function to filter for image file formats
function filterFilesForImages(myFolder)
{
    var returnFileList=new Array();
    var fileList=myFolder.getFiles();
    for (var i=0; i<fileList.length; i++)
    {
        // check if the file is an image file
        if (isImageFile(fileList[i]))
        {
            // add the file to the return list
            returnFileList.push(fileList[i]);
        }
    }

    return returnFileList;
}
```

This function creates an empty array so that a list can be returned. The list of files in the folder is obtained with the `getFiles()` method. The loop goes file by file and checks whether the file is an image file. The `isImageFile()` function has not been written yet, but it is next. If the file is an image file, the file is pushed into the array that is returned to the function.

> The `push()` method is a way to add items to the end of the existing array by extending the length of the array.

Now add the following code to **batchSaveJPEG.jsx**:

```
/////////////////////////
// SETUP
/////////////////////////
// a list of file extensions for image file formats
var gImageFileExtensions=new Array("jpg", "jpeg",
"gif", "png", "tif", "tiff", "psd");
```

The `gImageFileExtensions` array of file extensions is incomplete. However, these are the most common extensions for image files. You can add file extensions that you use to the list.

Add the following code to **batchSaveJPEG.jsx** in the FUNCTIONS section:

```
// check if a file is a known image file format
function isImageFile(myFile)
{
    var retVal=false;

    // first test if myFile is a file and not a hidden file
    if (myFile instanceof File && !myFile.hidden)
    {
        // get the file extension from the file
        var fileExt=getFileExtension(myFile);

        // check if the file extension is an image extension
```

```
        for (var i=0; i<gImageFileExtensions.length;
i++)
        {
            if (fileExt == gImageFileExtensions[i] )
            {
                // found it, so break out of the loop
                retVal=true;
                break;
            }
        }
    }

    return retVal;
}

// return the file extension of a file
function getFileExtension(myFile)
{
    var fileExt="";

    // dissect the file name to see if it has a file extension
    var lastDot=myFile.name.lastIndexOf(".");
    if (lastDot>0)
    {
        // find the file extension
        var strLength=myFile.name.length;
        fileExt=myFile.name.substr(lastDot+1,
strLength - lastDot);
        fileExt=fileExt.toLowerCase();
    }

    return fileExt;
}
```

The `isImageFile()` function starts by checking if `myFile` is an instance of the class `File`. The `instanceof` operator is similar to the `typeof` operator, which you've seen before. The `instanceof` operator tests for a specific class instead of returning the data type of a variable. In this case, `typeof` would simply return `object`, which is not specific enough.

Next, the `isImageFile()` function calls the `getFileExtension()` function to get the file extension. With the file extension, the function loops through all the known image file extensions checking for a match. If a match is found, the loop stops because of the `break` command, which immediately ends the loop and jumps outside its code block. If a match is found, then a value of `true` is returned; otherwise, a value of `false` is returned.

The next function processes a list of files. To include this function, add the following code to **batchSaveJPEG.jsx**:

```
// wrapper function to process and save a list of files
function processAndSaveFiles(fileList, outputFolder)
{
    for (var i=0; i<fileList.length; i++)
    {
        processFile(fileList[i], outputFolder);
    }
}
// process the file and save it in the outputFolder
function processFile(myFile, outputFolder)
{
    try
    {
        var saveDialogMode=app.displayDialogs;
        app.displayDialogs=DialogModes.NO;

        // open the file in Photoshop without dialogs shown
        app.open(myFile);

        // process the document
        // ** in this case nothing **

        // convert the document to save it as a JPEG in sRGB
        app.activeDocument.flatten();
        app.activeDocument.channels.removeAll();
        app.activeDocument.pathItems.removeAll();
        app.activeDocument.changeMode(ChangeMode.RGB);
        app.activeDocument.bitsPerChannel=BitsPer
ChannelType.EIGHT;
```

```
        app.activeDocument.convertProfile("sRGB
IEC61966-2.1", Intent.RELATIVECOLORIMETRIC);

        // use the default JPEG options for saving
        var myJPEGOptions=new JPEGSaveOptions();

        // save the file in the outputFolder
        var newFileName=getFileNameWithoutExtension
(app.activeDocument)+".jpg";
        var newFile=new File(outputFolder+"/"+
newFileName);
        app.activeDocument.saveAs(newFile,
myJPEGOptions, true);

        // close the document
        app.activeDocument.close(SaveOptions.
DONOTSAVECHANGES);
        app.displayDialogs=saveDialogMode;
    }
    catch(e)
    {
        // something went wrong
        alert("An unexpected error occurred processing
the file "+myFile.name);
        alert(e);
    }
}

// return the file name without the file extension
function getFileNameWithoutExtension(myFile)
{
    var fileExt="";

    // dissect the file name to see if it has a file extension
    var lastDot=myFile.toString().lastIndexOf(".");
    if (lastDot>0)
    {
        // find the file extension
        var strLength=myFile.name.length;
        fileExt=myFile.name.slice(0, lastDot -
strLength - 1);
```

```
        fileExt=fileExt.toLowerCase();
    }

    return fileExt;
}
```

The `processAndSaveFiles()` function simply loops through the file list. It is the `processFile()` function that does the work. Notice that `app.displayDialogs` is set to `DialogModes.NO`. Actions are able to toggle dialogs on and off. This property of `app` does the same type of thing. Opening images can lead to color profile mismatch dialogs. The various processes done to the image can also kick up dialogs. Because this script is meant to be like a batch process, it is written to fire and forget as it processes away on the folder of image files. At the end of the `processFile()` function `app.displayDialogs` is set back to its saved value, basically returning the runtime environment back to its original settings.

Most of the `processAndSaveFiles()` function is code that you have written before. The function does not really process the files other than convert them for saving as an sRGB JPEG file. Notice that the `outputFolder` variable is used when creating the `File` object for the `saveAs()` function.

There is also `getFileNameWithoutExtension()`, which does exactly what you think. The function works with strings just like `getFileExtension()` does.

That may seem like a lot of work to explain the `Folder.selectDialog()` method. Keep in mind all the other ideas introduced by this long script. Each script you write comes with new pieces of code, which you can use in other scripts. There are a bunch of functions in **batchSaveJPEG.jsx** that can be repurposed or copied as is. Although the script does not do much to the input images, you wrote a batch process. Now instead of using the **Batch Process** dialog, you can copy this file, make a few adjustments, and have a way to batch easily.

Presenting a Dialog to Select a File

Displaying a dialog to select a single file is straightforward. You can probably guess the procedure. Just as `Folder` has class methods, so does the `File` class. It has a method called `openDialog()`. You could add code like the following to any script to have the user select a specific file:

```
// ask the user to select a file
var sourceFile=File.openDialog("Select a source file");
```

The `openDialog()` method returns an instance object of the `File` class, just like the `Folder.selectDialog()` returns a `Folder` instance.

Creating Folders Using the `folder` Object

You've been writing scripts that deal with folders that already exist. It can be useful to have your script create a folder that does not exist on the hard drive. You may have noticed that both `Folder` and `File` objects are created with paths to their location. Although the object is created in the runtime environment of the script, that does not mean the file or folder actually exists on the hard drive. To instruct the operating system to actually create a folder, you must call the `create()` method on a `Folder` instance. The `create()` method then checks the object's path and asks the OS to create the folder (or file) to match the path. If the folder already exists, then nothing happens. No new folder is created, and nothing happens to its contents.

Suppose you want to create a folder on the **Desktop** for processed images. You might write code like this:

```
var processedImagesFolder=new Folder(Folder.
desktop+"/processed");
processedImagesFolder.create();
```

Creating and Writing Text Files

Creating files on the hard drive is about as simple as creating a folder. Files are opened, however, instead of created. The tricky part is writing data to the files. Suppose you want to have a log file that details the files processed as part of your batch script. You could modify the processAndSaveFiles() function in the **batchSaveJPEG.jsx** file like this:

```
// wrapper function to process and save a list of files
function processAndSaveFiles(fileList, outputFolder)
{
    try
    {
        // create a log file recording files processed
        var logFile=new File(outputFolder+"/
processed.log");
        logFile.open("w");
        logFile.write("Image files processed by the
script:\n");

        for (var i=0; i<fileList.length; i++)
        {
            processFile(fileList[i] , outputFolder);
            logFile.write(fileList[i] .name+"\n");
        }

        logFile.close();
    }
    catch(e)
    {
        // something went wrong
        alert("An unexpected error occurred processing
the files!");
        alert(e);
    }
}
```

The logFile variable is specified to be inside the outputFolder with the name processed.log. The open() method on the logFile creates the file and opens it for writing. That's what the "w" parameter

means to the method. The open() method has a bunch of options and subtleties to it. Look up the File.open() method in the **Object Model Viewer** for the details. With the preceding code, the file is opened just for writing. The code, in fact, writes a text header to the file stating "Image files processed by the script\n". That "\n" is important. That is the newline character. Files are easier to read if they have some formatting.

As each image file is processed, its name is written to the log file, followed by a newline for formatting. After the loop walks through all the files for processing, the logFile is closed. The close() is important.

Failure to close a file can lead to problems on the hard drive. It isn't that you will erase the hard drive or corrupt it, but you might confuse it. The hard drive may decide that the file should stay open, which might mean you lose that small amount of hard drive space. It is hard to say what really happens. The safest and best approach is to always call close() on an open file after you finish with it.

Copying Files

Sometimes letting the operating system copy a file is easier than opening the file using the Photoshop DOM and saving the file to a new location. Look up the File.copy() method in the **Object Model Viewer** for details. The basics are simple. You could modify the processAndSaveFiles() function in the **batchSaveJPEG.jsx** file by adding the following code after the logFile.close(); code:

```
// create a copy of the file on the Desktop
logFile.copy(Folder.desktop+"/"+logFile.name);
```

Designing and Organizing Your Scripts

As you write more code, you might start to notice certain patterns and coding ideas that repeat themselves. These are ideas you can use to help make future scripts easier to write. The key is recognizing the code

that can be general-purpose code and separating it from the code that is very specific for a task. Part of this process is to approach creating a new script the same way each time and to have around a few files you can always rely on.

Pseudo Code

Earlier you learned that comments can help you write your code. In the examples, the purpose of the comments has mostly been to explain what the code was doing, so you could learn new concepts. You might think that comments are the last part of the code written. It does not have to be that way. Comments can be the first things you write in an empty script file. These comments are instructions to you to start deciding on the flow of the work that will be done to solve the problem your script is answering. This is commonly known as *writing pseudo code.*

Pseudo code is a cross between human writing and JavaScript code. Take a look at the comments in the **batchSaveJPEG.jsx** file with all the code stripped away:

```
// a list of file extensions for image file formats

// ask the user for a folder to process
    // get the files in the folder
        // since there are image files to process,
        // ask the user for a folder to place the new files
            // process all the image files and save them

// function to filter for image file formats
        // check if the file is an image file
            // add the file to the return list

// check if a file is a known image file format
    // first test if myFile is a file and not a hidden file
        // get the file extension from the file
        // check if the file extension is an image extension
            // found it, so break out of the loop

// return the file extension of a file
    // dissect the file name to see if it has a file
extension
```

```
        // find the file extension

// wrapper function to process and save a list of files
        // create a log file recording files processed
        // create a copy of the file on the Desktop

// process the file and save it in the outputFolder
        // open the file in Photoshop without dialogs shown
        // process the document
        // ** in this case do nothing **
        // convert the document to save it as a JPEG in sRGB
        // use the default JPEG options for saving
        // save the file in the outputFolder
        // close the document

// return the file name without the file extension
    // dissect the file name to see if it has a file
extension
        // find the file extension
```

Using these comments as a starting point, you could figure out where the loops belong and add comments such as `// loop through all the files in the folder`. The comments explain the way the problem is broken down. As a result, you can more easily see beforehand which functions need to be written. If a function seems familiar, you might be able to find it in other scripts you've written.

There are two big ideas for pseudo code: figuring out the problem before you start writing code and recognizing where code can be reused so you do not have to solve the same problem again. Code reuse is like using keyboard shortcuts—it saves you time.

Template Files

As explained in Chapter 8, having a template file that you use as the basis for all your script files can be helpful. This idea was encouraged with each example. The idea is to make it easier for you to start writing code. A template file takes care of telling the runtime environment that you are coding for the Photoshop application using the `#target Photoshop`

line. All your scripts need that line of code. Why rewrite it every time and possibly forget it?

The template is a rough tool, but it does help you organize your code. In particular, it helps keep the functions separated from the main code. Did you notice that the code placed in MAIN is not in a function? It is really just free-standing code run from the top of the file to the bottom of the file. There is a reason variables, such as gImageFileExtensions, are put at the top of the file in a SETUP section. That code is run first, which allows any other code in MAIN or a function to access it.

The bottom line is that templates save you time. Notice a pattern so far?

Factoring Out Useful Functions

The **batchSaveJPEG.jsx** file has a lot of functions. There are reasons for that. In some cases, the functions are generic and can be used elsewhere—for example, the getFileExtension() function. That function could be copied and pasted into another script and work exactly the same way. Other functions help break down the large problem into smaller bits. The processFile() function is the place where the real work is done on each file. But notice that although that work is specific, getting to that point is fairly generic. Basically, the script loops through a bunch of files, separates out a list of the image files, loops through those files, and processes them. Very little needs to change if the processing needs to be done differently. Very little needs to change if different file types need to be found.

Figuring out which parts of solving the problem are functions and which of those are generic takes time and experience. The more code you write, the more code you read, the more you will be able to recognize what might be useful in other problems. And the more you'll recognize how a lot of problems have similar solutions.

Creating a Library File

One way to organize your most common functions is to build *library files*. A library file is simply a .jsx file full of functions. If the file is run, nothing happens. It has no main code. All the code is encapsulated in the functions. The getFileExtension() and getFileNameWithoutExtension() functions are good candidates for a library file. The file might be full of functions that deal with manipulating filenames. You might have a library file for saving documents using different file formats. You might remember doing similar things with your actions such that one action called another to save a file as a JPEG file but did not process the document otherwise.

There are conventions used with library files. Most library files include the word **Lib** in the filename. An example might be **FileNameLib.js.** That **.js** is another convention. The file extension indicates that the file contains JavaScript code, but because it is missing the **x** on the end, it means that the code is not executable.

> Start all library filenames with the tilde character (~). The tilde signals to Photoshop not to load the file into the **File** > **Scripts** menu. So you can place ~ **FileNameLib.js** into the **Presets/Scripts** folder without worrying about it cluttering up the **File** > **Scripts** menu.

Loading in Library Files and Referencing Nearby Files

Separating out the functions into a library file is easy: Just cut and paste from one file to another. Loading the library file so that your script can use the functions inside it is more work. Suppose you take the getFileExtension() and getFileNameWithoutExtension() functions out of the **batchSaveJPEG.jsx** file and save them in the ~ **FileNameLib.js** file. Assume that the ~**FileNameLib.js** file is stored in the same folder as the **batchSaveJPEG.jsx** file. The following code loads the library file so the function can be used:

```
/////////////////////////
// SETUP
/////////////////////////

// get the path to this script file
var scriptPath = $.fileName;
```

```
// create a file object for the script
var myScriptFile=new File(scriptPath);
```

```
// load in the library file, located in the same folder
$.evalFile(myScriptFile.parent+"/~FileNameLib.js");
```

Both `$.fileName` and `$.evalFile()` are new to you. If you look in the **Object Model Viewer** at the **Core JavaScript Classes**, the first class in the list is the `$` class (see Figure 12.15).

This general-purpose class has lots of global properties and methods. Explore as needed. The `$.fileName` property provides the path to the script file itself. The `$.evalFile()` method loads and runs the file specified. In the preceding code, the file is a library file, so no code is run, but all the functions are loaded. For that reason, any code following the `$.evalFile` method can call the functions.

Creating library files is easy, and they are simple to use. They can be a big timesaver for you and a great way to organize the code you write.

FIGURE 12.15 The `$` class definition.

EXPLORATIONS

The `$` object class has many useful properties and methods. The class can be useful when troubleshooting (also known as *debugging*) your scripts. The `$.writeln()` method was described in the "Explorations" section for Chapter 8 for just that reason. The `$` has other methods just as useful, including information about using the JavaScript engine, stopping for break points, and setting debugging flags to get even more information at runtime.

Use the **Object Model Viewer** to examine the `$` class. Also use the **Object Model Viewer** to look at the descriptions of the **Global Elements** category of the **Core JavaScript Classes**. You'll notice a few familiar functions. Unfamiliar classes `Reflection` and `ReflectionInfo` can also be helpful during debugging.

Take some time to explore all the classes in the **Core JavaScript Classes** list. There are real gems to be found here. You'll use many of them regularly, but for others, it is useful just to know about them in the strange cases in which they are the only tool able to help you build a solution or troubleshoot a problem.

Thirteen

BUILDING

Custom Dialogs

Using Scripting to Build Your Dialogs

In Photoshop, you can create your own dialogs using scripting. When you build a custom panel using Configurator, you drag and drop the controls onto the panel and then fill in some values for certain properties. Maybe you write a script to fill out the functionality. Configurator is a visual editor for building panels. To build a custom dialog, you have to do everything in code. The good news is that many things are already done for you. The ScriptUI classes handle a lot, but you still have to put it all together.

Something many people do not realize is that some Photoshop pieces are built using scripting. These custom dialogs built by Adobe are located in the **File** > **Automate** and **File** > **Scripts** menus. You may recognize a few of them. Look even closer and you may see how you can easily spot a dialog built with a script:

File > **Scripts** > **Script Events Manager...** (see Figure 13.1)

File > **Automate** > **Fit Image...** (see Figure 13.2)

File > **Scripts** > **Export Layers To Files...** (see Figure 13.3)

File > **Automate** > **Image Processor...** (see Figure 13.4)

FIGURE 13.2 The **Fit Image** dialog.

FIGURE 13.1 The **Script Events Manager** dialog.

FIGURE 13.3 The **Export Layers To Files** dialog.

FIGURE 13.4 The **Image Processor** dialog.

FIGURE 13.5 The **Merge to HDR Pro** dialog.

FIGURE 13.6 The **Photomerge** dialog.

File > Automate > Merge to HDR Pro... (see Figure 13.5)

File > Automate > Photomerge... (see Figure 13.6)

As you can see, some major features take advantage of scripting to build their user interfaces. Don't let the complexity of those dialogs or the heavy lifting that these features do scare you. You've been writing scripts now. You are capable of doing this.

Making a Simple Dialog

When you start something new, it's best to start with something small. Your first script showed the simple message **Hello, World**. Your first custom dialog will, too. Dialogs are a step beyond the

scripts you've been writing. You built user interfaces using the Configurator, but that really did not include interacting with the user beyond responding to clicked buttons. As you worked through the scripting examples, you added in more decision-making code and included user interaction more and more often. The batch processing script asked the user directly to select folders. Dialogs go beyond all these examples, however.

Dialogs interrupt the current workflow, such as when you have to choose the JPEG Options when saving a JPEG file. Dialogs also respond to the controls within them while the dialogs are open. Other controls may update values displayed or enable new controls in response to clicks from the user. Creating all this interaction is not difficult. It starts with creating a simple dialog.

Using the ScriptUI Classes

In ExtendScript's **Object Model Viewer**, one of the groups of classes listed in the first pop-up menu is the ScriptUI classes (see Figure 13.7). This group is what you use to build user interfaces using ExtendScript.

You should recognize a few of the classes defined in this group just from terms used in this book, and from your own computer travels—for example, `Button`, `Checkbox`, `Event`, `Panel`, `Slider`. The first dialog you build is simple and will include a few of these classes. The second dialog is more complex, including more of the classes.

Understanding How Dialogs Work

No matter how simple or complex, all dialogs behave in the same essential way from a coding perspective. The dialog is built. The dialog is displayed. The dialog is closed, and the results are processed.

Building a dialog is all setup. Initial conditions are checked, such as whether a document is currently open. Information needed to build the dialog is gathered from Photoshop, an open document, or wherever. The dialog itself is built object by object before it is displayed. This is almost like the way you specify a `Folder` object before it is created or opened. The dialog is an object that contains other objects. Each of these pieces must be created and told about each other. There is more to this procedure than just placing a control in a window. The control and the window might need to communicate with each other. All this is part of the setup done before the dialog is displayed to the user.

When a dialog is displayed to a user, all other activities in the application stop. This is known as *being in a modal state*. The application is stuck in a single mode of action until something changes to end the mode. You see this every time you do something like choose **File** > **Save As...** from the menus and a dialog opens asking where you want to save the document, what to name the document, and what file format to use when saving it. The same is true when you choose **Image** > **Image Size...** from the menus. A dialog opens and nothing else can be done in the application until the **OK** or **Cancel** button is clicked. Nearly all the menus are disabled, so you cannot even quit the application when a modal dialog is up.

While the dialog is displayed, the user interacts with the controls in the dialog. If the dialog is a simple alert, the interaction is limited to the **OK** button. Until that button is clicked, the dialog (and the rest of the application) waits for the user. After the button is clicked, the dialog can respond.

At some point, the user interacts with the dialog in a way that causes it to close. That interaction usually involves clicking an **OK** or **Cancel** button (or their equivalents). The dialog closes, but it also creates some data to be used as the code continues to process commands.

Defining a Dialog Window

A dialog is actually a window in the same way that a truck is a car. A dialog is a special type of window but is still a general object. The object you build for a dialog is a `Window` object.

FIGURE 13.7 The ScriptUI classes in the **Object Model Viewer**.

In the ExtendScript Toolkit, using the template file, create a new file named **helloWorldDialog.jsx** and add the following code:

```
/////////////////////////
// SETUP
/////////////////////////

// ** dialog stage #1 - build the dialog **

// create the dialog object and its UI objects
var theDialog = createHelloWorldDialog();
```

The first stage of how dialogs work is the setup to build the dialog, so the code to build the dialog begins in the SETUP section of your script. Next, you write the createHelloWorldDialog() function. To do that, add the following code to **helloWorldDialog.jsx**:

```
/////////////////////////
// FUNCTIONS
/////////////////////////

// create a simple Hello World dialog
// with an OK and Cancel button
function createHelloWorldDialog()
{
    // create an empty dialog window
    var myDialog = new Window('dialog', "Hello, World");

    // place the dialog 100px from the left
    // and 100px from the top
    myDialog.frameLocation =[100, 100];
```

This function is not complete yet. All that has happened so far is that a Window object has been created. The Window is a 'dialog' type. You can find other types in the *JavaScript Tools Guide* provided with the ExtendScript documentation provided by Adobe. Note that the single quotation marks used in this code example are a convention indicating that the string is a type instead of text. The type string can use double quotation marks just like any other string.

After creating the dialog, you set a location on the screen where it will be displayed.

Adding UI Elements to a Dialog

When the Window object exists, you can add controls and other user interface elements to it. Without these extra objects, the dialog is simply an empty window with a title bar, which in this case states **Hello, World**. Add the following code to **helloWorldDialog.jsx**, completing the createHelloWorldDialog() function:

```
    // add a group box for formatting the buttons into a row
    myDialog.buttonPanel = myDialog.add('panel');
    myDialog.buttonPanel.orientation = "row";

    // add a Cancel button
    myDialog.buttonPanel.cancelButton = myDialog.
buttonPanel.add('button', undefined, "Cancel");

    // add an OK button
    myDialog.buttonPanel.okButton = myDialog.
buttonPanel.add ('button', undefined, "OK");

    return myDialog;
}
```

You can add your own properties to instances. In the first part of the preceding code, you add a property called buttonPanel to myDialog and then set it to the panel object that is added to the dialog by using the add('panel') method call. Names are important and should be descriptive, just like variable names are descriptive. With user interface objects, the names can be referred to a lot, so it helps to know exactly which object is which.

The object added to the dialog is a 'panel', which like 'dialog', is detailed with other types in the *JavaScript Tools Guide*. A panel is basically a box for you to place other controls inside. The panel helps to organize and place the controls in the dialog. In this case, the panel orientation is set to "row" so that all controls added to it are placed in a row from left to right.

The **Cancel** and **OK** buttons are added next. Notice that they are added to the buttonPanel, not to the dialog directly. This places them in the buttonPanel, and the "row" orientation of the buttonPanel calculates where to place the buttons.

What you've done in the code so far is build the visual design of the dialog. You've created objects that are placed inside one another relative to one another. Notice that no pixel dimensions for size or location are specified. They aren't necessary. The objects size themselves according to information such as the text displayed or the size of the objects in the panel. The ScriptUI takes care of all this for you.

Adding Events to Buttons

The next step is to write the code for the interactive design of the dialog. This is the response of each control, when the user interacts with that control. What happens when the **OK** button is clicked? What happens when the **Cancel** button is clicked? At this point, these interactive behaviors have not been specified.

To add this behavior to the dialog, add the following code to **helloWorldDialog.jsx**:

```
// initialize a Hello World dialog so its buttons
// do something when clicked
function initHelloWorldDialog(myDialog)
{
    with (myDialog)
    {
        // OK button clicked
        buttonPanel.okButton.onClick = function()
        {
            // Close the dialog and return that the
            // OK button was clicked
            close(1);
        }

        // Cancel button clicked
        buttonPanel.cancelButton.onClick = function()
        {
            // Close the dialog and return that
            // the Cancel button was clicked
            close(2);
        }
    }
}
```

Each of the buttons has a function assigned to its onClick property. This code lets the runtime environment know that when the button is clicked, it needs to look at the button's onClick function and run the code in that function. Put another way, in this function, you declare functions and assign them to a variable. That variable is referenced only when the user interacts with that object. The code in the button object figures out that the user clicked the button and then looks up what to do for that behavior.

Buttons are simple objects. They do not have a lot of behaviors associated with them. A pop-up menu has a lot more going on. So do other objects like editable text. In this code, each button does almost exactly the same thing—close the dialog and pass back a number. The close() function is the stop function for the modal state of a dialog. Not only is the dialog not shown anymore, but the rest of the script can continue. The numbers represent which button was clicked to close the dialog. This information is important to the calling code. **OK** means to process. **Cancel** means to stop. This dialog has two buttons. Other dialogs have three buttons, each with a different meaning for the code that showed the dialog.

> Notice the use of the with operator. You don't need to keep typing myDialog. for each object. The with is shorthand for stating that each object referenced is a subobject of the object in the with parentheses.

Add the following code to **helloWorldDialog.jsx** in the SETUP section, below the call to the createHelloWorldDialog() method:

```
// hook up the dialog to respond to events
initHelloWorldDialog(theDialog);
```

This code is straightforward. Your code must call the function that sets up the interactive behavior after the dialog is created and before it is shown to the user.

Showing a Dialog

At this point, you have successfully created the dialog in the code. Now you need to write the code to show it. Showing the dialog places the application into a modal state preventing anything else until the dialog closes.

Add the following code to **helloWorldDialog.jsx** in the FUNCTIONS section:

```
// show the dialog and wait for its return value
function runHelloWorldDialog(myDialog)
{
    // Display the dialog
    return myDialog.show();
}
```

The code does not need to do much. More complex dialogs may do more in this stage. For the most part, though, all the code for this second stage of dialogs is taken care of for you. The code just needs to call show() to place it in front of the user. The code for the interaction and the waiting are already taken care of.

Next, add the following code to **helloWorldDialog.jsx**:

```
/////////////////////////
// MAIN
/////////////////////////

// ** dialog stage #2 - display the dialog **

if (runHelloWorldDialog(theDialog) == 1)
{
    // user pressed OK button

    // ** dialog stage #3 - process the dialog results **
    processHelloWorldResults(theDialog);
}
```

FIGURE 13.8 The **Hello, World** dialog shown in the runtime environment—Photoshop.

The code here is again simple. The runHelloWorldDialog() method is called. Its return value is compared to 1. This code checks whether the user clicked the **OK** button to close the dialog. If the **OK** button was clicked, then the processHelloWorldResults() function is called. This is a function you write in the next section. If the **Cancel** button was clicked, the code does nothing special.

As you should expect, there is not much to this dialog when it is shown (see Figure 13.8). The panel is shown as the box with a slight border to it inside the dialog. The two buttons are in the panel in a row. Nothing too special. Nothing too complex. Yet a good place to start.

Processing the Results

The dialog is closed when the user clicks the **OK** button or the **Cancel** button. If the **OK** button is clicked, the results of the dialog need to be processed (otherwise, what is the point of the dialog?). Because this is just a simple dialog with no real purpose or task to perform, the processing is simple.

FIGURE 13.9 The processed results of the **Hello, World** dialog.

Add the following code to **helloWorldDialog.jsx** to the FUNCTIONS section:

```
// process the dialog results by showing a message to the user
function processHelloWorldResults(myDialog)
{
    alert("You pressed the OK button.");
}
```

The code shows an alert dialog, as in Figure 13.9, just to verify to you, the developer, that the **OK** button was clicked to close the dialog.

So why put the alert() call in its own function? Habits and code organization are the answers. This code example has a few functions: createHelloWorldDialog(), initHelloWorldDialog(), runHelloWorldDialog(), and processHelloWorldResults(). Each function has a specific place in the three stages of the dialog. The code that uses these functions is simple. That code does not ever really need to change, regardless of the complexity of the dialog you create. It is only the functions that become complex as the dialog gets more complex. Separating the processing code in this example is simply a way to build a template for future dialog code.

Making a Complex Dialog

The **Hello, World** dialog is simple. This next dialog that is intentionally not yet is also close to being a real-world dialog that you might use every day. This is a longer code example to show the use of many different types of controls. This dialog gathers data for creating a High Pass layer, which can sharpen or blur a document (see Figure 13.10). When finished, the processing code checks the results and reacts accordingly.

FIGURE 13.10 The **Create a High Pass Layer** dialog.

In the ExtendScript Toolkit, using the template file, create a new file named **highPassDialog.jsx** and add the following code:

```
/////////////////////////
// SETUP
/////////////////////////

// ** dialog stage #1 - build the dialog **

// create the dialog object and its UI objects
var theDialog = createHighPassDialog();

// hook up the dialog to respond to events
initHighPassDialog(theDialog);
```

```
/////////////////////////
// MAIN
/////////////////////////

// ** dialog stage #2 - display the dialog **

if (runHighPassDialog(theDialog) == 1)
{
    // user pressed OK button

    // ** dialog stage #3 - process the dialog results **
    processHighPassResults(theDialog);
}
```

This code should look familiar. The names of the functions are slightly different from those in the **Hello, World** dialog, but otherwise the code is the same.

Adding a Panel with a Label

For the next step, add the following code to the FUNCTIONS section in **highPassDialog.jsx**:

```
/////////////////////////
// FUNCTIONS
/////////////////////////

// create a dialog for creating a High Pass layer
function createHighPassDialog()
{
    // create an empty dialog window
    var myDialog = new Window('dialog', "Create a High
Pass Layer");

    // place the dialog 100px from the left
    // and 100px from the top
    myDialog.frameLocation =[100, 100];
    myDialog.orientation = "row";
    myDialog.alignChildren = "top";
```

```
    // add a group box for the new layer options
    myDialog.optionsPanel = myDialog.add('panel',
undefined, "Options");
        myDialog.optionsPanel.orientation = "column";
        myDialog.optionsPanel.alignChildren = "left";
```

This code is nearly identical to the code for the **Hello, World** dialog. This time, when you call add() for the 'panel', there are two extra parameters. The first is for the bounds of the panel, which is set here to undefined. You want the ScriptUI code to calculate the properties such as bounds, size, and location. Passing in undefined is a signal to the method to do so. The next parameter is a string that is placed in the upper-left corner of the panel, interrupting the border.

Notice that myDialog has its orientation property set to "row". The dialog also formats its children containers and controls, just like the panel does. The myDialog property alignChildren specifies how the child objects are aligned. The dialog places objects in a row, so the choices for alignChildren are "top", "bottom", and "fill". The optionPanel has its orientation set to "column" and its alignChildren property set to "left". The options for a "column" are "left", "right", and "fill". All these settings and the ones with the other objects later in the function help to format the dialog to look more professional.

Adding Radio Buttons

A *radio group* with its radio buttons is a collection of options, wherein only one option can be chosen. Click one radio button and the previously selected option is unselected. Selecting one of these buttons is like filling in the bubbles on a multiple-choice test: There can be only one bubble filled in, only one selection.

To include radio buttons to the dialog, add the following code to the createHighPassDialog() function of **highPassDialog.jsx**:

```
    // add radio button group for sharpen vs blur choice
    myDialog.optionsPanel.choiceRadioButtons = myDialog.optionsPanel.add('group');
    myDialog.optionsPanel.choiceRadioButtons.orientation = "row";
    myDialog.optionsPanel.choiceRadioButtons.alignChildren = "top";

    // add text for user instructions
    myDialog.optionsPanel.choiceRadioButtons.staticText =
myDialog.optionsPanel.choiceRadioButtons.add('statictext', undefined, "Select operation to perform:");

    // create a group to align the radio buttons
    myDialog.optionsPanel.choiceRadioButtons.radioGroup =
myDialog.optionsPanel.choiceRadioButtons.add('group');
    myDialog.optionsPanel.choiceRadioButtons.radioGroup.orientation = "column";
    myDialog.optionsPanel.choiceRadioButtons.radioGroup.alignChildren = "left";

    // add a radio button with a label of 'Sharpen'
    myDialog.optionsPanel.choiceRadioButtons.radioGroup.radioButtonSharpen =
myDialog.optionsPanel.choiceRadioButtons.radioGroup.add('radiobutton', undefined, "Sharpen");
    myDialog.optionsPanel.choiceRadioButtons.radioGroup.radioButtonSharpen.value = true;

    // add a radio button with a label of 'Blur'
    myDialog.optionsPanel.choiceRadioButtons.radioGroup.radioButtonBlur =
myDialog.optionsPanel.choiceRadioButtons.radioGroup.add('radiobutton', undefined, "Blur");

    // add a tooltip with a description for instructions
    myDialog.optionsPanel.choiceRadioButtons.helpTip = "Choose which operation to perform.";
```

Each 'radiobutton' is created in a 'group' object. Radio buttons in a group force only one of the buttons to be selected at a time. The selected button has a value of true. A value of false means the button is not selected. This value mostly has meaning when processing the dialog results. During the dialog setup, setting a radio button to true is the way you specify which option is the default option.

Also note that a 'group' is like a 'panel', but a 'group' does not draw a border around itself.

The code includes some formatting. It also includes a 'statictext' object, which displays a string in the dialog.

There is also a helpTip property set. This string is used as a tooltip when the mouse pointer is over the control, providing more information about the option being displayed.

Adding Static and Editable Text

A static text object was created in the preceding piece of code. It is simply a string displayed on the dialog that cannot be changed. This type of text is usually for instructions or labels or units of measure.

The other type of text is editable text. Usually this control shows up as a box for the user to enter a number into or some other small piece of text such as a name. This control is designed to be changed by the user.

To include this control to your dialog, add the following code to the createHighPassDialog() function of **highPassDialog.jsx**:

```
// add a group for the radius parameter
myDialog.optionsPanel.radiusGroup = myDialog.optionsPanel.add('group');
myDialog.optionsPanel.radiusGroup.orientation = "row";

    // add text for the radius description
    myDialog.optionsPanel.radiusGroup.staticText =
myDialog.optionsPanel.radiusGroup.add('statictext', undefined, "Radius:");

    // add edittext field to display the radius value
    myDialog.optionsPanel.radiusGroup.editText =
myDialog.optionsPanel.radiusGroup.add('edittext', undefined, "3.0");
        myDialog.optionsPanel.radiusGroup.editText.preferredSize =[60, 20] ;

    // add a label for units after the edittext field
    myDialog.optionsPanel.radiusGroup.percent =
myDialog.optionsPanel.radiusGroup.add('statictext', undefined, "pixels");
```

Notice that the 'edittext' object is created with a string to display in the field—in this case, "3.0". The preferredSize property is set to 60 pixels by 20 pixels. The size is preferred but not an absolute requirement. It is a suggestion to the layout engine. The reason for it is so that the user has space to type and display numbers with more digits than **3.0**.

Adding a Slider

A slider control provides an easy way to quickly change numeric values in an edit text field. Instead of forcing a user to type a number in the field, this control allows the user to use the mouse to slide the number to the value desired.

Add the following code to the createHighPassDialog() function of **highPassDialog.jsx**:

```
    // add the slider control
    myDialog.optionsPanel.slider = myDialog.optionsPanel.add('slider');
        myDialog.optionsPanel.slider.minvalue = 0.1;
        myDialog.optionsPanel.slider.maxvalue = 250.0;
        myDialog.optionsPanel.slider.value = 3.0;
        myDialog.optionsPanel.slider.preferredSize = [160, 20] ;

    // add tooltips for the slider does
    myDialog.optionsPanel.radiusGroup.editText.helpTip = "The radius value of the filter applied.";
        myDialog.optionsPanel.slider.helpTip = "The radius value of the filter applied.";
```

A slider has a numeric range of possible values. So you want to specify the minimum and maximum values. You also want to specify the starting value. Note the `preferredSize` again—in this case, to stretch the slider to the width of the text above it in the dialog.

The `slider` and the `radiusGroup.editText` work together. Changing the `slider` changes the value of the `radiusGroup.editText` and vice versa. This is behavior code.

Now add the following code to create the new `initHighPassDialog()` function in **highPassDialog.jsx**:

```
// initialize a High Pass dialog so its
// buttons do something when clicked
function initHighPassDialog(myDialog)
{
    with (myDialog)
    {
      // Set the edittext field's value to the slider's
      // value if the slider changes
      optionsPanel.slider.onChanging = function()
      {
          optionsPanel.radiusGroup.editText.text =
optionsPanel.slider.value;
      }
```

```
        // Set the slider's value to the edittext field's
        // value if the edittext changes
        optionsPanel.radiusGroup.editText.onChanging =
function()
        {
            optionsPanel.slider.value = optionsPanel.
radiusGroup.editText.text;
        }
```

These behavior functions for the `slider` and the `edittext` objects are similar to the ones for the buttons. The user interacts with the object, and as a result, something happens. The interaction with each of these objects is that the values can change. So the event property is `onChanging`. As the `value` of the `slider` changes, the `text` displayed by `edittext` is updated. And vice versa. These controls work as a team.

Adding a Pop-up Menu

Pop-up menus are useful for displaying a list of options, but allowing only one selection. Their use in this dialog is like a radio group. But because there are so many options and because the options correspond to a pop-up menu in the **Layers** panel, a pop-up menu makes more sense than a radio group.

To add this menu, add the following code to the `createHighPassDialog()` function in **highPassDialog.jsx**:

```
// add a group for the blend mode pop UI elements
myDialog.optionsPanel.blendPopup = myDialog.optionsPanel.add('group');
myDialog.optionsPanel.blendPopup.orientation = "row";

// add a popup to select blend mode
myDialog.optionsPanel.blendPopup.popUp = myDialog.optionsPanel.blendPopup.add('dropdownlist');
myDialog.optionsPanel.blendPopup.popUp.text = "Select the Blend Mode:";
myDialog.optionsPanel.blendPopup.helpTip = "Choose the blending mode.";

// populate the pop-up with items
myDialog.optionsPanel.blendPopup.popUp.add('item', "Overlay");
myDialog.optionsPanel.blendPopup.popUp.add('item', "Soft Light");
myDialog.optionsPanel.blendPopup.popUp.add('item', "Hard Light");
```

```
myDialog.optionsPanel.blendPopup.popUp.add('item', "Vivid Light");
myDialog.optionsPanel.blendPopup.popUp.add('item', "Linear Light");
myDialog.optionsPanel.blendPopup.popUp.add('item', "Pin Light");

// set the default selected item in the pop-up list to the first item in the array "Overlay"
myDialog.optionsPanel.blendPopup.popUp.items[0].selected = true;

// set the value of the blend mode
myDialog.optionsPanel.blendPopup.popUp.mode = myDialog.optionsPanel.blendPopup.popUp.items[0];
```

The 'dropdownlist' is organized into a group for formatting. It has a text property that is its label. Then 'item' objects are added to it representing the menu items. The first item is the default item both selected and displayed. This control is the option for the blend mode. That mode is set to a new property called mode. As the selected item in popUp changes, the mode property must be updated. Because the mode property is a custom one, a behavior needs to be added to the object to do the updating.

Add the following code to the initHighPassDialog() function of **highPassDialog.jsx**:

```
// set the behavior for the blend menu
optionsPanel.blendPopup.popUp.onChange =
function()
    {
        // Capture any changes the user makes after
        // the dialog is displayed, updating the value
        // of the variable for the blend mode
        optionsPanel.blendPopup.popUp.mode =
optionsPanel.blendPopup.popUp.items[this.selection.
index];
    }
```

As you have seen with other behaviors, a function is created to respond when the user interacts with the control. The selected item in the popUp object can change, so the behavior corresponds to onChange. The function takes advantage of the this object identifier. The this object happens to be the optionsPanel.blendPopup.popUp instance. Rather than type that whole name, you use this as shorthand. The code sets the mode property based on which 'item' is selected.

Adding a Checkbox

Checkboxes, like many of the user interface controls, are familiar. In code terms, the checkbox represents a Boolean value for a variable. Is the variable true or false? Is the box checked or unchecked?

To include this feature to the dialog, add the following code to the createHighPassDialog() function of **highPassDialog.jsx**:

```
// add a check box for flattening when done
myDialog.optionsPanel.flattenBox = myDialog.
optionsPanel.add('checkbox', undefined, "Flatten when
finished");
myDialog.optionsPanel.flattenBox.value = false;
myDialog.optionsPanel.flattenBox.helpTip = "Check
to flatten the layers when processing completed.";
```

Nothing special or fancy here. Just note that the value is set to false, so the dialog does not flatten the layers when processing the dialog results.

Revisiting the OK and Cancel Buttons

You've seen the **OK** and **Cancel** controls before. Add the following code to **highPassDialog.jsx** to complete the createHighPassDialog() function:

```
// add a group box for the OK and Cancel buttons
myDialog.buttonPanel = myDialog.add('group');
myDialog.buttonPanel.orientation = "column";

// add an OK button
myDialog.buttonPanel.okButton = myDialog.
buttonPanel.add ('button', undefined, "OK");
```

```
    // add a Cancel button
    myDialog.buttonPanel.cancelButton = myDialog.
buttonPanel.add('button', undefined, "Cancel");

    return myDialog;
}
```

The difference between this dialog and the **Hello, World** dialog is that there are values to check. The radius value needs to be checked to be sure it is still in the valid range for the option. To perform this check, add the following code to **highPassDialog.jsx** to complete the `initHighPassDialog()` function:

```
        // OK button clicked
        buttonPanel.okButton.onClick = function()
        {
            // Check that the radius value makes sense (that it is a number)
            var radiusValueStr = isNaN(myDialog.optionsPanel.radiusGroup.editText.text);
            if (radiusValueStr == true)
            {
                alert("Please enter a valid number 0.1 - 250 for 'Radius'");
                return;
            }

            // If it is a number, make sure it's between 0.1 - 250 and warn the user if it isn't
                if (! (myDialog.optionsPanel.radiusGroup.editText.text >= 0.1
                  && myDialog.optionsPanel.radiusGroup.editText.text <= 250))
                {
                  alert("You must enter a number between 0.1 - 250 for 'Radius'");
                  return;
                }

            // Close the dialog - OK clicked
            close(1);
        }

        // Cancel button clicked
        buttonPanel.cancelButton.onClick = function()
        {
            // Close the dialog - Cancel clicked
            close(2);
        }
    }
}
```

The `return` calls stop the function from closing the dialog. The user must have valid data entered in the dialog. Note again that the **OK** button returns a 1 and the **Cancel** button returns a 2.

Showing the Dialog

There is nothing new here when it comes to showing the dialog. This code is provided for the completeness of the example. Add the following code to **highPassDialog.jsx** to the FUNCTIONS section:

```
// show the dialog and wait for its return value
function runHighPassDialog(myDialog)
{
    // Display the dialog
    return myDialog.show();
}
```

Retrieving the Results from the Dialog Object

This dialog has many options that need to be gathered from the dialog object. Because the task of this dialog is to create a layer and work with that layer, there must be a document open to work on. That requirement is tested here.

Add the following code to the FUNCTIONS section of **highPassDialog.jsx**:

```
// process the dialog results by showing a message to the user
function processHighPassResults(myDialog)
{
    // be sure there is a document open
    if (app.documents.length > 0)
    {
        // get the user choices from the dialog
        var radius = myDialog.optionsPanel.slider.
value;
        var bIsSharpen = myDialog.optionsPanel.
choiceRadioButtons.radioGroup.radioButtonSharpen.
value;
        var bFlatten = myDialog.optionsPanel.
flattenBox.value;
```

```
        // figure out the blend mode constant
        var userChoice = myDialog.optionsPanel.
blendPopup.popUp.selection.index;
        var blendMode = BlendMode.OVERLAY;

        if (userChoice == 1)
            blendMode = BlendMode.SOFTLIGHT;
        else if (userChoice == 2)
            blendMode = BlendMode.HARDLIGHT;
        else if (userChoice == 3)
            blendMode = BlendMode.VIVIDLIGHT;
        else if (userChoice == 4)
            blendMode = BlendMode.LINEARLIGHT;
        else if (userChoice == 5)
            blendMode = BlendMode.PINLIGHT;

        // run the operation on the activeDocument
        HighPassOperation(app.activeDocument,
radius, blendMode, bIsSharpen, bFlatten);
    }
    else
    {
        alert("This dialog requires a document to be
open to run successfully!");
    }
}
```

Each control still exists, just like the dialog still exists. You could even call `show()` on it again. Because each control still exists, the option value that control represents can be queried or calculated. Some values are Booleans, like sharpness, which comes from the radio group, and flatten, which is the checkbox. The radius is a number, which is the slider's `value` property. The blend mode is trickier. The value from the `popUp` object does not easily line up with the value constants in the Photoshop DOM for `BlendMode`. A big `if else` block figures out the correct blend mode that can be passed to the Photoshop DOM.

The option values are all passed to a new function `HighPassOperation()`.

Processing the Options

The purpose of the dialog is to create a High Pass layer. Sharpening is the localized brightening and darkening of edges in an image. If you choose **Filter** > **Other** > **High Pass...** from the Photoshop menus, you see that it turns the image mostly gray but with edges traced (see Figure 13.11). Using a duplicate layer with this filter and the lighting blend modes results in sharpening. Invert that High Pass layer and it does the opposite—it blurs. The filter has only one value for its option: the radius used to search for edges.

FIGURE 13.11 Showing the before and after of the High Pass filter.

Add the following code to the FUNCTIONS section of **highPassDialog.jsx**:

```
// creates a High Pass Sharpening or Blurring layer
function HighPassOperation(curFile, radius, blendMode,
bIsSharpen, bFlatten)
{
    // add a new layer with a useful name
    curFile.artLayers.add();
    if (bIsSharpen)
            curFile.activeLayer.name = "High Pass
Sharpen (radius " + radius + ")";
    else
            curFile.activeLayer.name = "High Pass Blur
(radius " + radius + ")";

    // move the layer to the top of the layer stack
    var idmove = charIDToTypeID( "move" );
    var desc5 = new ActionDescriptor();
    var idnull = charIDToTypeID( "null" );
    var ref4 = new ActionReference();
    var idLyr = charIDToTypeID( "Lyr " );
    var idOrdn = charIDToTypeID( "Ordn" );
    var idTrgt = charIDToTypeID( "Trgt" );
    ref4.putEnumerated( idLyr, idOrdn, idTrgt );
    desc5.putReference( idnull, ref4 );
    var idT = charIDToTypeID( "T   " );
    var ref5 = new ActionReference();
    var idLyr = charIDToTypeID( "Lyr " );
    var idOrdn = charIDToTypeID( "Ordn" );
    var idFrnt = charIDToTypeID( "Frnt" );
    ref5.putEnumerated( idLyr, idOrdn, idFrnt );
    desc5.putReference( idT, ref5 );
    executeAction( idmove, desc5, DialogModes.NO );

    // merge visible to the layer
    var idMrgV = charIDToTypeID( "MrgV" );
    var desc6 = new ActionDescriptor();
    var idDplc = charIDToTypeID( "Dplc" );
    desc6.putBoolean( idDplc, true );
    executeAction( idMrgV, desc6, DialogModes.NO );
```

```
    // run the High Pass filter on the layer with radius
    curFile.activeLayer.applyHighPass(radius);

    // change layer blend mode to blendMode
    curFile.activeLayer.blendMode = blendMode;

    // blur, instead of sharpen, if needed
    if (! bIsSharpen)
    {
        // invert the layer contents to blur
        curFile.activeLayer.invert();
    }

    // if the flatten check box was checked,
    // then flatten the document
    if (bFlatten)
    {
        app.activeDocument.flatten();
    }
}
```

You probably recognize ScriptingListener code when you see it now. The comments should also help you to dissect this code. Some calls using the Photoshop DOM are mixed in there. This sharpening technique may be new to you, but you can find references to it in other books and on the Internet.

What is important with this code for a more complex dialog is that it is made up of several pieces. Those pieces can be put together one at a time. You can build the dialog piece by piece, testing as you go. All things considered, the **Create a High Pass Layer** dialog is not really that complex. Take a look at the scripts for the dialogs mentioned at the beginning of the chapter. That is a lot of code. It may also be structured differently. With the **Create a High Pass Layer** dialog, we hope you wrote the code and then read the explanation. Being able to read code helps build your skills. You find new ways of doing something familiar and may even encounter things you did not think possible.

Building a custom dialog for Photoshop is work. You must determine whether the task needs a dialog. Perhaps a simple script would work. Perhaps the user interface might work better as a Configurator panel. ScriptUI offers other user interface controls and other ideas worth exploring.

EXPLORATIONS

At the end of Chapter 4, you learned about the idea of mirror diptychs. You may have explored the idea and built an action to create a mirror diptych from any image. That section also mentioned the idea of a grid. A grid places multiple images together in rows and columns, creating a single, larger image. With the right image, you can create mirror grids, like those in Figures 13.12 and 13.13.

Create a custom dialog that gathers the information needed to build a mirror grid and then automatically builds one. That script is simple to build given your knowledge of how to build dialogs and create mirror diptychs. Stretch your skills and build a dialog that can take a folder of images. The grids can be built one at a time from a single image, or built putting all of the images into a single grid. Add options to the dialog about how to rotate the images to fit and handle spacing between each image. This task is trickier, taking more code than you may have written for a single project. There also are some image problems to work out. All of it is doable, however, given how much you now know about scripting and image manipulation.

FIGURE 13.12 Mirror grid of a walkway on Revelle College at University of California, San Diego.

FIGURE 13.13 Mirrored grid of the tail of a Predator drone at MCAS Miramar Air Show.

CONCLUSION

Final Thoughts and Next Steps

If you are reading this section, hopefully you managed to work your way through the whole book. And if that's the case, congratulations! That is not an easy thing to do. Honestly, it is not meant to be. It was meant to help you learn the skills needed to continue your pursuit of controlling Photoshop. The goal of the book is not to do your work for you. The goal is to allow you to do your work better by giving you the knowledge to build your own tools, if you have to. In many cases, you won't have to do more than you do already. But every once in a while, you may require access to the horsepower available in Photoshop.

You can now build your own tools and create many things you might not have known how to create before. This might lead to more business. This might lead to more time to spend the way you want to spend it. This might lead you to find other solutions to problems you had not thought about. Other people might start coming to you for solutions to their problems. You now have specialized knowledge that many people do not and will never spend the time to learn. This may lead you to create new projects that can only be done using some of the new techniques.

Go create new things. Build new tools that make you want to create even more. Do it better and faster than you did before. And have fun.

Adobe References

Perhaps you are the type of person who found working through the examples interesting and challenging. The tasks gave you ideas for even tougher problems to solve and solutions to build. Perhaps you would like to learn even more. There are a few references and technologies from Adobe to check out if you want to go further to improve your control over Photoshop.

The Russell Brown Show: Dr. Brown's Scripts

http://russellbrown.com/scripts.html

Russell Brown routinely gives talks about scripting and automation at conferences such as PhotoshopWorld. He also keeps an eye out for what people are creating in the field. This website has video demos and links to several scripts worth checking out.

Julieanne Kost: Photoshop Videos

http://jkost.com/photoshop.html

Julieanne Kost travels the world teaching people how to use Photoshop better. She also makes videos of many of the topics she teaches. Several of these videos directly cover topics addressed in this book.

Adobe Photoshop Scripting on Adobe Developer Connection

www.adobe.com/devnet/photoshop/scripting.html

This is the official website for Adobe reference material on scripting. Many of the PDF files were installed with Photoshop on your computer and are referred to in this book.

Adobe Photoshop Developer Center on Adobe Developer Connection

www.adobe.com/devnet/photoshop.html

This is the official website for developing technology for Photoshop. This site is for hardcore developers who want to build their own plug-ins, develop Flash panels directly, and build apps to integrate from their tablet computer to Photoshop on their Mac or Windows machine. A lot of this technology requires knowledge of programming in compiled computer languages such as C, C++, or Objective-C. Big power for those with serious skills.

The technology is collectively referred to as the Photoshop SDK but also includes the recent Photoshop Touch technology.

Pixel Bender Technology on Adobe Developer Connection

www.adobe.com/devnet/pixelbender.html

Pixel Bender is technology for those really messing around with image processing. This is similar to building your own filters. On this site, you can follow the links to details about downloading the technology developed by others for everyday use in your own projects.

Photoshop Downloads on Adobe Labs

http://labs.adobe.com/technologies/photoshop/

Configurator was technology that you downloaded through Adobe Labs. Cutting-edge tools and technology and interesting experiments are placed on Adobe Labs. This can be an interesting place to start building something that can really blow people's minds or just offer a solution to a really specialized problem.

Bibliography

Naturally, Adobe is not the only place to find more information about the topics covered in this book. As mentioned before, there are some very good websites devoted to scripting Photoshop. There are also several vendors creating actions for many types of customers. There have even been some other books devoted to similar subjects. Some books were recommended in that first online class on scripting and automation.

- *The Photoshop CS2 Speed Clinic* by Matt Kloskowski, Peachpit Press, 2006.
- *Adobe Scripting* by Chandler McWilliams, Wiley Publishing, Inc., 2003.
- *Photoshop 7 Power Shortcuts* by Michael Ninness, New Riders Press, 2003.

Appendices

WHERE

Are the Files Located

Appendix A: Where Are the Files Located on Mac OS X

Actions (.atn)

/Users/[user name]/Library/Application Support/Adobe/Adobe Photoshop CS5/Presets/Actions/

Adobe Camera Raw Settings (.xmp)

/Users/[user name]/Library/Application Support/Adobe/CameraRaw/Settings/

Color Settings (.csf)

/Users/[user name]/Library/Application Support/Color/Settings/

Event-Only Scripts

/Applications/Adobe Photoshop CS5/Presets/Scripts/Event Scripts Only/

Export Actions for Use in Lightroom (.atn)

/Users/[user name]/Library/Application Support/Adobe/Lightroom/Export Actions/

ExtendScript Toolkit

/Applications/Utilities/Adobe Utilities - CS5/ExtendScript Toolkit CS5/

Keyboard Shortcuts (.kys)

/Users/[user name]/Library/Application Support/Adobe/Adobe Photoshop CS5/Presets/Keyboard Shortcuts/

Menu Customizations (.mnu)

/Users/[user name]/Library/Application Support/Adobe/Adobe Photoshop CS5/Presets/Menu Customization/

Metadata Templates

/Users/[user name]/Library/Application Support/Adobe/XMP/Metadata Templates/

Presets (Swatches, Styles, Gradients, Contours, Patterns, Custom Shapes)

/Users/[user name]/Library/Application Support/Adobe/Adobe Photoshop CS5/Presets/

Proof Setup Files (.psf)

/Users/[user name]/Library/Application Support/Adobe/Color/Proofing/

Script Events Manager Preferences

/Users/[user name]/Library/Preferences/Adobe Photoshop CS5 Settings/Script Events Manager.xml

Scripts

/Applications/Adobe Photoshop CS5/Presets/Scripts/

Tool Presets (.tpl)

/Users/[user name]/Library/Application Support/Adobe/Adobe Photoshop CS5/Presets/Tool/

Workspaces—Modified

/Users/[user name]/Library/Preferences/Adobe Photoshop CS5 Settings/WorkSpaces (Modified)/

Workspaces—Saved

/Users/[user name]/Library/Preferences/Adobe Photoshop CS5 Settings/WorkSpaces/

Appendix B: Where Are the Files Located on Windows XP

Actions (.atn)

\Documents and Settings\[user name]\Application Data\Adobe\Adobe Photoshop CS5\Adobe Photoshop CS5 Settings\Presets\Actions\

Adobe Camera Raw Settings (.xmp)

\Documents and Settings\[user name]\Application Data\Adobe\Camera Raw\Settings\

Color Settings (.csf)

\Documents and Settings\[user name]\Application Data\Adobe\Color \Settings\

Event-Only Scripts

\Program Files\Adobe\Adobe Photoshop CS5\Presets\Scripts\Event Scripts Only\

Export Actions for Use in Lightroom (.atn)

\Documents and Settings\[user name]\Application Data\Adobe \Lightroom\Export Actions\

ExtendScript Toolkit

\Program Files\Adobe\Adobe Utilities\ExtendScript Toolkit CS5\

Keyboard Shortcuts (.kys)

\Documents and Settings\[user name]\Application Data\Adobe\Adobe Photoshop CS5\Adobe Photoshop CS5 Settings\Presets\Keyboard Shortcuts\

Menu Customizations (.mnu)

\Documents and Settings\[user name]\Application Data\Adobe\Adobe Photoshop CS5\Adobe Photoshop CS5 Settings\Presets\Menu Customization\

Metadata Templates

\Documents and Settings\[user name]\Application Data\Adobe\XMP \Metadata Templates\

Presets (Swatches, Styles, Gradients, Contours, Patterns, Custom Shapes)

\Documents and Settings\[user name]\Application Data\Adobe\Adobe Photoshop CS5\Adobe Photoshop CS5 Settings\Presets\

Proof Setup Files (.psf)

\Documents and Settings\[user name]\Application Data\Adobe\Color \Proofing\

Script Events Manager Preferences

\Documents and Settings\[user name]\Application Data\Adobe\Adobe Photoshop CS5\Adobe Photoshop CS5 Settings\Script Events Manager.xml

Scripts

\Program Files\Adobe Photoshop CS5\Presets\Scripts\

Tool Presets (.tpl)

\Documents and Settings\[user name]\Application Data\Adobe\Adobe Photoshop CS5\Adobe Photoshop CS5 Settings\Presets\Tool\

Workspaces—Modified

\Documents and Settings\[user name]\Application Data\Adobe\Adobe Photoshop CS5\Adobe Photoshop CS5 Settings\Workspaces (Modified)\

Workspaces—Saved

\Documents and Settings\[user name]\Application Data\Adobe\Adobe Photoshop CS5\Adobe Photoshop CS5 Settings\Workspaces\

Appendix C: Where Are the Files Located on Windows 7 and Vista

Actions (.atn)

\Users\[user name]\AppData\Roaming\Adobe\Adobe Photoshop CS5
\Adobe Photoshop CS5 Settings\Presets\Actions\

Adobe Camera Raw Settings (.xmp)

\Users\[user name]\AppData\Roaming\Adobe\Camera Raw\Settings\

Color Settings (.csf)

\Users\[user name]\AppData\Roaming\Adobe\Color\Settings\

Event-Only Scripts

\Program Files\Adobe\Adobe Photoshop CS5\Presets\Scripts\Event
Scripts Only\

Export Actions for Use in Lightroom (.atn)

\Users\[user name]\App Data\Roaming\Adobe\Lightroom\Export Actions\

ExtendScript Toolkit

\Program Files\Adobe\Adobe Utilities\ExtendScript Toolkit CS5\

Keyboard Shortcuts (.kys)

\Users\[user name]\AppData/Roaming\Adobe\Adobe Photoshop CS5
\Adobe Photoshop CS5 Settings\Presets\Keyboard Shortcuts\

Menu Customizations (.mnu)

\Users\[user name]\AppData/Roaming\Adobe\Adobe Photoshop CS5
\Adobe Photoshop CS5 Settings\Presets\Menu Customization\

Metadata Templates

\Users\[user name]\AppData\Roaming\Adobe\XMP\Metadata
Templates\

Presets (Swatches, Styles, Gradients, Contours, Patterns, Custom Shapes)

\Users\[user name]\AppData\Roaming\Adobe\Adobe Photoshop CS5
\Adobe Photoshop CS5 Settings\Presets\

Proof Setup Files (.psf)

\Users\[user name]\AppData\Roaming\Adobe\Color\Proofing\

Script Events Manager Preferences

\Users\[user name]\AppData/Roaming\Adobe\Adobe Photoshop CS5
\Adobe Photoshop CS5 Settings\Script Events Manager.xml

Scripts

\Program Files\Adobe Photoshop CS5\Presets\Scripts\

Tool Presets (.tpl)

\Users\[user name]\AppData\Roaming\Adobe\Adobe Photoshop CS5
\Adobe Photoshop CS5 Settings\Presets\Tool\

Workspaces—Modified

\Users\[user name]\AppData\Roaming\Adobe\Adobe Photoshop CS5
\Adobe Photoshop CS5 Settings\Workspaces (Modified)\

Workspaces—Saved

\Users\[user name]\AppData\Roaming\Adobe\Adobe Photoshop CS5
\Adobe Photoshop CS5 Settings\Workspaces\

Index